ART HISTORY

*An Anthology
of Modern Criticism*

ART
HISTORY

An Anthology
of Modern Criticism

EDITED, AND WITH
INTRODUCTORY NOTES, BY
WYLIE SYPHER

GLOUCESTER, MASS.

PETER SMITH

1975

ACKNOWLEDGMENTS

NOTE: Many of the original texts carried lengthy and very specialized footnotes. In the interests of readability and space these footnotes *have not been reprinted* in this anthology. References to illustrations accompanying the original texts have also been omitted, and in some cases long passages in Greek have been omitted and represented by the English translations given in the original text.

The proposal for this anthology came from Andrew Chiappe and Jason Epstein, and Phyllis Seidel with others at Random House have been of the greatest help in dealing with permissions and similar tasks. Nor could the typescript have been completed without the patience, care, and good will of Frances Horton Thompson. Translations from Schoene and Frey were prepared by Marie S. Wells. Translations from Deonna, Will, Baltrušaitis, Francastel, and Cassou are the editor's.

For permission to reprint the selections in this anthology I am indebted to:

The Capitol Publishing Company for selections from *Primitive Art* by Franz Boas, copyright 1927, 1951.

Office International des Musées for "Primitivisme et Classicisme, les Deux Faces de l'Histoire de l'Art," by Waldemar Deonna, in *Recherches,* no. 2, 1946.

The University of Chicago Press for the selection from *Greek Sculpture* by Rhys Carpenter, copyright 1960.

Doubleday and Company for the selection from "The History of the Theory of Human Proportions as a Reflection of the History of Styles" by Erwin Panofsky in *Meaning in the Visual Arts,* copyright 1951.

E. de Boccard, Paris, for selections from *Le Relief Cultuel Gréco-Romain* by Ernest Will, copyright 1955.

Routledge and Kegan Paul for "The Methods of the Byzantine Artist" by Otto Demus in *The Mint,* no. 2, copyright 1948, and for selections from *The Psycho-Analysis of Artistic Vision and Hearing* by Anton Ehrenzweig, copyright 1953.

Jurgis Baltrušaitis for selections from *La Stylistique Ornementale dans la Sculpture Romane* by Jurgis Baltrušaitis, copyright 1931.

Verlag Gebr. Mann, Berlin, for selections from *Ueber das Licht in der Malerei* by Wolfgang Schoene, copyright 1954.

Filser Verlag, Munich, Augsburg, for selections from *Gotik und Renaissance* by Dagobert Frey, copyright 1929.

The Oxford University Press for selections from *Italian Painters of the Renaissance* by Bernard Berenson, copyright 1930, 1948.

Faber and Faber for selections from *The Birth and Rebirth of Pictorial Space* by John White, copyright 1957.

The Warburg Institute, London, for selections from *Architectural Principles in the Age of Humanism* by Rudolf Wittkower, copyright 1949.

Phaidon Press for selections from *Classic Art* by Heinrich Wölfflin, translated by Peter and Linda Murray, copyright 1952.

Dover Publications for the selection from *Principles of Art History* by Heinrich Wölfflin, translated by M. D. Hottinger, copyright 1932.

The Columbia University Press for selections from *Mannerism and Anti-Mannerism in Italian Painting* by Walter Friedlaender, copyright 1957.

Wittenborn and Company for the selection from *The Life of Forms in Art* by Henri Focillon, translated by Charles Beecher Hogan and George Kubler, copyright 1934, 1942, 1948.

The International University Press for the selection from *Psychoanalytic Explorations in Art* by Ernst Kris (and E. H. Gombrich), copyright 1953.

The Executors of the Klingender Estate for the selection from *Art and the Industrial Revolution* by Francis Klingender, copyright 1947.

The Cambridge University Press for the selection from *Academies of Art* by Nikolaus Pevsner, copyright 1940.

Presses Universitaires de France for the selection from "Destruction d'un Espace Plastique" by Pierre Francastel and for "La Nostalgie du Métier" by Jean Cassou, in *Formes de l'Art, Formes de l'Esprit,* copyright 1951.

The Journal of Aesthetics and Art Criticism for "Accident and the Necessity of Art" by Rudolf Arnheim, XVI, September, 1957.

CONTENTS

INTRODUCTION

ouRs has been called an age of criticism, and there are at
least two apparent reasons for the extraordinary vitality
shown by modern critics of the arts. One is that the arts
themselves have been going through a period of feverish
change and activity. When we review what has happened
since Cézanne, Rodin, and Sullivan, we must be convinced
that there have been few eras more revolutionary in paint-
ing, sculpture, and architecture. One of the most invigorat-
ing movements in Western art was Cubism. Developing as
it did from Impressionism and Post-Impressionism, Cubism
spread dynamically into every medium because it ex-
pressed certain fundamental revisions in our living and
thinking. We need not give credit to the Cubists alone for
this thoroughgoing revolution; they simply moved with
the times, with the tide that brought new forms of music,
poetry, science, philosophy, and politics. Cubism was
symptomatic.

In one of his rather misunderstood phrases, Matthew
Arnold said that the critical activity is lower than the crea-
tive, and the belief still lingers that an age of criticism is
sterile, the assumption being that we turn to criticism only
when the creative impulse has played itself out. We have
been told wrongly again and again that the early eight-
eenth century was such an age. We have often believed it
of our own age. But have not some of the most creative
eras in the arts also been ages of intense critical activity?

The Renaissance was such an age. So is ours. Whatever we may think of the modern arts, we can hardly deny that our almost compulsive urge to innovate has brought along with it a criticism that is new. "New Criticism" is a term that ordinarily denotes the theories of a small but influential group of critics of literature. There is also a new criticism of the plastic and pictorial arts, quite as ranging and incisive as the new criticism of literature.

This suggests a second reason for the renovations in modern art-criticism: the fact that so many of our former judgments about the arts, especially about painting and architecture, were phrased by nineteenth-century art historians who were parochial or misinformed. It is surprising, for instance, how some of Ruskin's and Burckhardt's notions lingered on in the background of our minds long after the arts themselves had changed. Revision of such notions was long overdue. Perhaps the Cubists hastened this revision, and its effects on art history were sweeping. There have been radical changes in the interpretation of primitive art, Greek classicism, Early-Christian art, Romanesque and Gothic, the Renaissance, realism, and the relations between art and science, between art and madness, between art and society. The revision is still in process.

We are far enough along in this renovation to pause and take a quick inventory of some of the findings in this new art-criticism. The following selections are samplings from a range of material that cannot possibly be embraced in any anthology. Yet they indicate the directions in which art history has been moving, even if they cannot represent the full scope of its achievement.

I say art history rather than aesthetics because the aesthetician is first of all concerned with the philosophic problem of the nature and meaning of art, its purposes, effects, limits, and relation to reality. There has been a revolution in aesthetics too, which has been described by Susanne K. Langer in *Philosophy in a New Key, Feeling and Form*, and *Reflections on Art*, by Theodore M. Greene in *The Arts and the Art of Criticism*, and, most comprehensively, by Guido Morpurgo-Tagliabue in his great *L'Esthétique Contemporaine*. The present collection is less theoretical and is composed chiefly of passages from art

historians whose studies have modified our views of primitive, Greek, Byzantine, Romanesque, Gothic, Renaissance, and modern works of art. These art historians often prove to be our best critics, and some, like Focillon and Wölfflin, are not afraid of theorizing. So even if these writers are not aestheticians, they frequently deal with aesthetic questions. And because our art criticism is increasingly involved with psychological and social criticism, I have included Ehrenzweig, Kris, and Boas, psychologists and anthropologists whose speculations are directly relevant to art history.

It has seemed best to arrange the selections in a sequence determined as far as possible by the historical periods with which they deal, from archaic to modern. The arrangement is also schematic, for one selection plays off against another: for example, what Boas says of primitive art bears upon Baltrušaitis' analysis of Romanesque sculpture and upon Cassou's discussion of the need for a *métier* in modern art; Schoene's study of light in medieval painting is supplemented by Frey's investigation of Gothic space and time; Berenson's interpretation of the Renaissance is found to be at odds with the inquiry into Renaissance pictorial space made by White and Wittkower; and Klingender and Arnheim will be seen to suggest two different aspects of the relation between technology and art. Many of the essays cluster about the theme of naturalism vs. anti-naturalism in art. Some of them are relevant to literature: for instance, the treatment of Greek classicism by Deonna, Panofsky, and Carpenter. Some have social implications.

A word about social interpretations of art. Obviously the most social of all social art historians are Marxist critics. But there is a lamentable dearth of intelligent Marxist criticism of the arts. I might have reprinted some of Plekhanov or, in spite of its bad reception, Frederick Antal's *Florentine Painting and Its Social Background*. Yet I have settled for selections from Klingender and Pevsner, Francastel and Cassou, non-Marxist historians who take a deeply social view of the arts.

Some readers will wish more attention had been given to sculpture and architecture; but the great bulk of criticism is devoted to painting.

Finally, there is the question of which texts are already easily available, and which are relatively unknown either because they are not in paperback or have not been translated into English. For such reasons I have omitted certain items that might be expected from Sir Herbert Read, from Arnold Hauser's *Social History of Art,* from Charles Seltman's *Approach to Greek Art,* to name a few. Instead, I have offered as fully as space allowed some lesser-known but important passages from French and German writers. My regret is not to have included many other selections: from studies by Roberto Longhi, one of the most talented Italian art historians; from Serge Eisenstein's writings on film, a vital modern art; from Moholy-Nagy and other Bauhaus leaders; from Émile Mâle, whose extended surveys of religious iconology do not easily adapt themselves to anthologizing; from Ernst Gombrich's wise and humane discussion of making and matching in art. These and other exclusions are partially remedied by the list of suggested readings preceding each selection. Even these lists could be indefinitely extended, thanks to the inexhaustible wealth of our current art criticism.

W. S.

ART HISTORY

*An Anthology
of Modern Criticism*

FRANZ BOAS

PRIMITIVE ART *(1927, 1951)*

ARISTOTLE SAID that art is essentially *techne* (craft), and Boas has shown how this is especially true for the primitive artist, who tends to reduce all his representations to formal patterns and conventional motifs because his "feeling for form is inextricably bound up with technical experience." This technical experience is influenced by the tools at the craftsman's disposal and by the fields he must decorate. Since his tools are simple and economical, they encourage him to emphasize the circles, spirals, lines, or other geometric designs he observes in nature. And because there is a blank space to be filled, he may also, for instance, represent a European man by placing a mustache on his forehead. Then too, the craftsman's own feeling for rhythm brings into primitive art a kind of "subjective causality." He is entirely capable of observing nature accurately, but as craftsman he subjects realistic details to patterns that are ornamental, symbolic, traditional, and highly stylized.

Boas' analysis of stylization and realism in primitive art is prefatory to most of the following selections on Greek, Early-Christian, Romanesque, Gothic, Renaissance, and abstract art. The problem of *métier* is basic to all the

arts, and today we find Jean Cassou lamenting the modern painter's lack of training in his craft. It is nothing less than the problem of style itself, and is as relevant to poetry as it is to plastic and pictorial arts. T. S. Eliot has said that the poet has only his medium to exploit—and the oral poetry of the Homeric epic was based upon formulaic phrases and lines, showing the same influences that operated in primitive plastic and pictorial art. This topic has been discussed at length by Albert B. Lord in *The Singer of Tales* (1960) and by Cedric H. Whitman in *Homer and the Heroic Tradition* (1958), as well as by T. B. L. Webster in *From Mycenae to Homer* (1958). The logic of the primitive mind is the theme of Claude Lévi-Strauss in *La Pensée Sauvage* (1962). The irrational logic of primitive art is treated in *The Eternal Present* by S. Giedion, (1962).

THE FORMAL ELEMENT IN ART

(Chapter II)

An examination of the material on which our studies of the artistic value of objects of primitive manufacture are founded shows that in most cases we are dealing with products of an industry in which a high degree of mechanical skill has been attained. Ivory carvings of the Eskimo; fur clothing of the Chukchee; wood carving of the northwest coast of America, of New Zealand, the Marquesas, or central Africa; metal work of Africa: appliqué work and embroidery of the Amur River; pottery of the North American Pueblos; bronze work of ancient Scandinavia are examples of this kind.

The close relation between technical virtuosity and the fullness of artistic development may easily be demonstrated by an examination of the art of tribes with one-

sided industries. While people like the African Negroes or the Malay are in possession of many industries, such as basketry, carving, weaving, metal work and pottery, we find others among whom the range of industrial activities is so narrow that almost all the utensils for their manifold needs are made by the same process.

The Californian Indians present an excellent example of this kind. Their chief industry is basketry. Almost all their household goods, receptacles for storage, cooking vessels, mortars for preparing food, children's cradles, receptacles for carrying loads, are made of basketry. As compared to this industry others employed for the manufacture of weapons and tools are insignificant. The building of houses, of canoes, woodcarving, and painting are only slightly developed. The only other occupation in which an unusual degree of skill has been attained is featherwork. A great deal of time is therefore given to the manufacture of baskets and an unusual degree of virtuosity is found among the basketmakers. The beauty of form, the evenness of texture of the Californian baskets are well known and highly prized by collectors. At the same time the baskets are elaborately decorated with a variety of geometrical designs or by the addition of shells and feathers. Basketmaking is an occupation of women and thus it happens that among the Californian Indians only women are creative artists. They are virtuosos in their technique and, on account of their virtuosity, productive. The works of art made by the men are, as compared to theirs, insignificant.

It so happens that conditions among the northern neighbors of the Californians are reversed. From Puget Sound northward the household goods and implements of the Indians are made of wood, and much of the time of the men is spent in woodworking. They are skilled joiners and carvers who through constant practice have acquired virtuosity in the handling of wood. The exactness of their work rivals that of our very best craftsmen. Their boxes, buckets, kettles, cradles, and dishes are all made of wood, as those of the Californians are made of basketry. In their lives basketry plays a relatively unimportant part. The industry in which they have attained greatest proficiency, is, at the same time, the one in which their decorative art

is most fully developed. It finds expression, not only in the beauty of form of the woodwork, but also in elaborate decoration. Among these people all other aspects of decorative art are weak as compared to their artistic expression in woodwork or in art forms derived from woodwork. All this work is done by men and hence it follows that the men are the creative artists while the women seem to be lacking in inventiveness and artistic sense. Here also virtuosity in technique and artistic productivity go hand in hand.

As a third example we might mention the Pueblo Indians of the Southern United States. In many villages of this region pottery is the dominant industry and in pottery is found the highest expression of art. The form of the clay vessel is characterized by great regularity and it becomes the substratum for decoration. Since pottery is a woman's art, women are the most productive artists among the Pueblos. However, the industrial activities of the Pueblos are not quite so one-sided as those of California and British Columbia. Therefore the men who are experienced in industrial work devoted to ceremonial purposes are not lacking in the ability of artistic expression.

I believe these examples demonstrate that there is a close connection between the development of skill in an industry and artistic activity. Ornamental art has developed in those industries in which the greatest skill is attained. Artistic productivity and skill are closely correlated. Productive artists are found among those who have mastered a technique, among men when the industries are in their hands, among women when they are devoted to industrial activities.

It will be admitted that aside from all adventitious form elements, the product of an experienced worker in any handicraft has an artistic value. A child learning to make a basket or a pot cannot attain the regularity of outline that is achieved by the master.

The appreciation of the esthetic value of technical perfection is not confined to civilized man. It is manifested in the forms of manufactured objects of all primitive people that are not contaminated by the pernicious effects of our civilization and its machine-made wares. In the household

of the natives we do not find slovenly work, except when a rapid makeshift has to be made. Patience and careful execution characterize most of their products. Direct questioning of natives and their criticism of their own work shows also their appreciation of technical perfection. Virtuosity, complete control of technical processes, however, means an automatic regularity of movement. The basketmaker who manufactures a coiled basket, handles the fibers composing the coil in such a way that the greatest evenness of coil diameter results. In making the stitches the automatic control of the left hand that lays down the coil and of the right that pulls the binding stitches over the coil brings it about that the distances between the stitches and the strength of the pull are absolutely even so that the surface will be smooth and evenly rounded and that the stitches show a perfectly regular pattern—in the same way as an experienced seamstress will make her stitches at regular intervals and with even pull, so that they lie like beads on a string. The same observation may be made in twined basketry. In the handiwork of an expert the pull of the woof string will be so even that there is no distortion of the warp strings and the twisted woof will lie in regularly arranged loops. Any lack of automatic control will bring about irregularities of surface pattern.

A pot of well-rounded form results also from complete control of a technique. Primitive tribes make their pottery without the aid of the potter's wheel, and in most cases the potter builds up his vessel by the process of coiling, analogous to the coiling of a basket. Long round strips of clay are laid down spirally beginning at the bottom. By continued turning and gradual laying on of more and more strips in a continued spiral the pot is built up. Complete control of the technique will result in a perfectly round cross section and in smooth curvatures of the sides. Lack of skill will bring about lack of symmetry and of smoothness of curvature. Virtuosity and regularity of surface and form are here also intimately related.

A similar correlation is found in the manufacture of chipped stone implements. After the brittle stone has been roughly shaped it is given its final form either by pressure with an implement that squeezes off long, thin flakes, or

by indirect chipping. In the former case the flaking implement is held in the right hand and by sudden pressure with the point of the flaker long flakes or small bits are removed from the surface. When the worker has attained complete control of this technique his pressure will be even and executed with equal rapidity; the distances between the points of attack will be the same and he will move his flaker in regular lines. The result is a chipped implement of regular form and surface pattern in which the long, conchoidal depressions caused by the flaking off of thin chips are of equal size and regularly arranged.

When indirect chipping is applied the thin part of the object which is to be worked is placed on a hard, sharp edge and by a smart blow on the body of the flint a strong vibration is produced which results in a break just over the sharp edge. In this way, place and size of the flake are perfectly controlled by the expert craftsman.

Quite similar are the conditions in woodwork. The smoothing of large surfaces is generally done with the adze. A skilled worker handles his adze automatically. The strength of the stroke and the depth to which it enters the surface of the wood are always the same and the chips removed have always the same size and form. The workman will also move the adze in even lines and strike the surface at even distances. The result of automatic action is here, also, evenness of surface and regularity of surface pattern.

These conditions are well described by Sophus Müller, who says, "A great part of the work on flint must be designated as luxury, and was done with the sole intent of producing a masterpiece of handiwork. When making an adze blade all that is needed for practical purposes is a good cutting edge. Smoothness of face, back and sides is not necessary, particularly since a large portion of these were covered by the attachment to the handle. With coarse and conchoidal chipping the blade would be equally serviceable. However, the maker wanted to produce excellent stone work, to the making of which he devoted all the care, taste and skill at his command and by this the manufactured objects undoubtedly increased in value.

These objects might be called therefore, in the strict sense of the term, works of artistic industry."

All these examples show that complete automatic control of a technique, and regularity of form and surface pattern are intimately correlated.

However, besides these, attempts at decoration occur in which a mastery of technique has not been attained. Among a few tribes almost all artistic work is of this character. Among the inhabitants of Tierra del Fuego are found only meager examples of painting, lacking in skill. The patterns are simply dots and coarse lines in which the arrangement is the essential artistic element. It is intelligible that a feeling for symmetry may exist without the ability of perfect execution. The modern Bushmen scratch patterns on ostrich eggs which serve as receptacles for water. Here we find the intent to give expression to form but with inadequate means. It is important to note that the same motive, two circles connected by a narrow band, occurs several times in these etchings. The circle might be suggested to the workman by the perforation of the shell of the ostrich egg through which the water is poured out, but the combination can hardly be derived on the basis of Bushman industries. Shall we consider the pattern as the result of the play of their imagination or as an attempt at representation? It seems to me important to note that the neighbors of the Bushmen, the Negroes of the Zambezi, use the same pattern and that rows of triangles and diamonds, such as are used by the Bushmen, are found on their implements also. The pattern may therefore have come from an outside source. Perhaps the decoration on ostrich eggs is poor only on account of the difficulties of handling the material. At least the zigzag patterns, found on a bracelet, show a much greater technical perfection than those found on the ostrich eggs.

Here may also be mentioned the painting and carving of the Melanesians. We see among them a wealth of forms in carvings of excellent technique. In some specimens, particularly from western New Guinea, we find complete mastery of the art. In the majority of cases, however, there is an imperfect control of technique, while there is an

astounding multiplicity of forms. The lines generally lack regularity and evenness. There is no clear proof of a general degeneration of the art and we may perhaps assume that in this case the development of a keen sense for form among all the carvers and painters of the tribe did not go hand in hand with a corresponding mastery of technique. It is not unlikely that foreign influence has led here to an exuberant form perception.

Setting aside any esthetic consideration, we recognize that in cases in which a perfect technique has developed, the consciousness of the artist of having mastered great difficulties, in other words the satisfaction of the virtuoso, is a source of genuine pleasure.

I do not propose to enter into a discussion of the ultimate sources of all esthetic judgments. It is sufficient for an inductive study of the forms of primitive art to recognize that regularity of form and evenness of surface are essential elements of decorative effect, and that these are intimately associated with the feeling of mastery over difficulties; with the pleasure felt by the virtuoso on account of his own powers. . . .

Another fundamental element of decorative form is rhythmic repetition. Technical activities in which regularly repeated movements are employed lead to rhythmic repetition in the direction in which the movement proceeds. The rhythm of time appears here translated into space. In flaking, adzing, hammering, in the regular turning and pressing required in the making of coiled pottery, in weaving, regularity of form and rhythmic repetition of the same movement are necessarily connected. These rhythmic movements always produce the same series of forms. Examples of rhythmic surface forms determined by perfect control of a technique are found in many industries and in all parts of the world. Exquisite regularity of flaking is found in the Egyptian flint knives. It is not so frequent in the flaking of American Indians. The adzed boards of the Indians of the North Pacific Coast bear chipping marks of great regularity that give the appearance of a pattern. On surfaces that are to be painted these marks are often polished off with grit-stone or shark skin, while on unpainted parts they are kept, presumably on account of

their artistic effect. In Oriental metal work the strokes of the hammer are so regular that patterns consisting of flat surfaces originate. Other examples of the artistic effect of the regularity of movement are found in the prehistoric corrugated pottery of the North American South West. The coils are indented by pressure of the fingers and a series of indentations form a regular pattern on the surface. The effect of automatic control is seen nowhere more clearly than in basketry, matting and weaving. It has been pointed out before that evenness of surface results from regularity of movement. The rhythmic repetition of the movement leads also to rhythmic repetition of pattern. This is most beautifully illustrated by the best examples of California basketry.

The virtuoso who varies the monotony of his movements and enjoys his ability to perform a more complex action, produces at the same time a more complex rhythm. This happens particularly in weaving and related industries such as braiding and wrapping with twine. Skipping of strands—that is, twilling—is the source of many rhythmic forms, and twilling is undertaken by the virtuoso who plays with his technique and enjoys the overcoming of increased difficulties.

In many cases rhythmic complexity is clearly the result of careful planning. I have referred before to the rhythmical arrangement on fringes of the Thompson Indians of British Columbia.

Another good example is a double necklace in which the rhythmic series is—

black, red, yellow, green, blue, green,

both in the inner and outer lines while the connecting links have the order

black, red, yellow, green, red, blue. . . .

Like symmetry, rhythmic repetition runs generally on horizontal levels, right and left, although not quite as preponderantly as symmetry.

Piling up of identical or similar forms occurs in nature as often as lateral symmetry. Plants with their vertical succession of leaves, branches of trees, piles of stones,

ranges of mountains rising behind one another, may suggest vertical arrangements of similar elements. However, much more common are repetitions in horizontal bands; of simple arrangements of single strokes in rows; and of complicated successions of series of varied figures that recur in regular order.

It follows from what has been said before that the forms here discussed are not expressive of specific emotional states and in this sense significant.

This conclusion may be corroborated by a further examination of decorative forms.

We have already indicated that the artistic value of an object is not due to the form alone, but that the method of manufacture gives to the surface an artistic quality, either through its smoothness or through a patterning that results from the technical processes employed. However, the treatment of the surface is not controlled solely by technical processes. We may observe that in the art products of people the world over other elements occur that are due to the attempt to emphasize the form.

The application of marginal patterns is one of the most common methods employed for this purpose. In many cases these are technically determined. When, for instance, a woven basket is finished off, it is necessary to fasten the loose strands and this leads generally to a change of form and surface pattern in the rim. The strands may be turned down, wrapped and sewed together, they may be braided, or woven together and left standing as a fringe. In a bark basket the rim must be strengthened by a band, to prevent splitting of the bark, and the band and the sewing set off the rim from the body. A thin metal disk may have to be strengthened by rolling in the outer rim. . . .

Thus we reach the conclusion that a number of purely formal elements, some of which are more or less closely connected with technical motives, others with physiological conditions of the body, and still others with the general character of sense experience, are determinants of ornamental art. From this we conclude that a fundamental, esthetic, formal interest is essential; and also that art, in its simple forms, is not necessarily expressive of purposive action, but is rather based upon our reactions to forms that

develop through mastery of technique. The same elements play also an important role in highly developed art forms. If it is true that these elements are in part not purposive, then it must be admitted that our relation to them is not essentially different from those we have towards esthetically valuable phenomena of nature. The formal interest is directly due to the impression derived from the form. It is not expressive in the sense that it conveys a definite meaning or expresses an esthetic emotion.

It might be thought that this condition prevails only in the domain of decorative art, and that representative art, dance, music, and poetry must always be expressive. This is to a great extent true so far as representative art is concerned, for the term itself implies that the art product represents a thought or an idea. It is also necessarily true in poetry, in so far as its materials are words that convey ideas. Nevertheless a formal element may be recognized in these also, a form element quite analogous to the one we found in decorative art. It determines certain aspects of the characteristic style. So far as representative art is ornamental, the formal principles of decorative art enter into the composition and influence the representative form. In dance, music, and poetry, rhythm and thematic forms follow stylistic principles that are not necessarily expressive but that have objectively an esthetic value. We shall discuss these questions more fully at another place.

REPRESENTATIVE ART

(Chapter III)

While the formal elements which we have previously discussed are fundamentally void of definite meaning, conditions are quite different in representative art. The term itself implies that the work does not affect us by its form

alone, but also, sometimes even primarily, by its content. The combination of form and content gives to representative art an emotional value entirely apart from the purely formal esthetic effect.

It has been customary to begin the discussion of representative art with a consideration of the simple attempts of primitive people or of children to draw objects that interest them. I believe that the art problem is obscured by this procedure. The mere attempt to represent something, perhaps to communicate an idea graphically, cannot be claimed to be an art; just as little as the spoken word or the gesture by means of which an idea is communicated, or an object—perhaps a spear, a shield, or a box—in which an idea of usefulness is incorporated, is in itself a work of art. It is likely that an artistic concept may sometimes be present in the mind of the maker or speaker, but it becomes a work of art only when it is technically perfect, or when it shows striving after a formal pattern. Gestures that have rhythmical structure, words that have rhythmic and tonal beauty are works of art; the implement of perfect form lays claim to beauty; and the graphic or sculptural representation has an esthetic, an artistic value, when the technique of representation has been mastered. When a tyro attempts to create a work of art, we may recognize and study the impulse, but the finished product teaches only his vain efforts to master a difficult task. When man is confronted with a new problem like the building of a house of new, unfamiliar material, he is apt to find a solution, but this achievement is not art, it is a work adapted to a practical end. It may be that the solution is intuitive, that is, that it has not been found by an intellectual process, but after having been solved it is subject to a rational explanation.

Just so when man has to represent an object, he is confronted with a problem that demands a solution. The first solution is not an artistic but a practical achievement. We are dealing with a work of art only when the solution is endowed with formal beauty or strives for it. The artistic work begins after the technical problem has been mastered.

When primitive man is given a pencil and paper and

asked to draw an object in nature, he has to use tools unfamiliar to him, and a technique that he has never tried. He must break away from his ordinary methods of work and solve a new problem. The result cannot be a work of art—except perhaps under very unusual circumstances. Just like the child, the would-be artist is confronted with a task for which he lacks technical preparation, and many of the difficulties that beset the child beset him also. Hence the apparent similarity between children's drawings and those of primitive man. The attempts of both are made in similar situations. A most characteristic case of this kind was told to me by Mr. Birket-Smith. He asked an Eskimo of Iglulik to draw with a pencil on a piece of paper a walrus hunt. The native was unable to accomplish this task and after several attempts he took a walrus tusk and carved the whole scene in ivory, a technique with which he was familiar. . . .

We revert now to a consideration of the simple, crude representative drawings. The most important inference that may be drawn from the study of such representations, graphic as well as plastic, is that the problem of representation is first of all solved by the use of symbolic forms. There is no attempt at accurate delineation. Neither primitive man nor the child believes that the design or the figure he produces is actually an accurate picture of the object to be represented. A round knob on an elongated cylinder may represent head and body; two pairs of thin, straight stripes of rounded cross section, arms and legs; or in a drawing, a circle over a rectangle may suggest head and body; straight lines, arms and legs; short diverging lines at the ends of arms and legs, hands and feet.

The break between symbolic representation and realism may occur in one of two ways. The artist may endeavor to render the form of the object to be represented in forceful outline and subordinate all consideration of detail under the concept of the mass as a whole. He may even discard all details and cover the form with more or less fanciful decoration without losing the effect of realism of the general outline and of the distribution of surfaces and of masses. On the other hand, he may endeavor to

give a realistic representation of details and his work may consist of an assembly of these, with little regard to the form as a whole.

An excellent example of the former method is the Filipino woodcarving. Head and chest show the concentration of the artist upon the delimiting surfaces and an utter disregard of detail. The same method is used in the figure of a harpist belonging to the ancient art of the Cyclades.

In an African mask, the surfaces of forehead, eyes, cheeks, and nose are the determinants of the form which has been treated decoratively with the greatest freedom. There are no ears; the eyes are slits with geometrical ornaments; the mouth a circle enclosing a cross. In . . . a painted carving from New Guinea, the outline of the face, emphasized by the hair line, eyes, and mouth, is easily recognized, but all the other parts are treated purely decoratively.

The opposite method is found, for instance, in Egyptian paintings and reliefs in which eyes, nose, hands, and feet are shown with a fair degree of realism, but composed in ways that distort the natural form and which are perspectively impossible. A still better example is . . . an attempt of one of the best Haida artists from Northern British Columbia to illustrate the story of an eagle carrying away a woman. The face of the woman is evidently intended as a three-quarter view. Facial painting will be noticed on the left cheek; the left ear only is shown as seen in profile; the mouth with teeth is placed under the nose in mixed full profile and front view, and has been moved to the right side of the face. In the lower lip is a large labret shown *en face,* for only in this view was the artist able to show the labret with its characteristic oval surface. The nose seems to be drawn in profile although the nostrils appear *en face.*

In a graphic representation of objects one of two points of view may be taken: it may be considered as essential that all the characteristic features be shown, or the object may be drawn as it appears at any given moment. In the former case our attention is directed primarily towards those permanent traits that are most

striking and by which we recognize the object, while others that are not characteristic, or at least less characteristic, are considered as irrelevant. In the latter case we are interested solely in the visual picture that we receive at any given moment, and the salient features of which attract our attention.

This method is more realistic than the other only if we claim that the essence of realism is the reproduction of a single momentary visual image and if the selection of what appears a salient feature to us is given a paramount value.

In sculpture or modeling in the round these problems do not appear in the same form. Here also attention may be directed primarily towards the representation of the essential, and the same principles of selection may appear that are found in graphic art, but the arrangement of the parts does not offer the same difficulties that are always present in graphic representation. As soon as man is confronted with the problem of representing a three-dimensional object on a two-dimensional surface and showing in a single, permanent position an object that changes its visual appearance from time to time, he must make a choice between these two methods. It is easily intelligible that a profile view of an animal in which only one eye is seen and in which one whole side disappears, may not satisfy as a realistic representation. The animal *has two* eyes and *two* sides. When it turns I see the other side; it exists and should be part of a satisfying picture. In a front view the animal appears foreshortened. The tail is invisible and so are the flanks; but the animal has tail and flanks and they ought to be there. We are confronted with the same problem in our representations of maps of the whole world. In a map on Mercator projection, or in our planiglobes, we distort the surface of the globe in such a way that all parts are visible. We are interested only in showing, in a manner as satisfactory as possible, the interrelations between the parts of the globe. We combine in one picture aspects that could never be seen at one glance. The same is true in orthogonal architectural drawings, particularly when two adjoining views taken at right angles to each other, are brought into contact, or in copies of

designs in which the scenes or designs depicted on a cylinder, a vase, or a spherical pot are developed on a flat surface in order to show at a single glance the interrelations of the decorative forms. In drawings of objects for scientific study we may also sometimes adopt a similar viewpoint, and in order to elucidate important relations, draw as though we were able to look around the corner or through the object. Different moments are represented in diagrams in which mechanical movements are illustrated and in which, in order to explain the operation of a device, various positions of moving parts are shown.

In primitive art both solutions have been attempted: the perspective as well as that showing the essential parts in combination. Since the essential parts are symbols of the object, we may call this method the symbolic one. I repeat that in the symbolic method those features are represented that are considered as permanent and essential, and that there is no attempt on the part of the draftsman to confine himself to a reproduction of what he actually sees at a given moment.

It is easy to show that these points of view are not by any means absent in European art. The combination of different moments in one painting appears commonly in earlier art—for instance when in Michelangelo's painting, Adam and Eve appear on one side of the tree of knowledge in Paradise and on the other side of the tree as being driven out by the angel. As a matter of fact, every large canvas contains a combination of distinct views. When we direct our eyes upon a scene we see only a small limited area distinctly, the points farther away appear the more blurred and indistinct the farther removed they are from the center. Nevertheless most of the older paintings of large scenes represent all parts with equal distinctness, as they appear to our eyes when they wander about and take in all the different parts one by one. Rembrandt forced the attention of the spectator upon his main figures by strong lights, as upon the swords in the great scene of the conspiracy of Claudius Civilis and his Batavians against the Romans, but the distant figures are distinct in outline, although in dark colors. On the other hand, Hodler, in his painting of a duel, draws compelling attention to the points of the

swords which are painted in sharp outline while everything else is the more indistinct the farther removed it is from the point on which the interest of the artist centers.

Traits considered as permanent characteristics play a role even in modern art. Until very recent times the complexion of man was conceived as essentially permanent. At least the strong changes that actually occur in different positions have not been painted until very recent times. A person of fair complexion standing between a green bush and a red brick wall has certainly a face green on one side and red on the other, and if the sun shines on his forehead it may be at times intensely yellow. Still we are, or at least were, not accustomed to depict these eminently realistic traits. We rather concentrate our attention upon what is permanent in the individual complexion as seen in ordinary diffuse daylight. We are accustomed to see the accidental momentary lights weakened in favor of the permanent impression.

In primitive, symbolic representations these permanent traits appear in the same way, sometimes strongly emphasized. It will be readily seen that children's drawings are essentially of the character here described. They are not memory images, as Wundt claims—except in so far as the symbols are remembered and reminders—but compositions of what to the child's mind appears essential, perhaps also as feasible. A person has two eyes which have their most characteristic form in front view, a prominent nose which is most striking in profile; hands with fingers which are best seen when the palms are turned forward; feet the form of which is clear only in profile. The body is essential and so is the clothing, hence the so-called Röntgen pictures in which covered parts are drawn. These drawings are a collection of symbols held together more or less satisfactorily by a general outline, although single traits may be misplaced. The same traits prevail commonly in primitive drawings. When Karl von den Steinen had the South American Indians draw a white man, they placed the mustache as a characteristic symbol on the forehead, for it sufficed to place it as a symbol on the most available space. The Egyptian paintings with their mixture of profile and front views and transparent objects

through which hidden parts may be seen, must be viewed in the same manner. They are not by any means proof of an inability to see and draw perspectively; they merely show that the interest of the people centered in the full representation of the symbols.

When exceptionally great weight is attached to the symbol, so that it entirely outweighs the interest in the outline, the general form may be dwarfed, and forms originate that, from our perspective point of view, lose all semblance of realism. The most characteristic case of this kind is found in the art of the Northwest coast of America, in which the whole animal form is reduced to an assembly of disconnected symbols. A beaver is adequately represented by a large head with two pairs of large incisors and a squamous tail. However, in this case we are no longer dealing with crude representations, but with a highly developed art. Its form proves that in its development symbolic representation has been of fundamental importance.

The second form of representation is by means of perspective drawing, in which the momentary visual impression regardless of the presence or absence of characteristic symbols, is utilized. This method is not by any means absent in the drawings of primitive man as well as in those of children, but it is not as common as symbolic representation. In a way most crude symbolic forms contain a perspective element, although it does not extend over the whole figure, but only over parts which are more or less skilfully put together, so that a semblance of the general outline is maintained. This is the case in Egyptian paintings, in those of Australians, and in North American picture writing. In other cases the art of perspective drawing rises to real excellence. The silhouettes of the Eskimo may be mentioned as a case in point. Their figures are always small, scratched into ivory, antler or bone, and filled with hachure or with black pigment. Form and pose are well done. Although there is generally no perspective arrangement of groups each figure is well executed and renders a single visual impression. We find perspective of groups in the rock paintings of South Africa, not perfect, but indicated by the overcutting of figures and by the

relative sizes of objects near by and of those seen at a distance. Perspective realism of single figures is even more fully developed in the paintings of later paleolithic man, found in the caves of southern France and of Spain. Less skilful efforts at perspective representation are not rare. On mattings from the Congo region, on basketry hats from Vancouver Island rather clumsy attempts have been made. In those from the former region there are animals in profile, in the latter whaling scenes: men going out in a canoe and hauling in a harpooned whale.

Much more common are carvings in wood, bone or stone, or pottery objects that are not symbolic but true to nature. Ivory carvings of the Eskimo, Chukchee, and Koryak, prehistoric carvings, pottery from North America are examples.

As stated before, a sharp line between the two methods of graphic representation cannot be drawn. In most cases symbolic representations are at least in part perspective, either in so far as the general form is maintained, or as parts are shown in perspective form; while perspective representations may contain symbolic elements. When the Pueblo Indian paints the form of a deer with a fair degree of perspective accuracy, but adds to it a line running from mouth to the heart as an essential symbol of life; or when the symbols are arranged with a fair degree of correspondence to perspective order we have forms in which both tendencies may be observed. Indeed, some degree of conventional symbolism is found in every drawing or painting, the more so, the more sketchy it is; in other words, the more the representation is confined to salient traits. This is particularly true in all forms of caricature.

If representative art did develop into absolute realism, stereoscopic color photography would be the highest type of art, but this is obviously not the case. Setting aside the emotional appeal of the object itself, an accurate copy of a natural object, such as a glass flower, a painted carving, an imitation of natural sounds or a pantomime may attain an intense emotional appeal, they may excite our admiration on account of the skill of execution; their artistic value will always depend upon the presence of a formal ele-

ment that is not identical with the form found in nature.

Stress must be laid upon the distinctive points of view from which the two methods of graphic representation develop, because the development of perspective drawing is often represented as growing out of the cruder symbolic method. As a matter of fact the two have distinct psychological sources which remain active in the early, as well as in the late history of art. Vierkandt designates the various methods of representation as suggestive (*andeutend*), descriptive (*beschreibend*), and perspective (*anschaulich*). Of these the former two correspond to what I have called here symbolic. They differ only in the more or less fragmentary character of the symbols. The perspective type does not develop from the former two as the result of an evolution; it is based on a distinct mental attitude, the early presence of which is manifested by the realistic, perspective paintings of a number of primitive tribes.

The theory of a continuous development from symbolic to realistic art is one of the numerous attempts to prove a continuous development of cultural forms, a steady, unbroken evolution. This viewpoint has had a deep influence upon the whole theory of ethnology. Evolution, meaning the continuous change of thought and action, or historic continuity, must be accepted unreservedly. It is otherwise when it is conceived as meaning the universally valid continuous development of one cultural form out of a preceding type, such as the assumed development of economic forms from food gathering through herding to agriculture. In past times these three stages were assumed to be characteristic of all human development, until it was recognized that there is no connection between the invention of agriculture and the domestication of animals —the former developed through the occupation of woman who gathered the vegetable food supply, the latter through the devotion of men to the chase. The men had no occasion to become familiar with the handling of plants, and the women had just as little opportunity of dealing with animals. The development of agriculture and of herding can, therefore, not possibly be derived from the same sources.

It is no less arbitrary to assume that social forms must have developed in regular universally valid sequence, one certain stage always being based on the same preceding one in all parts of the world. There is no evidence that would compel us to assume that matrilineal organizations always preceded patrilineal or bilateral ones. On the contrary, it seems much more likely that the life of hunters in single family units, or that of larger groups in more fertile areas has led to entirely different results. We may expect continuous evolution only in those cases in which the social and psychological conditions are continuous.

After this brief excurse, let us revert to our subject. Representations become works of art only when the technique of their manufacture is perfectly controlled, at least by a number of individuals; in other words, when they are executed by one of the processes that are industrially in common use. Where carving is practiced, we may expect artistic form in carvings; where painting, pottery, or metal work prevail, artistic form is found in the products of those industries in which the highest degree of technical skill is attained. The Eskimo carves in ivory, antler or bone, of which he makes his harpoons and many other utensils; his best representative work is made with the knife and consists of small carvings and etchings in which he applies the same methods that he employs every day. The New Zealander carves in wood, makes delicate stonework, and paints; his best representative work is made by these methods. Metal work and ivory carvings from Benin, headmasks from the Cameroons, woodcarvings from the Northwest coast of America, pottery from Peru, from the Yoruba country, Central America and Arkansas, basketry of the Pima, embroideries and woven fabrics of the Peruvians, are other examples.

Since representations that are intended to have artistic value are made in the most highly developed technique it is not surprising that the formal style of the technique gains an influence over the form of the representation. The angular lines of weaving with coarse materials and the steplike forms of diagonals which are determined by this technique impress themselves often upon representations and become part and parcel of a local style. There develops

an intimate relation between the formal and representative elements that brings it about that representation receives a formal value entirely apart from its significance. The deeper the influence of the formal, decorative element upon the method of representation, the more probable it becomes that formal elements attain an emotional value. An association between these two forms of art is established which leads on the one hand to the conventionalization of representative design, on the other to the imputation of significance into formal elements. It is quite arbitrary to assume a one-sided development from the representative to the formal or *vice versa*, or even to speak of a gradual transformation of a representative form into a conventional one, because the artistic presentation itself can proceed only on the basis of the technically developed forms. At another place we shall discuss this subject more fully.

In all aspects of life may be observed the controlling influence of pattern, that is, of some typical form of behavior. As we think in a pattern of objective, material causality, primitive man thinks in a pattern in which subjective causality is an important element. As our personal relations to blood relatives are determined by the pattern of our family, so the corresponding relations in other societies are governed by their social patterns. The interpretation of the pattern may change, but its form is apt to continue over long periods.

The same stability of pattern may be observed in the art products of man. When a definite type has once been established, it exerts a compelling influence over new artistic attempts. When its control continues over a long period it may happen that representations are cast in an iron mold and that the most diverse subjects take similar forms. It appears then as though the old pattern had been misunderstood and new forms had developed from it. Thus, according to Von den Steinen, the figurines on carvings from the Marquesas, which originally represented two figures back to back, have determined the type of entirely new representations, or, as he prefers to put it, they have been misunderstood and developed in new ways. I do not doubt that in some cases this process of misin-

terpretation occurs, but it is not the one that interests us at this place. Striking examples of the overmastering influence of a pattern may be found in many parts of the world. The style of the Northwest coast of America is so rigid that all animal figures represented on plain surfaces are cast in the same mold; the overwhelming frequency of the spiral in New Zealand is another example; the interwoven animal figures of early medieval Germanic art; the angular patterns of the North American Indians; all these illustrate the same condition. In an art, the technique of which does not admit the use of curved lines and in which decorative patterns have developed, there is no room for curved lines, and the curved outlines of objects are broken up into angular forms. The patterns, or as we usually say, the style, dominates the formal as well as the representative art.

However, the style is not by any means completely determined by the general formal tendencies which we have discussed, nor by the relations between these elements and the decorative field, but it depends upon many other conditions. . . .

WALDEMAR DEONNA

PRIMITIVISM
AND CLASSICISM—
The Two Faces
of Art History (1946)

ALTHOUGH THIS ESSAY may seem overschematic, it indicates how the conventional esteem for classic art has been modified by our recent concern with the primitive. Whereas it was once assumed that primitive art is inferior to classic art, Deonna is now quite conservative in proposing that the arts generally offer us two faces, primitive and classic, and that one is not necessarily superior to the other. It should be evident that Deonna has intentionally oversimplified the contrasts between these two orders of art, and that we often find, as we do in Gothic, the primitive mingling with the classic, or one phase sliding over toward the other. Nevertheless, this essay is a summary phrasing of one of the main themes of modern art-criticism, and it will suggest why, by common consent, African sculpture (when-

ever it is authentically primitive) is now acknowledged to be one of the great artistic accomplishments of man. Thus Deonna's contrasts are an axis about which revolve many of the preceding and following selections. The contrast of primitive with classic, as here stated, involves some of the points made by Adolf Hildebrand in his famous essay on "The Problem of Form in Painting and Sculpture," first published in 1893. Hildebrand argues that artistic form is never actual form, since there must be a translation from cubical to visual, from three-dimensional to two-dimensional in sculpture as well as painting. To avoid the "disturbing" or "agonizing" quality of the cubical, it must be translated to a relief-view; otherwise the unity of the artistic "idea" of the object is lost. Even a statue must be seen as existing in an ideal visual plane.

Deonna's extended study of primitive and classical mentalities is his three-volume *Du Miracle Grec au Miracle Chrétien* (1945-48). Werner Schmalenbach's *African Art* (1954) illustrates many of Deonna's categories of the primitive. There is a disconcerting reinterpretation of the "classic" Greek mentality in E. R. Dodds' *The Greeks and the Irrational* (1951, 1957), which may raise some doubts about Deonna's views.

PRIMITIVISM
AND CLASSICISM—
The Two Faces of Art History
(from *Recherches*, no. 2, 1946)

The Constants of Art. As a classical archaeologist I have wished to know what that miracle of Greek art was of which we have so often spoken without ever giving exact explanations. Yet I have readily seen that if we want to understand the deep originality of Greek art, we cannot isolate it from other ancient arts; on the contrary, we

must constantly compare it with them—with Egyptian and Eastern arts, for instance—to throw light on basic differences between them. But these very differences, this very contrast I found in antiquity, I rediscovered in later Christian eras in similar technical and spiritual expressions.

Two Conceptions of Art. Is not the reason for this that under the changing and local aspects which give the arts their own character so decisively that one cannot mistake an Egyptian for a Roman statue or a Greek figure for a Gothic one, all are governed by certain general laws, and, there being a lasting opposition between them, by two fundamentally different artistic conceptions? This basic contrast, these "historical constants," have sometimes been noted by certain writers like Strzygowski, Wölfflin, d'Ors, etc., without, however, their drawing all the inevitable conclusions and without their seeing that they apply not only to some artistic periods but to the whole history of art from its origins to our day.

TWO CONCEPTIONS OF ART

Classic Conception. The Art of Optical Representation. The artist is inspired by the surrounding forms of his world: men, beasts, nature, various things; he notes them accurately with an "optical vision," and by an "optical transcription" he can render them as they appear to him. They interest him for many reasons, but also and more and more for themselves, for their own character, for the aesthetic sentiment he feels in seeing and representing them. This representation of reality affords many nuances. It can be transformed by the artist's ideas, by his aesthetic sense; it is none the less true that it is basically exact observation. Beautiful and idealized as they may be, Phidian or Renaissance statues, and the Greco-Roman Faiyum painting, or paintings of the sixteenth century, represent a humanity and a nature that are answerable. Yet once committed to this sort of imitation, art is led by a logical extension of this method to carry it to its conclusion and to render reality with increasing exactitude in its incidental features, constantly changing. Unavoidably it becomes naturalistic; and thus the idealism of the Greek fifth century and the

Christian thirteenth is followed by the still timid realism of the fourth and the fourteenth centuries, then the frank realism of the Hellenistic and the fifteenth centuries. At the close of this development, art purports to give a complete illusion of reality in forms that are no longer anything but a servile copy. Such a conception is "objective"; art is an "imitation"; the artist submits to actuality. It is the conception of Greek and Christian "classicism," and I call it "classic" or "modern."

"Primitivist" Conception. Abstract Art. In other cases the artist can be inspired by actuality, but not at all for the purpose of reproducing it as he sees it. On the contrary he distorts it or "denatures" it by mental patterns; actuality does not interest him for its own sake, but as a means of serving his practical needs, his desires, his notions, or an aesthetic feeling independent of actuality. Actuality is merely an accessory for him, so much so that he can transcend it and create fields of imaginary designs without reference to it, as is the case in the almost entirely ornamental art of the Arabs or Merovingians. Such art is "abstract," "subjective"; far from submitting to actuality, the artist subjects it to himself. I call this conception "primitive," or, rather, "primitivism": it is the conception of all the ancient arts outside Greece when they were not under Hellenic influence; it is likewise that of Muslim arts, and Christian art when it is not classic.

The Primacy and Universality of Instinctive Primitivism. If I call it such, I do not imply that it is peculiar to "primitive" arts in a rude state, but to indicate that it is instinctive and therefore universal. Doubtless it inevitably appears in all the arts at their origin, ancient or modern, and in all "primitive" arts whether the primitives be children, folk artists, alienated artists, or unskilled artists of any kind—in all those who have a regressive technique. There the primitivist mentality is linked with the limitations of a maladroit method, or with a hand which is yet unable or no longer able to transcribe the complexity of forms and which reduces them instinctively to easier patterns.

Primitivism Intentionally Preserved. Yet it is not through incompetence that primitivism has remained the

mode of all ancient and modern arts except classicism, and that it always reappears whenever classicism wears away. Often it is kept because it is suited to the ends assigned to art and to the needs it must fill, which are not at all those of classicism. In some cases these preferences have been sustained by habit, tradition, or infirmity of aesthetic sense: Eastern, Punic, Iberian, Gallo-Roman arts, etc. Other arts, again, have remained faithful through religious or social tradition, even while having a technical facility brought to perfection, allowing them to create any kind of semblance, or while being endowed with a mature aesthetic sense: such are the arts of ancient Egypt and Byzantium. If primitivism triumphs at the end of the ancient world and destroys classicism, the reasons are not solely technical, social, or economic regression, but also that it suits a general cast of mind which is no longer classical. And the renewed primitivism of certain modern artists is similarly the expression of a deliberate anti-classical tendency. For, since it is instinctive, primitivism is the only alternative when one rejects classicism. Primitivism always reappears when one wearies of classicism and seeks something else.

Acquired and Temporary Traits of Classicism. The very notion of classicism is neither instinctive nor universal. Art never originates in an optical imitation of reality; on the contrary, this latter occurs only belatedly after art has passed through a primitive phase. Greece itself, primitivist at first, only by way of the archaic began to discern the classic, which it brought to fulfillment about 500 B.C., thereafter exhausting its possibilities. From its origins to the twelfth century, Christian art reverted to primitivism, and was not freed from it until the Gothic thirteenth century, which again, after several attempts at recovering the classic mentality, reëstablished this mentality and imposed it throughout the period lasting to our own day.

Because it is a belated growth, and in a sense abnormal, classicism is wont to vanish, whereas primitivism abides; and similarly, in man himself the most recently acquired abilities are the first to disappear with the onset of age and a weakening of faculties. In paleolithic culture, whose vast evolution is obscure to us in its details, art,

after its two-dimensional instinctive vision, reached an optical three-dimensional vision during the Magdalenian era, and modeled animals spatially in paintings of graduated hues. But this last phase was followed during the Azilian and Neolithic ages by a return to instinctive schematism. At the close of antiquity, Greek classic art was conquered by the primitivism which had survived in muted form within it and which had always persisted abroad. The classicism recovered in Christian art could not obliterate the primitivism which, still tentative in its appearances in flamboyant Gothic, in Baroque, in rococo, openly struggles against the classic in our own day without our being able to say which of the two will triumph.

From these two conceptions—objective, optical imitation and subjective, abstract representation—derive many artistic consequences opposed to one another.

SOME TRAITS OF PRIMITIVISM

Man and Nature. Primitive arts do not accord man a dominant or exclusive status. Some do represent him because he is part of the environing world and because his figure is useful in conveying social or religious meanings; but they do not make man the center of all that interest which also attaches to other representations—beasts, plants, landscape. Still other arts make only very limited use of the human figure; some neglect it almost entirely. So it is in Iranian arts devoted to landscape; or in Scythian, given chiefly to animals; or in Celtic, which is ornamental. These agree in this common trait, more or less pronounced.

For them the aspects of nature are not entirely divorced from one another or isolated by firm boundaries. They mutually interpenetrate, being linked with each other in many strange combinations of elements borrowed from flora, fauna, and man. All primitive arts like to create fantastic beings, gatherings of monsters in religious or ornamental roles—Egyptian, Mesopotamian, Aegean gods and demons, the beasts of Romanesque cathedrals.

Lack of Regard for the Human Body. They do not feel obliged to revere the integrity of man's body, and they treat it arbitrarily. According to their sundry needs,

they stretch or shrink it out of all likeness; within a stone block the Mesopotamian cuts an absurdly squat figure not four and a half heads tall; the body submits to the exigencies of the field to be decorated: lengthening, contracting, twisting as in Romanesque art. The very organs are deformed: the ear, the eye, the head grossly enlarged when their magical or symbolic meaning is stressed. For kindred reasons, or by mere ornamental fantasy, the body is cut up: there are isolated heads, hands, legs. In the same figure, one of the organs is multiplied—head, arms, breasts, etc. Several bodies fuse with each other. A torso may be covered by inscriptions or even with ornaments having no relevance to it, as if it were only a field to be decorated. In a word, there are a thousand possibilities all springing from the same motif.

Ornamental Character. Primitive arts are basically ornamental. In them reality must accommodate itself to distortions and decorative schemes. Supremely ornamental, Scythian, Celtic, Coptic, Arabian, and Irish arts delight in the play of masterly line. Whenever they accept the human figure (and they readily avoid it), it must bend to that law and transform itself wholly or partially to ornament. All ancient Eastern arts schematize hair, beard, garments into whorls, shells, flamelets, etc. Among Celts and Gallo-Romans, the hair is treated in S-characters or half-circles, by which they convey meaning. Similarly, in Irish art the whole body disintegrates into one large ornament.

Intellectual Realism. In such arts there is another reason for altering actuality, which should not be rendered as it appears to us, but as it *is*, unchanging in itself, conceived mentally in its most imperious logical clarity. The body is hidden by a garment that covers it; figures in groups mutually hide each other; motion alters aspect by foreshortening; distance makes those in the background seem smaller—such are accidental disturbances we must disregard. Primitives replace our optical realism by intellectual realism. Thence many of the formulas and conventions which seem bizarre to us, but which are perfectly logical and clear to them—and to us, too, when we are aware of their basis. Thence those figures with eyes fullface in profiled heads, or profiled heads on frontal torsos, or

frontal torsos with profiled legs, each organ being shown in the position stressing it and giving it maximum legibility. The body appears through the garment as if it were nude, just as a child shows a man's legs through his breeches or his teeth through a closed mouth. There is no foreshortening, no perspective, as we know it; primitive perspective uses different formulas, arranging figures of the same height one behind the other, placing them side by side, ranking them at the same level, etc.

Arts of the Surface. Ornamental as it is and not attempting to show actuality as it looks, primitivism assigns art the primary task of covering surfaces, subjecting its figures to architecture or the architectural field or the surface of utensils. The field is closed; men and things crowd into it in silhouette, lacking depth, according to a law of intellectual realism, not seeming to sink into a distance as they do in foreshortening and modern perspective. Its tendencies are toward drawing or relief; and painting is also flat—high relief being unknown. When isolated, the figure is meant to be seen frontally as if it were set upon an ideal plane, therefore lacking depth and not revolving. Moreover, the statue-in-the-round, except in Egypt, where it was needed for magical rites of cult and burial, is rare; and one can soon enumerate the Hittite, Assyrian, Persian, Achaemenian, Parthian, or Sassanid free-standing statues. Everywhere the figure is shallow, stenciled upon the surface instead of being embedded in it; the anatomical details and folds in drapery are often reduced to thin tracings. In brief, this vision of reality is contained within only two dimensions. Similarly, wherever primitivism rules, it is hostile to *fleshliness;* it lightens or suppresses high relief, flattens carving, which tends to be no more than engraving as one finds it in Byzantine art and in Western Christian art of the High Middle Ages; it rejects foreshortening and accurate perspective.

Repetition. Without resisting, the artist yields to his instinctive tendency to repeat. Figures follow each other in duplicate, often without any change in pose, dress, feature to differentiate them or give them individuality. Folds in drapery are parallel, as if, one fold having been traced, there was no attempt to think of anything different.

Statues have only a few postures, standing, seated, etc., repeated monotonously. Usually the faces remain apathetic, neutral, unemotional, and, except in Egyptian portraits, without individuality.

The Geometric Spirit. There is no attempt to render the complexity of life, the varying contours of beings and things, which are reduced to abstract designs. In drawings, the body easily becomes rectangular or triangular; in sculpture there are cubes and cylinders; garments fall in parallels, curves, or splaylike fans, but everywhere rigid and regular.

Symmetry. Symmetry dominates primitive arts, which repeat the same detail time after time around a central point or along a real or ideal axis. A rigid frontality stiffens the body, reiterates the same features and details at right and left of a vertical median. Some figures have an absolute symmetry in posture, hair, dress, gesture. Anatomically, this symmetry unifies the irregularity of organs: in Egypt, the two sides of the knee are exactly alike, which is contrary to actuality. Egyptian and Eastern compositions are balanced about a center, animals and persons being copied one after another, but reversed.

Lack of Observation. Such conditions hinder freedom of observation. Whenever he wanted to, the Egyptian artist could see and render actuality with precision. However, his errors—in transcribing anatomy, for instance— were frequent. Curiously enough, instead of his observation becoming more exact with the passing of time, it weakened; the most accurate works are those of the first dynasties, attesting a care for exactitude one does not find later. Constant study of the model, which alone leads to correcting errors, is not required of the artist since he does not intend to copy reality and since he must, as we shall see, repeat traditional formulas, employing a figurative language rather than actual life.

Utility. All man's activities have at their start a basically practical role, an immediate utility, whether secular or magical or religious. Primitive arts are, and remain, applied or "interested." They are auxiliary to the religion that created them; they are part of it; they serve

the gods, the dead; they fill the needs of kings and noble-men. Conservative as it is everywhere, social constraint and religion, especially, keep art traditional and impede its free evolution.

Art-Language. Primitivism expresses its ideas and its social needs by art, and considers art as a language inherent in matter. Primitive graphic art phrases religious impera-tives, voices beliefs, recounts the exploits of gods and kings; a statue expresses a notion of the divinity, giving him a body of stone in which he can magically incarnate himself as the soul of the dead incarnates itself in an effigy; it commemorates an act-of-faith by the dedicant. Art embodies symbols. Writing and art, having a common origin, merge and work to the same end. Obsessed above all by the idea he must express, the artist takes appear-ances as only accessory, and this conviction is an obstacle to accurate and beautiful rendering; like tradition, it fixes forms and hinders their evolution.

Aesthetic Interest Secondary. The main thing being to produce a work that is useful rather than accurate or beautiful, aesthetic concern is subordinate. It is even absent in certain primitive arts, which thus rob them-selves of a strong motive for change.

Lack of Individualism: Anonymity. The artist's indi-viduality plays only a minor part. Subject to social re-straints that demand a repetition of sanctioned formulas, the artist can hardly innovate or express his originality. Rare indeed are names of Egyptian, Oriental, or even Byzantine artists that have come down to our own day. These arts are above all anonymous.

Evolution: Tradition. They show no consistent evolu-tion in the sense of progress modifying forms, one devel-oping into another. Egyptian art seems to have been wholly formulated during the first dynasties, and its most perfect specimens are the most ancient. From the start, primitive principles were sustained by an imperious tradition which the stifled desires for truth, reason, life, and beauty could not resist. Until the end, tradition ruled them.

All ancient and modern primitive arts do not reveal, perhaps, every one of these traits, but they do reveal at least most of them; and one can find them as easily in

Eastern (Byzantine) or Western Christian arts as in those of Egypt or Mesopotamia.

SOME TRAITS OF CLASSICISM

Contrast these traits with those of classicism as we see it in Greece after the fifth century B.C. and in all arts associated with a kindred conception.

Supremacy of the Human Body. Man is the measure of everything, dominating artistic thought to the point of making other aspects of nature, animate or inanimate, only accessory, or even ignoring them entirely in certain eras. Man alienates himself from nature, with which primitivism willingly identifies him; he opposes himself to it. Classicism isolates man upon an exalted pedestal; his body inspires sculpture and design, controls technical experiments, and almost alone stimulates aesthetic feeling.

Reverence for the Human Body. Classicism takes it as contrary to man's dignity to dehumanize the body, by which it is charmed. It no longer treats man as dismembered or merged with beasts or plants in monstrous forms. It progressively abandons these fantastic creatures, which reappear only under the influence of its rival.

Revolt from the Decorative Spirit. Classicism is also hostile to the decorative mode that distorts natural forms, which classicism would represent as they are. What a difference between nude or draped figures of the fifth century, so simple and accurate, and the statues with complicated hair and garments in Chaldean or Roman arts!

Optical Realism. Classicism replaces intellectual realism by optical realism, which requires a rendering of things as they look to the eye. In design, no more mingling of figures disparately fullface and profile; but through foreshortening, the true postures of bodies turning in space; and through perspective, their position and scale conforming to the beholder's vision. In statues, no more frontality, but a relaxation of posture, whether still or moving.

Volume. Classic art favors plasticity. Statuary, brought into the foreground because it enhances the human figure, becomes truly volumetric, a solid surrounded by air, about

which one can circulate and get satisfying multiple views. Through foreshortening and perspective the figure in painting or relief is immersed in depth, which seems like a window opening into the distance. The modeling is no longer shallow or linear, but solidly fills the folds of drapery and follows the ridges and hollows of hair, eyes, lips, muscles. The resources of light, ignored by primitive art, are enlisted to make the body mobile in light and shadow, with modulated colors to give an illusion of aerial perspective.

Diversity, Complexity of Life, Precise Observation. The artist aspires to the variety of life and nature, where one being or object never is exactly like another. Contrast Eastern friezes, where figures proceed in series, with the Panathenaean procession, where one figure is never identical with its neighbor, but is itself alone, individualized by some variation in pose, gesture, and dress. The drapery on any figure reveals the same care to avoid repetition of folds in either contour, breadth, depth, or arrangement. The poses no longer are stereotyped, whether in sculpture by a law of frontality or in drawing by the two-dimensional conventions that are dominant outside classicism. They are as various and accurate as those in life. One could cite innumerable instances of Greek art that oppose the spirit of diversity to that of repetition. Simply because the classic artist would imitate life, his precise observation focuses on rendering with the greatest exactitude not only a diversity of posture but also of form, position, scale of organs in the body, its anatomy, the fall of garments, the personal traits of figures, their age, their beauty or ugliness, their expressions, their feelings. After the monotonous abstractions of primitivism comes the varying appearance of actuality. Eupompos the painter said to the sculptor Lysippus, "One must imitate nature, not the artist's work." The Greek artists had no need of such advice to study their models with growing mastery, while their primitive confrères for centuries repeated the work of those who preceded them, making changes that were insignificant because these changes did not get at basic principles themselves.

Abandonment of Symmetry. No longer was there

rigid symmetry. Frontality, which is a sort of facing, was broken, and soon all similarity between two sides of a figure ceases, in pose, gesture, details of drapery, bosses of hair. In pedimental compositions, on vase paintings, the masses balance, one passage equating with another but without ever being a stereotype of the other.

Abandonment of the Geometric Spirit. There was no longer a geometric formula for the body, or anything contrary to the modifications in life with its changing contours.

Secularization: Humanization. As elsewhere, art begins in Greece by being almost entirely in the service of religion, and religion always has an effect on it. But gradually art is obliged to yield to influences that tend to secularize it and lead to development. The gods, already so human, further anthropomorphize themselves to the degree of becoming plain mortals engaged in sundry human tasks, with forms that lose their ideal grandeur until they are little more than beautiful bodies. Having reduced the gods to his own plane, man demanded for himself an ever nobler role. Primitivism served religion and spiritual needs above all; classicism threw off this yoke to satisfy human desires.

Abandonment of an Art-Language. Greek art is likewise a language. But in opposition to primitivism, where idea prevails over expression, the form now tends to prevail over the idea. The images of gods, the mythical legends, are increasingly emptied of their deeper meaning to become primarily pretexts for representing beautiful forms and bodies, too often without spiritual life. Imitation of actuality and a quest for beauty drew classicism toward that decline which proved to be destructive and into which it sank during its Christian phase.

Aesthetic Sense. Here the aesthetic sense is more important than utility, serving the artist as an effectual motive for change and refinement. The images of gods are no longer intended to excite only religious fervor nor are they devised only for ritual purposes; they must stimulate aesthetic feeling. The wish for beauty often triumphs over tradition. It wipes from the body features that injure the integrity of the flesh; it accepts ideal nudity, drapery—

either for its own sake or in relation to the nude—and normal postures. It encourages the artist and spectator to see a flawless body. More artistic than other folk, the Greeks treat as subsidiary the notion of practicality, especially religious practicality, to make beauty triumph as an end in itself. Christian classicism will follow the same course, freeing itself from devotional uses in order to secularize art and make the aesthetic quest dominant in it.

Reason. Reality and beauty—but also reason. The willful distortions of the human body, its malformations and grotesqueness, its decorative oddities do not bother primitivism by their abnormalities, because primitivism does not seek *vraisemblance*. The classic subdues everything to the control of reason, in art as in other activities. It perceives the fantasticality of those mental constructs uniting in the same figure features seen fullface and in profile, or of a perspective in which buildings are above each other and trees all in the same plane; it knows that the rigid, monotonous attitudes in primitivism are not at all those in changing actuality. It is offended by monstrous images, almost wholly rejecting them; or if it keeps them, it rationalizes them and makes them plausible.

Individuality. Primitivism is not congenial to individualism. But one of the characteristic traits of the classic spirit is precisely its individualism, which reappears in each of its enterprises. The artist wants to think and create freely; he makes his work personal, and after the fifth century the history of art concerns artists who innovate, who find their own styles, and who have consciousness of their own value, freeing themselves continuingly from conventional pressures.

Innovation. Greece does not ignore the valuable contribution of tradition. But in her case tradition never paralyzes innovation, is never able to numb the wish to think and express freely or to counter traditional arts by a new art whose development is an entirely different thing. Art passes through the inevitable phases involving more and more exact observation of reality, and, after the idealism of the fifth century—often recalling certain primitive abstractions and harmonizing them with revised principles—

tends toward realism, then toward a naturalism more and more emphatic.

THE HISTORICAL EVOLUTION: ANTIQUITY

Primitivism from the Origins of Greek Art to the Close of the Sixth Century B.C. Since primitivism is instinctive and universal, Greek art had to pass through this phase. Indeed, from its origins until the close of the sixth century, it obeyed the same laws as all arts elsewhere, and that is why, except for certain foreign influences having secondary effects, it has so many similarities to arts in Egypt and the East. Here are the same conventions: two-dimensional vision, intellectual realism suppressing foreshortening and perspective, shallow graphic modeling of body and clothing, geometrizing of forms, sculptural frontality, symmetry, decorative stylizing of hair, garments, etc.

Development of Classicism within Archaism. Yet after this primitivist era there appears another spirit of observation, reason, and beauty. It is devoted to the human body, ideal nudity, the study of anatomy and drapery (as yet incorrect but constantly rectified), the invention of the figure in action, elsewhere ignored, and other traits besides. Already the differences are noticeable between a Greek sixth-century statue and a primitive Egyptian or Eastern statue, and one glimpses a transforming of art.

Classicism. It struck root about 500 B.C., a date at which the age of classic Greek art opened: easier positioning of bodies that had formerly repeated an arrested frontality and stereotyped movements, beauty in nudity and garments, deep and nuanced relief, variety, three-dimensional vision bringing foreshortening, perspective, pictorial relief, etc. Thereafter, throughout several centuries, art evolved by extending the results of these optical, rational, and aesthetic laws of representation, from the fifth-century idealism to the growing naturalism that reached its final limits in the Hellenistic and Greco-Roman epochs.

Ventures in Optical Imitation outside Greece. Outside Greece, certain artists occasionally approached a conception kindred to Hellenic classicism, attempting in Egypt to break frontality, trying foreshortening, perspective, re-

liefs in contrapposto. But everywhere these are only spo-
radic attempts quickly abandoned because they do not suit
the notions these peoples had of art, its methods, its aims.

The Antagonism of Two Formulas. Ancient history
shows a polar opposition of these two formulas after the
hour Greece broke away from the universal primitive vi-
sion, substituting a classic vision as the main guide in all its
art and producing one aspect of "the Greek miracle."
From that time on, there was nothing in common between
Egyptian or Oriental sculpture or painting and Greek
sculpture and painting. Each held a different course, and
their interpretations, like their attitudes, radically diverge.

We can phrase these differences in a tabular summary:

FORMAL TRAITS

Primitivism	Classicism
Posture. Statuary at rest: Frontality controlling stereotyped poses	Posture. Statuary at rest: Rupture of frontality allowing lifelike poses
Posture. Statuary in movement: Movement, activity ignored in major statues. Restricted to relief arts and to figurine, which obeys (nearly without exception) frontality	Posture. Statuary in movement: Achievement of statue in active movement in most varied poses
Posture. Statues in groups: Limited by frontality and lack of true movement to a few formulas	Posture. Statues in groups: Entire freedom of grouping, thanks to rupture of frontality and achievement of movement
Two-dimensional vision. Drawing: Ignorance of foreshortening, perspective, and attending methods	Tri-dimensional vision. Drawing: Foreshortening, linear and aerial perspective
Two-dimensional vision. Drawing: Flat colors without shadowing	Tri-dimensional vision. Drawing: Modeling figure by hatchings, shadows, highlights. Pictorial modeling in relief.

FORMAL TRAITS—*Continued*

Primitivism	*Classicism*
Two-dimensional vision. Relief: Low relief. Linear, superficial modeling of body and drapery	Spatial vision in three dimensions. Relief: Full relief, deeply cut modeling
Nudity: Social, not aesthetic	Ideal nudity: Appreciation of the beauty of man's body
Anatomical transcription: Inaccurate, schematic, neglecting changes caused by movement	Anatomical transcription: Accurate and increasingly precise; changes due to movement
Drapery: Garments a social convention, not an aesthetic vehicle. Conventional treatment of folds	Drapery: Material takes on aesthetic value in itself and by its relation to the body. Accurate, deep, fluid cutting of folds, adapted to movement
Differentiation of persons, sexes, ages; physiological, ethnic traits; portraits, etc.: Little stressed, reduced to few types	Differentiation of persons: Increasingly exact and complicated
Expression of feelings: Neutral faces, a few stereotyped expressions	Expression of feelings: Quest for pathos and all the nuances of man's moods
Law of composing figures alone or in groups: Conventions in design, frontal statuary, neglect of movement, drapery, aesthetic nudity allow only a few formulas	Law of composition: Breaking of frontality, achievement of movement in statues, ideal nudity, aesthetic use of drapery, foreshortening, etc. allow complicated designs affecting the single figure (e.g., bodily rhythm, eurhythmy, relation of nude body to garment) or the group, either sculptured or drawn

REASONS FOR THESE DIFFERENCES

Primitivism	*Classicism*
Lack of interest, or minor interest, in the human figure	The human figure an essential element in art
Distortion of the human figure	Respect for living form, transcribed in its integrity
Distortion through mental formulas of intellectual realism	Accurate transcription by optical realism
Distortion through laws of ornament	Elimination of ornamental distortion
Arts of surface: bi-dimensional	Arts of volume: quest of the third dimension and the fleshly
Tendency to repetition, symmetry, often absolute	Variation and balance replacing bi-symmetry
Geometric conception, abstract art	Realist conception, imitative art
Lack of observation	Exact observation
Utilitarian arts	Trend to disinterested creativity
Religion dominant	Secularization, humanization
The art-expression of ideas; art above all a language	Art tending to make the formal aesthetic image dominant over the idea to be expressed
Minor role of aesthetic sense	Dominance of aesthetic sensibility
Irrationalism	Rationalism
Inconspicuous role of individual	Increasing prominence of the individual
Pressure of tradition	Individual experiment overcoming tradition

The Persistence of Primitivism outside Greece. Outside Greece, all lands with their local peculiarities remained faithful to the last to instinctive or inherited primitivism. Their attachment is no proof whatever of inferiority, incompetent technique, or blundering, as sometimes is said, but, we repeat, the result of an artistic mentality different from the classical. Besides, even after they came under Hellenic influence, their primitive tradition persists among them either as a parallel current or else in composite methods.

Hellenization of the Ancient World. Confident of its achievement, Greece, with its innovating methods, wants to take over the world. Beginning early, Hellenization proceeds actively after Alexander and his successors have knit together alien lands by bonds that had slackened since the Median wars. Classic art penetrates Egypt and the depths of Asia, even to India and Afghanistan, and on the west to Italy, which expands Hellenization by means of its conquest of all the provinces of the Roman world. Yet by this too-intimate touch with the alien, classic art begins to lose its purity, allowing itself shortly after Alexander to be tinged with Eastern and primitive tendencies it had previously repressed; and this leads to its decline.

The Defeat of Classicism. The classical reforms spring from a temper too alien to be foisted upon traditionalist folk in the East, Egypt, or even the West. Everywhere Hellenization is only partial, superficial, transitory. Then too, classicism had during several centuries fulfilled the logical consequences of its own laws. The optical imitation lying at its very roots had led it toward an excessive realism; the worship of the human body had drawn it toward sensuality and voluptuousness, and the preoccupation with beauty toward emptying forms of all spirituality. By dint of wishing to imitate humanity at its most commonplace, classicism brought the gods to earth, debasing them. Exhausted, unable to renew itself, it no longer meets the needs of the soul or mysticism, which are more and more urgent and which are better satisfied by the abstract methods of primitivism. Politically the Orient and the barbarians, heirs of primitivism, see their influence grow. And the economic decay of the Roman Empire, undermining the elites

to the advantage of lower classes, is a factor, along with many others, in this change. So as one approaches the end of the ancient world, one sees everywhere the devaluing and decline of classicism and the triumph of primitivism. Everywhere the principles and methods of the latter are resurgent. They mean the demise of classicism even in Italy, long the docile student of Greece, whose influence could not, however, stifle indigenous impulses—even in Greece itself, where classicism arose but where an instinctive primitivism had always survived mutely in popular arts, in rural areas, and in religious tradition.

HISTORICAL EVOLUTION: THE CHRISTIAN WORLD

Primitive Christian Art. In the Coptic, Syrian, and Byzantine East, and in the West, Christian art turned primitive again. It always was so in Byzantium, and in the West too until toward the close of the twelfth century. That is why during these eras this art shows so many traits in common not only with the art of late antiquity which, turning back to primitivism, heralded it, but also with all those arts of any period or locale whatsoever that obey the same impulse.

The Development of Classicism within Christian Art. Yet strangely enough a new classicism was being born inside Western art, partly under the influence of memories of antiquity perhaps; and it was about to renew the "Greek miracle" in a "Christian miracle." Beginning with the Carolingian era the lost feeling was recovered: for the human body, the relief, statuary-in-the-round, at first in figurines and then in the tenth century in reliquary statues. One again finds monumental and narrative sculpture; and during the Romanesque period there revived a desire to observe more accurately. Romanesque art is primitive again, but exactly as in archaic Greece, a change is coming. That is why these two eras offer so many similarities in the images they create.

Liberation: Classicism of the Thirteenth Century. Just as liberation came in Greece about 500 B.C., it came in the Christian art of the West about the Gothic thirteenth century. There is the same break with conventions, the relin-

quishing of frontality in sculpture, the study of drapery and even anatomy, the elimination of decorative complexities, a supple and deep modeling, a noble and plain truthfulness—in a word, the many traits that permit us to liken the images of the thirteenth century to those of fifth-century Greece.

Rhythmic Evolution. Since Christian art turned classic again, using methods like those of the Greeks, we should not be surprised to see it passing through the same phases. After the idealism of the fifth century B.C. and the thirteenth century A.D. comes the growing naturalism of the fourth and fourteenth centuries, and the intense naturalism of the Hellenistic era and the fifteenth century A.D.

The Renaissance. The renaissance of classic methods is thus prior to the great Italian "Renaissance." It belongs to the French spirit as the classic "Naissance" belongs to the Hellenic spirit. Properly speaking the Renaissance merely extends and defines a movement previously begun; it gives a more classical tone by imitating the ancients; it is filled with enthusiasm for the fleshly beauty of the body, its nudity, its anatomy; it presses further the exploration of the third dimension, foreshortening, perspective, chiaroscuro; it frees art more completely from its religious bondage; it exalts man and individuality.

From Classic Renaissance Art to Our Own Day. Art still exists under the auspices of classicism and the Renaissance; such are the methods used by most of our artists without having introduced anything except minor changes.

The Revival of Primitivism. But no more than in antiquity is instinctive primitivism dead. Mutely it manifests itself in flamboyant Gothic, Baroque, and the Louis XV style: however, only in ornamentation and in certain traits that do not quarrel with basic classical laws. It was granted to art at the close of the nineteenth century and the opening of the twentieth to see primitivism breach these basic laws and propose the replacing of an optical by an abstract conception under the pretext of recovering a fresh vision—and it can hardly be denied that this vision is older and more universal. To be inspired by the archaic Greeks is to return to a non-classical Greece; to be inspired by Negro or South Sea fetishes of popular art, or to imitate Byzantine or

Romanesque is to return always to the same source. To sanction Cubism, Futurism, Dadaism, Surrealism is to allow art, as it has done for thousands of years, to paint things not as one sees them but as one thinks them; it is to replace visual reality by abstraction. So one recovers the same traits and conventions that are always typical of primitivism: frontality, a union of features seen fullface and in profile, a decorative schematizing of clothes and hair, rejection of foreshortening and normal perspective, fragmentation of the human body, which is no longer reverenced. Art today is on the same gradient which appeared at the close of antiquity, for our present culture shows strange analogies with the expiring ancient world. Will primitivism once again vanquish classicism, and are we moving toward a new medieval age?

RHYS CARPENTER

GREEK SCULPTURE *(1960)*

OUR INTERPRETATION of the development of Greek art has been deeply affected by our better understanding of how the primitive artist works, and by our current admiration for the formal elements in primitive arts generally. Whereas the nineteenth century believed in the supremacy of "classic" Greek art, especially Greek sculpture, we have been inclined to favor more primitive Greek works. Unlike many modern critics, Carpenter refuses to belittle the classic, but he does analyze the conflict between the "canonic control" in archaic Greek sculpture and the increasingly naturalistic statuary of the classic period, and he traces the "oscillation" between these two different forms of art. He notes that if we make a "section" of an archaic statue and of a classic statue, the former will be inert inside the block, whereas the latter will be "organic"—that is, the rhythmic movement of the surface will be found to surge up from the vitality at the interior of the marble. Carpenter also stresses the difference between early Greek sculpture that is basically glyptic (carved) and the later sculpture that is basically plastic (modeled), a point of great interest to modern sculptors. One of the subtler remarks in Carpenter

is his contrast between the visual field, which is optical, and the visual world, which is tactile—a contrast we must have in mind while reading Wölfflin on Renaissance and Baroque art. Carpenter points out the dissimilarity between Greek treatment of the naked male figure and the clothed female figure, which led toward a kind of "petrified dress-making" and brought with it a realism that undermined the heroic male canon.

Charles Seltman in his *Approach to Greek Art* (1948) raises a question relevant to Carpenter's discussion: was sculpture as important to the Greeks themselves as we have traditionally assumed? Seltman finds that the Athenian was probably more interested in celature (the "minor" art of metal-chasing, engraving, embossing, or carving small objects) than in "major" statues. In fact, Seltman thinks that Phidias may have been looked upon as celator rather than as sculptor. Our long-sanctioned views of Greek art may be false because we know Greek statuary mostly through Greco-Roman copies, not through originals, which are notoriously few. Thus we have perhaps talked a great deal of nonsense about Greek sculpture, just as we may have talked a great deal of nonsense about Greek drama, since we know only thirty-odd plays out of hundreds written and acted.

Carpenter has traced "the formal evolution of a style" in *Greek Art* (1962), and his account of the decay of a primitive canon in sculpture may be considered in relation to the decay of a canon in Greek drama. This latter has been discussed in H. D. F. Kitto's *Greek Tragedy* (1939, 1954, 1961) and, more technically, in August C. Mahr's *Origin of the Greek Tragic Form* (1938). Carpenter's views are also relevant to the observations of T. B. L. Webster in *Greek Art and Literature, 530-400* (1939), *Art and Literature in Fourth-Century Athens* (1956), and *Greek Art and Literature, 700-530* (1959).

THE ARCHAIC PHASE

(Chapter II)

═══════════════════════════════

Archaic sculpture, whether Greek or other, has a peculiar appeal and exercises a very special charm for the present day. Its conventional irrealism (to coin an appropriate term) is no deterrent to its enjoyment; and its mimetic naïveté, its decorative self-sufficiency, its vigor and clarity and wholeheartedness, all contribute to make the contemplation of archaic sculpture an unperturbed delight.

But it is improbable that even the most convinced admirers of the archaic have any comprehension of the source of its peculiar qualities. Nor could they offer any explanation for the extraordinary stylistic similarity which pervades all archaic sculpture, no matter what its provenance or period.

There is, of course, no compelling need that the appreciative public should be so informed. The human values of art depend only indirectly on its intellectual understanding; and the study of the technical evolution of its forms of presentation is closer to the contemplative attitude of Science than the emotional apprehension of Art. However, there will always be those who are curious to explain to themselves intelligibly, in contradistinction to those who wish only to experience emotionally, sculpture's strangely moving transformations; and to these the present analysis is directed.

The distinctive and ever-recurrent behavior of glyptic sculpture in its early phase of development is primarily due to no other cause than the physiology of human vision. Since some familiarity with this subject is fundamental to a proper comprehension of the pathology of the archaic style, a seeming digression here is unavoidable.

Everyone who has paused to consider the phenomenon of vision must have been struck by the anomaly that

the eyes can convey immediate sight of tridimensional objects possessing spatial extension and distributed at appreciably discrepant distances, although all the while the retinal screen has captured only a two-dimensional projection (or, as we rightly say, a picture) of such a world.

The frequently hazarded explanation that our stereoscopic apprehension of a third spatial dimension is due to binocular vision (because each eye necessarily communicates a different view, and the superposition of these two slightly disparate pictures produces, as the stereoscope demonstrates, a tridimensional effect)—this explanation is hopelessly inadequate. By wearing a patch over one eye, anyone can convince himself that even a totally unfamiliar scene is stereoscopically just as vivid and spatially just as intelligible with only one eye functioning. If this experiment seems inconclusive, it may be further urged that if binocular vision were the source of spatial apprehension no one should be able to differentiate spatial depth and distance while regarding a mirror or a photograph or a painted scene; for in all these whatever appears far or near is actually at the same distance from the eye and therefore cannot be evaluated by muscular adjustment to focus. If binocular vision (which is sensibly effective only for objects comparatively close to the viewer) has any useful biologic function, it should be that of giving more immediate and accurate apprehension of the distance of objects threateningly or otherwise significantly close to us. For objects more than fifteen feet away it is said not to be a muscularly detectable adjustment, while beyond fifty feet it is completely inoperative. Yet visual space does not cease to possess depth for us beyond either of these critical distances. I presume that we possess two eyes instead of one for the same reason (or want of reason) that so many of our other bodily parts occur in symmetrical pairs. Similarly, biauricular hearing has its discriminatory uses; but we can distinguish sounds in our environment quite adequately with one ear only.

Nor is a second common suggestion that stereoscopy is a function of linear perspective any more tenable, since (in the sense in which the late fifteenth and early sixteenth-century Italian painters relied on it as a scaffolding for

spatial construction) such an effect exists only where a framework of precisely oriented axes chances to have been introduced into the field of vision. It is true that in an architectural or other artificial environment there necessarily appears such a triaxial articulation in the walls, floors, and ceilings, the stairways and furniture within doors, and in sidewalks, streets, façades, roads and railways, telephone poles, and orchards and vineyards of the world outside; and these, as they are projected on a panel surface, such as the optic screen of our retinas, create a spatial frame for depth and distance. But natural surroundings without these man-made intrusions—woods and glades and downs, dells and streams and lakes, mountains and moors—exhibit no such geometrical structure (which explains why the spatial scaffolding in the Renaissance paintings is so implacably architectural); yet we behold distance and spatial recession in a landscape with the same vividness (though perhaps not with the same degree of measured accuracy) as in any other scene.

It has at times been counted against the pictorial attainments of antiquity that the laws of linear perspective were never understood. In Greco-Roman paintings space opens outward on divergent axes toward ampler background distance, instead of converging inward on the panel toward a point of extinction. Psychologically (and hence perhaps with greater artistic advantage) the older solution corresponds to our actual experience of a world that continuously expands with distance instead of shrinking as it recedes. The mid-Renaissance painters' perverse conviction that the apprehension of aerial space in a picture was wholly a matter of linear perspective threatened for more than a generation of artists to do serious damage to their art by constricting it to a geometric theorem.

The true explanation of the mechanism of stereoscopic vision has been given in brilliantly convincing analysis by James J. Gibson in his too-little-known book, *The Perception of the Visual World* (Houghton Mifflin Co., 1950). Its closely reasoned investigations have for central proposition the thesis that the mechanical conversion of the tridimensional external world of illuminated physical objects into its two-dimensional projection upon the retinal

screen (a process which can be very exactly duplicated by the camera's focused lens and the color film) produces a complex series of "gradient" appearances. It is the stepwise arrangement of these "gradients" according to size, shape, hue, and luminosity, which provides the seeing mind behind the eye with the material for their comprehension in terms of spatial depth and distance. Thanks to our habitual interpretive acceptance of these "gradients," our experience of a tridimensional world is not an intellectual inference from retinal data but is directly given to us in perception. Our retinas capture an illuminated *visual field* which the act of conscious seeing presents to us as an external *visual world*.

The distinction between these two italicized terms is vital to any scientific analysis of the representational arts. Any relatively full and faithful reproduction of the contents of a visual field is a picture, whether executed with pigments on a panel to produce a painting or mechanically fixed as a photograph or otherwise presented or suggested. In complete contradistinction, sculpture mimics not the visual *field*, but the visual *world* external to it.

Lest this explanation succeed only in clouding an *obscurum per obscurius*, it would be well to add some description of these "gradients," the intermediaries through which the visual field of the retina is perceived as a visual world in external space. Most of them are already quite familiar to us from their occurrence in paintings, while others will reveal themselves on introspection as everyday characteristics of the world as it is seen. Thus, there are gradients of hue and atmospheric density in the graduated transition of color in normal landscape from foreground brilliance of green and brown to distant blue and horizon purple, accompanied by a progressive blurring of objective definition. Gradients of this type are normally operative only over considerable distances. Much closer to the spectator, and hence more effective for the visualization of immediate spatial depth, are the gradients of pattern and geometric structure. These are apparent in any repetition of an areal shape, which projects itself in diminishing size as its distance from the eye increases, and becomes continuously more and more foreshortened as the angle of

vision lessens. (Exaggerated examples of this effect are Vermeer's and Pieter de Hoogh's tile-floored interiors and courtyards; but there are almost equally striking instances in the diminishing scale of less uniform structures such as plowed and hedged fields, boulders and hill crests, stream beds and pasture land, groves and forests.) Among such geometric gradients the effects of linear perspective find their rational place. In addition, there are gradients of texture and surface, dependent on micropatterns too minute for unaided vision to disintegrate into their constituent elements. There are also gradients of luminosity and color intensity, rather summarily reproduced by the chiaroscuro with which painters impart modeling to objects which otherwise would appear flat. (Thus, despite all intellectual conviction to the contrary, the sun cannot be seen as a sphere but only as a flat disk, because it shows no gradients of luminosity; whereas a painter can convert a flat disk into an apparent sphere by introducing highlights, half-lights, and shadow.)

In order to make still more evident the differences between the visual field and the visual world (both inevitably present in any and every act of seeing), it may be helpful to draw attention to the profound discrepancy between things as they are viewed as transient occupants of the optic screen's field and as they are perceived as permanent denizens of the external visual world. Thus, all the bounding edges which are set parallel in the objective world (such are the sidewalk curbs that line a city street, and the house fronts with their thresholds and eaves and their lintels over doors and windows) do not recur as parallels in the visual field, but converge toward a common and yet invisible point. Not only do all objects of measurably uniform width, such as streets and railway tracks, become ever narrower as their boundaries converge in the visual field, but even as they dwindle they move *up* the screen instead of away from the viewer. (Herein lies the explanation of the classical Greek idiom which refers to a ship putting out from the shore as sailing "up the sea"; in the physical world the sea remains level to the earth's slow curvature; but in the visual field a departing vessel moves *up* to the horizon line, whereupon it reverses its

direction and moves *down* until it disappears *below*.) Just as paradoxically, while each object tends to maintain a constant size in the physical world, it incessantly alters its size in the visual field. More disturbingly still, it perpetually changes its shape and outline as it shifts position on the retinal screen.

But enough has been said to make it clear that, although they correspond one to another according to fixed equivalent forms, the visual field and the visual world are members of two utterly different orders.

For an understanding of sculptural formal behavior, the all-important point to be made out of all this should now be obvious: While painting presents visual fields, and visual fields only, the productions of sculpture are fully objectified members of our visual world. This is the meaning behind the common remark that paintings are "illusion," while statues and buildings are considered "real." Actually, a piece of sculpture is as much an illusive mimicry as a painted figure; but it operates at a different visual level.

If one could succeed in making an exact duplication of all that the eye beholds at any moment, that is, by reproducing the mosaic of colored light which forms on the retina (and precisely such a record is afforded by the camera obscura and the color film), such a duplication would inevitably be a *picture*, since any counterfeit of a visual field has intelligible status only as a visual field. (This explains why we can see depth and distance in a painting or photograph; by accepting it as a workable visual *field* we see a visual *world* before us.) It follows that the optical content of vision, however exactly reproduced, will not be sculpture. None of the gradient appearances in which the world is presented to our sight can be introduced by the sculptor into his work; for these, being pictorial conversions, have no objective existence. Instead, his aim must be to reproduce solid shapes, of which his eyes inform him, but which he has never directly beheld as such. He cannot "carve what he sees" because he sees only pictorial transformations. He must somehow reach out beyond sight of the visual world to the source in which vision originates.

To that source we all have direct sensuous access, if not with our eyes, then through our fingers; for with these, by touching and grasping we can extensively explore and spatially examine the material objects in our visual world. It is because of this immediate sensuous contact that the art of sculpture so generally has recourse to modeling in plastically conformable media such as wax or clay. But glyptic sculpture admits no comparable resource—at least, not until some device has been invented for translating a pliant plastic version in clay into the undeformably rigid replica in cut and polished stone. Until such an operation can be performed the construction of a preliminary plastic model will not greatly assist the carver of monumental statuary, since he cannot, by using his eyes, duplicate in stone a prepared clay figure with any greater ease or accuracy than he could copy its living prototype. Neither performance is technically feasible because of the physiological barrier of pictorial vision. Being a purely glyptic discipline, Greek monumental sculpture in its earlier periods shows no trace of any dependence on clay models. Being an art of direct creation in solid form, it must be so judged and so perceived.

It must not be imagined that this was an unfortunate accident, and that by mere historical mischance—because it was sculpture in stone which the Greeks encountered in Egypt and adopted for their use—Hellenic sculpture was handicapped or misled. There seems sufficient evidence for the assertion that monumental sculpture in terracotta (which is to say, in modeled clay) was developed at Corinth and thence communicated to Sicily, Magna Graecia, and Etruria. Certainly the impressive "Zeus-with-Ganymede" of Olympia testifies to Greek, as the dramatic warriors in the New York Metropolitan Museum,[1] and the elegant Veian gods in the Villa Giulia in Rome, testify to Etruscan mastery of this technically none too easy craft. If the rest of Greece continued to carve its statues out of blocks of marble, it was not because it never occurred to its artists that they might have used clay.

Although it is true that the modeler of clay can feel his way directly into tridimensional form, it is equally true that sculpture is a visual and not a tactile art, because it is

made for the eyes to contemplate and not for the fingers to feel. Moreover, just as it reaches us through the eyes and not through the finger tips, so it is created visually, no matter how the sculptor may use his hands to produce his work. Insofar as it is something other than a mimetic craft for the accurate reproduction of living forms (and it would not be art if it were only this), sculptured form cannot be apprehended tactilely, or evaluated by its tactual fidelity.

It may be argued—and with entire warrant—that sculpture frequently involves an appeal to our sense of touch and physical contact; but so does painting. Such tactile sensations are, in either art, induced and secondary, being derivative of subjective mental association. In a painting by Titian or Bronzino, the representation of material textures, such as fur or velvet, may be so visually exact that it evokes in us a memory of how velvet and fur may feel when we stroke them. I do not think that sculpture's tactual appeal is very different or much stronger. Any dissenting opinion is probably inspired by the heightened physical actuality of sculptural presentation: we cannot directly sense a painted texture by touching the canvas, whereas we can actually explore with our fingers the solid sculptural shape. But the logic is faulty if it is thence inferred that sculpture is more immediately involved in the tactile sense; for, at best, we can only touch the material medium and not the artistic representation which is intended and calculated for the eye's contemplative vision.

Since there is no immediately evident guarantee of greater success for visual presentation attaching to a plastic rather than a glyptic technique of production, it would be unreasonable—at this stage of our survey—to challenge as mistaken the Greek acceptance of a glyptic tradition. Rather than reform or reject it, Greek genius enhanced it and raised it to new status in artistry by exploring and exploiting its hitherto unrealized potentialities.

This long digression into the physiological and psychological mechanism of human vision was unavoidable, since without it there is no possibility of rationalizing the specifically distinctive features of archaic glyptic art. Nor is it easy to understand why sculpture is so difficult an

enterprise, subject to such a retarded speed of development, unless there is kept constantly in mind the simple theorem that the human eye has no direct access to the domain of solid substance.

As the exterior world is present in vision, its geometrically solid objects define themselves as *areal shapes,* that is to say, as areas of modulated color to which an enclosing boundary imparts intelligible overall shape. Such an areal shape can be exactly counterfeited by tracing a line mimicking its boundary or contour. But the other constituent elements of the visual field, the "gradients" of luminosity, texture, diminishing pattern, perspective, and the rest, cannot be recorded by the sculptor because all are properties of the visual field only, being optic "signs" or "signals" of the objective world without materially objective existence. This is the reason why the prime components of archaic sculptural representation are the defining contour line, by which an entire structure is given intelligible shape, and the areal surface pattern, by which each distinguishable part or portion inside the total boundary is given a recognizable appearance.

Since foreshortening is a geometrical conversive gradient existing only for the visual field, the least foreshortened aspect of any object will necessarily appeal to the sculptor as the nearest equivalent to its actual structural shape. Hence the areal shapes which the sculptor records will be their *frontal aspects* of maximum extension in the plane of the visual field. The so-called memory images and frontality phenomena of an outmoded theory of archaic stylistic peculiarities are more properly to be reinterpreted as areal shapes subjectively constructed out of unforeshortened aspects.

If we examine the ear on an archaic *kouros,* it will be instantly evident that the sculptor has treated this organ as a self-contained entity, unrelated to the other recordable features, and possessing its own distinctive configuration. Only in its size and relative location has it been considered as participant in the whole bodily structure. It might be suggested, without metaphoric intent, that the artist has made much the same distinction that ordinary speech observes when it applies to a specific word, such as the

English "ear," as a sundered label to which all ears, but ears only, are entitled. As member of a generic class, just as it has a distinctive but universally applicable name in speech, so will an ear possess for the archaic sculptor a characteristically differentiating, but abstractly generic, shape in the visual "language" of statuary. In everyday visual experience this characteristic shape is apprehended and identified as a recurrent pattern of appropriate size; and such a pattern is precisely what is applied by the sculptor to the block of his statue by first tracing its discoverable outline in frontal projection, then cutting back the marble around this outline, and lastly grooving into the stone the linear pattern of its interior configuration. As the result of such a procedure, the statue's ear is represented by an isolated patternization solidly attached to the main mass of the marble block and rather uniformly raised above it.

It would be tedious to pursue such an examination for each feature of the human head and body. The outcome would always be the same—a succession of patterned linear shapes, cut away so as to stand out, or grooved to sink in, but always anchored, as it were, on the surface of the block. Because the seeing eye receives only two-dimensional projections of the illuminated surfaces of objects, it operates with flat areal shapes, to the detriment of the converted dimension of spatial depth. The archaic sculptor draws on this fund of areal shapes and reprojects them, spatially unconverted, upon his statue's surface. (In technical jargon, he "fixates his visual field.")

Although (presumably) the experiment has never been performed, it would be entirely feasible to acquire plaster casts of archaic statues and saw them horizontally across to lay bare their geometric transverse section. Such "stereographs" would be to the stylistic theorist what X-ray photographs are to the medical investigator: they would show what was going on inside the body of these statues. For the archaic period the cross section would invariably demonstrate that only the outer rind of the block is alive, while all the rest is unaffected, being unreached by the sculptor's formative activity. This observation would apply with especial cogency to the early archaic draped statues,

where nothing stirs beneath the blank expanse of costume.

To recapitulate, because of the physiological mechanics of human vision, the archaic sculptor is fettered in his work to the frontal plane of the block which he cuts. That block, in order to be serviceable to his final intent, has been given some abstractly simple overall shape, such as an erect quadrangular pier for a *kouros,* or a cube surmounted by a solid rectangle for a seated figure; and out of this, by chipping or splintering off the superfluous envelope, the sculptor must make emerge the shape and substance of a human body. But because his eye receives only flat projections in areal shapes when he looks abroad at the objective world, and he has only pictorial access to reality, he has no ready apprehension of solid depth, but tends to carve all interior detail as flat pattern projected upon the undifferentiated smooth surface of the block. In the stilted (and mildly ridiculous) language of a pretendedly scientific vocabulary, the clinical description of archaic glyptic sculpture would be an undeveloped stereomorph upon which linear areal patterns have been projected.

The design of these superficially attached patterns is highly schematic, in the sense that they are generalized formulas which, once they have been accepted, will be made to serve over and over again, without structural alteration. Not merely are they transferred from one piece of work to the next; but on the same statue, wherever any extended surface is to be covered, they will be repeated in orderly precision of sequence and arrangement. It is the same creation of pattern through repetition of identical units of design which attaches to ornamental motifs decoratively applied, such as may be found in loom-woven cloth, or plaited basketwork, or vases decorated without pictorial intent.

The linguistic parallel is here again pertinent. Just as human speech is content to repeat unchanged the same phonetic sound-pattern every time there is reference to the same kind of object, so the archaic sculptor, having devised an appropriately characteristic *schema* (or pattern-shape) sees no merit in altering or modifying it, but repeats it intact whenever and wherever he has need of it.

His is not yet a servile imitation of the casual irregularities of the physical world of things, but a craft of precision applied to schematically perfected visual abstractions, whose geometric clarity imposes accuracy of execution as proof of artistic competence. Since marble must be tooled to pattern's guiding line, that line must be cut as cleanly as it is drawn—if straight, then truly straight to the ruled line; if curvilinear, to a geometrically consequent curve. There is thus a mental component (if only on the humbler spiritual level which modern Gestalt psychology explores) in all archaic form, operating against all haphazard irregularities in favor of a decorative repetitiousness of pre-established design. This produces an effect precisely comparable to that which Greek architecture exacted in the carving of its string-course ornaments. On the exquisitely cut detail of the Erechtheion at Athens, from the end of the fifth century, and the circular tholos at Epidauros, from the second quarter of the fourth, the running design on the carved moldings shows an exactly spaced and identically repeated ornamental pattern in which geometrical harmony is all-important, and the faithful reproduction of botanical species of leaf or flower has been discarded. So it is with archaic sculptural detail where stereotyped patterns are repeated over surfaces which serve only as the ground to support and carry them.

The decorative quality so noticeable in archaism is thus ascribable to an appreciation of the symmetrical structure of abstract pattern overriding the concrete evidence of unsymmetrical variability and imprecision in the physical world.

Since pattern depends on two-dimensional symmetry (tridimensional pattern being only mathematically comprehensible and not accessible to sight, except as distorted in pictorial projection), visible pattern is an attribute of the visual *field* rather than of the visual *world*. That is why it is of such paramount importance to the art of painting. On a pictured panel, the visual field imposes its pattern upon the unpatterned visual world which it portrays, and thus fuses into a single moment of vision the abstract appeal of geometric form with the interested recognition of representational content. But during the contemplation

of sculpture, the visual field is not a fixed constant, as in a painting, but a shifting and changeful appearance where patterns can appear only as they attach to some particular (and therefore partial) view. In consequence, pattern will occupy the sculptor's attention most insistently in the archaic phase while he still works with pictorial projections of the visual field and has not yet advanced to any more extensive reproduction of its implied tridimensional structure. Precisely because it is only a visually projected surface appearance, the appeal to pattern, which archaism so effectively exploits, must weaken as the sculptor masters stereometric configuration.

We have not yet exhausted the formative influence of the norms of visual behavior upon the idiom of early glyptic sculpture.

It is an important formal property of the linear patterns, which the archaic sculptor projects on his block of marble, that each tends to be self-contained within a fully closed contour. As we look abroad on the world, seeking to understand the content of vision, we habitually convert every total visual field into an assembly of *things*, each of which is set apart by a characteristic shape within a defining boundary. As a result, everyone habitually regards noses, mouths, and ears, because they have individually distinguishable shapes, as isolated structural parts of the human body, without reflecting that it is only our own nominal analysis which has segregated them from the anatomical continuity of skin, flesh, and cartilage. It is this process of nominal objectification which compels the archaic sculptor in his reproduction of the human form to convert each distinguishable feature into a discrete unit of design—that is to say, a patterned shape delimited and set apart by its own enclosing boundary of closed contour. By this schematic disintegration into contiguous pattern, the nude torso is similarly converted into an assemblage of closely fitted pieces, a mosaic of linear shapes replacing the actual continuity of surface and organic singleness of structure. It is from this substitution of an architecturally consistent and structurally ordered design for the luminous pictorial gradations of the actually seen appearance of the body that the tectonic appeal of sculpture emanates.

Of this tectonic appeal much may be said—perhaps not unprofitably. It is most pertinently exemplified in Greek architecture. The exterior colonnade of a Greek temple, or the columned front of a stoa, communicates visually an impression of gravitational balance and structural stability in terms of abstractly patternized elements. The distinctively individual pattern-shapes of these component elements, intelligibly fitted one to another in a fixed sequence, combine to produce the overall design of the "order." And this design is maintained on a single horizontal plane as a panel of evenly repeated *areal* shapes. So extreme an adherence to the projected two-dimensional appearance threatens to destroy any comprehension of the structure's depth and substantial mass. (The architects of the Renaissance were fully aware of this property when they applied the classic orders as an ornamental cover plate to any and every irrelevant construction which they chose to set behind them.) But this restriction of the visible building to the flat pattern of its façade was prevented from fatally weakening the essential architectural impression of ponderational support and material strength by compensating the loss in visible depth and density with a subtle linear articulation of the structural profiles and surfaces. One has only to look attentively at a standing Greek order, with this in mind, in order to see how effectively visual suggestion operates through entasis in the slendering column, unadorned bulk in the architrave, diminution of unitary scale in the frieze and cornice, and disintegration of the ponderable load through unrestricted ornament on eaves and gutters. This visual communication of weight carried in balanced support is what is intended by the expression "tectonic appeal."

Since any life-size marble statue weighs rather more than a ton, its brute mass constitutes a stone structure embodying (one might say) a potential architectural appeal. It is hardly an exaggeration to assert that the Greek sculptor had an artist's awareness of this, and sensed the surface structure of the nude in its sculptural transformation as a sort of architecturalized living order in which, as in a Greek building, the superimposed parts structurally vitalized a total design.

Equally compelling evidence for a sense of tectonic form may be found in Greek ceramics. In any typical shape of the Hellenic potter's craft, each structural part—the foot or base, the containing body, the protruding handles, the narrowing neck, the turned lip—is a functional element distinguished by an appropriate shape of calculated size in pertinent location; and all these are subsumed to a total shape whose contour supplies coherence and structural participation to every element. If the comparison is not pressed too closely, a Greek vase may be likened to a statue in the abstract; it is an articulated organism presenting in visual terms its structure and its gravitational balance. Reversing the comparison, a nude *kouros* may be said to display the tectonic coherence of a Greek vase.

It has been very widely recognized that the classic representation of the nude human form does not faithfully reproduce the normal appearance of the body, but reinterprets or re-creates or idealizes, or in some other manner mutates it, as though to improve on nature by substituting art for actuality. There is, indeed, a specific sculptural idiom for the nude which is universally identified as "classical"; and this has been admired and frankly imitated by some as an unsurpassable norm, and outspokenly stigmatized by others as a frigid convention fit only for academic epigoni. There is no theme connected with classic art about which more voluble opinions have been uttered and less pertinent judgments passed. But if there is to be any comprehension of its true quality, the Greek formulation of the nude must be studied genetically. To be sure, historic origin is not necessarily the same as ultimate validity; the art's aesthetic value must be something more than the end-term of its technical development. Nonetheless, one always has a better chance of understanding what a thing is if one has watched how it came to be. And the classic conventions for the nude are all directly descended—with only a single important modification of their character—from the archaic linear formulation, which in turn had its source in optical physiology. (The "single modification" was the conversion of the grooved linear demarcation of archaic areal pattern-shapes into a recession and protrusion of their surfaces, when the superficially attached schemata were reshaped into modeled

depth of marble—a remark that will become clearer as our study proceeds.)

In the standard Greek formulation of the nude, as it occurs over and over again on surviving statuary, it is the enormous hip muscle which gives most offense to the modern anatomist. Undeniably, this is a preternatural exaggeration of normal appearances. Genetically, it resulted from a vigorous inguinal boundary line, drawn to demarcate the limb from the torso to which it attaches. It was allowed to survive in the classic canon because it helped to give structural articulation and definition. The overemphatic pectoral muscle, the oversharp separation of deltoid and biceps, the reduction of the thorax to an assembly of polygonal segments—all these are likewise the result of archaic linear representations preserved because of their structural eloquence and their tectonic vividness. Lacking any comparable interpretative presentation of its forms, the human nude tends to be sculpturally weak and unimpressive. Uninformed, it remains uninforming.

The tectonic structure of the anatomic canon, as formulated by the archaic masters and fully established before the close of the archaic phase, was to give to all classic nude sculpture a quality of coherent power and organic unity such as no merely exact duplication of the outward appearance of the human body ever attains. In the colossal "Horse-tamers" of the Quirinal, which copy at twice its size a figure from the Parthenon's east pediment, the late fifth-century formulation of the canon may be read most clearly. For the early fourth century the bronze "Ballplayer" from Antikythera preserves it intact, but with the divisional boundaries now less sharply lined and the transitions from part to part more tempered. For the late fourth century the "Apoxyomenos" of the Vatican, reflecting the growing realism of the Lysippic circle, shows the canon modified by more complex study of muscular articulation and moving, as it were, beneath the surface to reinterpret the linear scheme in fully plastic form. Praxiteles may seem to have departed from the canon by veiling it in a luminous envelopment of blurringly continuous surface; but where the eye cannot detect it in a normal photograph, oblique lighting of the marble will always

bring out the persisting canon. It is, in fact, the veiled tectonic structure beneath the sensuously formless light-mirror of the surface which prevents Praxiteles from converting the properly sculptural into an improperly pictorial appeal. (His is a dangerously misleading manner for the modern imitator.) In the prolonged academic tradition of the imperial Roman era, the tectonic canon is still predominant, thanks mainly to the conditioned Roman taste which reverted to the period between Myron and the pupils of Lysippos as the Golden Age of sculptural art. Not until all sense for the classic tradition became submerged during the final decline can the tectonic formula be said to have lost its dominance over statuary form.

If the preceding analysis of the essential determining influences in archaic sculpture is substantially correct, it will be apparent that the formal study of sixth-century glyptic art is primarily a scrutiny and comparison of schematic linear forms. These schematic forms will be seen to have grown in complexity as the phase matures; for on the one hand they reflect a cumulative increase of detailed observation of natural appearances, and on the other they show a diversion and enrichment for decorative use. Since these two interests serve basically incompatible ends (because one moves toward, the other away from, fidelity to nature), the career of archaic sculpture seems at times an erratic oscillation between heightening realism and increasingly decorative unreality. There will be masters and apprentices in contemporary workshops, of whom some will be attracted in the one, others in the opposite direction. As a result, the incautious critic may fail to grasp the contemporaneity of their diversely oriented efforts and confuse logical with chronological sequences. A similar simultaneity of progressives and reactionaries, of stylistic mannerists, uninventive conservatists, and observant innovators has long been noted among the archaic vase-painters; but a comparable differentiation in the work of the sculptors is less easy to detect and still more difficult to prove. The true calendar sequence of sixth-century sculpture is, in consequence, still uncertain and, even where rather generally assumed as established, susceptible to extensive future revision. . . .

ERWIN PANOFSKY

THE HISTORY OF THE THEORY OF HUMAN PROPORTIONS *(1921)*

WHETHER OR NOT the Greeks considered celature more important an art than monumental sculpture, the humanistic tendency of Greek thought is represented in the sort of figures allegedly created by Phidias for the pediments of the Parthenon. Such images, presenting man in noble form and scale, illustrate that side of Greek experience embodied not only in Aeschylus and Sophocles but also in Aristotle's convictions about the human being living in the city-state. These plastic images are, in short, a focus for all the Greek ideals of man. We know that these majestic representations of man developed from archaic statues that probably traced back to hieratic Egyptian-like sculpture, and that the classic image of man broke out of the confines of archaic carving. Thus the shift from Egyptian to Greek sculpture epitomizes what happened when Western man discovered himself to be a man living with his fellow men in the

polis. The archaic statue is transformed into an image that symbolizes the modern self of Western culture, just as in Homer the epic figure of Achilles the warrior is transformed through grief into a half-tragic hero. In the correlative forms of classical drama and classical sculpture, the Greeks translated their experience into human proportions. Thus there is profound meaning in Panofsky's analysis of the difference between the Egyptian formula for treating the human figure and the Greek sense of human proportion.

In "The Invention of Space," in *Essays in Honour of Gilbert Murray* (1936), Francis M. Cornford deals with some larger aspects of the Greek sense of space. In *From Religion to Philosophy* (1912, 1957) Cornford shows how Greek thought became humanized.

THE HISTORY OF THE THEORY OF HUMAN PROPORTIONS AS A REFLECTION OF THE HISTORY OF STYLES

(from *Meaning in the Visual Arts,* 1955)

Studies on the problem of proportions are generally received with skepticism or, at most, with little interest. Neither attitude is surprising. The mistrust is based upon the fact that the investigation of proportions all too frequently succumbs to the temptation of reading out of the objects just what it has put into them; the indifference is explained by the modern subjective viewpoint that a work of art is something utterly irrational. A modern spectator, still under the influence of this Romantic interpretation of art, finds it uninteresting, if not distressing, when the historian tells him that a rational system of proportions

or even a definite geometrical scheme, underlies this or that representation.

Nevertheless, it is not unrewarding for the art historian (provided that he limit himself to positive data and be willing to work with meager rather than dubious material) to examine the history of canons of proportions. Not only is it important to know whether particular artists or periods of art did or did not tend to adhere to a system of proportions, but the how of their mode of treatment is of real significance. For it would be a mistake to assume that theories of proportions *per se* are constantly one and the same. There is a fundamental difference between the method of the Egyptians and the method of Polyclitus, between the procedure of Leonardo and the procedure of the Middle Ages—a difference so great and, above all, of such a character, that it reflects the basic differences between the art of Egypt and that of classical antiquity, between the art of Leonardo and that of the Middle Ages. If, in considering the various systems of proportions known to us, we try to understand their meaning rather than their appearance, if we concentrate not so much on the solution arrived at as on the formulation of the problem posed, they will reveal themselves as expressions of the same "artistic intention" (*Kunstwollen*) that was realized in the buildings, sculptures, and paintings of a given period or a given artist. The history of the theory of proportions is the reflection of the history of style; furthermore, since we may understand each other unequivocally when dealing with mathematical formulations, it may even be looked upon as a reflection which often surpasses its original in clarity. One might assert that the theory of proportions expresses the frequently perplexing concept of the *Kunstwollen* in clearer or, at least, more definable fashion than art itself.

By a theory of proportions, if we are to begin with a definition, we mean a system of establishing the mathematical relations between the various members of a living creature, in particular of human beings, in so far as these beings are thought of as subjects of an artistic representation. From this definition we can foresee on what varied paths the studies of proportions could travel. The mathematical relations could be expressed by the division of a

whole as well as by the multiplication of a unit; the effort to determine them could be guided by a desire for beauty as well as by an interest in the "norm," or, finally, by a need for establishing a convention; and, above all, the proportions could be investigated with reference to the object of the representation as well as with reference to the representation of the object. There is a great difference between the question: "What is the normal relationship between the length of the upper arm and the length of the entire body in a person standing quietly before me?" and the question: "How shall I scale the length of what corresponds to the upper arm, in relation to the length of what corresponds to the entire body, on my canvas or block of marble?" The first is a question of "objective" proportions—a question whose answer precedes the artistic activity. The second is a question of "technical" proportions—a question whose answer lies in the artistic process itself; and it is a question that can be posed and resolved only where the theory of proportions coincides with (or is even subservient to) a theory of construction.

There were, therefore, three fundamentally different possibilities of pursuing a "theory of human measurements." This theory could aim either at the establishment of the "objective" proportions, without troubling itself about their relation to the "technical"; or at the establishment of the "technical" proportions, without troubling itself about their relation to the "objective"; or, finally, it could consider itself exempt from either choice, viz., where "technical" and "objective" proportions coincide with each other.

This last-mentioned possibility was realized, in pure form, only once: in Egyptian art.

There are three conditions which hinder the coincidence of "technical" and "objective" dimensions, and Egyptian art—so far as special circumstances did not create ephemeral exceptions—fundamentally nullified, or, better yet, completely ignored, all three. First, the fact that within an organic body each movement changes the dimensions of the moving limb as well as those of the other parts; second, the fact that the artist, in accordance with normal conditions of vision, sees the subject in a certain fore-

shortening; third, the fact that a potential beholder like-wise sees the finished work in a foreshortening which, if considerable (e.g., with sculptures placed above eye level), must be compensated for by a deliberate departure from the objectively correct proportions.

Not one of these conditions obtains in Egyptian art. The "optical refinements" which correct the visual impression of the beholder (the *temperaturae* upon which, according to Vitruvius, the "eurhythmic" effect of the work depends) are rejected as a matter of principle. The movements of the figures are not organic but mechanical, i.e., they consist of purely local changes in the positions of specific members, changes affecting neither the form nor the dimensions of the rest of the body. And even fore-shortening (as well as modeling, which accomplishes by light and shade what foreshortening achieves by design) was deliberately rejected at this phase. Both painting and relief—and for this reason neither is stylistically different from the other in Egyptian art—renounced that apparent extension of the plane into depth which is required by optical naturalism (*skiagraphia*); and sculpture refrained from that apparent flattening of the three-dimensional volumes which is required by Hildebrand's principle of *Reliefhaftigkeit*. In sculpture, as in painting and relief, the subject is thus represented in an aspect which, strictly speaking, is no *aspectus* ("view") at all, but a geometrical plan. All the parts of the human figure are so arrayed that they present themselves either in a completely frontal projection or else in pure profile. This applies to sculpture in the round as well as to the two-dimensional arts, with the one difference that sculpture in the round, operating with many-surfaced blocks, can convey to us all the projections in their entirety but separated from each other; whereas the two-dimensional arts convey them incompletely, but in one image: they portray head and limbs in pure profile while chest and arms are rendered in pure front view.

In completed sculptural works (where all the forms are rounded off) this geometrical quality, reminiscent of an architect's plan, is not so evident as in paintings and reliefs; but we can recognize from many unfinished pieces

that even in sculpture the final form is always determined by an underlying geometrical plan originally sketched on the surfaces of the block. It is evident that the artist drew four separate designs on the vertical surfaces of the block (supplementing them on occasion by a fifth, *viz.*, by the ground plan entered on the upper horizontal surface); that he then evolved the figure by working away the surplus mass of stone so that the form was bounded by a system of planes meeting at right angles and connected by slopes; and that, finally, he removed the sharply defined edges resulting from the process. In addition to such unfinished pieces, there is a sculptor's working drawing, a papyrus formerly in the Berlin Museum, that illustrates the mason-like method of these sculptors even more clearly: as if he were constructing a house, the sculptor drew up plans for his sphinx in frontal elevation, ground plan and profile elevation (only a minute portion of this last is preserved) so that even today the figure could be executed according to plan.

Under these circumstances the Egyptian theory of proportions could, as a matter of course, dispense with the decision whether it aimed at establishing the "objective" or the "technical" dimensions, whether it purported to be anthropometry or theory of construction: it was, necessarily, both at the same time. For to determine the "objective" proportions of a subject, i.e., to reduce its height, width, and depth to measurable magnitudes, means nothing else but ascertaining its dimensions in frontal elevation, side elevation, and ground plan. And since an Egyptian representation was limited to these three plans (except that the sculptor juxtaposed while the master of a two-dimensional art fused them), the "technical" proportions could not but be identical with the "objective." The relative dimensions of the natural object, as contained in the front elevation, the side elevation, and the ground plan, could not but coincide with the relative dimensions of the artifact: if the Egyptian artist assumed the total length of a human figure to be divided into 18 or 22 units and, in addition, knew that the length of the foot amounted to 3 or 3½ such units, and the length of the calf to 5, he also knew what magnitudes he had to mark off on his painting ground or on the surfaces of his block.

From many examples preserved to us we know that the Egyptians effected this subdivision of the stone or wall surface by means of a finely meshed network of equal squares; this they employed not only for the representation of human beings, but also for that of the animals which play so prominent a role in their art. The purpose of this network will be best understood if we compare it with the deceptively similar system of squares used by the modern artist to transfer his composition from a smaller to a larger surface (*mise au carreau*). While this procedure presupposes a preparatory drawing—in itself bound to no quadrature—on which horizontal and vertical lines are subsequently superimposed in arbitrarily selected places, the network used by the Egyptian artist precedes the design and predetermines the final product. With its more significant lines permanently fixed on specific points of the human body, the Egyptian network immediately indicates to the painter or sculptor how to organize his figure: he will know from the outset that he must place the ankle on the first horizontal line, the knee on the sixth, the shoulders on the sixteenth, and so on.

In short, the Egyptian network does not have a transferential significance, but a constructional one, and its usefulness extended from the establishment of dimensions to the definition of movement. Since such actions as striding forth or striking out were expressed only in stereotyped alterations of position, and not in changing anatomical displacements, even movement could be adequately determined by purely quantitative data. It was, for instance, agreed that in a figure considered to be in a lunging position the length of pace (measured from the tip of one foot to the tip of the other) should amount to 10½ units, while this distance in a figure quietly standing was set at 4½ or 5½ units. Without too much exaggeration one could maintain that, when an Egyptian artist familiar with this system of proportions was set the task of representing a standing, sitting, or striding figure, the result was a foregone conclusion once the figure's absolute size was determined.

This Egyptian method of employing a theory of proportions clearly reflects their *Kunstwollen*, directed not toward the variable, but toward the constant, not toward the symbolization of the vital present, but toward the

realization of a timeless eternity. The human figure created by a Periclean artist was supposed to be invested with a life that was only apparent, but—in the Aristotelian sense —"actual"; it is only an image but one which mirrors the organic function of the human being. The human figure created by an Egyptian was supposed to be invested with a life that was real, but—in the Aristotelian sense—only "potential"; it reproduces the form, but not the function, of the human being in a more durable replica. In fact, we know that the Egyptian tomb statue was not intended to simulate a life of its own but to serve as the material substratum of another life, the life of the spirit "Ka." To the Greeks the plastic effigy commemorates a human being that lived; to the Egyptians it is a body that waits to be re-enlivened. For the Greeks, the work of art exists in a sphere of aesthetic ideality; for the Egyptians, in a sphere of magical reality. For the former, the goal of the artist is imitation (*mimesis*); for the latter, reconstruction.

Let us turn once more to that preparatory drawing for a sculpture of a sphinx. No fewer than three different networks are used, and had to be used, since this particular sphinx, holding the small figure of a goddess between his paws, is composed of three heterogeneous parts, each of which requires its own system of construction: the body of a lion, whose proportioning adheres to the canon suitable for this breed of animal; the human head, which is subdivided according to the scheme of the so-called Royal Heads (in Cairo alone more than forty models are preserved); and the small goddess, which is based upon the customary canon of twenty-two squares prescribed for the whole human figure. Thus the creature to be represented is a pure "reconstruction," assembled from three components, each of which is conceived and proportioned exactly as though it were standing alone. Even where he had to combine three heterogeneous elements into one image, the Egyptian artist did not find it necessary to modify the rigidity of the three special systems of proportion in favor of an organic unity which, in Greek art, asserts itself even in a Chimaera.

We can foresee from the foregoing paragraphs that the classical art of the Greeks had to free itself completely

from the Egyptian system of proportions. The principles of archaic Greek art were still similar to those of the Egyptians; the advance of the classical style beyond the archaic consisted in its accepting as positive artistic values precisely those factors which the Egyptians had neglected or denied. Classical Greek art took into account the shifting of the dimensions as a result of organic movement; the foreshortening resulting from the process of vision; and the necessity of correcting, in certain instances, the optical impression of the beholder by "eurhythmic" adjustments. Hence, the Greeks could not start out with a system of proportions which, in stipulating the "objective" dimensions, also irrevocably set down the "technical" ones. They could admit a theory of proportions only in so far as it allowed the artist the freedom to vary the "objective" dimensions from case to case by a free rearrangement—in short, only in so far as it was limited to the role of anthropometry.

We are, therefore, much less exactly informed of the Greek theory of proportions, as developed and applied in classical times, than of the Egyptian system. Once the "technical" and "objective" dimensions have ceased to be identical, the system, or systems, can no longer be directly perceived in the works of art; we can glean, on the other hand, some information from literary sources, frequently linked to the name of Polyclitus—the father, or at least the formulator, of classical Greek anthropometry.

We read, for example, in Galen's *Placita Hippocratis et Platonis*: "Chrysippus . . . holds that beauty does not consist in the elements but in the harmonious proportion of the parts, the proportion of one finger to the other, of all the fingers to the rest of the hand, of the rest of the hand to the wrist, of these to the forearm, of the forearm to the whole arm, in fine, of all parts to all others, as it is written in the canon of Polyclitus."

In the first place, this passage confirms what had been suspected from the outset: that the Polyclitan "canon" possessed a purely anthropometric character, i.e., that its purpose was not to facilitate the compositional treatment of stone blocks or wall surfaces, but exclusively to ascertain the "objective" proportions of the normal human being; in no way did it predetermine the "technical" measure-

ments. The artist who observed this canon was not required to refrain from rendering anatomical and mimetic variations, or from employing foreshortenings, or even, when necessary, from adjusting the dimensions of his figure to the subjective visual experience of the beholder (as when the sculptor lengthens the upper portions of a figure placed high or thickens the averted side of a face turned to three-quarter profile). In the second place, Galen's testimony characterizes the principle of the Polyclitan theory of proportions as what may be called "organic."

As we know, the Egyptian artist-theoretician first constructed a network of equal squares and then inserted into this network the outlines of his figure—unconcerned as to whether each line of the network coincided with one of the organically significant junctures of the body. We can observe, e.g., that within the "later canon" the horizontals, 2, 3, 7, 8, 9, 15 run through completely insignificant points. The Greek artist-theoretician proceeded in the opposite way. He did not start with a mechanically constructed network in which he subsequently accommodated the figure; he started, instead, with the human figure, organically differentiated into torso, limbs and parts of limbs, and subsequently tried to ascertain how these parts related to each other and to the whole. When, according to Galen, Polyclitus described the proper proportion of finger to finger, finger to hand, hand to forearm, forearm to arm and, finally, each single limb to the entire body, this means that the classical Greek theory of proportions had abandoned the idea of constructing the body on the basis of an absolute module, as though from small, equal building blocks: it sought to establish relations between the members, anatomically differentiated and distinct from each other, and the entire body. Thus it is not a principle of mechanical identity, but a principle of organic differentiation that forms the basis of the Polyclitan canon; it would have been utterly impossible to incorporate its stipulations into a network of squares. For an idea of the character of the lost theory of the Greeks, we must turn, not to the Egyptian system of proportions, but to the system according to which the figures in the First Book of

Albrecht Dürer's treatise on human proportions are measured.

The dimensions of these figures are all expressed in common fractions of the total length, and the common fraction is indeed the only legitimate mathematical symbol for the "relations of commensurable quantities." The passage transmitted by Galen shows that Polyclitus, too, consistently expressed the measure of a smaller part as the common fraction of a larger—and, finally, the total—quantity, and that he did not think of expressing the dimensions as multiples of constant *modulus*. It is precisely this method—directly relating the dimensions to each other and expressing them through each other, instead of separately reducing them to one, neutral unit ($x = \frac{y}{4}$, not $x = 1$, $y = 4$)—which achieves that immediately evident *"Vergleichlichkeit Eins gegen dem Andern"* (Dürer) which is characteristic of the classical theory. It is no accident when Vitruvius, the only ancient writer who handed down to us some actual, numerical data regarding human proportions (data evidently deriving from Greek sources), formulates them exclusively as common fractions of the body length, and it has been established that in Polyclitus' own *Doryphoros* the dimensions of the more important parts of the body are expressible as such fractions.

The anthropometric and organic character of the classical theory of proportions is intrinsically connected with a third characteristic, its pronouncedly normative and aesthetic ambition. Where the Egyptian system aims only at reducing the conventional to a fixed formula, the Polyclitan canon claims to capture beauty. Galen expressly calls it a definition of that "wherein beauty consists" (*kallos synistathai*). Vitruvius introduces his little list of measurements as "the dimensions of the *homo bene figuratus*." And the only statement that can be traced back with certainty to Polyclitus himself reads as follows: "the beautiful comes about, little by little, through many numbers." Thus the Polyclitan canon was intended to realize a "law" of aesthetics, and it is thoroughly characteristic of classical thought that it could imagine such a "law" only in the form of relations expressible in terms of fractions. With the sole

exception of Plotinus and his followers, classical aesthetics identified the principle of beauty with the consonance of the parts with each other and the whole.

Classical Greece, then, opposed to the inflexible, mechanical, static, and conventional craftsman's code of the Egyptians an elastic, dynamic, and aesthetically relevant system of relations. And this contrast was demonstrably known to antiquity itself. Diodorus of Sicily tells, in the ninety-eighth chapter of his First Book, the following story: In ancient times (that is to say, the sixth century B.C.) two sculptors, Telekles and Theodoros, made a cult statue in two separate parts; while the former prepared his portion on Samos, the latter made his in Ephesus; and on being brought together, each half matched the other perfectly. This method of working, so the story goes on, was not customary among the Greeks but among the Egyptians. For with them "the proportions of the statue were not determined, as with the Greeks, according to visual experience," but as soon as the stones were quarried, split and prepared, the dimensions were "immediately" (to tenikauta) established, from the largest part down to the smallest. In Egypt, Diodorus tells us, the entire structure of the body was subdivided into 21¼ equal parts; therefore, once the size of the figure to be produced had been decided upon, the artists could divide the work, even if operating in different places, and nevertheless achieve an accurate joining of the parts.

Whether the anecdotal content of this entertaining story is true or not, it displays a fine feeling for the difference, not only between Egyptian and classical Greek art, but also between the Egyptian and the classical Greek theories of proportions. Diodorus' tale is of importance, not so much in that it confirms the existence of an Egyptian canon as in that it accentuates its unique significance for the production of a work of art. Even the most highly developed canon would not have enabled two artists to do what is reported of Telekles and Theodoros as soon as the "technical" proportions of the work of art had begun to differ from the "objective" data laid down in the canon. Two Greek sculptors of the fifth, let alone the fourth, century, with even the most exact agreement upon both the

system of proportions to be followed and the total size of the figure to be carved, could not have worked one portion independently from the other: even when strictly adhering to a stipulated canon of measurement, they would have been free with regard to the formal configuration. The contrast which Diodorus wants to bring out can, therefore, hardly mean, as has been supposed, that the Greeks, as opposed to the Egyptians, had no canon at all but proportioned their figures "by sight"—apart from the fact that Diodorus, at least through tradition, must have had knowledge of Polyclitus' efforts. What he means to convey is that for the Egyptians the canon of proportions was, of itself, sufficient to predetermine the final result (and, for this reason, could be applied "on the spot" as soon as the stones were prepared); whereas from the Greek point of view something completely different was required in addition to the canon: visual observation. He wants to make the point that the Egyptian sculptor, like a stonemason, needed nothing more than the dimensions to manufacture his work, and, depending completely upon them, could reproduce—or, more exactly, produce—the figures in any place and in any number of parts; whereas, in contrast to this, the Greek artist could not immediately apply the canon to his block, but must, from case to case, consult with the *kata ten 'orasin phantasia,* a "visual precept" that takes into account the organic flexibility of the body to be represented, the diversity of the foreshortenings that present themselves to the artist's eye, and, possibly, even the particular circumstances under which the finished work may be seen. All this, needless to say, subjects the canonical system of measurement to countless alterations when it is put into practice.

The contrast which Diodorus' story is intended to make clear, and which it does make clear with remarkable vividness, is thus a contrast between "reconstruction" and "imitation" (*mimesis*), between an art completely governed by a mechanical and mathematical code and one within which, despite conformity to rule, there is still room for the *irrationale* of artistic freedom. . . .

ERNEST WILL

THE GRECO-ROMAN
CULT-RELIEF *(1955)*

ALONG WITH the reappraisal of primitive art has come a thorough reinterpretation of sculpture formerly called "barbaric" because it was produced in so-called "dark" ages. The long reaches of time before fifth-century Athens, the troubled years while the Roman Empire was disintegrating, the whole early-Christian era, and the epoch of Byzantine supremacy were thought to be dark, or even barbaric. All this is changed, as is clear from the tendency in André Malraux to rehabilitate "degenerate" art. This selection from the researches of Ernest Will concerns the quickened and changed religious needs of a "dark" period when mystery-cults were thriving, and when Christianity was being born; and there is a corresponding revision in sculptural form when the devotee needs to feel the "presence" of a god who is no longer seen in profile but face to face with his worshiper. The problem here is a new "will-to-form" in late-Roman works, with a flattening of reliefs and an apparently illogical use of frontal and profile views of beasts, men, and gods. Even a brief visit to the Louvre

or British Museum will suggest that from Sumerian and Assyrian art onward the representation of gods and heroes in profile or fullface betokens changing religious attitudes. Josef Strzygowski, in works like *The Origin of Christian Church Art* (1923), claimed Eastern origins for Christian religious and artistic attitudes. Will finds the origin in the West itself.

That late-Roman art is not a degeneration or decay is also the theme of Alois Riegl's famous and difficult *Spät-römische Kunstindustrie* (1901 ff.). Riegl shows how this art manifests a new sense of space without which medieval art could not have been. If antique art bound forms to the plane, late-Roman art, by undercutting relief figures, flattened them decoratively in repeated patterns such as we see in Byzantine art; but at the same time it released these figures into a new kind of deep space partly created by cast shadows. This *Tiefraum* was not yet coherently organized, and left individual figures isolated in "optical" space which was "negative," yet patterned. This new deep space appears in radical form in the basilica. Thus the last phase of antique art is not the loss of a canon so much as an opening of a road toward modern art. The twining reliefs spiraling up Trajan's Column are already index to an art that places the figure, alone, in infinite space. And the early-Christian sarcophagus reveals a rhythm that is unclassical and "painterly" as well as sculptural. Hence we must have Riegl and Will in mind when we read the following selections from Baltrušaitis, Schoene, and Frey.

Will's discussion of the cult-relief can be related to many recent studies of Greco-Roman mystery religions, especially Martin P. Nilsson's *Greek Popular Religion* (1940), *Greek Piety* (1951), *History of Greek Religion* (1925, 1949, 1952), and *The Dionysiac Mysteries of the Hellenistic and Roman Age* (1957). The problems of changing artistic forms are treated in Max Dvořák's *Kunstgeschichte als Geistesgeschichte* (1928). Will's study is a scholarly treatment of the problems of "degenerate" or "regressive" art about which André Malraux writes in *Voices of Silence* (1953) and other works describing "metamorphoses" in art. Panofsky has called this kind of metamorphosis a "disjunction"—using old forms to convey new meanings.

GENERAL PRINCIPLES
OF REPRESENTATION:

Frontality in Relief and Painting in Egypt and the Ancient Near East

(Chapter IV, Section B)

═══════════════════════════

If it has been possible to hold to the Parthian, or generally Iranian, origin of the convention of frontality, this is simply because in the era when it appears suddenly with unexpected vitality, it represents a novelty and is not related to the local traditions of regions where it is born and develops. This fact, perhaps too obvious to have gained attention, deserves to be more closely examined. What are the historical conditions surrounding the development of frontality?

Even a slight knowledge of Egyptian art makes clear a salient fact about the representation of the human being in relief or painting: the face is ordinarily in profile. This convention is the more striking since the face seen entirely sidewise is placed on a frontal torso with flattened shoulders and since the legs are, once again, seen in profile, the feet especially being drawn at full length. A deeper study shows, on the one hand, that this formula is very old, appearing with the first ventures in Egyptian art itself, and on the other hand, it shows the fact that the fullface head (which can be turned whenever the artist wants to render a special pose or motion) becomes more frequent only with the New Empire.

The reasons for this phenomenon have often been investigated, and are examined with special finesse by H. Schaefer's researches into Egyptian art. Basically this art is not illusionistic but emblematic; it seeks not so much to make us see as to understand, not to imitate so much as to

betoken. Thus, in its rendering of figures and things, it gathers the essential elements, each seen from an angle which most fully reveals it, and unified in defiance of natural law or any over-all consistent view. In this way, it achieves an image of man such as we have just described, in which the profiled face is one of the most arresting traits.

Furthermore, the Egyptian artist was not incapable of presenting the full face—the supposition is somewhat absurd if one thinks of the great technical skill his creations show—and his statuary, using a strict "law of frontality," always shows the human figure fullface. But the graphic arts, relief, and painting prefer the face in profile. Essentially narrative, they chose the pose allowing them most easily to bring into relation the various figures in the same episode. So one notes a major fact, the importance of which will be clear later: the use of dissimilar or even contradictory conventions in different kinds of plastic representation, on the one hand statues-in-the-round, on the other relief and painting.

In the last analysis this choice seems to us a logical one: the profile is better adapted to the peculiar aim of the graphic image. Similarly, one reaches the opposite conclusion in examining instances of fullface images. H. Schaefer mentions two important examples, that of the god Bès, whose body and face are both frontal, and that of an hathoric head,[2] for both of which he is willing to consider Asiatic influences. Actually these two exceptional cases are to be accounted for by rules native to Egyptian art itself. Thus, it is one thing to render a head as part of a body, and it is another thing to render it alone: nothing can give so satisfactory a notion of the isolated head as a full face. Furthermore, one must not lose sight of the meaning of these hathoric heads. They have been taken, and not without reason, considering their role, as *gorgoneia;* and their magical (apotropaic) use seems, indeed, the more probable for this Egyptian image in the place where it usually appeared, that is, as ornament on a capital. Doubtless the same interpretation suits the image of Bès, whose very ugliness is indicative. Such visages can be thought effective only if they present themselves fullface.

Elsewhere it may be that the influence of statuary inspired this or that rendering in fullface. It is nonetheless true that generally the full face is employed for certain special purposes, particularly religious or magical. In this connection it has been stressed that the Egyptian relief made no exception for either gods or kings on this score, and that this strictness of rule hindered the creation of the devotional relief-image, the *Andachtsbild*, where the god had to be represented fullface, directly confronting his worshiper; the statue-in-the-round was assigned that task.

But if the choice of face or profile is logical, if it is wrought or seen by an artist who is aware of and master of his techniques, it seems hard to link one or the other of these conventions to a primitive phase of art. In fact, among even very ancient Egyptian works like red-figured vases, the profile is already well attested. Similarly, if it is true, as a child's drawing seems to prove, that at its beginnings art shows man fullface, it is no less clear that this must be taken as an extremely primitive phase, and that every form of slightly developed art is capable of using indifferently either fullface or profile, yet makes an arbitrary choice.

For a long time it has been held that ancient Mesopotamian art followed rules very like those of Egyptian art. The basic laws are identical: Mesopotamian art is as hostile to illusion, and as given to emblematic representation. A recent work by C. Flavigny enables us easily to summarize the conventions in vogue; one learns, in particular, that the canon reserved for the human figure in graphic representation underwent no change: profile is the rule.

Mesopotamian art, however, is less severely formal than its contemporary in the Nile valley. The exceptions, that are more common, are also more significant. One notes, in effect, two different, quite distinct groups: first, the god in fullface; then, the hero in fullface. Among the former group, the major instance is the great fertility goddess. Often wholly nude, she assumes various poses, especially with her arms; as a rule she is strictly fullface. To say that this goddess appears thus "to show her submissive attitude and to offer herself" is surely to use too modern a phrase, to say the least. Actually, the goddess as

the great vessel of fertility and fecundity could hardly fail to exhibit the physical symbols of her power, her breasts and her sexual organ; but these features are apparent only if the figure is fullface. Furthermore, this basic necessity is underscored in the widespread archaic use of crude figurines showing the maternal goddess in the pose just described. Besides, certain indications lead us to believe that the distinction between the domains of sculpture-in-the-round, and in relief, was less sharply made in hither Asia than in Egypt; in northern Syria, and even in Assyria, one could mention some ancient examples of cult-reliefs (or *Andachtsbilder*) in which the god is also rendered fullface.

More meaningful for our study is the case of the hero in fullface: this image in combat with a monster or wild beast—a remote prefiguration of Mithra the Bull-Slayer—is one of the oldest themes in Mesopotamian art, and one of the most frequently inscribed on cylinders. Variation in details is wide, but what should be noted here is that the hero and his antagonist are both in equal numbers rendered in fullface and in profile. The attempts made to explain this anomaly have been vain, and if one considers that fullface and profile occur together simultaneously on the same cylinder, he can only conclude that the treatment of the motifs, perhaps originally separate, were quickly combined and used indifferently in a simple concern for variety. As to any possible relations with representations of Mithra, we have already stressed that there is no direct link between these works of Mesopotamian art in its first phases and the figure of the Bull-Slayer as the Hellenistic era developed it in the very regions where the hero-with-monster was widespread.

Furthermore, it seems that during the course of art in the ancient Near East the tendency toward the profile was strengthened, if anything, by developments. Hittite or Syro-Hittite monuments allow us only to confirm what we have noted for Mesopotamia proper: the rules and the exceptions are the same. Assyrian art, infinitely more life-like and realistic than either its forebears or in contemporary Anatolia, made almost no use of fullface representation with a consistency nearly parallel to that of Egyptian

art. And one does not expect in Persian art, so unadventurous in its basic notions, any revolution in the primary conventions of plastic representation; even the collaboration with Greek artists, which seems to have occurred in the great monumental frescoes at Persepolis and elsewhere, is not translated into any change in inspiration.

If the case of Persia is apt to raise doubts about the Iranian origin of frontality, the late pre-Islamic art of Iran, bearing the name of the Sassanids, seems to dismiss all likelihood of the "Parthian" theory. At a date when the success of frontality is increasingly evident in the Roman Empire, and was already assured in the frontier provinces, in the area that was to become the very domain of Parthian art, the masters who celebrated the glory of Sassanid kings, still faithful to Eastern and Achaemenian tradition, did not in any way reject the profile convention; in the huge rock-sculptures wrought by their hands, they gained a prestige still unchallenged. How can we think that this tradition had been interrupted during the course of many centuries of Parthian domination?

This short review of the "face or profile" problem in the arts of the ancient Near East and Egypt leads to some tentative conclusions.

1—All these arts are equally nonillusionistic and conventional, and generally accept the principle of the profile-view for the human figure in relief and painting.

This tendency is primitive; we do not find, as far back as we can observe, a change from fullface to profile, but at most a coexistence of the two types previous to the definitive formulation of conventions. In other words, the primitive phase invoked in this question does not seem relevant to the arts as practiced.

This situation does not alter in the course of time; on the contrary, one can even say that it is reinforced in the last phases of Near Eastern art in the exact degree to which technique was perfected.

2—Thus, all these arts made a strict distinction between statuary-in-the-round—an art of cult or "presentment," without exception taking a fullface view—and relief and painting, narrative and descriptive arts, where the profile is felt to be necessary.

3—The fullface view in the graphic arts themselves, whenever it infrequently appears, results from the basic law of conventional art. It is accounted for by special aims, usually of a religious kind; the idea always dominates the image. Or else—and the instance should be kept in mind—the influence of statuary-in-the-round makes itself felt.

These findings make it singularly clear that the substitution of fullface for profile in the Near Eastern arts cannot be explained by the effects of an internal evolution, but indicates a true revolution, a break with the distant past and an inauguration of a new era. The two suggested explanations to account for this change do not, however, offer any satisfactory reason for this phenomenon. Two circumstances are, in fact, opposed to the theory of a return to primitivism. A study of actual conditions under which the profile method was chosen shows first of all that the artist, no matter how incompetent, can as easily execute a profile as fullface, fullface as profile, and secondly, that if the artist opts more often for one than the other, his choice is determined by special considerations. And as one cannot presume that the Syrian artist of the early-Empire was consciously a "primitive," like our sculptors and painters of recent times, we must find reasons for his revised choice and show, besides, why and in what way this choice commended itself to him in preference to ancient formulas. For simple novelty cannot any longer be thought an adequate stimulus. The fallacy of the theory of a return to primitivism is precisely here. In truth, Eastern arts are already "primitive," and remain so; their methods do not change in the least, since they remain devoted to stereotypes, satisfied to substitute one convention for another, fullface for profile. Therefore, one cannot logically speak of a return to primitivism or a reappearance of primitive methods. The explanation that is suitable in the case of Greek art is not suitable in Eastern arts; primitivism reveals itself not in using this or that convention, but simply by using conventions. Thus, the hypothesis of inspiration from abroad or the importing of a new convention, offers a more plausible solution, and here is the merit one finds in the Parthian theory if its

error were not proved by the facts we have mentioned. But if the East cannot furnish an adequate explanation of our problem, where must we turn?

First, it is not uninstructive to describe the circumstances under which the fullface convention succeeds the profile convention. Yet nothing is more delicate. The Hellenistic period, which once again looks like the critical moment in this evolution, has left us nothing but rare and second-rate vestiges throughout hither Asia, just numerous enough to show that in local art (we mean whatever is not purely and simply Hellenistic) the profile tradition persisted.

Nevertheless, certain monuments deserve our attention. First, there are the famous reliefs of the tomb of Antiochus I of Commagène (69-34 B.C.) at Nemroud Dagh. The subjects, and the low-relief technique, place these compositions in the tradition of Achaemenian art, not without clear traces of Hellenic influences. Now the heads of these personages, if not their bodies, are still uniformly treated in profile.

But let us consider one of these works more closely. It illustrates the old Eastern theme of the king in the presence of his god—here King Antiochus before Zeus-Orosmades. The Lord of the Sky is seated in a fullfaced position on his throne, a pose emphasizing legs and chest in spite of the difficulties such foreshortening can cause the artist; the King himself approaches from the left; the two are looking at each other, the god turning his head toward his devotee, who responds to his glance. What a profound difference from a composition treating the same theme, the cult-relief of Zeus-Kyrios at Dura, dating from A.D. 41. Here the enthroned god appears with legs in profile, but torso and visage in fullface, his glance directed toward the spectator. It is not impossible to associate this type with ancient Mesopotamian works, but what is original is the pose of the mortal drawing near with his oblation; he, likewise, is entirely fullface, more attentive to the spectator than to his god. It is clear that the revolution we mentioned earlier has taken place.

Corresponding historical evidences are available at Palmyra. We have only second-rate fragments of so-called

archaic sculpture from this site, but it is notable that the figures are rendered in profile even though, at the temple of Bel, dedicated in A.D. 32, a severe frontality rules as thoroughly in body as in face: the change takes place here almost exactly at the start of our era.

Finally, the representations of Dolichenian Jupiter[3] furnish the same proofs. The half-dozen images of the god found in Syria proper—unfortunately they are difficult to date—have certain common traits: the god wears oriental garb and the head is in profile. Only the group at Biredjik has a frontal position, but it is joined with Roman breast-plates, and the monument does not differ from those that have been found in Europe: an odd and revealing discord between these native monuments and those of the West, and the more revealing because the earliest are of clumsy treatment and are undisputedly accepted as popular and primitive! The cause of the change, if not its precise date, discloses itself plainly enough. In a word, the triumph of frontality in Syria coincides with the coming of Roman legions. What important fact can one link with that date, except precisely the Roman invasion with its undeniable effects on Eastern culture? Will it not be contrary to all expectation that Western influence—and not Parthian, already on the wane—should have played a major role? . . .

WESTERN ORIGIN OF EASTERN FRONTALITY
(SECTION D)

. . . We shall recapitulate, as follows, the development of the Greek and Roman relief so far as it concerns the problem of frontality: Classicism, breaking the barriers dividing relief from statuary-in-the-round, freed, at the same stroke, "fullface" and "profile," each of which hence-forth is not confined to a single category of plastic repre-sentation. Furthermore, the influence of statuary-in-the-round is especially evident in the growing prominence of high-relief on the one hand, and on the other, the concern for affirming the "presence" of certain personages leads to the adoption of a partial frontality, and in general, the orientation of figures toward the beholder. This develop-ment, threatening the illusionistic nature of classic repre-

sentation, began in the fifth century B.C., becoming more pronounced in the fourth century and later; and it affected the whole corpus of Greco-Roman art, being not in the least confined to popular works. The primitivistic trend in these latter is confirmed and encouraged in the precedent given by high art, and could only accentuate and standardize the entire evolution.

Thus, if we seek to define the relation between West and East in the problem of frontality, we should cling to the following basic points:

1—The arts of the ancient Near East hold uniformly in painting and relief to a convention of the face-in-profile.

2—Greek art, then Roman, knew in theory the principle of rendering in fullface; after the fourth century appears a kind of frontality consisting in turning the major figures in any scene toward the spectator, while developments in high-relief increase the number of single figures in fullface.

3—With the Roman era, frontality of body and face alike becomes a strict formula in Eastern arts.

The relations between East and West become obvious in this setting. The convention of frontality does not belong to Eastern traditions and owes its existence to no oriental convention, either Parthian or popular. Its appearance marks a true revolution, which could happen only under the auspices of an art in which fullface representation was normal: that art was originally Greek, then Roman. The ancient Eastern arts could not resist the impact of Western culture; the ancient formulas collapse before such an attack, and in reconstructing themselves they defer to the mastery of the West, borrowing from it what might appear to be a daring innovation in native art, frontal representation. For the West, however, this was a short-lived victory. Eastern art holds to its fundamental laws, the imperative need for a convention, for a unique and constant vision of the human being. Whether this convention be fullface or profile matters little; one can alternate with the other, but they cannot coexist. Thus, the Eastern character of a work resides not in the use of a frontal convention but in its style, and if we compare the previously mentioned frescoes at Dura with their Western

prototypes, it is not frontality that most of all distinguishes them, but their harshness, the fixed nature of their poses, the symmetry and repetition of figures as opposed to movement and freedom.

One may be tempted to contrast the logical rigor of our argument with a certain dearth of artistic documentation; but will not the clinching proof be furnished by those monuments where, in a fashion, we see the struggle taking place between Western innovations and Eastern traditions? Such monuments are certainly among the rarest, and we should hold ourselves to a typical example. Egypt offers us an undeniable instance of mongrel representation where the origins of fullface and profile are clearly manifest. Among the frescoes on a tomb at Hermopolis Magna, one finds scenes grouping a good many figures; on the whole they are treated in traditional Egyptian style with persons in profile. In one of the panels, the image of Death is a lone exception; she looks like a foreign body, and, in fact, she does not deny her Hellenic origin. Only she is fullface.

The main conclusion to be drawn, then, concerns the question in which direction influences ran in the problem of frontality: from West to East. In striking fashion, this fact underscores the independence of evolution in Greco-Roman art; we must never forget it in estimating the role of the cult-relief in this evolution. . . .

CONCLUSIONS

The foregoing investigations and findings have allowed us to draw a number of partial conclusions, and what remains is to assemble and coordinate them if we wish to define the place of the cult-relief in the art of the Empire.

According to our prefatory remarks, the cults in which the relief is the chief, and nearly unique, form for rendering deity are those of gods alien to the Greek and Roman pantheon, the barbarian gods like the Thracian Hero or the Danubian Horsemen,[4] or Eastern, like Mithra and Dolichenian Jupiter. Obviously, in this foreign element, we shall find the answer to more than one of the questions we ask. But again, it is advisable to take this element at its

true worth, above all mistrusting simple and summary solutions. The problem of the cult-relief is not among those allowing division into any pattern of "influence" and "borrowing." Among the series we have studied, only that of Dolichenian Jupiter can pretend to ancient artistic traditions, and we have tried to show that, in the very homeland of the cult, the divine image was probably a relief; but we have also underlined that the cult-relief was not any more familiar to the ancient East than to the Greco-Roman world (though possibly more usual in a certain narrow area). And if we note at what point the image of bull-slaying Mithra makes a radical break with the authentic traditions of the East, we shall no longer believe in the possibility of borrowing or the persistence of an ancient motif, but we shall recognize the originality of this image by its traits as quickly as by its material form, the relief.

Generally speaking, the "novelty" of the divine image offered by cult-reliefs struck us each time as startling. Yet that "novelty" has a double aspect. Most of all the substitution of the relief for the statue doubtless indicates a change in religious inspiration. The mystery cults like those of Mithra and the Danubian Horsemen, or "personal" cults like those of the Thracian Hero, are precisely the ones testifying to such a change. We have strongly stressed the particular demands of the devotee as revealed by the image of the god sacrificing the bull, the Hero-Hunter, the Warrior-Brothers, and we have said that the image had the function of keeping the god's redeeming act always present to the eyes of the faithful. Thence, one understands the advantage of relief over the free-standing statue: illustration of the action, rendering of auxiliary but indispensable figures, like the horse and the bull, and the addition of symbols and secondary episodes, were not finally possible except in the graphic form relief offers. In a word, it is the subject—the new and original subject— that presides at the birth of the cult-relief. But if novelty of subject justified a recourse to new forms, one must add that the foreign nature of the divinities aided, or even made possible, a break with traditional types.

All links with the past were not, however, broken; the difficulty is to find more accurately from what tradi-

tional data the makers of cult-reliefs were wont to draw. Happily, the most important of our series have allowed us to identify the new types, and to define their character. Thus, the direct model for the image of the Thracian Horseman was found in the image of the Hellenic Hero-Horseman, and the model for the Danubian Brethren in the Hellenic Dioscuri; for Mithra the Bull-Slayer the recollection of the Hellenic Wild-Beast-Tamer seems equally undeniable. But what seemed notable everywhere is the common source of the three themes in the repertory of heroes; obviously the artist, when faced with a new theme and with gods lacking Olympian attributes, on every occasion opted resolutely for a less sublime formula, offered him by a popular instead of a grand style. The world of heroes and minor divinities like Nymphs seems traditionally to have been devoted to the relief, doubtless for practical reasons (such as familial grouping of deities, the lack of temples, etc.) allied to those that assure the diffusion of the cult-relief. Finally, the image of our divinities is not a simple transposition of foreign prototypes or a complete assimilation by pure and plain borrowing of Greco-Roman types, but an original reworking, so far as the god's person is concerned, blending the suitable formula with Greek artistic traditions.

We have summed up our findings by the term "Greek" or "Roman interpretation." Our cult-reliefs are indeed the result of an attempt made by Greece and Rome to assimilate alien gods, and it is proper to emphasize that the consequence was a new and original formula, having its own place among other instances of this interpretation.

Study of theme, however, and tracing religious origins, could not lead us farther, and there remained the crux of our task—the problems of form. For at the start, a "Greek" or "Roman" interpretation seemed like a compromise between dissimilar or even opposed cultures; and so the choice of a dominantly Hellenic formula, such as the figure of the hero replacing that of the god, did not enable us to predict the stylistic traits the figure would be given—for there the chance of modifying or altering Greek or Roman conventions stayed open.

To begin with, we made a special effort to order the

chronological data, and our conclusions, if they are not exactly revolutionary, and if they often result in only a loose approximation, do not seem negligible. In fact, one may hesitate which phrase to use, Greek or Roman interpretation. The latter term recommends itself by the simple circumstance that the works examined belong almost without exception to the Imperial era, and in every way the great diffusion of the cult-relief dates itself within this period. Yet we have already proved in the case of Dolichenian Jupiter and Jupiter of Heliopolis, as with other Asiatic gods, that the images offered by the works of the Imperial epoch actually trace back to a Hellenistic type. We have sought to prove that this Hellenistic formula ought to be assigned to the Thracian Horseman along with Mithra, and one recalls that for the image of the Bull-Slayer we have reached a relatively precise date, about 100 B.C. There is every chance, also, that divinities like Mèn or Sabazios[5] received a new Hellenized treatment at about the same time. The main and stubborn exception seemed to be presented by the Danubian Horsemen; but we have noted that we can without difficulty place the origin of the Divine Twins type in the same period, if historical evidence does not compel us to link it with the Roman conquest of Dacia.

Thus, this exception conclusively underlines a major fact. In developing cult-reliefs, the Hellenistic age not only fixed the type repeated in succeeding centuries, it also fixed once and for all the modes of representing it. So it is undeniable that the breastplate worn by the "warrior-gods" on our monuments is a Roman breastplate; but this breastplate merely replaced an earlier version of this armor, and the figure of the harnessed, helmeted god is quite plainly Hellenistic. In other cases, such as that of the "Phrygian" costume, this adaptation was not required: an ancient Greek type here persists with extraordinary tenacity. The Imperial era, then, merely follows a tradition solidly established and fixed in a preceding period.

This is the time to recall the conclusions to which our study of "Cavalier Gods" has led. The domain of these gods was, in fact, the Hellenistic world as the Alexandrian conquest embraced it, the only milieu in which they could

take form being the world resulting from this conquest. It is the same with other gods of our cult-reliefs. To the extent that the monuments we have studied, especially those to Mithra, were found in the Western provinces of the Empire, this could hardly have happened, except as a consequence of works somehow imported or transplanted. And when we are driven to accept an Imperial date, as for the appearance of Mithraic reliefs of multiple episodes, we can also hardly avoid recognizing the effect of conventions fixed long before. In brief, cult-reliefs are a special but decisive case of "Greek" interpretation.

The relatively early date of the birth of the cult-relief without doubt explains its most surprising features. It fell to Greek art, once again in full expansive force, to give a new visage to oriental and barbarous gods, and it is exactly this preponderance of the Greek element that seems to be the most remarkable fact in our study of historical data that until now appeared to afford a firm base for the theory of Eastern contribution. If, for instance, it is well-established that the addition of heavenly luminaries traces back to an old tradition in the East, we have nevertheless seen that not only the anthropomorphic figuration, whether in the guise of astral chariots and their drivers or, in elliptical form, of busts of Sol and Luna, reveals a deep Hellenization; but also that the simple presence of these luminaries was common in Greek art after an innovation due to the great masters of the fifth century. After the Hellenistic period, then, there existed two parallel traditions. It is indeed hard to assign the place of one or the other in works of the Imperial age. One can, however, with a certain logic, grant that in this case oriental ideas heightened and sustained the image created by Greek art.

On the contrary, it is useless to appeal to oriental influence to explain the custom of surrounding the god's image by a whole world of symbols and attributes of various sorts. We have indicated that the requirements of legend and all the demands made by religious or political propaganda resulted after the Hellenistic era in the development of such symbols and attributes and in their close union with the divine image. But at the point where the theory of oriental influences and non-Hellenistic tend-

encies seems best grounded, we have been led to the most unexpected conclusions: we refer to the problem of so-called oriental frontality. Not only does this frontality show itself to be without any root in truly Eastern traditions, but its very appearance in Greco-Mesopotamian art at the start of our era represents, in actuality, the result of Western influence on the East. All together, the traits of the new style manifest on such monuments can be explained in the perspective of a free evolution of Greco-Roman art. The borrowings, as we have noted in various forms of the god-with-a-beast, for example, reduce themselves to a few primary types.

This claim requires some explanation, for some will doubtless hesitate to accord the image of the Bull-Slayer any place in the "normal" development of Greek or Roman art. To tell the truth, the appraisal of what is Greek or non-Greek in such works as ours, often rests upon unconscious or tacit prejudice. The prevailing attitude—natural and understandable—is to hold that Greek art found its perfect expression in works by Phidias, Polyclitus, and other great masters of fifth-century classicism; and one can be tempted, as a result, to think of all deviation from that ideal as non-Greek. But this attitude cannot be that of the historian. Certainly it is undeniable that the trend to illusionism is inherent in Greek art and the trait by which it essentially distinguishes itself from the arts of other ancient peoples. Yet, Greek art never refused a task acknowledged by all other ancient arts, that of interpreting religious, political, or other ideals. And that is how methods contrary to illusionistic representation could cause deviation from a straightforward evolution. Classic Greek art— like all classic art—embodies a perfect moment, but a transitory moment associated with certain historical circumstances; as image of a special regime, it imposed a special law on methods of expression. But these formulas quickly show themselves inadequate to meet the more complex needs and trends in later periods, and particularly the one we call Hellenistic. The extended horizon of the Greek in this age, no longer bounded by city walls, the conquest of new lands, and encounters with wholly alien traditions, brought profound changes in spirit. Our study of

frontality has revealed a striking instance of these changes: what it has of the "oriental" in certain special cases is its trait of strict conventionality; otherwise, it has its primary roots in a taste for the pathetic and theatrical, in the desire for "presence," in certain social and political needs also, of which the first manifestations made themselves felt in Greece after the triumph of classicism.

Therefore a method of representation or a motif that seems unknown to classicism or irreconcilable with its temper, is not, however, alien to the normal and regular evolution of Greek art. Our cult-reliefs belong to this evolution; and if one is tempted to believe that the spread of the image of barbaric or oriental gods was a clear sign of the retreat of the Western spirit—a retreat after which the triumph of cults and their attendant creeds is, in another sense, hardly in doubt—a deeper inspection has shown us that in art history such conclusions are radically incorrect.

As Hellenistic creations, and representatives of the evolution of Greek art, our reliefs are also faithful witnesses of the development of the art of the Empire, and not only in the degree that this art continues the Hellenistic tradition. During the course of our study we have noted the "popular" nature of our monuments; but this trait is above all the mark of provincial art. This is apparent in the two series of Horsemen, whose domain does not extend much beyond the boundaries of their native land, and it is also true of an "Imperial" cult like Mithra's. In the history of the art of this cult precisely such regional variants are found to be of greatest interest. Consequently, one is led to regard these reliefs from another angle, bringing attention to bear upon what they tell us of the development of art in the provinces.

Likewise, the Danubian stele, with its complicated design, appears to us as the humble reflection of the triumphal imagery of the Empire; its origin seems allied to the modest tastes and artistic abilities of legionaries, its evolution sustained by the practice of a special skill— metal work (toreutics)—and its diffusion partly assured by local casters' and carvers' shops, doubtless affiliated with other shops spread along the frontiers from East to West.

If in this instance one cannot pass beyond plausible hypothesis, the Mithraic cult allows firm conclusions, and it is exactly the problem of relations between East and West that Mithraic monuments bring into full daylight. "Between East and West" implies between Eastern and Western halves of the Empire; for sprung from Hellenistic traditions, these monuments properly belong to the art of the Eastern half, and their spread through the Western provinces thus poses a problem whose significance reaches beyond the narrow limits of a single cult.

Earlier we have followed the route over which Mithraism came from its Anatolian fatherland to the banks of the Rhine and Danube; the carven monuments of this cult have revealed to us, as we followed it, the existence of the route that played a major role in the formation and expansion of Imperial art along the Germanic frontiers. But that route, conveying Hellenistic traditions, did not pass through the capital of the Empire, and thus, side by side with "Imperial" art, there appears vividly the activity of independent provincial centers, of the same Hellenistic origin. Indeed, the figure of the Bull-Slayer received small attention in the capital; on the contrary, along the banks of the Rhine the relief with multiple episodes takes its place among the original creations of Imperial art.

These remarks lead us at last to weigh the deep causes for the "inferiority" of most of our cult-reliefs, a mediocrity we find at the root of the scorn in which they generally are held. Doubtless it seems at first to be associated with the provincial and popular nature of the monuments. Indeed, in the case of the Cavalier Gods, one can believe that the poverty of the people, and the barren life of backward provinces, would inhibit the creation of works of art worthy of the name. In the case of Mithraism, which drew its devotees from very dissimilar conditions, this meagerness may at first surprise us; but the hermetic character of the cult, which always prevented it from rousing the enthusiasm of the masses, or even protected it from such, without doubt was a powerful and invincible restraint; at most an artist vain of his name would sign a Bull-Slayer conforming to the best traditions of a classicizing taste.

Yet, before such rare instances of "beautiful Roman sculpture" we perhaps understand the real and deep causes of the mediocrity just mentioned. For if the different cults to which our reliefs belong showed a new and potent faith, if they were able to become heirs to dying political and official cults, in the domain of art they show themselves to be merely conventional, strictly bound by the intellectual and artistic modes of their day. If the East contributed its eternal spiritual gifts to the birth of these new cults, it was unable to add that of artistic expressiveness; it was from Greece, with its rich store of methods, that they sought aid.

The great Rhenan Mithraic reliefs, with their complicated monumental structure, their richly illustrated framework, are a truly new and original formula in the history of ancient art and religion; they still set before our eyes a most exact prefiguration (and with triumphal arches, the only ones antiquity offers us) of the superb porches of Romanesque and Gothic churches of the Middle Ages. Yet no direct path leads from one to the other; these reliefs of many episodes will not leave the night of Mithraic caves; they will not open new ways for an art already stereotyped to which they owe their origin and their form; they betoken only a final achievement, a venture that remained sterile and short-lived—not an innovation fertile in future developments. But is not this because at the instant of their formulation, at the opening of the second century of our era, that Hellenistic art whose powerful impulse we have been tracing everywhere, had, in a way, reached the end of its course and weighed, if anything, heavily on artistic creation, which it was unable to stimulate or revive?

OTTO DEMUS

THE METHODS
OF THE
BYZANTINE ARTIST *(1948)*

ROMAN ART by no means perished when Rome fell to the barbarians. Quite the contrary: Rome, which borrowed so much from Etruscans and Greeks, perhaps reached its artistic fulfillment, not in Italy, but in Constantinople, where the mighty art of Byzantium sprang from Roman traditions adapted to Eastern methods and mediums. In many ways Byzantine art was a consummation of Imperial art, and this consummation did not occur until Rome went down to disaster at the opening of the so-called "dark" ages. The arts of Byzantium have a strong hold on the modern mind. They seem to be primitive, but are not. In spite of using certain primitive methods—flattening the figure, employing hierarchical perspective, emphasizing the conceptual rather than the natural—the Byzantine sculptor, painter, and architect were skilled to the degree of sophistication. The mosaic, a characteristic Byzantine medium, exists in a space that generates multidimensional

values from its two-dimensional surface. As one critic has lately remarked, the "resonance" of mosaic does not, like the fictitious pictorial space in Western perspective, separate the visual from the other senses. It lives within a truly architectural space that is "realized" more fully than Renaissance pictorial space. Byzantine is an abstract, non-naturalistic art devoted to expressing the transcendental and the eternal. In his book *Abstraction and Empathy* Wilhelm Worringer called it crystalline, because by intense stylization it redeems man from nature, from time, from the accidents of history.

Supplemental to Demus' essay is his book *Byzantine Mosaic Decoration* (1948). Also useful are Edgar Waterman Anthony's *History of Mosaics* (1935), John Beckwith's *Art of Constantinople* (1961), and Percy B. Ure's *Justinian and His Age* (1951), along with Tamara Talbot Rice's *Icons* (1960), and David Talbot Rice's *Byzantine Art* (1954).

THE METHODS OF
THE BYZANTINE ARTIST

(from *The Mint*, no. 2, 1948)

In the three hundred years from 900 to 1200—the Macedonian and Comnenian epochs—Byzantine art developed a system of church decoration more consistent than any other pictorial system of decoration of which we have knowledge. This system was evolved within the architectural framework of the Byzantine cross-in-square church, a type of building which reached its full maturity at the conclusion of the Iconoclastic controversy and has remained the leading type of Byzantine ecclesiastic architecture ever since. In these churches the interior is conceived as one homogeneous unit; it consists of an inner cross, sur-

mounted by a central cupola, and its angles are filled in by low-vaulted corner rooms. The main element is the vaulting, a homogeneous, if differentiated, baldachin, which covers the whole church, suspended, as it were, and as Byzantine writers phrased it, "with a golden chain from heaven." The hanging character of the architecture—its development downward from the cupola to the pendentifs or squinches, the barrel vaults of the cross, the lower corner vaults and, finally, the niches and lunettes of the lowest tier—is faithfully mirrored in the decoration. This architecture, with its hollow forms, its unaccentuated walls, called for a decoration in color, not for sculptural ornament. Even the smallest chapel had its cycle of images; but the classical solution was evolved in the mosaic churches of the eleventh century.

The decoration of these churches is arranged hierarchically, descending from the image of the All-Ruler, Christ Pantocrator, in the heavenly sphere of the cupola, to the Evangelic cycle in the squinches, pendentifs, and higher vaults—the zone interpreted by theologians, painters, and beholders as the Holy Land—and, finally, to the cycle of Saints depicted in the lowest, the terrestrial zone of the church. The division into three corresponds to the three zones of Byzantine Cosmology, Heaven, Holy Land or Paradise, and the terrestrial World. The Byzantine church was an image of the Byzantine Cosmos with its well-ordered hierarchy of values. The higher an image was placed in the interior of the church, the more sacred was it considered to be. The symbolic interpretation went further; it magically identified the various parts of the church with the Holy Places, which were made holy by the earthly life of Christ; and the images were arranged with regard to this topographical symbolism. The faithful beholder could make, could complete a symbolic pilgrimage to the Holy Land simply by contemplating the images in his parish church; and this was, perhaps, the reason why real pilgrimages to Palestine played so unimportant a part in Byzantine religious life; and why there was so little response in Byzantium to the Crusading idea of Western Europe.

Besides being an image of the Cosmos and a magic

counterpart of the Holy Land, the Byzantine church was also, to the pious beholder, a symbolic image of the Christian year. Within the three zones the icons are arranged according to the liturgical sequence of the Ecclesiastic Festivals, as they come in the Calendar. Every image came to the forefront of veneration at the time of its festival, to step back again into the cycle for the rest of the year when its magic moment had passed.

This complicated symbolism was all based on a new conception of the image, worked out in the course of the Iconoclastic controversy. According to this conception the image, if painted in the "right manner," was a magic counterpart of its Prototype, the Holy Person or Event it represented; a magic identity existed between the image and its Prototype, and the veneration accorded to the image was considered a tribute paid to the Holy Persons themselves. These and the Holy Events confronted the beholder in their spatial receptacles, in the cupolas, the vaults, the curved niches. So the image enclosed a part of the real, physical space: it was not separated from the beholder by the "imaginary glass pane" of the picture surface behind which an illusory picture begins to develop. The image opened into the real space in front. The interior of the church became itself the picture space of the icons, the ideal Iconostasis. The beholder was bodily enclosed in this grand icon of the church; he was surrounded by the congregation of the Saints, he took part in the holy events he witnessed.

In the three zones of the interior the decoration is differentiated both in the idea of action expressed in the images and in the conception of the images themselves. An eternal and holy presence is made manifest in the paintings of the highest zone, and in these all narrative and transient elements are suppressed. In these, the timeless dogma is offered to one's contemplation. The decoration of this zone consisted, not of pictures in the normal sense of the term, not of isolated single figures, but of new, specifically Byzantine compositional units in real space; they did not depict, they *were,* magic realities: a holy world beyond time and causality, admitting the beholder, not only to the vision, but to the magic presence of the Holy. In the

middle zone, the timeless and the historical elements are combined in accordance with the peculiar character of the festival icon, which simultaneously depicted an historical event and signified a station in the ever-revolving cycle of the ecclesiastical year. In this second zone, the pictures are so composed as to offer a flat image to the beholder without, however, losing the character of a spatial receptacle for the Holy Figures. Isolated as holy icons and, at the same time, related to their neighbors as parts of the evangelical cycle, the paintings of the second zone are half picture, half spatial reality; half scene, half timeless representation. But in the lowest stratum of the church, in the third zone, there are to be found neither narrative scenes nor dogmatic representations. The guiding thought in this part of the decoration—the community of All Saints in the Church—is realized in the sum only of all the single figures. They are all parts of a huge image, the frame of which is provided by the building of the church as a whole.

The images of mid-Byzantine church decoration are related to each other and formed into a unified whole, not by theological and iconographical concepts only, but also by formal means which create an all-embracing optical unity. The optical principles used for this purpose aim, broadly, at eliminating the diminution and deformation of perspective. The most obvious of them is the staggering in size of the images and figures according to the height or distance at which they are seen. But the tendency to eliminate the effects of perspective foreshortening goes further. The proportions of the single figures were also subjected to this process. Mid-Byzantine mosaic figures are often described as "elongated, ascetic, emaciated," and so on. They have, indeed, all these characteristics (from which modern authors too often draw conclusions about the psychology of style), if they are viewed (or photographed) from a level from which they were never meant to be seen—figures in cupolas from high scaffolds, for instance. Seen from below, these figures appear in normal proportions—that is, they appeared so to the Byzantine churchgoer who, from what we know about his reactions, must have registered the optical facts in a more straight-

forward way than ourselves. We are apt to see more analyt-
ically and, if we have a chance to measure distances and
angles, to correct perspective distortions automatically. In
Byzantine decorations the artists themselves anticipated
these distortions which would appear to the view from
below, and they corrected them by elongating the figures.
They also adjusted the proportions of the figures to the
curved surfaces on which they were depicted. Thus the
legs and lower parts of figures in cupolas or vaults were
elongated more strongly than the upper parts, because the
upper parts, being placed in the more curved sections of
the cupolas or vaults and consequently on surfaces which
stand approximately at an angle of 90 degrees to the
optical axis, suffer less from distortion than the lower parts
in the more vertical outer ring of the cupola or the more
vertical parts of the vault.

Another kind of preventive distortion occurs in apsidal
mosaics. Figures on the outer edges of the semicylindrical
niches of main apses, for instance, would appear to those
who can see them from the center of the church only (a
nearer view being barred by the Iconostasis and the inac-
cessibility of the Sanctuary) much reduced in breadth, and
so abnormally slender. To counteract this effect of fore-
shortening, such figures were made broader and more
thickset than their neighbors which could be seen at a
more normal angle. Where it was iconographically possible
and where the figures could be seen from near and from
far, they were correctively broadened on the edges of
semicircular niches by giving them broadly expanding pos-
tures, giving them the necessary additional breadth with-
out spoiling the normal appearance of the figures for the
near view. The mosaics of Hosios Lucas in Greece are
striking examples of this solution—in the two semicircular
niches of the Narthex, for instance, where the Washing-
of the Feet and the Doubting of Thomas are depicted. In
the "Washing of the Feet" the figure (St. Andrew) at the
extreme edge, is represented as walking into the picture
from the right, striding with garments spread out in
breadth and accentuated by broadening motifs round
shoulders and hips. The Apostle (St. Luke) at the left
edge of the niche is shown unbinding his sandals; he rests

one foot on a chair and so assumes a very broad pose. In the "Doubting of Thomas" the figure at the extreme left is made to look broader than the preceding ones by the simple expedient of giving it whole, whereas the others are partially hidden by the backs of their neighbors.

The broadening of figures on the edge of apses which can only be seen at an oblique angle, occurred once again in the development of monumental painting—in the Italian High Renaissance, when similar concepts were revived, probably not without knowledge of the Byzantine solutions. You can find one of the chief of these later examples in the sketches by Sebastiano del Piombo for the fresco decoration of the first Chapel to the right in San Pietro in Montorio, in Rome. The tradition may in this case have been handed down by Venetian art.

Other and more complicated oblique, preventive distortions are to be seen in the figures and faces on the barrel vaults of sanctuaries, for instance among the Angels in the Sanctuary of the Hagia Sophia in Constantinople. From the near view, these figures look badly distorted; but they look quite normal and undistorted if you see them at an oblique angle from below. Even the technical processes took account of the "correct" point of view: the cubes, for instance, which make up the mosaic tympanum above the main door in the narrow Atrium of Hagia Sophia, visible only at a steep angle from below, are set obliquely into the wall, so as to have their surfaces standing normally (at an angle of 90 degrees) to the optical axis of the beholder.

Underlying these corrective distortions and technical processes there is a principle closely akin to that principle which dominates mid-Byzantine iconography: the picture and those who see it are drawn together into a close relationship. Every care is taken that it should appear undistorted; and to this end a very subtle system of perspective lore was evolved and used. However, this never became a systematic science, as it did in the Western Renaissance; it always remained a purely artistic and formal principle without any codified laws. It aimed at no rigid consistency, but it had the effect of establishing formal unity throughout the main parts of the decoration. Byzantine perspective might be described as "negative" perspective. It takes

account of the space which surrounds, and is enclosed by, the image, and which intervenes between the image and the beholder; and it aims at eliminating the perspective effects of this space on the beholder's vision. The Western artist, by contrast, subjected his figures to the laws of perspective in order to let them appear as real bodies seen from below, with all the distortions which this view brings about. He created an illusion of space, whereas the Byzantine artist aimed at eliminating the optical accidents of space. Western practice leads to a picture of reality, Byzantine practice to preserving the reality of the image. The Byzantine image escaped the casualness, the haphazardness of spatial projection; it always remained an "image," a Holy Icon, without any admixture of earthly realism. By eliminating the perspective effects of space, the Byzantine artist was able to bring out the emotional values of height and remoteness in their purest form. Looking at Byzantine decoration, seeing the image undistorted, in spite of the great height at which it appears, one feels lifted up to its level, high above the ground; above the ground to which the beholder of Western decorations is firmly fixed— pressed down, as it were, by the "worm's eye view" of the *di sotto in sù*. In this way, not only spiritually but also optically, the Byzantine was received into the heavenly sphere of the holiest icons; he participated in the sacred events, he was admitted to the Holy Places of which the icons are the magic counterparts. Moving along the main axis of the church and viewing thence the holy icons above him, he was able to perform a symbolic pilgrimage. He was not fixed to one point, like the spectator in front of those Western decorations, whose illusory, perspective constructions seem to "stand up" from one particular viewpoint alone; as the Byzantine moved along the liturgical axes of the church, the rhythm of the cupolas and vaults moved with him and the icons came to life without losing their character as icons.

Only those parts of the building which the Byzantine worshiper was not allowed to enter bodily were presented to him as fixed projections. But even these fixed projections are connected with the rest and take part in the movement. The worshiper's glance is led from one part

to the other round the conch of the apse and down the semicircular walls. Everything in the vaulted parts of the building is smoothly connected with the neighboring forms, no hard limits or accents stop the wandering of his gaze. Even the edges are rounded so as to lead the eye from one wall to another.

That this is no mere impression of the modern art critic projected into the past, that it was a conscious achievement of Byzantine decorative art, is made quite clear by the documents of contemporary aesthetic appreciation, by the mid-Byzantine Ekphraseis.[6] These Ekphraseis stress again and again the fact that one's glance is not to rest upon one part of the scheme, but must wander on in ever-changing direction. The very words of these descriptions, in verse and in prose, suggest a dynamic movement round the center of the church. Gregory of Nazianzus speaks of the church built by his father as "a temple returning into itself on eight columns," as "radiating downwards from the cupola" and as being "surrounded by ambulatories." Procopius, in his description of the Hagia Sophia, underlines the fact that the eye is not allowed to rest on any of the parts of the church but is attracted by the next as soon as it has settled on the first. Photius, in his Encomium of the New Church, the *Nea*, is even more explicit: "The Sanctuary seems to gyrate round the beholder; the multiplicity of the view forces the beholder to turn round and round and this turning of his is imputed by his imagination to the building itself."

There is another point elucidated by the Byzantine Ekphraseis. The pictorial decoration is described in terms which suggest the reality, the actual presence, of the scenes and persons depicted. The Encomiasts did not write: "Here you see in mosaic how Christ was crucified"; they said: "Here Christ is crucified. Here is Golgotha, there Bethlehem." The spell of magical reality dictated the words. This magical reality of the decoration which, formally speaking, expressed itself in the spatial character of the whole and in the life imparted to it by the movement of the eye in space, cannot be rendered satisfactorily by photographs. Byzantine church decorations reveal their supreme qualities only in their own *ambiente,* in the space in and for which they were created.

To this spatial *ambiente* belongs also the actual light. Just as the Byzantine decorator did not represent space, but used it by including it in his icons, and just as he took into account the intervening space between the icon and the worshiper's eye, so he never represented or depicted light as special lighting coming from a distinct source; he used real light in the icons, and allowed for the effects of light in the space between the icon and the eye in order to counteract its form-destroying influences. He included shining, radiating material, especially gold, which is so arranged that it not only produces a rich effect of color, but also lights up the spatial icon. The deep niches under the cupolas of Hosios Lucas and Daphni which would otherwise be dark, are effectively lit by highlights appearing in the apices. These radiant highlights separate Mary and the Angel in the "Annunciation" and they surround the Divine Child in the "Nativity," the landscape background of which is interspersed with gold just in those places where the golden cubes collect the focal light. Generally speaking, colors indicating solid forms were interspersed with golden cubes only in places where the gold is apt to shine owing to the curving of the surface. This economy contrasts strongly with the indiscriminate use of golden highlights in the colonial sphere of Byzantine art. In Byzantium proper the golden cubes stress only the formal and iconographic foci. The centers of iconographic interest and the centers of formal composition, which in classical Byzantine art are identical, are stressed by the strongest light. It surrounds the main figures as with a halo of sanctity. The reflections move as the eye moves and with the course of the sun, but, thanks to the nature of the spatial receptacles of the icons, they always play round the main figures. At night, the light of the candles and oil lamps creates fitful reflections on the golden surface from which the figures stand out in significant silhouette.

It is not only the derivative effect of light which is included and used, but also the direct light of windows which sometimes open in the grand icons themselves, in the cupolas and apses. The effects of this were noticed— as the Ekphraseis again prove—and reckoned with. The same was true of the conditions of light under which the icon was seen. The images were not only placed, but also

shaped and colored to meet these conditions. Thus in
Hosios Lucas, there is an icon of Christ on one of the sec-
ondary vaults, whose forms would have been swallowed up
by the splendor of the surrounding golden ground lit by a
neighboring window, if it had not been modeled in a singu-
lar way which, in spite of the almost blinding radiance all
round, brings out forcibly the vigorous relief of the face.

This special kind of modeling recalls the inverted
tonality of photographic negatives: the face itself is com-
paratively dark, with greenish highlights which contrast
strongly with the reddish-brown of the main features. Yet
the highlights do not appear on the raised motifs of the
face-relief in the places where one would expect to find
them in normal modeling; their arrangement is altogether
unrealistic. They are concentrated in the grooves and fur-
rows of the facial relief—very much, in fact, in those places
where one would expect to find the deepest shadows. But
these lights delineate the pattern of the face more clearly
and forcibly than a normal modeling could have done. It
is as if light broke through the features, as if it radiated
through the relief at its seemingly lowest points. The
arabesque of these highlights is strong enough to bring out
the features despite the radiance of the golden ground, the
disturbing effect of which is further heightened by the fact
that only one half of the vault is lit in brightest brilliancy
whereas the other is always obscured by dim shadow.
Three more images in the same compartment (Mary and
two angels) are treated in the same way. That the singular
conditions of lighting in this compartment of the church
were indeed the reason for choosing this extraordinary
means becomes quite clear if the medallion of Christ I
have already described is compared with a corresponding
image of Christ in the other transept—set probably by the
same artist. In this the light is much quieter and the artist
could, in fact he did, employ the normal positive modeling
with the shading of the face from light to dark.

Quite apart from its technical value as clarifying the
form, the inverted modeling of the first of these two icons
produces a peculiar effect which, at least to the modern
beholder, has something mysterious and even "magical"
(in the modern sense of the word) about it. Later Byzan-

tine painters were quick to perceive and employ this effect. The inverted modeling with flashing highlights played indeed an important part in Palaeologan and especially in Russian painting. As happened so often in the course of the development of Byzantine art, a particular practice employed by earlier artists only under particular conditions, was later seized upon as a means of conveying a certain expressive quality—a by-product originally, but one now sought after for its own sake. A purely optical technique became a vehicle of expression.

In other cases the artists regulated the effect of too much or too little light by the use of darker or lighter shades of color. Although the basic colors were more or less fixed by iconographic rules, there was always ample room for differentiation in the shades the artists actually employed. In using different shades the artists took the spatial conditions into account so as to achieve clearness of form and thought. The general arrangement of tones follows the partition of the building into three zones. Thus the lightest hues are to be found in the uppermost zone of the cupolas and high vaults, where tinged white and gold preponderate. The light colors correspond to the idea of immaterial heavenly splendor; but they were at the same time necessary to bring out the modeled forms at the great height, surrounded as these are by the glittering, color-destroying gold. Darker shades would produce mere silhouettes, opaque islands in the luminous ground. The next zone, the zone of the Festival Cycle, admits of a greater wealth of color. Even so, the colors here have a bloom and lightness, and dark and heavy tones are excluded. These tones do, however, dominate the lowest register, that of the Saints, where dark brown, dark green, deep blue, and violet make up the main scale, which fits in well with the tones of the marble lining. In this way the arrangement of color helped to underline the hierarchical scheme of the decoration.

The technique of modeling—that, too, is subject to a not dissimilar differentiation. Some images seem to be composed of splintery, disconnected fragments of forms; the bodies seem to be deeply furrowed by cuts and dark holes. It has been surmised that this style belonged to an earlier

phase in the evolution of Byzantine art, that it was "older" than the graded modeling which is the normal technique; and that figures executed in this way are either earlier in fact or at least deliberately archaic. But in fact the two "styles," with all the intermediary forms, are strictly coeval: they belong to the same date, the same phase of style.

The application of different techniques in one single decoration was made necessary by the great differences in size of the single icons and by the great variety of optical conditions. Graded modeling with cubes of given sizes and of a limited gamut of tones is technically and aesthetically advisable only within a certain, not too wide, range of size. The limited scale of tones at the disposal of the artist did not permit the modeling of large-scale forms—a fold, for instance—by means of a continuous succession of shades, because the tones were used up already near the contours. The mosaicists of the classical period sought to achieve the effect of plastic relief, which could not be gained by normal and continuous modeling, by abruptly setting contrasting shades of light or dark against each other without any attempt at continuity. This treatment suggests, seen from a distance, especially in the scanty light of the churches, a relief more powerful than could be produced in the normal way. It was, of course, ultimately rooted in late antique illusionism. It demanded on the part of the beholder a faculty of seeing in an illusory way; it demanded that he should himself supply the transitional shades and so connect the contrasting tones one with another.

Although, at the beginning, this technique was more or less an optical device, it took on iconographic significance in the course of time. The reason for this was that the figures so treated (that is, the largest and most distant images in the cupolas and the apses) were at the same time the most holy images, thanks to the parallelism of remoteness (in height or in distance from west to east) and holiness. But the holiest, largest, and remotest of these images were the Pantocrator in the zenith of the cupola and the Virgin in the conch of the main apse, so it came about that the abrupt way of modeling was gradually associated iconographically with the holiest images—more espe-

cially with those of Christ and the Virgin. These images retained, from the twelfth century onwards, their abrupt modeling even where there was no technical or optical need for its application, even, that is to say, in small portable icons and in miniatures. Gradually it was forgotten that the abrupt modeling was originally an optical device in spatial decoration; it became more and more a mark of distinction, of sanctity—a process probably fostered by the abstract and antinaturalistic character of the broken forms themselves. For these forms were apt to be filled with the expressive meaning of unearthly holiness. If, in Byzantine art, forms offered themselves to expressive interpretation, we may be certain that the opportunity was accepted, especially if it favored those spiritual qualities towards which all religious art in Byzantium tended. It must be added that on Byzantine soil, the original optical significance of the broken modeling was sometimes rediscovered, especially in periods when the sources of antique illusionism began to flow again, as they did, for instance, in the Palaeologan era. The mosaics of the Kahrieh Djami in Constantinople or the frescoes in the Transfiguration Cathedral of Novgorod (1379) are examples in which were combined both the illusory significance and the expressive value of the broken modeling. Nevertheless, it is difficult to realize that the golden network which forms the draperies in Italian duecento panels is, in the last analysis, a legacy of Hellenistic illusionism.

The translation of an optical device into an element of hieratic expressionism which occurred in the course of the twelfth century, accords with the general development of twelfth-century art in Byzantium. Not only did Hellenistic illusionism cease to be understood: the whole optical system of church decoration was gradually losing its consistency at that time, one of the most crucial periods in the development of Byzantine art.

The system of mid-Byzantine monumental decoration was one of the purest creations of the Byzantine spirit in the Middle Ages. The subtle art, easier to appreciate than to analyze, by which single parts were welded into one macroscopic whole, recalls classical Greek devices such as the curvatures of the Doric Temple, or the rhythmical sym-

metries in the construction of the Attic Drama. Like these devices, too, it has escaped analysis for a long time. The devices of the Byzantine painters which went furthest to achieve the optical union of the single parts, that is, these corrections of perspective, can be followed back to Greek theorists of a period which was at least the heir of Classical Antiquity. It was the Neoplatonic tradition which, if not the source, was certainly the upholder of the tradition of this corrective lore. The fifth-century philosopher Proclus defined perspective (*skenographia*) as the art of preventing an image from appearing distorted by the distance or the height of its emplacement. It is characteristic that this lore, originally evolved for the use of monumental sculpture, should have been applied in mid-Byzantine art to monumental mosaics, which, after the Iconoclastic controversy, supplanted sculpture-in-the-round. But it is difficult to say whether the application from the ninth century onwards of these corrections of perspective was due to theory directly transmitted or to a spontaneous artistic renaissance.

The Greek element was only one of several factors in the new mid-Byzantine system. Its role was that of a formal, artistic means designed to achieve optical unity. But the Byzantine monumental system was above all a spiritual matter. The central spiritual conceptions of the system, the identity of the icon with its prototype, the reality of the icon in the space of the church, and the venerability of the icons, may all be described as "magic realism." This magic realism, which may have originated from the sculptured idol, appeared in monumental painting at first in the religious art of Eastern Hellenism, probably in Parthian, or, more generally, Iranian art. The problem is bound up with the problem of where frontality in religious painting originated. The original home of hieratic frontality, as the only convincing representation of magic presence, is sought by most scholars in northern Mesopotamia or in Iran. The earliest complete representation in painting, not only of the god, but also of priests and donors in frontal presence, is to be found in Mesopotamia, in Dura-Europos. The figures in Dura, of the priest Konon and his companions, have rightly been called "Oriental forerunners of Byzantine painting,"

and for the sovereignty of the frontal figure in Byzantine painting the widespread influence of Parthian art in the Near East seems to have been responsible. This Oriental factor in the formation of Byzantine art brought with it, not only frontality itself—with its various consequences, the handicapped gestures, hanging feet, etc.—but also the outcome of frontality in spatial projection: that is to say, elimination of depth behind the picture plane, the simplicity and distinctness of outline, the flat relief of the interior design tending towards the linear and, perhaps most important of all, the communication between the painted figure and the real space in front. Amongst other means, this communication was brought about by making the feet of the figures overstep the lower boundary line of the picture plane. The fact that these frontal figures surround the church on all sides makes the empty space in the middle appear as their real domain. They were present to the eye in a much more immediate way than they could ever have been in an art depending upon illusion. Only a central idea was needed, with its compelling force, to elaborate this magic realism of Parthian art into the spatial cosmology of the Byzantine church. And the central idea came in the theory of representation which grew out of the Iconoclastic controversy. It was this which made possible the fusion of the two chief constituent elements of mid-Byzantine art, the optical refinements of Greece and the magic realism of the Orient.

JURGIS BALTRUŠAITIS

ORNAMENTAL STYLISTIC IN ROMANESQUE SCULPTURE *(1931)*

THE HEIGHTENED INTEREST in Byzantine art has been accompanied by a greatly deepened respect for Romanesque as one of the supremely religious styles of the West. Indeed, the tendency of late has been to look upon Romanesque, not Gothic, as the authentically Christian art of ages we have ceased to call dark. The sculpture of the tenth, eleventh, and twelfth centuries has been intently studied as a system of art essentially different from the art of the High Middle Ages as revealed at Amiens or Reims. Romanesque art is monumental and so formalized that it is subjected to geometric order. By classifying its underlying geometric designs, Baltrušaitis proves that Romanesque sculpture reconciles natural forms with a rigorous conceptual scheme, and thus harmonizes two different orders of reality. Romanesque sculpture stylizes whatever it treats, and by contrast Gothic sculpture seems to be a breakdown, or partial breakdown, of one of the most for-

mal canons in Western art. In one of his memorable phrases, Baltrušaitis says that the Romanesque figure of man obeys a law of the frame, and he examines how the images of saints and beasts are transformed into decorative and conceptual designs that belong to the architectural order from which they spring. Baltrušaitis' study implies that Gothic and Renaissance sculpture represent a humanism which artistically may not have been entirely profitable. Much of what he says of Romanesque sculpture also applies to early stained glass.

Two other works belong with Baltrušaitis' book: Louis Bréhier's *L'Homme dans la Sculpture Romane* (1927), and Henri Focillon's *L'Art des Sculpteurs Romans* (1931). M. M. Davy in an *Essai sur la Symbolique Romane* (1955) deals with the creative power of the eleventh century. There are also the great works by Joan Evans: *Romanesque Architecture of the Order of Cluny* (1938), and *Cluniac Art of the Romanesque Period* (1950).

THE FRAME

(Chapter I, Section 1)

Whether or not a statue is free-standing, an art object or a decorative relief, whether it is set against a wall or upon a base, every sculpture projects itself against a ground. Whether or not the artist intends it, whether there is harmony or contrast between statue and ground, there is relation between the two. Designed for temple or landscape, the sculpture is supplemental, tending to merge with its ground, or to be divorced from it. Sometimes the statue emerges from it, sometimes it is in contrast. These harmonious, contradictory, or neutral relations are meaningful. When harmony is conscious or intentional, the ground or setting takes on a creative value. A pattern of contacts and agreements is reached between sculptural

volume and the milieu where it is situated. When it is a question of monumental sculpture affixed to a wall or on a pedestal intimately related to the ground, these relations are of heightened significance, and it is by examining them that we shall approach the study of relief designed to adorn a building.

The first thing to strike us when we glance at a great many romanesque façades is the care with which relief fills up voussoirs, capitals, tympanums, and friezes. It completely overruns them, being distributed over the surface with remarkable plenitude and regularity. Not an angle, not the slightest area of the sustaining surface is neglected. Often it happens that the ground disappears behind the tide of these figures. Reduced to a minimum, it appears only as a few strokes of shadow.

This "horror of the void" in decorative passages not only produces an abundance of figures; it conceals a close rapport between the relief and its frame, which takes on a very special value in such art. It is the controlling means of organizing sculptural composition. It not only defines; it dictates the movement of the figures. It draws them together, it distributes them in groups, it determines their proportions and their balance. It intrudes into the very structure of their form, and its dominating role at once solicits our attention.

It is odd to see how sculptural figuration obeys all the modifications of its frame, how it immediately reacts to each of its variations. Thus, in examining certain extremely simple reliefs thematically unified, for example, into a row of figures, one sees strange adaptations. Inserted into different elements of the building, subjected to the geometry of dissimilar frames, they are composed in entirely different ways.

If the rectangle of a lintel (Autun, Bellenaves, Carennac, Charlieu, Mauriac, Moissac, Neuilly-en-Donjon, Semur-en-Brionnais), or of a capital (the cloister at Saint-Ours of Aosta), or of a frieze (Arles, Saint-Gilles) sets a single scale for the frontal figures, bounding by two horizontals the level of feet and heads, the pentagon of the so-called Auvergnat lintel destroys it.

The breaking of the upper horizontal and its change

into a double ramp breaks the isocephaly of the whole group. Here the sloping lines making an angle control the arrangement of the heads. One sees the figures progressively enlarge in proportion as they approach the central axis (Le Chambon, Place des Gras and Notre-Dame-du-Port at Clermont-Ferrand, Mozac, Riom). The central figure elongates, while the rest are stepped down toward the ends, where they crowd. At Chambon, at Mozac, at Riom, for instance, their scale is doubled. Their proportions are distorted. They become implausible; the slightest void is filled; throughout, the frame is painstakingly crowded.

Situated in a tympanum this row of figures is again transformed. The hemicycle breaks frontality. The figures at the sides, wedged into narrow corners, are no longer on the vertical axis. They kneel or bow to suit the curve of the archivolt (Beaune, Carennac, Corneille-de-Conflent, Tredington, Valcabrère).

This need for utter and symmetrical plenitude tightens the relation between relief and frame. The human body carved within tympanum or frieze is not casually located. Its form is not free there. It obeys certain laws at the decree of the architectural element that carries it. Mindful of covering the surface for which it is destined, the image swells or shrinks. It keeps its frontality or it bends. It duplicates itself. Attracted to the frame, it intently draws toward it. It accords with it until their outlines are fused.

A certain kind of frame demands the same axis, the same balance, corresponding proportions, the same symmetry. The frame becomes something more than a simple limited space destined for sculpture. It becomes an ordaining power. It designs the relief. Its potency does not cease at the outside contours of the ensemble. It reaches into the very interior of the volumes. . . .

SOME TYPES OF FRAME

(Chapter I, Section 2)

=========

. . . The arrangement of figures, their pose, their gestures, their very form are controlled by the confines that create them: the superimposing of bodies one above another in a pattern of circles, weaving legs together into intersections, apparently inexplicable movements in hidden and harmonious linear designs.

The circle reappears also in the contours of nimbuses surrounding saints' heads. It defines them, isolating them from others. It is also a frame. It is strange to see how this frame becomes dynamic, how it invades the sculptural disposition. . . .

The frame brings its power to bear. It has the force and rigor of a stable element that does not change, in opposition to changing material. It seizes upon the relief, magnetizing it, penetrating it, carving it. However severe its design, it does not paralyze the image; it creates it. It directs its activity.

Inscribed within a framework, a figure finds itself as if inside a charged field. Gripped by a system of imperious forces, by its secret currents, it stretches, sways, shrivels or expands, lengthens or truncates itself, extends or withdraws its limbs. It recreates and transmutes itself.

The frame becomes a region of constant metamorphoses.

We have seen different images unfold themselves inside the same schema. Here tormented, there passive, they all inscribe themselves within the same geometry. It is interesting to follow the same motion, but with reverse meaning. One sees not differing images passing through the same frame, but different frames—rectangles, lozenges, circles—passing through the same image. . . .

CONCLUSION (Chapter I, Section 5)

Whether it be man or beast, angel or monster, carved on a Romanesque church, it is governed by a whole system of laws: the magnetism of the frame, the concern for plenitude, the quest of a scheme of contacts and adjustments, of internal harmonies, and harmonies with the whole fabric, the architectural demands affect its composition, even its anatomy.

The sculptor is not concerned with the grand equilibrium of the human body in itself or the soundness of its agreeable proportions, but with the geometry of his frame and the structure of the edifice sustaining it.

For the law of anatomical harmony, the organic concord of elements, the perfect coordination of parts kept within the body itself, he substitutes another order. Abstract designs enter into its structure. They demolish his own canon. The rectangle squares the person. The oval bends and curves him. Geometric diagrams hew and disperse his profiles. There appear trapezoidal-triangular-polygonal personages, capital personages, archivolt personages. Angels, beings of all sorts, and beasts alike take on a new life and aspect. A whole world is born within these frames, a world unmindful of nature, a world that quickens in a space defined by formal patterns.

Thus, abstract form presides at this creation. The sculptor is not only an image-maker; he is a mathematician concerned with ratios. He is a geometer who meditates lines, angles, curves. He combines them variously; he fits them together; he superposes them; he regenerates their features. He inscribes them on walls, on archivolts, on capitals, on the most important members of the building. He also inscribes them inside the figured relief.

Before going on with our inquiry, we must study this geometric science, its temper, its bearings, its logic, its methods.

We shall attempt this by basing our treatment on ornament. As purer and emptier form, and thus more readily envisioned, it defines thought itself. It spreads right

over the façade; it frames portals, runs along friezes, enlaces shafts. It is not burdened with realistic references. A coordination of lines, it phrases itself only by the rigor of its curves, the knowing arrangement of its coils. . . .

THE GENESIS OF A METHOD

(Chapter III)

Abstract thought, whose significance we have glimpsed in certain reliefs, realizes itself in ornament. There it unfolds. There we see an activity taking precise form that invents and elaborates like a sort of dialectic centered in fixed principles. But this game is not caprice. It has rules. It constructs schemas, evolves its formulas by deducing one from another, reasons out its designs, clarifies a whole mathematic of forms conceived as a texture of curves, lines, and angles.

This fidelity to geometric measure does not exclude the artist's attraction to anecdotes, legends, and fables. The romanesque sculptor is not merely a geometer. He is a figural artist. Surrounded by men and beasts, and living in a universe of both things and imagination, he feels the urge to describe and narrate; the narrative impulse is always running strongly across his speculations. This makes its demands and has its own vitality. Thus, two worlds, seemingly opposite, encounter each other: the agitated, chaotic, unstable world of material figures, and the immobile world of designs and structures based upon an abstract order. Theoretically, it seems that one exists apart from the other, that there is no way to unite them, and that the system cannot accommodate even a fantastic perception of an actual being.

Yet every line, whether fixed by brush or chisel, and whether it transcribes the image of man or ornament, can be read in two ways. To begin with, it is a geometric phrase, a certain organization of space, a concord of numerical proportions suggesting to us an idea of equilibrium, harmony, and measure, and giving a solution to a mathematical problem. On the other hand, it is also a sensation, it traces a contour, it defines a profile, it takes on narrative meaning, it becomes an idiom in which to tell stories.

By harmonizing in the same line at the same instant two meanings, geometric and figural, one brings into contact the two contrary worlds we have distinguished. Abstract form and figured form intersect within the same linear design. They work together toward a solution. Inside the grid invented by the mind representations appear, a whole legendary existence awakens, and different visions come into play. Amid things existing outside in nature there is likewise glimpsed and defined a whole geometry. Through these nice fusions the sculptor contemplates the universe. Thus there comes a hidden bond between two modes of thought, between two orders.

In observing the ornamental scale we have uncovered its basic motif, a firm curve serving as a departure for a whole development of complicated formulas. Its inflexible purity reappears behind different patterns. This primary motif is the foundation for many structures. It describes all kinds of figures, some of an almost dry legibility, others involved and nearly unreadable, but alike deduced from the same scheme. We shall see how the same curve introduced into figured relief represents, quite apart from ornamental abstract designs, images belonging to the actual world of people, beasts, things.

First note that the two categories of forms, seemingly irreducible, are not irreducible in nature itself, which affords arrangements in living organisms that are already ornamental and geometric. Nature abounds in symmetrical designs expanding from a center or enclosed in triangles and polygons. Harmonic curves reveal themselves in the botanical world, and organic life itself everywhere seems to follow a design. The romanesque artist is clever at discovering and using these regular forms which spontane-

ously accord with his own inventions. He sees interlaces in the snake and decorative diagonals in crossed legs. At Gravedona, the snake and the interlace exist side by side, inlaid upon the same wall. The serpent, able to twist itself into any curve whatever, is the literal double of the interlace, to which it sufficed to add a head to make it part of the biological world. The loops made by the twisting of each figure are nearly interchangeable. At Avy-en-Pons, a row of men with crossed legs is carved on the voussoirs of the archivolt. The series of crossed legs decorating the intrados of the arch makes a suite in "X" of perfect regularity. They serve as actual tori in a purely architectural capacity.

In this case, the coinciding of the two schemas, that of the decorative cross and that of crossed legs, has aided the solution and allows a nearly perfect identity of two elements, geometric and figural. The problem becomes more difficult when it involves harmonizing a living form with a more complex decorative formula. It is awkward, for instance, to reconcile closely a system of triangles with the human body. Yet the romanesque artist succeeded in doing precisely this. In the crypt of Saint Bénigne de Dijon we find a capital adorned by an arrangement of this sort. A triangle enclosed by two lines parallel to its sides and running into bumps placed at the angles is carved on each face. Two ovals, one above the other, complete the design. It is a complex pattern of a motif already invented. On one of the nearby capitals it takes on figural meaning: a grotesque and hardly recognizable human body appears amid the network of these lines. The oval at the top becomes a head. A few additional cuttings having marked the eyes, a nose and mouth were enough for the metamorphosis. The parallel lines marking the sides of the triangles indicate the contours of the arms, of unconvincing appearance, attached to some indeterminable part of this fantastic body. The oval below transforms itself into a torso. Thus a figural image emerges from a geometric design.

The complication of a form does not, then, prevent a double treatment with a double meaning. At the same moment it can be, without contradiction, an abstract scheme and a living being. In both cases the structure is

the same. There are two aspects of the same arrangement, and the difficulty in making the identity exact is not disadvantageous to the development of the method. On the contrary, this refines it. The technique becomes more nuanced and subtle, requiring greater skill. It naturally leads the artist who has once used it to become a virtuoso, and to exploit the very difficulty further. An experience of this kind is a point of departure. The mind that conceived and executed it multiplies its intractable oddities and delights to make it brilliant in a hundred ways. A single solution is not the last; it brings others in its train.

Thus it is not surprising that from the natural, then intentional, accord between the abstract figure and the animate figure one should proceed to a deeply studied reconciliation between the ornamental motif and the living being. In the crypt of Saint Eutrope de Saintes we find an instance of remarkable purity. One may say that the artist has tried to give, in two unimpeachable examples, the key to a whole system and secret of a style. We have already mentioned many capitals decorated with ornamental designs which we have identified as Motif III [a variant of the palmette motif]. These motifs are not always a purely linear pattern; they are also human figures. So, on one of the ambulatory capitals (a capital perfectly preserved except for the two corner heads which are of a more degenerate period) one finds this motif delineating the body of a man. The F-leaf is here transformed into a head, like the oval we have noted in the crypt at Dijon. The branches E-T of the frame are widely spread arms; the branches E-P, spread legs; the small decorative ringlet binding the two approaching stems in E becomes the girdle of a robe whose folds follow the curves E-P.

In this way one sees a triple interplay achieved between the economy of the capital, the ornamentation, and the figure. The ornament has the role which was assigned to it on the basket of the capital. Its different features translate or underscore its architectural function. In its entire handling it is architecture itself. At the same time and without ceasing to be faithful to its law and remaining a decorative design, it is a representation of an animate figure endowed with a body, head, and four limbs. This

strange figure is not an applied ornament; it does not come from outside, seeking to embody itself at all costs with the architectural system and the decorative calligraphy. It was born thence, or at least the accord is so close that it is impossible to distinguish the triple aspects of a unique composition. The palmette lobes alone remain ornamental without undergoing figural treatment. But on a capital in the Limoges museum conceived in the same manner and belonging to the same sculptural family, these lobes are in their turn given a treatment which incorporates them into a living figure without their losing their decorative quality. They become two wings attached to a seraph's girdle. The two E-T curves, transformed at Saintes into outspread arms, are here two upward-arching wings. The corner figure has nonetheless two arms, auxiliary, it is true, to the ornamental pattern, and one of them holds a residual palmette entirely faithful to its type, as if to witness the decorative birth of the composition.

Consequently, we can now give its full meaning to a peculiar composition we have previously met, which furnished us with an interesting example of the figure conforming to the frame. This is the "spread" angel at Vézelay. Its outstretched arms and outflung legs are designed as the curves of two tangential medallions. If we compare it with the figure carved on the capital at Saintes, we see that the attitude and movement are more than similar in these two cases. The meeting of two circular frames gives nearly the same figure as two ornamental stems sweeping together. The two T-E-P passages of the *rinceau* can have, as we noted it at Adaste, a strictly semicircular form, and thus we have a complete coincidence of medallion frame with ornamental curve. We have already remarked a great many instances of coincidence, or possible identity, between frame and living form. Thence, we understand the process. At first the frame serves as a limit; then the anxiety for coverage brings a relation between the frame and the relief, and its main outlines are repeated within the composition. Finally, the frame vanishes as physical limit but persists as a constantly controlling ideal boundary. Such are the first steps in the accord between the abstract and the figural, between a mental pattern and

living stuff, like the skeleton of a system invoked to unite the two in even more intricate bonds.

On the other hand, we have seen this intricacy unfolding with mathematical severity in a system of pure ornament. A world of designs far more subtle than the rectangular lintels, roofed lintels, hemicycles, rectangles, lozenges, and medallions of the architectural frame provide an inexhaustible repertory. These themes, born of elemental motifs, proliferate and diversify by fusing their manifold aspects, like the working-out of a thesis, or a deduction always being revised.

Can we recognize in the more complex realm of ornament the relatively simple accord (in spite of its strangely distorting results) that exists between frame and figure? The capital at Saintes, the angel at Vézelay, illustrate that we can. It remains to prove that this is not an exceptional case, a chance intersection, but that the creative energy in ornament is as lively as the activity of the frame, and that the technique giving birth to the various phrases of an ornamental system operates with the same vigor in the creation and arrangement of living figures. We shall see that ornament has the same function as the frame. The intellectual attitude native to the romanesque sculptor which allow him to read nature through the design in his mind, finds its basic expression in the harmony between the architectural system and its ordered figures. It has mature and full expression in the ornamental patterning of images. It is there that we can comprehend not a number of habitual methods or conventionalities easily described and catalogued, but, instead, a genuine dialectic. . . .

CONCLUSION

Our account of romanesque sculpture is doubtless very incomplete. It has not touched every aspect of that great art. We have been especially concerned to throw light upon a method whose analysis is justified not solely by the number of examples (for otherwise we could have mentioned many others), but by the unity that links them. We only say that behind the immense variety of romanesque images the same rigorous laws operate, accounting for this

activity even when it appears to be an expression of wild fantasy.

Neither spontaneous improvising nor purely poetic caprice gave birth to this inexhaustible wealth—as we are too often led to believe—but the pondered coordinating of well-defined methods. The affirmation of a style is made through the abundance of this exuberant repertory. The sculptures we have studied—and many others belonging with them—appear as a body, as an infinite range of formulas arising from one another in a kind of dialectical system. This structural unity and interdependence of elements and forms has made our task easier than might have been expected, for the path from premise to conclusion was often easy and direct, and in some cases it was even possible to foresee the latter. In tracing this logical sequence we have been able to follow the entire development: the birth, expansion, and decline of a style, the appearance of a controlling direction, its extension, its governing role, its consequences.

First of all, we have seen architecture lead to the birth of a system. The relief destined to adorn an edifice, to emphasize and validate its various members, loses its plastic meaning if one isolates it from the monument that carries it. One may say that the architect guided the sculptor's chisel; in any event, one is inseparable from the other: they work together either by planned collaboration or by tacit and instinctive sympathy.

The primary element of composition, then, was imposed by the architectural system. Incorporated with wall, tympanum, archivolt, or capital, the decor painstakingly adapted itself, molding itself to the edifice, submitting to the frame.

Throughout this intervention by monumental masses and the forces they brought to bear upon the reliefs decorating them, we have distinguished several phases. First, by its tendency to plenitude the relief expands up to its limits, and in doing so brings about a primary accord between architectural and sculptural schemes. The frame has bounded and enclosed the design. This happens not only through a contact of outlines. The frame extends its effects into the interior of relief-compositions by means of

their axes; it repeats itself there like a kind of doublet. The imprint is so strong it persists even after the framework has vanished. It is natural to think that architecture, having first found its law, imposed its form on sculpture, which was constantly drawn toward it, and that architecture afforded the earliest examples of accord between abstract and figural. On the other hand, there existed an enormous repertory of abstract themes—varieties of ornamental patterns. We have noted how in treating the same curve the artist is able to give it the most daring features. Many groups of designs seem to have been evolved one from the other; sometimes with severe economy, sometimes with great wealth they spread over the same architectural elements as figural compositions. There, right alongside figural reliefs, the geometric logic of the sculptor was brought into play, and he developed the methods that allowed him to organize a surface and describe a figure. We do not pretend to define the chronological sequence; possibly these developments came simultaneously; it is even probable. What matters is that the ornament, linked with architecture, served as a sort of laboratory for monumental sculpture. Further, we find in the two domains the same sequence, the same method. It would seem that in ornament a psychology of the abstract took bodily form and crystallized, that the artist, obsessed with his own ingenuity, laid aside the world of perception to indulge himself, like an Arabian decorator, with pure inventions of the mind. But nothing of the kind. Amid the pattern he enriched ceaselessly, whose extreme flexibility is capable of the most diverse modulations and readings, he rediscovers nature; or, better, a half-real, half-fictive world where a poetic legendry, belonging at the same instant to the realm of the organic and the realm of spirit, reveals and incarnates itself.

Upon the armature of ornament appear people, beasts, monsters. While they all remain faithful to a grand linear system, they continually re-create themselves. There is a constant metamorphosis within the same frame. Slightly varying contours and nuancing profiles, one transforms the spiral of the siren into snake, bird, quadruped, monster. This pattern of internal evolution, operating like a dialectic

in the invention and play of ornament, recurs with astonishing fidelity in the invention and transmuting of figures. It is transposition into another key.

The study of the crook gives us another aspect of the life of ornament; it enters into the image, taking on there the three dimensions of a body. From a decorative plane it leads us to a mass about which we can turn. The unfolding of forms begins again inside this very mass. Finally, major compositions have shown us striking instances of the use of an ornamental stylistic. Many tympanums fuse visions of the Apocalypse or scriptural episodes with the palmette. But while a single design can serve as mold for many figurations of small or average scale, here the primary themes are chosen with nicer judgment. In themselves these vast ensembles are of major interest.

The persistence of a design does not mean monotony of figures. On the contrary, in that very uniformity one discovers their variety. Thanks to this plastic arrest we can retrace the evolution of figural forms, their ancestry, their heredity. By placing reliefs one beside the other and reconstructing their complete range, one sees with greater clarity their technique. We see how the forms, at first simply traced, define themselves, complicate themselves, or simplify themselves, coming into play and changing. One follows every venture in creation; one recovers hidden resemblances between reliefs apparently unlike.

But the technique of these designs presents only one side of the problem, for in relation to the outside world they are distortions. The intrusion of a geometric pattern into a figural, mobile, changing body destroys the normal form. Beasts bent into decorative contours alter their aspect. Malproportioned, disfigured by the rigor of abstract line, they turn into monsters. Dismembered, flayed, forced into the most unlikely poses, man gains a potent mimicry. Here is a fantastic world whose eloquence is due to a preordained disturbance. Thus, two contradictory principles confront each other and end by being reconciled: a law of composition by imitating nature and a law of composition by conforming to a reign of the mind, or, in other words, figural form and abstract form. What is the result of this conflict? The ordonnance imposed by abstract form

brings disturbance into figural form, for figural form as such cannot enter into the realm of the abstract. So we have a curious spectacle of most unexpected consequences. The abstract form, wholly balanced and symmetrical, when transposed into the figural order, causes vigorous movement. The rigor of the ornamental armature brings about an illusion of freedom in the figures. Thanks to the union of these two polar forces, a complex art emerges, at once science and confusion. But the equation can be unbalanced. Then we see the collaboration ceasing between two antithetic methods. Each one tends to be self-sufficing, the abstract geometry evolving a range of designs that no longer govern, but merely decorate the figure. In the rigor and regularity of lines and angles it seeks the eloquence of its own effect. The world distorted by the monumental structure now begins to live an independent life, yet still retaining its original cast. The creatures thus conceived still carry the yoke of a law that no longer bears directly upon them. Molded forever by the setting that begot them, they carry its mark even after they have quitted it.

WOLFGANG SCHOENE

ON LIGHT
IN PAINTING *(1954)*

THIS BOOK is a philosophic speculation upon the meaning of light in medieval and modern painters. Schoene traces the steps by which Gothic light, which was the essence of reality and a symbol of God, changed during the Renaissance into a mode of brightness that can be withdrawn— so that the world can disappear in darkness. In medieval light there is no shadow: light is form and color, and is represented by gold, which is a transcendental *Sendelicht*, the presence of divinity. If light is the world, it is also ideal space. This transcendental *Eigenlicht* is a heritage of Neoplatonism, which equated God with light. But after Aquinas and during the Renaissance light becomes a physical phenomenon, something quite different from the spiritual essence that made medieval light a sign of Logos or Being. Renaissance light-and-shadow are local effects, and the loss of light in shadow is also a loss of God in the world. Thus, medieval light changes into Renaissance cast shadows, modeling, highlights, *sfumato*, and reflected light, or light thrown from a local source within or without the

painting. During the modern period, when science triumphs over theology, painters use *Beleuchtungslicht* instead of *Sendelicht,* and color and form are separable from light. Instead of being a spiritual essence, light is now a sensuous effect, making our world one of relativity, transiency, and illusion. One of the ultimate results of making light a phenomenal effect is Impressionist painting. In these different uses of light we can read the gradual secularization of man.

In 1953, Alastair C. Crombie, in *Robert Grosseteste and the Origins of Experimental Science,* studied the late-medieval attention to optics and the refraction of light, an anticipation of the experimental notions of Francis Bacon and the attempt to find a "natural reason" for things. Thus, both Crombie and Schoene are concerned with the trends described in Johan Huizinga's *Waning of the Middle Ages* (1924, 1954). However, Guilio C. Argan in his essay on Fra Angelico (1955) points out that light was still a qualitative rather than a quantitative experience in this half-medieval painter. Light is the essence of Fra Angelico's painting, which is a counteractive to Alberti's theory that space is the essence of reality. Angelico is still able to transform the "sight" of things into "vision." As Argan puts it, space is "science without love" and light is "science with love." The whole problem of light is complicated by Leonardo's "blue distance," which brings the time-element into color, and thus has bearing upon the theories of Dagobert Frey as well as Schoene.

THE MEANING OF MEDIEVAL PICTORIAL LIGHT

(Chapter I, Section 11)

The pictorial light of the Middle Ages is the essential light of the painted world and at the same time it is, as such, a transcendental light. In order to deal with this question in the sense we intend, we must detach ourselves

from the objects in this painted world and from its connection with the artistic means of plastic representation. Also, whenever there were representations of secular objects in the art of the Early- and High-Middle Ages, there can be no doubt that the theme of salvation according to Christian belief predominates, and that this and not the secular objects directs the molding of forms, including the idiom of light in medieval art (this of course being chiefly an unconscious process, as generally is true in artistic creation). At the same time, the pictorial light in medieval painting is distinguished from that in modern painting by the fact that its individuality depends commonly not upon any special motif in the picture (whether we have before us Christ's entry into Jerusalem or his transfiguration, the light is the same), but upon the pictured events of basic import for the history of salvation (Christian reality, Christian truth). If this is true, the meaning of medieval pictorial light as essential light is at once clearly denoted by the fact that the very events themselves of the life and suffering of Christ appear as the source of light in the sense of light from above, radiating toward us as unearthly light—which leads, in brief, to a notion of light as revelation. However, the notion of its being apparent to our world only through this alien light, and the colors relating it to this world, is based upon the fact that without such a link the light of revelation would reach us only abstractly and not as immediately sensed.

The meaning of medieval pictorial light can therefore be called metaphysical, or ontological. In using this conception of a metaphysics, or ontology of light, which more satisfactorily interprets what is represented by medieval pictorial light than any theory of the symbolism of light, I rely upon Clemens Baeumker, and offer in what follows excerpts from his exhaustive study on "The Metaphysics of Light in Antiquity and the Middle Ages"—of course without being able or wishing to substitute any narrow or constrained reading of them. We are coping with the question whether and how far the medieval metaphysics of light can help explain the meaning of medieval pictorial light as it is concretely rendered.

Admittedly, my survey condenses the ideas of a

millennium into a few pages, so that what is constant may seem to be overstressed in view of the differing conceptions in certain epochs, tendencies, countries, or writers; however, I trust that no misrepresentation of the facts has crept in. The precise restatement of what is implied at any given time in the history of the metaphysics of light offers great difficulties. At the start of his excursus, Baeumker indicates this with the following remark: "In view of the close connection between prevailing religious conceptions and the philosophic theories of individual thinkers in antiquity and the Middle Ages, speculation in natural philosophy at very different periods commonly seized upon the idea of equating God with light, and tried to interpret it. Sometimes God is identified with physical light or light-giving fire; sometimes light is only an image for something not understandable by the sensuous imagination; sometimes, finally, the point of view hovers between these two, in that the idea of light is an encompassing one, including within it light as both a lower material appearance and a higher intelligible prototype. In both cases God is light in the actual sense—that is, not merely a figurative sense. But only for the former is light taken in the material sense alone. Both interpretations, but chiefly the first, take a pantheistic turn. After all, one cannot draw a hairline between the three notions. Especially where a spiritual light is expressly contrasted with the physical, doubt sometimes arises whether the former should be considered as light in the actual (even if analogous) sense, or whether the expression is meant as merely an image."

Light-theories in the Middle Ages use the notion of light not only to clarify knowledge of the spirit, but also to define "being" more closely, the absolute divine being, as well as the finite things proceeding from him. The premises behind this medieval light-metaphysics lie in the light-metaphysics of antiquity. Extending Plato's doctrine that "What is the good in the realm of the intelligible is the sun in the realm of the visible," Philo of Alexandria (c. 25 B.C.-A.D. 50) designates God as archetypal light; and following him, Plotinus (205-270) and then Proclus (410-485) develop the notion of emanation, which is so distinctive for the Middle Ages: perceptible light as the image of

intelligible light (the prime principle of all) from which it proceeds through an emanation by virtue of force (*dynamis*), not as a substantial expansion of essence (that is, as an emanation "in terms of substance"), but as a dynamic emanation or a giving forth of God's force, not of God's being (*emanatio per virtutem*).

The New Testament says "*Spiritus est Deus, et eos qui adorant eum, in spiritu et veritate oportet adorare*" ("God is a spirit and they who worship Him must worship Him in spirit and in truth"—John 4:24). Since, however, in the syncretistic Hellenistic mystery religions, the language of which Paul and St. John's Gospel to a large extent also speak, *phos* (*lux*, light) has become a synonym, among others, for *pneuma* (*spiritus*, spirit), God can elsewhere be spoken of as "the father of lights" (*a Patre luminum*—James 1:17) "dwelling in the light which no man can approach unto (*qui . . . lucem inhabitat inaccessibilem*—I Timothy 6:16), and it can be said most expressively in our context: "*quoniam Deus lux est et tenebrae in eo non sunt ullae*" ("God is light, and in Him is no darkness at all"—I John 1:5). The oldest Christendom, to be sure, was cool toward speculation about the lightlike nature of God, and thought, for example, that if one called God light he did it because God is creator of light. Augustine (354-430), however, simply took this last word of the first epistle of St. John and associated it with the idea of truth: "*Deus veritas est; hoc enim scriptum est: quoniam Deus lux est*" (God is truth; for it is written: God is light).

With Augustine begins the Christian metaphysics of light. He modifies the Neoplatonic teaching about light through the Christian teaching of creation by distinguishing between uncreated and created light (*Alia est lux de Deo nata et alia lux quam fecit Deus*). The uncreated light is God himself, the one undivided Trinity, the eternal truth, which, as truth, is at the same time light; light shines before everything, not with alien but with its own brilliance. And it is of decisive importance that the designation of God as light is no metaphor: "Christ is not called light in the same way He is called the cornerstone; rather, the former is in the *literal* sense, and the latter in the

figurative" (*neque enim et Christus sic dicitur lux, quo-modo dicitur lapis: sed illud proprie, hoc utique figurate*). After the uncreated light comes the created, which, as spiritual light, represents in a substantial (that is, essential) sense the angels; in the epistemological sense, truth based on reason; in the religious sense, illumination by grace; and as physical light, it is the outer light in the natural world and, as such, the first, rarest, and most efficacious in that world.

The doctrine of Pseudo-Dionysius the Areopagite (c. 500) is similar to ideas developed by St. Augustine so far as we are concerned, so that I need not go into it. With it closes the chapter of light-metaphysics as found in writings by the Church fathers. Is it by chance that it coincides chronologically with the creation of the medieval pictorial light in early-Christian and early-Byzantine art?

In early scholasticism (ninth to twelfth centuries) only a very few echoes of these notions are heard. To be sure, Johannes Scotus Eriugena (c. 850) keeps the doctrine of Pseudo-Dionysius to some degree alive through translating and commentary on his writings, and Rupert von Deutz (c. 1070-1135) speaks in an Augustian sense of God as the true light. But otherwise when God is called light, we are dealing, according to Baeumker, rather with current figurative modes of expression. Whether there is any special significance in the evident pause in the development of the metaphysics of light precisely at this time—which was particularly fruitful in the history of light in art (in Ottonian book illumination)—or whether it can be explained by the fact that speculation was directed to other questions, is not for me to judge.

But meanwhile the Neoplatonic metaphysics of light found an even better reception in the Judaic and Arabic philosophy of the ninth to eleventh centuries, which was contemporaneous with early scholasticism, teaching the emanation of the lower from the higher as an outpouring of light. And as this philosophy becomes better known to high scholasticism, the Neoplatonic theory of light regained currency from the end of the twelfth century on, in close connection with St. Augustine and Pseudo-Dionysius. The latter's writings are repeatedly translated, and in the course

of the thirteenth century are commented on again and again. The most important representatives of this thirteenth-century metaphysics of light, who according to their tradition must now be designated as "Neoplatonic-Augustinian-Arabic," are of course Robert Grosseteste (1175-1253), Albertus Magnus (1193-1280), and his pupil Ulrich von Strasbourg (active c. 1250-1277), as well as Bonaventura (1221-1280), and the unknown author of the *Liber de intelligentiis* (mid-thirteenth century), formerly ascribed to Witelo. I shall single out a few details from the wealth of material Baeumker has presented.

Guillaume d'Auvergne (died 1249) teaches the flowing of all being from the first principle as a spiritual emanation of light: "The divine being fills all things with the light radiating from it and thereby establishes the created being, which is a reflection of the first light as the light in the air is a reflection of the sun."

Albertus Magnus (1193-1280) also designates "the primal cause as pure light, than which there is no higher —an ineffable and nameless light, which acquires a name only when it is revealed"; and he describes the emanation of things from the first principle as the arising of light out of light in degrees of emanation: "The lower stage of emanation begins each time where the light of the higher meets with obscuration. However, Albert, along with Isaak Israeli (c. 900), calls obscured light shadow . . . limitation and darkening in contrast to the more widely diffused and brighter light characterize it" (*Umbram autem vocamus differentiam, per quam coarctatur et obumbratur amplitudo luminis a priori procedentis secundum genus cujuslibet causae*). The lower stage of emanation originates "in the shadow of the higher" (*semper posterius oritur in umbra praecedentis*).

Vincent of Beauvais (c. 1250), following the Jewish philosopher Avencebrol (eleventh century), teaches "The essential form of things is light, which clothes matter; the more intense the light, the more perfect (*perfectior*) the substance (essentiality of things)," a mode of expression that often recurs in high scholasticism, wherein the idea "more perfect" usually is phrased not as in Vincent by *perfectior* but by *nobilior;* the words *nobilis, nobilitas*

denote here a transcendental essence corresponding to
lux. The degree of *nobilitas* each thing has, determines its
rank within the divine order of the universe. In this sense,
we read in Bonaventura, for example, "*Lux enim est una
forma communis reperta in omnibus luminaribus, et secun-
dum cujus participationem majorem et minorem sunt magis
et minus nobilia.*"

Baeumker gives a detailed account of the especially
important light-theory of Bonaventura (1221-1274). It
adheres closely to St. Augustine. God is the nature of light
in its highest degree (*potissime*); He is "the eternal light
in which the essence of light and the act of giving light
are not different" (*lumen aeternum, in quo non differt
essentia luminis et ipse actus lucendi*) and, as such, is at
the same time the source of all spiritual light (*fons lucis
spiritualis*) and of the created spiritual light that stands in
an analogous relation to it (*Lux spiritualis est communis
creatori et creaturae secundum analogiam*). "In the area
of physical nature, however, as Dionysius the Areopagite
said, nothing is so similar to eternal spiritual light as visible
material light" (*Lux inter omnia corporalis maxime assimi-
latur luci aeterni, sicut ostendit Dionysius . . . , et
maxime in virtute efficacia*).

In speaking of this physical light, Bonaventura differ-
entiates between light (*lux*) and the emanation of light
(*lumen*), in which connection we can disregard the fact
that he does not always sharply separate the two ideas.
Lux is thought of as substantial form (*forma substantialis*)
in things, therefore not as accident. *Lumen* has an acci-
dental relationship to *lux;* regarded from the *lux*, it is sub-
stantial nevertheless. The arising of *lumen* from *lux* is,
however, no movement, but a generation (*generatio*) or
outpouring (*diffusio*) occurring in the self-reproduction
(*multiplicatio*) of *lux*.

The created light (*lux spiritualis et corporalis*) is in
analogous relation to the uncreated divine light, but is
along with *lux* a self-reproduction of divine *lux: lux de luce*.
The graduated being of things is therefore a diffusion of
light, which on its part shares the divine light.

Finally there is the *Liber de intelligentiis* as edited
by Baeumker. It was at first ascribed by him and others to

Witelo (active in the third quarter of the thirteenth century), but according to later investigations by Baeumker, probably is not the work of Witelo, but evidently stems from about the middle, if not the first third, of the thirteenth century, presumably written in Paris. The ideas of the *Liber de intelligentiis* about light resemble those of St. Augustine, Grosseteste, and Bonaventura: they are, however, not, as in them, woven into various other topics, but are dealt with in clear form by themselves, and they go further than Bonaventura in that they bring the theory of light into systematic connection with the emanatistic conception of the flow of things, and with the interpretation of their activity as a flowing-into. The primal cause (God) is substance (substantiality); the primal substance, however, is light, and furthermore, light in the real, not the transferred sense—light in its essence. Now, since the primal substance produces a flowing-into-all-else (*influens in aliam*), and is itself generative light, each of the graduated substances down to the four earthly elements (*substantiae naturales, sicut elementa*)—fire, air, water, and earth—have a share in primal light—even if not in its essence, since only in God do essence and existence really coincide; yet they take part in His being (*participatio lucis est participatio esse divini*). The self-reproducing light as a bearer of causal influence: with this the two images of "flowing from the source" and "emanating light" are made to correspond. However, everything retains just as much of the divine being as it has light (*Unumquodque quantum habet de luce, tantum retinet esse divini*).

Here we are at the end of our survey of the medieval metaphysics of light. If we try to summarize its common basic ideas, the following propositions emerge: God is light, and indeed in a literal sense. Everything created by God is light of His light: with reference to God in the sense of an emanation of divine force, and with reference to man in the sense of analogy. Insofar as each created thing has light, it partakes of divine being.

Now we must return to the question posed at the start: whether a legitimate contribution to the understanding of medieval pictorial light can be extracted from the ideas of a medieval metaphysics of light. The answer is

difficult. In formulating its theories of beauty, medieval speculation had no concern with the artistic creations of the time. All students of the matter are agreed that the scholastics' theoretical notion of beauty (indeed, one can add: scilicet, conception of light) has no immediate reference to art; scholasticism produced no theory of art. One can now put these questions against the question whether the phenomenon of medieval pictorial light in the sense we have tried to visualize it, might not properly be understood in terms of intellectual history—indeed, as an unintentional contribution to medieval light-metaphysics made in the idiom of representational art. Yet, a comprehensive view of what is phrased abstractly in speculation and concretely in art would assume that the phenomenon of "light" in each case finds its source and direction in the palpable light-experience of man. That is obviously true for art; but does it hold true for philosophy?

Whoever traces cursorily the history of light-metaphysics from the Hellenistic mystery religions to high-scholasticism knows that the idea of light includes a great many phenomena which seem to us today to have little or nothing to do with light that is a physiological sense-datum. Such, for example—to hold ourselves to the realm of the created world—is the postulation of light as the fundamental form of matter as such (Bonaventura's notion), out of which also stems Ulrich von Strasbourg's conception of beauty, which he has defined as "the form of anything, insofar as it is, through its form-giving nobility (*nobilitas*), like a light radiating over that to which it has given form."

Nevertheless, it can be shown that the speculative conception of light has always remained closely in contact with palpable light-experience, out of which it originally grew: "Among all objects of perception," says the *Liber de intelligentiis*, "light is the one that arouses the greatest desire" (*lux inter omnia apprehensioni est maxime delectabile*). The *nobilitas*, the God-given order of rank, the hierarchical participation in the divine being of the four elements of fire, air, water, earth, is recognized by the degree of their tangible light-content. Also, within the single elements, the following holds true: in the ocean, the upper light-containing water is *nobilior* than the darker

water below; in earth, the shining coal, metals (gold and silver), sparkling precious stones, and glass (produced from ashes, sand, and fire) have a higher *nobilitas* than ordinary rock, and so forth. Thus, less light means inferior *nobilitas*, a theory that results from the notion in light-metaphysics that "the lessening of the strength of light proceeds not from a weakness of its essence, but from the lesser receptivity of matter." The ever-recurring term *nobilitas* (which, as has been said, means a transcendent essence) implies that even for visible light the philosophic light-concept tends to extend itself to optical, along with spiritual, realities. The same thing is shown conclusively in medieval cosmology, which, thanks to Dante, remains familiar to all mankind: Around the eight spheres of planets and fixed stars, whose light increases in brightness and purity from sphere to sphere, oscillates the ninth, the crystal heavens, the *primum mobile*, which pulls all with it by its motion. And around it in eternal calm, as the furthermost "limit" of the God-created universe, lies the empyrean, the true "heaven," the place of the blessed and the angels (intelligences): the completely pure light (*nobilissimum corpus*, Bonaventura calls it) which through its self-reproducing (*multiplicatio*) and outpouring (*diffusio*) moves all lower spheres (through a pouring-forth of longing to unite with it) and penetrates down to the earth, which forms the center of the cosmos in which its force is gathered as into a focal point (Grosseteste: *"Omne namque corpus naturale habet in se naturam caelestem luminosam"*). To the human eye the light of the empyrean is, to be sure, inaccessible; but it still belongs to created light. In what further relationship it stands to the divine archetypal light—this question remains open: *"Qui (Deus) lucem inhabitat inaccessibilem, quem nullus hominum vidit, sed nec videre potest"* (I Timothy 6:16). In any case, the usual opinion of Dante scholars that the empyrean is the "seat of Divinity," insofar as it applies to Dante at all (in the *Convivio*, at any rate, he expressed himself thus), is not to be generalized. The empyrean is the first in the God-created universe: *"Cum caelum empyreum sit primum creatum inter corpora"* (Bonaventura). It is the place of angels (intelligences), but the *Liber de intelli-*

gentiis designates it expressly only as their physical seat, and contrasts it to their spiritual locality, God: *"determinatur quid sit locus intelligentiae proprius, qui locus duplex assignatur, corporeus et incorporeus; corporeus, sicut caelum empyreum, incorporeus sicut deus."* Is not the last canto of the *Divine Comedy* also founded on such "indeterminateness" concerning the relationships between the empyrean and God regarding the conception of space and light? The verses that describe the vision of God, the *vera lux,* keep the incomprehensible in a splendid way within the incomprehensible, as it says at their very beginning:

> Da quinci innanzi il mio veder fu maggio
> Che'l parlar nostro, ch'a tal vista cede;
> E cede la memoria a tanto oltraggio. (Par. 33:55-7)

After all this there can be no doubt that the medieval metaphysics of light has repeatedly taken its bearings from the sensuous experience of light. Light in painting has, however, remained outside its field of vision. Yet surely one can say precisely how it would have been treated had it been invoked as an example (which is exactly not the case): the leaded windows in cathedrals would have been considered simply as jewels and glass, the gold-size as the metal gold, and the colors in painting as hues in the sensed world. Indeed the light in painting—or, more precisely, the light-material—would have been assigned a high rank within visible light, but its true element, the artistic, would not have been signified. But this light insofar as it is artistic light (painted light in the literal sense) must be the critical point for us. This critical point is that by virtue of its elemental quality, this essential light, apparent as it is in episodes pertaining to the legend of salvation, is markedly alien from the usual light of the material world, so that everyone who yields to it (and thus "sees" it) experiences it directly as "a light at one and the same instant dissimilar." The language of art is not the language of speculation, which can differentiate material from spiritual light, but has, so to speak, only *one* word for "light." The speculative notion of light must attempt to embrace optical and spiritual realities and experiences dialectically; in the artistic light-word both are one. By eliminating

shadows, medieval painting raises its sensuous light to the plane of transcendental light, for all sensed light in nature is shadow-giving light. After all, we can never realize clearly enough that to look at a work of art "as such" was denied the medieval mind because of the theological structure of its thought. It *could* not, therefore, cope with the "artistic" at all, or speak directly about it. It *had* to formulate things as it did, just as today we *must* formulate things otherwise. Necessarily, it attempted to grasp the sense of a work of art, like the sense of everything else in the created world, by concepts like *imago, imitatio, exemplum, symbolum, allegoria, analogia,* etc.: "*Materialia lumina, sive quae naturaliter in caelestibus spatiis ordinata sunt, sive quae in terris humano artificio efficiuntur, imagines sunt intelligibilium luminum, super omnia ipsius verae lucis.*" Today we too deal quite frequently with these concepts, but very properly not without historical qualifications and hardly ever when referring to a work of art as such. Yet this is a large topic.

We are drawing to a close. At the opening of this section I spoke from the standpoint of the concrete evidence: how the meaning of medieval pictorial light as essential light is graphically shown in the fact that the things portrayed in the story of salvation themselves appear as the source of light, how its meaning as light from above is indicated by the fact that they radiate toward us as unearthly light, which, in brief, led us to a notion of light as revelation. These conclusions drawn from the evidence now find striking verification in the central ideas of medieval light-metaphysics, so that we can surely say, without doing violence to facts, that the essential light in medieval painting is meant to denote God in a "nonobjective" sense. As pictorial light, it belongs, however, to created light, in St. Augustine's terminology, so that the question arises as to how it is related, as created visible light, to the true divine light. Here we must scrupulously return to the evidence: in its highest realizations (for instance, in Ottonian book-illumination, in gold-size, in cathedral windows), the relationship of pictorial light as essential light to the true divine light seems to go beyond the idea of analogy in the direction of an idea of equiva-

lence manifest in what is graphically portrayed; and as a
light from above it seems to phrase concretely the incom-
prehensible process of the emanation of divine force in all
its mystery.

We may add that here art accomplishes more than
philosophy, more than thought turned toward the unat-
tainable. It is indeed suggestive to invoke the philosophers'
conclusions for comparison, but it is hardly advisable to
transfer such conclusions directly to artistic works, since
then the special value of art as knowledge is all too readily
lost. . . .

In the theories of Bonaventura and the *Liber de intel-
ligentiis,* the medieval metaphysics of light reached its
height. Yet, at the same instant, the first decisive opposition
came from the "Aristotelian" Thomas Aquinas (1225/27-
1274). In his system there is room only for an epistemo-
logical treatment of light, no longer a metaphysical one.
In this regard, Baeumker points out: "He (Thomas) ex-
pressly rejects St. Augustine's statement that in the realm
of the spiritual the concept of light is used in the literal
sense, for in the literal sense light is something wholly
sensuous. If God is called the 'true light' in the Gospel
According to St. John, this proves just as little for that
conception as does the fact that Christ was the vine in
the literal, not the transferred, sense, because He says of
Himself 'I am the true vine.' In no analogous sense does
the light refer to both spiritual and corporeal, so that it
is first spiritual and then corporeal; but it is spiritual only
in a metaphorical way. For in an analogous statement
there must be a common element involved in the very con-
cept—what is stated here as well as there, though in a
completely different way. In this instance the common
element lies not in the concept of *light,* but in the *making
manifest (manifestatio)* which happens through the light.
This making manifest of course appertains to the spiritual
in the higher sense rather than to the tangible. If one
considers this idea of manifesting, one can, to be sure,
along with the Bible call God and the spiritual generally a
'true light'; yet this is no literal use of the word 'light' but
remains a metaphorical use of the term. Just as definitely
Thomas opposes the ontological exploitation of the concept

of light. It is not true that light is the primal physical substance."

I have gone so far as to mention these notions in Thomas (which were formulated when glass-painting had already passed its height) because they seem like a philosophic preparation for the change which was to take place after 1300 in the history of pictorial light: the transformation from essential to illuminating light.

LIGHT, SHADOW, COLOR

(Chapter II, Section 13)

Leonardo has clearly defined the notions of light and shadow in the artistic world of illuminating light. Let us take, for example, a sphere lying on a table which is lighted from the side by a candle. Leonardo designates the source of this light from the candle as *luce* (the causal illuminating light), and the light on the illumined side of the sphere as *lume* (bestowed light, corporeal light). He hits upon a corresponding distinction for shadow: the shadow on the shaded side of the sphere he calls "primary shadow" (*ombra primitiva*, corporeal shadow), and the other shadow which, extending from here, fills the air and strikes the table, "derived shadow" (*ombra derivativa*, thrown shadow). Further, he defines the relationship of light and shadow to darkness, and the pictorial function of light and shadow, in the following statements:

"Darkness is the withdrawal of illuminating light (*luce*) and illuminating light is the withdrawal of darkness. Shadow is a mingling of darkness and illuminating light."

"Shadow is the diminution of light."

"Being illuminated is having a share in illuminating light."

"Shadow by nature belongs to darkness, the bestowed light (*lume*) is of the nature of illuminating light (*luce*). The one (*ombra*) conceals, the other (*lume*) reveals. . . ."

The stress on the duality of illuminating light and darkness contained in these definitions of Leonardo's, and his distinction between *lux* (illuminating light, source-light) and *lumen* (bestowed light, corporeal light), as well as between primary shadow (corporeal shadow) and derived shadow (thrown shadow) hold good during the era of illuminating light, and also give us usable keys for understanding theoretically the pictorial light in painting of the fourteenth and fifteenth centuries. . . .

In the fifteenth century (or more precisely from 1420 on), two kinds of developments occur: for one thing, corporeal shadow grows deeper, and for another, derived shadow now also appears alongside it, particularly as outright thrown shadow on floor and wall (for instance, in Campin) as well as in the form of aerial shadow (atmospheric shadow—darkness, as in Van Eyck or Masaccio). Herewith, illuminating light (*luce*) becomes artistically operative, so that now we can really speak of illumination. In this connection, Masaccio's "Shadow Cure" (Brancacci Chapel) is one of the most impressive works of art: Peter heals the lame by their passing through his shadow (Acts 5:15); earlier painting would not have been able to portray this event effectively.

In its details, the history of illuminating light in the fifteenth century is very complicated. It can be inferred from the history of shadow and color. I must hold myself to a few suggestions.

Furthermore, in the entire corpus of fifteenth-century European painting there are numerous pictures that practically never use derived shadow. Others bring it in only as cast shadow, not as atmospheric shadow (for example, Rogier's works in contrast to those by Van Eyck or Bouts). Cast shadow is also nearly always extraordinarily short, even when the light falls laterally; and—especially indicative—it almost never hits the figures, but nearly always only their surroundings (floor, architecture, and so on);

at the figures it breaks off. Very impressive instances of this are found in Konrad Witz, who for his part ingeniously and basically uses cast shadow in particular.

From these references one sees that in the fifteenth century illumination did not yet have unlimited dominance, a fact suggesting that there is a constant presence of a continuous scale of illuminating light: corporeal light, corporeal shadow, thrown shadow, darkness. Consequently, the source of light, even though perceptible, remains as a rule unobtrusive; the path of light still hardly cuts directly across picture and beholder when face-to-face, and the local colors spread out on enclosed surfaces are often transparent on the white painted background or else otherwise luminous in themselves, thereby still operating as elements of the old essential light and, as such, likewise restricting the effort of illuminating light. Through such circumstances it becomes evident why pictorial light in many paintings and frescoes of the fifteenth century has an air of hovering between essential light and illuminating light. On the other hand, there are still individual masters—Jan van Eyck and Masaccio, for example—largely exempt from such restrictions, so that one can see the history of a waning essential light and the history of a strongly growing illuminating light overlapping each other in the fifteenth century, until toward 1500 in Italy and 1500-1520 in the North illuminating light finally establishes itself. Perugino's Munich painting "The Madonna Appears to St. Bernard" (c. 1494) offers a fine example of this: in the foreground, clear, distinctly illuminated figures—that is, "corporeal light"—but streaming in from the background, the light of the natural heaven itself—that is, "illuminating light"—and both separated and united by the darkness of the arched roof of the hall. . . .

PRINCIPLES OF LIGHT, SHADOW, AND COLOR IN PAINTING OF THE SIXTEENTH-EIGHTEENTH CENTURIES

(Chapter III, Section 18)

In the world of essential light, the source of light (illuminating light) and the painted world coincide. In the world of illumination, they are separated from each other. If we would appreciate the meaning of illumination, however, we must also, for obvious reasons, study the illuminating light: the luminous echo of the illuminating light in the painted world is less significant on its own account than as a bestowing of illumination, and thus, as evidence of its nature and substance. Thus, the question of the *source* of such light will be the center of this chapter.

In his *Book on Painting* Leonardo made just about all the definite observations concerning light, shadow, and color that are possible in this world of illumination. Here we must confine ourselves to what is most important. We have already mentioned his distinction between illuminating light (*luce*) and cast light (*lume*), between primary shadow (*ombra primitiva*) and derived shadow (*ombra derivativa*), as well as his definition of shadow as a "mixture of darkness and illuminating light," which rests on a discernment of the duality of illuminating light and darkness, and likewise, his designation of the functions of light and shadow: "Shadow conceals, light reveals."

Now, concerning light itself, he differentiates between five kinds or, more exactly, five modes of its appearance in the painting (they are evident if one combines his statements):

1—Light in a well-defined sheaf of rays such as extends from sun, moon, and flames (*lume particulare*)

2—Light in a loose sheaf of rays such as enters through a door, a window, or other such limited opening

3—Environing daylight without sun (*lume universale*)

4—Reflected light (*lume reflesso*)

5—Light shining through diaphanous (not transparent, only translucent) material such as linen, paper, and the like.

Correspondingly, he differentiates between three kinds of shadow: the two shadows that are produced by sharply defined or broad sheaves of light, and the shadow that arises from environing diffused daylight.

Finally, there is still to be mentioned his definition of chiaroscuro: "Between bright and dark, that is, in the middle between light and shadow, there is to be found something that one can call neither bright nor dark, but that shares in a certain measure brightness and darkness. Sometimes it stands equidistant from brightness and darkness, and sometimes it is nearer one than the other." Such chiaroscuro is sometimes formed on the illuminated body by a gradual transition from corporeal light to corporeal shadow, otherwise in the zone between illuminating light and darkness within the medium of the "atmosphere."

So much for the explanation according to Leonardo. When we consider painting with illuminating light from the point of view that the source of its light is of decisive importance, we note that it must attempt to erect an entirely unbroken scale between the illumination (the source of light) and the lighted world, so that by this means the mode and nature of the illuminating light is readable, or inferable, from the picture itself. The painting of the seventeenth century has succeeded in this to a large extent; and in this respect painting in the fifteenth and sixteenth centuries is a beginning, and painting in the eighteenth and nineteenth centuries an end.

The immediate relation between the source of light and the illumined pictured world can be described in three different ways if we consider the limits of possibility:

1—The source of light standing outside the pictured world sends a sharp beam of light into the picture. Here painting can limit itself to the representation of corporeal

light, corporeal shadow, cast shadow, and darkness (approximate or total) without endangering the clear continuity between pictoria and light-source (Caravaggio).

2—The source of light existing outside the pictured world sends into the painting a broad sheaf of light whose effect is essentially diffuse. In order to make the connection between illumined pictured world and light-source clearly continuous here, the painting must represent the intermediate phases in the path of light thus: (light source)—light-filled atmosphere (*chiaro*scuro)—illuminated side of objects (corporeal light—transition to the shadowed side of objects (chiaro*s*curo)—shadowed side of objects (corporeal shadow)—shadow-filled atmosphere (derived shadow, chiaro*scuro*)—cast shadow (derived shadow)—(darkness).

The breadth of variation in pictorial light is greater in this second possibility than in the first. The painter of the first mode must place his accent rather equally on light and darkness, since otherwise the continuing sharp beam of light is not representable. The painter of the second mode can put emphasis either strongly on light or strongly on darkness, or on both equally. In the first case, there results pictorial light suggesting so-called "free light" (for example, Velázquez' equestrian portrait of Don Balthasar Carlos), in the second case, one suggestive of light-by-night, and in the third case, a balanced chiaroscuro-pictorial light (for instance, Rembrandt's "Journey to Emmaus," 1648, in the Louvre).

3—The source of light appears in the pictured world itself. Here the immediate relation between it and the pictoria illumined by it is clear throughout, no matter whether the path of light itself makes use of the sharply defined ray (as, for example, in Zucchi's "Amor and Psyche"), or of the continuity described just above (Claude, Rembrandt).

These three possibilities determine the history of pictorial light in modern painting. By contrast with the history of pictorial light in ancient painting, which was indeed acquainted with illumination and shadow, things depend directly on the relation between light-source and illuminated pictoria. It would be wrong to grant Caravaggio a minor rank merely, or to evaluate this achievement

solely, for example, on the basis of Rembrandt, or the *plein-air* nineteenth-century painting.

The five "sorts" of illuminating light distinguished by Leonardo are not "kinds" but "modes of occurrence" of light illuminating a painting. If we understand by "kind," class or category, then we can distinguish among three or four kinds of illuminating light in painting of the fifteenth-eighteenth centuries:

1—"Natural" illuminating light: sun, moon, daylight.

2—"Artificial" illuminating light: candle, torch, fire, etc.

3—"Sacred" illuminating light: a halo or something comparable.

4—"Indifferent" illuminating light: by this concept I wish to designate, through what is concretely rendered by any pictorial light, the illuminating light that cannot immediately be identified in type or nature with any of the above-listed kinds of illuminating light. The term "indifferent" is therefore not used to describe any characteristic of the light concerned. It is only intended to imply that the latter bears an indifferent relationship to designations like "natural," "artificial," or "sacred," not that it is indifferent in its operation. The question whether in the "indifferent" case we are dealing with the problem of a "genuine kind of illuminating light" can remain open for the present. I know that the notion of "indifferent" can make for misunderstandings, and I should have been able to say "nameless" or "unnamable" light were it not that these words lack the neutrality of the foreign term I wished to use; for the word "indifferent" will have in my investigation a function similar to the indeterminate X in a mathematical equation.

DAGOBERT FREY

GOTHIC AND RENAISSANCE *(1929)*

FREY'S CONTROVERSIAL BOOK deals with the relation of space and time in the arts, holding that Gothic art is seen "successively" whereas Renaissance art is seen "simultaneously." Gothic space does indeed apparently unfold in a linear or "genetic" way, as can be seen when one glances along the nave of Amiens or along the ranks of statues on the façade. The Renaissance introduced "simultaneous" space by means of its "closed" perspective and, especially in painting, constructed areas where every figure is instantaneously seen to fall into complex and harmonious relations with other figures. It is of course true that Gothic space is infinite and atmospheric as compared with the blocklike spaces in Romanesque art, and it is likewise true that in architecture and sculpture as well as in painting the Renaissance organized space coherently into a system of geometry dependent upon proportions simultaneously grasped. Yet the problem may not be quite so neat: Gothic space is very systematic, as the ground plan of almost any cathedral will show, and Renaissance space, at least in

painting, is not always in consistent or coherent mathematical perspective, as Leonardo's "blue distance" suggests. The treatment of space and time is involved with light, color, and atmospheric tone, as Schoene explains. Frey's theory is, however, an important modification of Lessing's famous axiom that the plastic arts are essentially spatial in form, whereas literature must be temporal in form. Particularly important is Frey's interpretation of the Gothic mode of vision as a single texture of experience fusing space, time, and matter, "genetically."

The implications of Frey's theory for other arts are discussed in Joseph Frank's "Spatial Form in Modern Literature" (*Sewanee Review*, Spring, Summer, Autumn, 1945). Erwin Panofsky has indirectly treated similar questions in *Gothic Architecture and Scholasticism* (1951). A less theoretic approach is in John Fitchen's *Construction of Gothic Cathedrals* (1961), and Paul Frankl's *The Gothic* (1960), along with Miriam Schild Bunim's *Space in Mediaeval Painting* (1940). Other valuable discussions are: Henri Focillon, *Art d'Occident* (1938, 1947), Otto von Simson, *The Gothic Cathedral* (1956), and Hans Jantzen, *High Gothic* (1957, 1962). The full history of Gothic is given in Paul Frankl, *Gothic Architecture* (1962).

GOTHIC AND RENAISSANCE

(Chapter II)

By establishing clarity in its conception of space as the basis of the Renaissance scientific and artistic development, we have not yet grasped the epistemological problem in full depth. The decisive question still remains as to what epistemologically the basis of this conception of space is, and how it differs from that in the period of the preceding style. Again we must go further back for an answer to this question.

When we have recognized the purely intuited conception of three-dimensional continuous space as the real

Renaissance innovation, there arises a legitimate objection regarding the powerful architectural creations of the Gothic period that such an architecture must have as its premise an especially well-developed conception of space and that an intense sensitivity to depth perspective is apparent in it. Therefore, we can hardly contrast the Renaissance as a period of definite spatial vision with the Gothic as a period of a nonspatial vision that is linear or surface. Then too, the contrast cannot be due to a basic concern with empty space in the one and a predominantly plastic concern in the other. The mere opposition of three-dimensional and two-dimensional, of near-seeing and far-seeing, of haptic and optic, cannot account for the difference between Renaissance and Gothic. It cannot be a matter of spatial and non-spatial, but rather of spatial conceptions of fundamentally different orders. In this essential difference in spatial conception we must seek to grasp the central historical problem.

Let us start our investigation with painting, because here the contrast between Gothic and Renaissance spatial representation emerges more clearly; then let us see whether the basic differences apply to other arts. Two chief aspects of Gothic painting appear strange or paradoxical to our own understanding of a picture, depending as it does on our Renaissance mode of vision: the spatial juxtaposition in representing events which are separated in time, and the lack of a uniform scale in rendering the objects presented within the same pictorial unit.

Like the people of the Renaissance, we require that all the details in a painting be grasped together as a whole and at a glance, or, more exactly stated, that our perception of the successively seen parts be fused into one unified pictorial impression. We let the picture in its entirety have its effect on us; we scan it at a glance in order to take it in simultaneously as a whole, and only then do we shift our attention to the details, arranging them over and over again into a total composition which is enriched and completed through them. We see the whole, so to speak, at once; the perception is instantaneous.

The Gothic approach is just the opposite: it proceeds from one item to the next, taking in the content of the

painting as it moves along. In being thus read, the picture comes to life before one's eyes; it rolls off, as it were, like a film before the observer, except that the successive pictorial impressions do not depend upon the mechanical movement of the film, but upon the intellectual movement of the viewer. This psychological process of reading successively differs from the Renaissance simultaneous viewing. In Gothic, this is not merely an auxiliary psychophysical process of perceiving, or for arriving at a total unitary grasp; rather, it is intrinsically a basic mode of experiencing the content of a painting. The Renaissance synthesis of total conception depends upon simultaneity; the Gothic depends upon a succession of partial ideas.

Even the medieval picture offers a unity; this is, however, not conditioned, as in the Renaissance, by a unity of space and simultaneity of what is presented, but by the genetic formative principle underlying it. If we designate the medieval mode of artistic synthesis as genetic, we must deal with this notion more precisely, and from two sides, *per exclusionem*. The genetic principle that governs pictorial unity is by no means to be taken as identical with the process by which the work of art has originated, either psychologically or technically. Medieval works of art afford us far less insight into the psychological and technical steps in their creation than do Renaissance and Baroque works. The aesthetic value of the *sketch* involves a notion of the intuitive process of creation that is thoroughly foreign to the Middle Ages. The expression of artistic inspiration (a notion, by the way, first phrased in the Renaissance), of a spontaneous idea or a "first version," which we feel most intimately and directly in the sketch, derives its artistic integrity from the personality of the artist. The Middle Ages did not know this subjective approach. The genetic medieval handling is not a reflection of artistic creativeness, but inheres objectively in the method of pictorial representation. On the other hand, this does not imply that a genetic treatment must always represent episodes or events in time; basically, it also applies to rendering objects in a state of rest, as in the depiction of inanimate objects.

What is at rest, too, is envisioned as a successive

impression of single pictorial elements. The genetic pictorial principle represents a mode of synthesizing sense impressions peculiar to the Gothic frame of mind. In terms of Goethe's morphology, we may say that everything can be considered as form (*Gestalt*) or as formation (*Bildung*). Thus, Goethe defines the former as "the state of being of a real creature in which something is abstracted from what is in motion, and it is assumed that something unified has been established and finished and fixed in character," while the latter denotes "what is being brought forth or in process of being brought forth."

Even in light of this contrast, the essence of the Gothic mode of conception is not adequately defined: to understand it correctly we must first notice a phase preliminary to the pictorial art of the Early- and High-Middle Ages, both with regard to the single separate forms from which the composition is built and with regard to the composition itself and the way it is unified.

During the Romanesque period the strange isolation of single figures in pictorial composition is conspicuous above all else, no matter whether these are placed next to each other without ornamental relation or whether they gain their own spatial frame and setting by means of an ornamental division into fields. Each single figure, even individual parts of the body—insofar as they are essentially distinguished, as, for example, heads or hands—every object, every accessory, consequently has its own identity, becoming the symbolic sign for a certain *quidditas* or substance (in the terms of scholasticism), a strictly circumscribed notion or "idea" in the Platonic sense. From these hieroglyphic signs, the painting is put together in the manner of picture-writing. In the oldest illuminated encyclopedia preserved to us, the manuscript of Rabanus Maurus of 1023, whose prototypes Goldschmidt dates back as far as Carolingian times, we find curious representations which seem almost like still-life: we see, for instance, in the article "De opuscolorum varietate" a table portrayed with two books standing half open and one laid down; in the article "De campis," a hedge fence; in the article "De portis," a painted double door; in the article "De curia," an arch on columns. Although the group of books may remind

us a little of the Duerer drawing with a reading desk, or of Hercules Seghers' engraving with similar things, the meaning remains fundamentally different. The representations in Rabanus Maurus are standardized illustrations of graphic clarity, but of conceptual significance only for book, field, doors, etc. This is very obvious in the picture for the article "Quae in sanctis canonicis libris contineantur": a writer sitting before his desk in the fashion of the evangelists, and over him, without spatial connection, five single folios—the books he has written. In like manner, rain was signified by a combination of two symbols: sky, represented by three stars and falling drops; and dew, by sky, falling drops, and a bush. . . .

The Gothic style took over from Romanesque this pictorial mode of rationally linking together individual conceptual forms. Yet the method of shaping and combining these forms has become radically different: whereas the form-symbol in Romanesque art was the expression of an ideal transcendental content, it now receives an objective concrete meaning. Accordingly, the pictorial combination of individual forms does not now depend upon an entirely intellectual, logical relation, but upon a rendering in space and time. The arrangement within the picture now actually involves relating figures and objects to one another in space or time. But this spatial relationship within the painting is not based upon a geometrically determined correspondence between actual spatial quantities and the pictorial ones; it is not a copy of real space, but is inherently determined by what object is represented. Consequently, things huddled close together in the picture can represent things widely separated, below and above are new modes of rendering before and behind, and things side by side can depict things one behind the other. Here are not the abstract conceptual ideas into which Romanesque art disintegrated even the continuous flow of epic narrative; here is not the transcendental allegorical representation it put in its place. Instead, here are concrete individual phenomena that actively enter into relationship with each other, and yet they still remain derivatives of that early-medieval ideality. They are not simply individual phenomena: as such they are also representatives of con-

ceptual abstractions. The fundamental mode of thinking
has not changed—only its basic conceptual content. Herein
lies the source of the "spiritual naturalism" (Dvořák) in
the Gothic.

Out of the spatial, temporal, and causal relations—
that is, the narrative content of the pictorial composition—
there arises also another meaning: the formal structure. In
place of an axial or balanced composition there increas-
ingly appears a preference for a directional arrangement
from left to right, the way writing goes, or from the bottom
upward, yet not in the sense of a hierarchic scheme of
values, but of a spatial-temporal sequence of events.

Even if Italy is precocious in historical development,
partly because of the stronger after-effects of the spatial
sense of ancient architecture, partly because of tradition,
and partly because of the unification of pictorial space in
Eastern Romanesque art, as compared with that of the
North (which holds longer and more tenaciously to the
more abstract, ornamental conception native to it), the
successive epic mode of conception still is the basis of
trecento pictorial representation. Even the compositional
unity in Giotto consists not in a spatial-temporal unity, not
in simultaneity of appearance as in the Renaissance, but
in the realm of action implied by the content, in a unity
of epic motifs, and in the artistic economy of the story. It
is significant that the personal development of the artist,
from the Arena Chapel to the Peruzzi and Bardi Chapels,
in no way leads to a stricter unification of space; on the
contrary, an expansion of space, or an accumulation of
diverse locales, is to be observed ("The Birth of John the
Baptist," "The Ascension of St. John," "The Confirmation
of the Order"). However, this does not mean a loosening
of the epic composition or a novella-like spinning-out as
with the Sienese, but rather an enlarged encompassing of
a unity of action, a symptom characterizing mature style.
The "architectonic" of Giotto's pictorial composition is
wholly anchored in the events represented and in the pic-
torial molding of the story. So hero and antagonist stand
facing one another ("The Bribery of Judas"), the parties
massed together on both sides like hostile armies, while in
the middle the tension reaches a balance in a symbolic act

("Expulsion from the Temple," "Massacre of the Inno-
cents in Bethlehem"); and in that way the action is led
back to the rhythmic countermovements of entering and
confronting ("Meeting at the Golden Gate," "Entrance
into Jerusalem"). It is always the inherent relation of figure
to figure, group to group, the reading off of temporal
events, that provide these strangely immobile figures with
an unwonted life and the gripping suggestion of dramatic
activity. In this is apparent the difference from Masaccio,
with whom simultaneity of pictorial representation is the
decisive tactic; in this regard, Giotto is completely Gothic,
in spite of the anticipation of the Renaissance which people
since Vasari have again and again thought they recognized
in him. Precisely what distinguishes Giotto from the spe-
cial Gothic art of the *trecento,* from his Florentine succes-
sors, from the Sienese, and from the Camposanto frescoes
in Pisa is deeply rooted in the medieval mode of concep-
tion. It is the ideal power of symbolizing which grasps
each form and action in an image suggestive of super-
individual meaning, that lifts earthly events to an evoca-
tion of spiritual strengths and principles. Rintelen has
given a splendid characterization of this quality in Giot-
tesque art: "As if a logical development is supposed to be
offered, Giotto conceives the single parts not as episodes
in a drama but as factors in the cooperation of which the
event emerges in its full symbolic and intelligible mean-
ing."

The further development does not lead in a straight
line from Giotto to Masaccio. Just that which we sense in
the former as anticipation of the Renaissance, the scenic
unity or spatial conciseness of pictorial composition, is not
immediately carried further, and does not show itself to be
ready for development. Does all that lies between, there-
fore, mean only a feeble imitation or even a setback?
Simone Martini's picturesque monument to the military
leader Guidoriccio in the town hall at Siena, a large-scale
representation of a spreading landscape, is just as much
something new as Ambrogio Lorenzetti's view of a city in
the frescoes of Good Government. Space becomes larger,
all-embracing and boundless; Giotto's narrow stage be-
comes an open area. The vehicle of this spatial conception,

however, here too remains the epic content. While the story is spun out in a fictional "delight in narration," the spatial representation is also expanded. Along with the narrative, the space is developed in chronological succession. Thus, the great wall paintings in the Camposanto in Pisa, in the Spanish Chapel in Florence, in St. George's Chapel in Padua, in the Eagletower in Trent, in the papal place in Avignon are turned into theological tracts, histories, or novellas.

But the successive conception is not confined to single paintings; it spreads out beyond, links paintings with one another, unites them into a grand pictorial cycle. Amira has made the remark that in the Sachsenspiegel illustrations, figures often point out of the picture and thus establish the connection with what precedes or follows. Even in Giotto, the artwork finds its perfection, in spite of the self-sufficiency of individual pictures, only in their arrangement in a row, in their cyclical succession. Suida has indicated the fact that in the Peruzzi as well as the Bardi Chapel each sequence of single pictures is composed with a common standpoint in view. According to the word of Gregory the Great, the pictures in a church become, as it were, a book in which even the simple man, ignorant of letters, may read. As epic experience, Gothic pictorial art finds its exhaustive expression in the embracing iconographic schemes of church painting and sculpture. These pictorial "encyclopedias"—like the *summae* in scholastic philosophy—reinterpret the material ecclesial edifice into a spiritual thought-structure by the mighty epics of the story of salvation and its typological Old-Testament models as they confront us in the *biblia pauperum;* in the pictorial histories on portable altars, doors, fasting cloths, altarcloths and retables; in the illustrated frames representing the Lord; and in crucifixes.

A work like the seventy-meter-long embroidered Bayeux tapestry is to be seen not only as an historical record according to its content, and as a decorative wall-ornament according to its form, but above all is to be valued poetically as an epic composition. It is no simple chronicle story of the Norman conquest of England, but an artistically constructed epic telling us of Harold's ingrati-

tude and perfidy, of guilt and atonement, powerful in its heroic ascent and its tragic decline like one of Shakespeare's royal dramas. As a document of a divine judgment that represents William as executor of a divine justice, the pictorial work was bequeathed to cathedrals built by William. The lengths of the scenes, as time-values, are measured one against the other with full artistic meaning as one takes the entire composition into account; delays and retarding episodes are created, and the decisive turning-points are stressed in accentuated self-sufficing scenes. It is significant in this well-thought-out composition that the climax of the action falls almost exactly in the middle of the series of pictures: the death of King Edward, the coronation of Harold, to whom homage is paid by nobility and common folk; and immediately following, the announcement of the turn of fate, the appearance of the comet foretelling evil; and the prophetic dream of Harold —for so indeed we must read the next picture that was wrongly interpreted as a message—the dream of bad conscience, about a mighty hostile fleet, which is indicated in the lower strip that formerly was only a border ornament and decorative, but here, as later in the depiction of battle scenes, is incorporated into the story. Meanwhile, a ship with several men is already traveling secretly to France to bring William news of breach of oath. After the profusion of short scenes, which practically tumble over one another, there follows the arming of the avenging forces. In viewing the pictures, one must let the chronological continuity affect one as in a work of poetry, in order to feel the anxious sultriness, the increasing tension before the decisive clash. This completeness with which the building of the mighty fleet, the equipping and crossing, the victualing and erecting of a fortified camp are told, is not the historian's pedantic loquacity, but a conscious artistic device. Then comes the news of the approach of Harold, who has received word of the invasion. Again short scenes: a house that the Normans set aflame, from which a woman flees fearfully with her child, designates like a signal-beacon the outbreak of war; William's charger is brought to him. Only by actually seeing the sequence is the wonderful composition of the next scenes to be gath-

ered: the army marching off. First we see the riders crowded close, ready for departure; gradually the mass is loosened and sets itself in motion, then finally, in complete abandon, changing over into an extended gallop. The movement is checked again in the last two riders, who receive from a scout of the vanguard a report of the sighting of the hostile forces. Here a longer temporal arrest in forward motion is portrayed with a penetration such as is not attainable in simultaneous representation. In a comparable way the last "canto," too, depicting the battle, is constructed entirely as a unit, and as an experience of the event: the attack by the Norman cavalry that comes to a halt before the closed ranks of the English, the rising melee of battle, which reaches its climax in the scene of toppling horses, Harold's death, and the flight of the English, wherewith the depiction, once more with the greatest artistic economy, abruptly breaks off.

The question arises whether a painter of genius has here directly put a poem into pictures, or whether an epic poem provided him his model. But even then transposing such a well-conceived, generous composition into graphic form would remain a very great accomplishment. . . .

Not until the Renaissance absolute conception of space, and the spatial unity of pictorial composition, does there come that fundamental cleavage between painting and poetry, which leads finally to the problems formulated by Lessing's *Laocoön*. Spatial extension and chronological succession are now contrasted as precisely the essential difference between the art of portraying and the art of writing: hence the special laws of representation peculiar to both kinds of art are derived.

Already in Leonardo's *Paragone of Painting and Poetry* simultaneity is stressed in the one and chronological succession in the other, as a basic distinction. For Leonardo the difference between the two arts lies in "whether one hears something that gives joy to the eye told in a long space of time, or whether he sees it with the same speed in which the actual things are seen." Simultaneous seeing, stressed by him again and again as the basis of painting, is compared characteristically with the simultaneous hearing of musical harmony. "A painting puts its contents into

your visual faculty in a flash . . . it does this in the same span of time in which also the harmoniously sounding, sense-pleasing total inter-relatedness of the parts which make up the whole are joined with one another." For harmony is "born only in moments." The poet is reproached "for giving in his science no total relatedness produced in one and the same instant, and for the fact that rather, on the contrary, one part proceeds out of the other successively; the succeeding one does not arise without its predecessor's dying." The art of poetry can only describe beauty "by mentioning the individual components of such beauty, and these are separated from one another by time, so that time itself interposes a forgetting between them and separates the parts of the composition, which the poet cannot assemble or present without considerable duration and expense of time, and by which, since he cannot distinguish them, he is likewise unable to construct that harmonic total effect that is formed by divine ordonnance (through their conjoint presence). And thus the beauty that is described cannot achieve the simultaneity which the viewing of painted beauty attains." The process of describing is very suggestively characterized: "as if we should wish to exhibit a face bit by bit, always covering up again parts previously shown, so that no coordinated proportional representation can occur, for the eye would not take it in with its visual power at one instant." We see that Leonardo has clearly recognized simultaneity of vision as an essential condition of proportionality and of a painting fully realized in the Renaissance sense.

Simultaneous unity of content in a painting is, however, scientifically attained in perspective. Just as a moving eye produces a successive perception of a painting, so a fixed point of view assumes perspective as its basic condition. This Brunelleschi and Alberti already recognized, and in Vignola-Danti's treatise on perspective the notion is clearly put: It is necessary that perspective be seen "in one glance (*in una occhiata*) without moving the head or eye."

Yet, simultaneity in perceiving a picture also requires a synchronization of what is represented; by grasping the picture spatially as a unit we also assume the depicted

events to be simultaneous. And so the Renaissance conception had to give the death-blow to the "continuous representation" of the Middle Ages. Perspective and continuous representation are irreconcilable in their very presuppositions. In spite of this, the medieval joy in storytelling is felt long afterwards, and we still can find in Leonardo an attempt, quite forced to be sure, to coordinate theoretically the old healthy tradition of continuous representation with the demand for pictorial spatial unity and with perspective. After severely criticizing the medieval mode of composition for being in several registers one above the other in the same painting "so that they require a different point of view from the first one," he advises the following compromise: "And if you wanted to ask: How shall I start when I have to paint a saint's life that is divided into separate episodes in the same wall-painting?, I should answer this query as follows—you should set the primary plane with its vanishing-point at the eye-level of the one who beholds the story, and on this plane you figure the event in large scale. Then you put in all the remaining accessories in the full story on all kinds of hills and plains by gradually diminishing the figures little by little. On the rest of the wall you then make trees of a size proportionate to the size of the figures, or angels if that suits the story, or birds, clouds, and such things."

This odd compromise between the medieval and Renaissance-type of conception can be traced chiefly in Northern painting until well into the Baroque period. But precisely this reinterpretation, which continuous representation undergoes in line with Leonardo's instructions, enables us to bring the change in conception into full view.

Through the different mode of conception and observation, however, there is clarified a second basic difference between the composition in Gothic painting, as opposed to that of the Renaissance: the lack of a uniform scale in the picture. The whole Renaissance appreciation of painting depended upon seeing in full all relationships and proportions. This, again, as Leonardo already knew, is grounded in the notion of the temporal unity of the picture. Just as medieval painting does not know this simultaneity of vision, so also the demand for a unified

scale in it is unimportant. For the medieval mode of vision, that of successiveness, it has no meaning. Since the separate parts of the picture and the separate objects in the pictorial content are not seen simultaneously, but successively, each element in the painting is independent, and fundamentally unrelated to others in size. Within the picture, spatial synthesis is not attempted, but occurs in a fashion that is like a description in the autonomous imagination of the viewer: as a successive experiencing of the picture-content. The scales of relationships in pictorial composition are not set by any spatial relationship, but by the epic context. Consequently, not the spatial arrangement, but only the sequence in which the figures are to be scanned and considered, determines their size and their interrelationships.

From the epic character of the composition it becomes evident that the accentuation of individual figures by means of their size is intended to denote their hierarchic dignity or social rank, or their special significance in the story. Further, there also emerges the fact that all objects intended to designate the setting or scene of action, as, for instance, houses or trees, are not represented in their actual size in relation to people, since they are conceived only as abstract signs. Their scale in relation to actors in the episode has to be specified only insofar as it is relevant to the content represented, like the stepping of someone out of a house.

A spatial conception is implicit in the spatial adjustment of figures to one another. Inasmuch as these figures are thought of as moving in space, the surface of the painting takes on spatial meaning even if, at first, only as a most indefinite notion. What is not yet imagined concretely is an ideal spatial depth, in front of which the figures move on a narrow real spatial platform. That is the meaning of the gold-sized or diapered background, which, as we have already often noted, represents not an actual enclosed space, such as a curtain or a tapestry, but implies only undifferentiated space in which figures stand or move. This is especially striking in the example of a French miniature of the fourteenth century showing two knights on horseback in combat before a background deco-

rated with scrolls, so that only half of one severely fore-shortened horse is represented while the hind quarters are lost in the scrolls. Thus, the horse does not stand in front of the figured surface, but rather amidst the space symbolized by the surface pattern.

Only what stands near-to is accessible to the imagination, and thus to representation. In this fashion, figures seem to be standing far forward, near enough to be touched, before an indeterminate, incomprehensible nothing which, however, is somehow spatially felt. Only gradually is vision able to penetrate into the background and to relate distant things with the foreground, the narrow shelf where the figures stand. More and more this indeterminate and, as it were, empty space becomes permeated with content and filled up with subject matter; and more and more the physical world merges into the gold-size, as, for example, on one leaf of the Buxtehude altar-piece by Master Bertram, the quaint hilly terrain with the shepherd and trees that mount up on the side to the top edge of the painting, while the figures of the angel and Joachim stand on just a narrow strip of grass. More and more the gold-size retreats into the background to become, at last, sky. So we see the spatial conception passing over from immediate space to space in depth.

This consistent development in power of imagination is quite generally to be seen phylogenetically as well as ontogenetically. Riegl has convincingly pointed out the gradual progress in antique art from immediate space in Egyptian art to space-in-depth in late-Romanesque. In this same way, the child develops spatial conceptions, starting with haptic space (space tangible to mouth and grasp), then to kinaesthetic perception, embracing step by step his immediate surroundings, then advancing by zones into depth, as it were.

With this gradual, felt permeation of depth in Gothic there comes a development in spatial conception of the greatest significance for following periods. As the apperception advances from one spatially discrete individual thing to another, and links them spatially with one another, a spatial continuum is created between them that is expanded farther and farther. Within this continuum, the

interval between one person and another is thought of as a means of measurement, and the observer himself wanders through the painting, experiencing through his viewing of the pictorial content its spatial unfolding. In this successive genetic reading of space, the conception of a spatial continuum is necessarily implied. Starting with this, the fifteenth century mastered the unification of an absolute space. In so doing, the North and the South take paths that are radically different, even if they proceed from the same suppositions. If the South reaches a unification of space through rationalizing the spatial concept, the North consistently moves farther along the path taken by the Gothic, and develops it directly from qualitative experience of space. Reciprocal influences have a fruitful effect, yet do not change the general trend of developments.

We can observe how the meaningful graduation of size according to content develops into a spatial one that not only fails to agree with optical-mathematical premises, but actually often utterly contradicts them. The strangest form of this type is so-called "reversed perspective." In this, the larger figures are grouped in the background and the smaller in front. Certainly it is not a question here of a true inversion of normal perspective. This peculiar phenomenon, one which is even stranger to an eye schooled by the Renaissance, is explained readily on the basis of a purely contextual treatment of space proceeding from the main action or the main personages. Everything that surrounds and accompanies this core of the story and that occurs around it or characterizes its setting appears smaller, and can be represented that much smaller the further it stands apart from it—no matter whether it is, relative to the observer, in front of or behind the main scene. This decrease in size, on which the effect of space depends, is thus not derived from any geometric relation of observer to pictorial space, but by reference to the contextual core of the painting. The pictorial space is read out in all directions, proceeding from the main group. As the pictured action is completed by representing what precedes and what follows, it is built up spatially in this way in all directions. If we seek to acquaint ourselves in this manner with

the content of the painting, we can immediately make this spatial effect come to life.

At a much more advanced stage of development in the North, we can still notice that although reduction in size seems to be consistently carried out according to distance, this decrease in size is, however, really determined according to narrative meaning, in contrast to a linear perspective arising from an inherent logic of scale. In the illuminated manuscript *Les histoires romaines de Jean Mansel*, of 1454, a dance is represented. On a dais right in the foreground a folk dance is going on; in the background, reduced by perspective, we see a city with a street extending into the distance, and a spacious landscape. Above the dais is a raised platform arranged for the orchestra, which is placed in the same pictorial plane as the dancers, so far as distance is concerned; yet the musicians are drawn smaller than the latter. Here the question is one of a purely subjective diminution in vertical perspective: just as the sizes are decreased from front to back with the increasing distance in space, so, too, for the observer standing below, a decrease occurs vertically. Of course this reduction is not conceived mathematically, and could not be conceived mathematically in this form at all; yet in spite of this, the representation directly conveys an effect that is spatially illusionistic.

Another example is shown by a miniature in a French translation of Boccaccio's *Teseide*: a battle on the seashore densely crowded with figures. The diminution in perspective is logically carried out, not, however, from the front backwards, but from right to left, in a diagonal suggesting depth. The starting-point for the movement of the eye is thus set by the figure of the leader in a red tunic in the right foreground, who is the focal point of the composition for both meaning and color.

Thus, the pictorial content yields the clue from which the pictorial conception develops. Only insofar as space is filled with matter does it become comprehensible. Space is conceivable only insofar as it is determined by content—as adapted space. The Middle Ages know only such space. From this qualitative definition of space arises the princi-

ple of *horror vacui*, characteristic of all primitive spatial apprehension.

The Renaissance opposes to this a geometrically determined space, that is to say, quantitative space.

In his rejection of the medieval mode of composition, Alberti neatly phrases this change: "I have to find fault with painters who, because they want to appear rich in ideas, leave no little spot empty, so that they do not create a composition but spread out a miscellaneous confusion . . . simplicity will indeed please him who in his stories seeks dignity above all else." To convey this notion, Alberti uses the scarcely translatable expression *solitudine*, which makes the lonely, corporeal, monumental figures of Andrea Castagno or Piero della Francesca rise before us memorably. One might prefer to translate the strange term by "simplicity and quiet greatness," if there were not something more concrete comprised in Alberti's expression than in Winckelmann's words, which are pervaded by sentimental romanticism. . . .

Two radically different modes of conception oppose one another in Gothic and Renaissance. In Gothic the representation is deeply complex. Space and time are not yet separated as categories and are not yet conceivable as abstracted from the total experience: they fuse into a unified, tightly knit, inseparable texture of experience. Space and time in their special Renaissance form of perception and conceptualization are essentially alien to the Gothic imagination and have no meaning for its mode of thinking. In this inseparable fusion of space with time is grounded the phenomenon of Gothic movement. Since space can be comprehended only in time, all conception of space is conception of movement. Yet this conception of movement is not to be understood in the Renaissance sense or according to our own sort of conception, as a temporal change of position in absolute space, but as a continuing "becoming" and "changing" of space, by which alone space as such is to be seen, or is to be conceived at all. Since this unity of space with time is afforded only by subjective experience, the movement is likewise subjective; it is experience of space in its perpetual and continual changing. It is a comprehension of space in its endless

diversity of appearance, in its eternal variation. On the nature of this experience of the world are based the indefiniteness, and manifold meanings of the figures, the joy in the greatest possible mutability, and the boundless creative fantasy of the Middle Ages.

This complex way of conceiving space and time as unified also involves space and matter. The body is not, as it was in antiquity, a being in contrast to a nonexisting space that only begets space; and just as little is space the primal medium of being, enclosing matter, as it was according to the Renaissance notion. Space and matter flow together to form a single conception; in their essence they are one, and are separate only in appearance. In primitive experience, space is synonymous with an awareness of the changeability of matter: matter is, so to speak, only the principle by which space manifests itself. Therein lie the incorporeality and the irrealism of all Gothic art, without its being merely a visual appearance. One would be making the gravest error if one took a Gothic structure to be merely an optical, pictorial impression; it should be understood as being thoroughly spatial and three-dimensional. But this spatial realization adheres neither in the simple corporeal form, the static skeleton, nor in the mere hollow space. In the subjective, genetic mode of spatial realization both together become an inseparable experience. And only the conception of space and matter as being fused seems to explain the phenomenon of inner unity in a Gothic structure, which is hardly comprehensible to us. One cannot separate the exterior from the interior of a Gothic cathedral; they mutually determine each other, they are contained potentially one in the other, they must be thought of as one if we are to understand their essence and their meaning. And yet we must not conceive of the wall, fashioned three-dimensionally inside and outside, as the supporter of this unity, without bringing in something entirely alien to its essence. The unity lies in a fundamentally different kind of conception, according to which corporeal forms are only an expression of form itself developing in space.

In this conception, which is not yet grasped intellectually, or rationalized, there is already, even though still

vague, a basic spatial perception that became decisive for the Renaissance and for our whole modern outlook— namely, the continuity and infinity of space. There was no direct path open from the discrete corporeal notion of antiquity to the geometric construct of space in the Renaissance. Zeno's paradoxes of the arrow at rest and Achilles and the tortoise were insoluble by ancient methods of reasoning. Perspective and the heliocentric system were, to be sure, conceived in their basic principles, but they could not become a fully realized conception. Only after the Gothic resolved the conception of space into a temporal experience could the theory of a continuous space be developed out of this genetic mode of thinking. Only by that means could there come the further development of imagining space as a unity independent of the notion of the material contained within it. And so the complex space-time conception of the Gothic is a necessary prerequisite to the Renaissance.

BERNARD BERENSON

ITALIAN PAINTERS
OF THE
RENAISSANCE *(1930)*

IN SPITE of his lifelong concern with highly technical ques-
tions of attribution, Berenson was also able to write per-
ceptively on the aesthetic effect of painting in the early
and high Italian Renaissance—its plastic and pictorial
modes of vision, tactile values, and atmospheric quality.
This aesthetic criticism in Berenson is, in part, an extension
of the aesthetic interpretations of Renaissance art offered
by late-nineteenth-century writers like John Addington
Symonds and Walter Pater. Symonds, for example, said
that the chief value in Renaissance art was "the emphasis
laid upon physical strength and beauty as good things and
desirable, the subordination of classical and medieval
myths to one aesthetic law of loveliness." Burckhardt, too,
saw the tactile values in Renaissance painting, "the en-
chanting splendor of the flesh in itself." In speaking of the
new Renaissance tactile sense and humanized space, Beren-

son gave a more refined meaning to the notion that the Renaissance was a period of naturalistic art in contrast to the symbolic art of the Middle Ages. This is a thesis that cannot be accepted without modification, but nobody has written better about the way in which the Renaissance painter gave "a higher coefficient of reality to the object represented."

Berenson's interpretations can be compared with what is said in Anthony Blunt's *Artistic Theory in Italy, 1450-1600* (1940), and in Sidney J. Freedberg's *Painting of the High Renaissance in Rome and Florence* (1961). Berenson's essays reflect many of the premises that underlie Burckhardt's *Civilization of the Renaissance in Italy*.

THE FLORENTINE PAINTERS

(Book II, Section ii)

The first of the great personalities in Florentine painting was Giotto. Although he offers no exception to the rule that the great Florentines exploited all the arts in the endeavor to express themselves, he, Giotto, renowned as architect and sculptor, reputed as wit and versifier, differed from most of his Tuscan successors in having peculiar aptitude for the essential in painting *as an art*.

Before we can appreciate his real value, we must come to an agreement as to what in the art of figure painting—the craft has its own altogether diverse laws—*is* the essential; for figure painting, we may say at once, was not only the one preoccupation of Giotto, but the dominant interest of the entire Florentine school.

Psychology has ascertained that sight alone gives us no accurate sense of the third dimension. In our infancy, long before we are conscious of the process, the sense of touch, helped on by muscular sensations of movement,

teaches us to appreciate depth, the third dimension, both in objects and in space.

In the same unconscious years we learn to make of touch, of the third dimension, the test of reality. The child is still dimly aware of the intimate connection between touch and the third dimension. He cannot persuade himself of the unreality of Looking-Glass Land until he has touched the back of the mirror. Later, we entirely forget the connection, although it remains true that every time our eyes recognize reality, we are, as a matter of fact, giving tactile values to retinal impressions.

Now, painting is an art which aims at giving an abiding impression of artistic reality with only two dimensions. The painter must, therefore, do consciously what we all do unconsciously—construct his third dimension. And he can accomplish his task only as we accomplish ours, by giving tactile values to retinal impressions. His first business, therefore, is to rouse the tactile sense; for I must have the illusion of being able to touch a figure, I must have the illusion of varying muscular sensations inside my palm and fingers corresponding to the various projections of this figure, before I shall take it for granted as real, and let it affect me lastingly.

It follows that the essential in the art of painting—as distinguished from the art of coloring, I beg the reader to observe—is somehow to stimulate our consciousness of tactile values, so that the picture shall have at least as much power as the object represented, to appeal to our tactile imagination.

Well, it was of the power to stimulate the tactile consciousness—of the essential, as I have ventured to call it, in the art of painting—that Giotto was supreme master. This is his everlasting claim to greatness, and it is this which will make him a source of highest aesthetic delight for a period at least as long as decipherable traces of his handiwork remain on moldering panel or crumbling wall. For great though he was as a poet, enthralling as a story-teller, splendid and majestic as a composer, he was in these qualities superior in degree only, to many of the masters who painted in various parts of Europe during the thousand years that intervened between the decline of

antique, and the birth, in his own person, of modern paint-
ing. But none of these masters had the power to stimulate
the tactile imagination, and, consequently, they never
painted a figure which has artistic existence. Their works
have value, if at all, as highly elaborate, very intelligible
symbols, capable, indeed, of communicating something,
but losing all higher value the moment the message is
delivered.

Giotto's paintings, on the contrary, have not only as
much power of appealing to the tactile imagination as is
possessed by the objects represented—human figures in
particular—but actually more; with the necessary result
that to his contemporaries they conveyed a *keener* sense of
reality, of lifelikeness than the objects themselves! We
whose current knowledge of anatomy is greater, who ex-
pect more articulation and suppleness in the human figure,
who, in short, see much less naïvely now than Giotto's
contemporaries, no longer find his paintings more than
lifelike; but we still feel them to be intensely real in the
sense that they powerfully appeal to our tactile imagination,
thereby compelling us, as do all things that stimulate our
sense of touch while they present themselves to our eyes,
to take their existence for granted. And it is only when
we can take for granted the existence of the object painted
that it can begin to give us pleasure that is genuinely artis-
tic, as separated from the interest we feel in symbols.

At the risk of seeming to wander off into the bound-
less domain of aesthetics, we must stop at this point for
a moment to make sure that we are of one mind regarding
the meaning of the phrase "artistic pleasure," in so far at
least as it is used in connection with painting.

What is the point at which ordinary pleasures pass
over into the specific pleasures derived from each one of
the arts? Our judgment about the merits of any given work
of art depends to a large extent upon our answer to this
question. Those who have not yet differentiated the spe-
cific pleasures of the art of painting from the pleasures
they derive from the art of literature, will be likely to fall
into the error of judging a picture by its dramatic presen-
tation of a situation or its rendering of character; will, in
short, demand of a painting that it shall be in the first

place a good *illustration*. Others who seek in painting what is usually sought in music, the communication of a pleasurable state of emotion, will prefer pictures which suggest pleasant associations, nice people, refined amusements, agreeable landscapes. In many cases this lack of clearness is of comparatively slight importance, the given picture containing all these pleasure-giving elements in addition to the qualities peculiar to the art of painting. But in the case of the Florentines, the distinction is of vital consequence, for they have been the artists in Europe who have most resolutely set themselves to work upon the specific problems of the art of figure painting, and have neglected, more than any other school, to call to their aid the secondary pleasures of association. With them the issue is clear. If we wish to appreciate their merit, we are forced to disregard the desire for pretty or agreeable types, dramatically interpreted situations, and, in fact, "suggestiveness" of any kind. Worse still, we must even forgo our pleasure in color, often a genuinely artistic pleasure, for they never systematically exploited this element, and in some of their best works the color is actually harsh and unpleasant. It was in fact upon form, and form alone, that the great Florentine masters concentrated their efforts, and we are consequently forced to the belief that, in their pictures at least, form is the principal source of our aesthetic enjoyment.

Now in what way, we ask, can form in painting give me a sensation of pleasure which differs from the ordinary sensations I receive from form? How is it that an object whose recognition in nature may have given me no pleasure, becomes, when recognized in a picture, a source of aesthetic enjoyment, or that recognition pleasurable in nature becomes an enhanced pleasure the moment it is transferred to art? The answer, I believe, depends upon the fact that art stimulates to an unwonted activity physical processes which are in themselves the source of most (if not all) of our pleasures, and which here, free from disturbing physical sensations, never tend to pass over into pain. For instance: I am in the habit of realizing a given object with an intensity that we shall value as 2. If I suddenly realize this familiar object with an intensity of

4, I receive the immediate pleasure which accompanies a doubling of my mental activity. But the pleasure rarely stops here. Those who are capable of receiving direct pleasure from a work of art, are generally led on to the further pleasures of self-consciousness. The fact that the psychical process of recognition goes forward with the unusual intensity of 4 to 2 overwhelms them with the sense of having twice the capacity they had credited themselves with: their whole personality is enhanced, and, being aware that this enhancement is connected with the object in question, they for some time after take not only an increased interest in it, but continue to realize it with the new intensity. Precisely this is what form does in painting: it lends a higher coefficient of reality to the object represented, with the consequent enjoyment of accelerated psychical processes, and the exhilarating sense of increased capacity in the observer. (Hence, by the way, the greater pleasure we take in the object painted than in itself.)

And it happens thus. We remember that to realize form we must give tactile values to retinal sensations. Ordinarily we have considerable difficulty in skimming off these tactile values, and by the time they have reached our consciousness, they have lost much of their strength. Obviously, the artist who gives us these values more rapidly than the object itself gives them, gives us the pleasures consequent upon a more vivid realization of the object, and the further pleasures that come from the sense of greater psychical capacity.

Furthermore, the stimulation of our tactile imagination awakens our consciousness of the importance of the tactile sense in our physical and mental functioning, and thus, again, by making us feel better provided for life than we were aware of being, gives us a heightened sense of capacity. And this brings us back once more to the statement that the chief business of the figure painter, as an artist, is to stimulate the tactile imagination.

The proportions of this book forbid me to develop further a theme, the adequate treatment of which would require more than the entire space at my command. I must be satisfied with the crude and unillumined exposition given already, allowing myself this further word only,

that I do not mean to imply that we get no pleasure from a picture except the tactile satisfaction. On the contrary, we get much pleasure from composition, more from color, and perhaps more still from movement, to say nothing of all the possible associative pleasures for which every work of art is the occasion. What I do wish to say is that *unless* it satisfies our tactile imagination, a picture will not exert the fascination of an ever-heightened reality; first we shall exhaust its ideas, and then its power of appealing to our emotions, and its "beauty" will not seem more significant at the thousandth look than at the first.

My need of dwelling upon this subject at all, I must repeat, arises from the fact that although this principle is important indeed in other schools, it is all-important in the Florentine school. Without its due appreciation it would be impossible to do justice to Florentine painting. We should lose ourselves in admiration of its "teaching," or perchance of its historical importance—as if historical importance were synonymous with artistic significance!—but we should never realize what artistic idea haunted the minds of its great men, and never understand why at a date so early it became academic.

Let us now turn back to Giotto and see in what way he fulfils the first condition of painting as an art, which condition, as we agreed, is somehow to stimulate our tactile imagination. We shall understand this without difficulty if we cover with the same glance two pictures of nearly the same subject that hang side by side in the Uffizi at Florence, one by "Cimabue," and the other by Giotto. The difference is striking, but it does not consist so much in a difference of pattern and types, as of realization. In the "Cimabue" we patiently decipher the lines and colors, and we conclude at last that they were intended to represent a woman seated, men and angels standing by or kneeling. To recognize these representations we have had to make many times the effort that the actual objects would have required, and in consequence our feeling of capacity has not only not been confirmed, but actually put in question. With what sense of relief, of rapidly rising vitality, we turn to the Giotto! Our eyes have scarcely had time to light on it before we realize it completely—the throne

occupying a real space, the Virgin satisfactorily seated upon it, the angels grouped in rows about it. Our tactile imagination is put to play immediately. Our palms and fingers accompany our eyes much more quickly than in presence of real objects, the sensations varying constantly with the various projections represented, as of face, torso, knees; confirming in every way our feeling of capacity for coping with things—for life, in short. I care little that the picture endowed with the gift of evoking such feelings has faults, that the types represented do not correspond to my ideal of beauty, that the figures are too massive, and almost unarticulated; I forgive them all, because I have much better to do than to dwell upon faults.

But how does Giotto accomplish this miracle? With the simplest means, with almost rudimentary light and shade, and functional line, he contrives to render, out of all the possible outlines, out of all the possible variations of light and shade that a given figure may have, only those that we must isolate for special attention when we are actually realizing it. This determines his types, his schemes of color, even his compositions. He aims at types which both in face and figure are simple, large-boned, and massive—types, that is to say, which in actual life would furnish the most powerful stimulus to the tactile imagination. Obliged to get the utmost out of his rudimentary light and shade, he makes his scheme of color of the lightest that his contrast may be of the strongest. In his compositions he aims at clearness of grouping, so that each important figure may have its desired tactile value. Note in the "Madonna" we have been looking at, how the shadows compel us to realize every concavity, and the lights every convexity, and how, with the play of the two, under the guidance of line, we realize the significant parts of each figure, whether draped or undraped. Nothing here but has its architectonic reason. Above all, every line is functional —that is to say, charged with purpose. Its existence, its direction, is absolutely determined by the need of rendering the tactile values. Follow any line here, say in the figure of the angel kneeling to the left, and see how it outlines and models, how it enables you to realize the head, the torso, the hips, the legs, the feet, and how its direction,

its tension, is always determined by the action. There is not a genuine fragment of Giotto in existence but has these qualities, and to such a degree that the worst treatment has not been able to spoil them. Witness the resurrected frescoes in Santa Croce at Florence!

The rendering of tactile values once recognized as the most important specifically artistic quality of Giotto's work, and as his personal contribution to the art of painting, we are all the better fitted to appreciate his more obvious though less peculiar merits—merits, I must add, which would seem far less extraordinary if it were not for the high plane of reality on which Giotto keeps us. Now what is behind this power of raising us to a higher plane of reality but a genius for grasping and communicating real significance? What is it to render the tactile values of an object but to communicate its material significance? A painter who, after generations of mere manufacturers of symbols, illustrations, and allegories, had the power to render the material significance of the object he painted, must, as a man, have had a profound sense of the significant. No matter, then, what his theme, Giotto feels its real significance and communicates as much of it as the general limitations of his art and of his own skill permit. When the theme is a sacred story, it is scarcely necessary to point out with what processional gravity, with what hieratic dignity, with what sacramental intentness he endows it; the eloquence of the greatest critics has here found a darling subject. But let us look a moment at certain of his symbols in the Arena at Padua, at the "Inconstancy," the "Injustice," the "Avarice," for instance. "What are the significant traits," he seems to have asked himself, "in the appearance and action of a person under the exclusive domination of one of these vices? Let me paint the person with these traits, and I shall have a figure that perforce must call up the vice in question." So he paints "Inconstancy" as a woman with a blank face, her arms held out aimlessly, her torso falling backwards, her feet on the side of a wheel. It makes one giddy to look at her. "Injustice" is a powerfully built man in the vigor of his years, dressed in the costume of a judge, with his left hand clenching the hilt of his sword, and his clawed right hand grasping a

double-hooked lance. His cruel eye is sternly on the watch, and his attitude is one of alert readiness to spring in all his giant force upon his prey. He sits enthroned on a rock, overtowering the tall waving trees, and below him his underlings are stripping and murdering a wayfarer. "Avarice" is a horned hag with ears like trumpets. A snake issuing from her mouth curls back and bites her forehead. Her left hand clutches her moneybag, as she moves forward stealthily, her right hand ready to shut down on whatever it can grasp. No need to label them: as long as these vices exist, for so long has Giotto extracted and presented their visible significance.

Still another exemplification of his sense for the significant is furnished by his treatment of action and movement. The grouping, the gestures never fail to be just such as will most rapidly convey the meaning. So with the significant line, the significant light and shade, the significant look up or down, and the significant gesture, with means technically of the simplest, and, be it remembered, with no knowledge of anatomy, Giotto conveys a complete sense of motion such as we get in his Paduan frescoes of the "Resurrection of the Blessed," of the "Ascension of our Lord," of the God the Father in the "Baptism," or the angel in "St. Joachim's Dream."

This, then, is Giotto's claim to everlasting appreciation as an artist: that his thorough-going sense for the significant in the visible world enabled him so to represent things that we realize his representations more quickly and more completely than we should realize the things themselves, thus giving us that confirmation of our sense of capacity which is so great a source of pleasure.

NORTH ITALIAN PAINTERS

(Book IV, Section xiv)

Thus far we have dealt with artists whose mode of visualization never broke through the forms created at Padua under Donatello's influence and developed under the inspiration of the Antique by Mantegna. I have spoken in Book III, *Central Italian Painters,* of visualization, how important a part it plays in art, how it is affected by success or failure in comprehending the specific problems of art, and how the works it produces modify and even dictate the way each one of us looks at the visible world. I need not repeat what was said there. But here, where the treatment is necessarily more historical, for the better understanding of what is to follow, I must add, in the abbreviated and almost cryptic form required by the exiguity of this small book, one or two observations that would need as many volumes for their full development with commentary and instances.

During the three centuries from about 1275 to 1575, when Italy created masterpieces deserving universal attention, two changes in visualization took place. At the beginning, we discover a method founded on line—first on dead line, to which debasement had reduced form, and then on ductile, and at times even functional line, which revived the attenuated forms, gave them contours, and lifted them up to the exalted beauty of the early Sienese. Under Niccolò Pisano, Arnolfo, and Giotto this linear mode of visualizing began to give place to the plastic, based upon the feeling for planes and the striving for fully realized substance and solidity. Arrested by the lack of genius among the followers of these two pioneers, plastic visualizing had to await the fifteenth century for its complete triumph. The victory was scarcely achieved when that great but unconscious revolutionary, Giovanni Bellini,

hitherto an adept of the plastic vision, began all at once
to visualize in still another mode, which, to differentiate it
from the linear and the plastic, I may call the commence-
ment of the pictorial mode. This happened because he had
a revelation of the possibilities of color. Before his day,
except in a rudimentary way at Verona, color, no matter
how enchanting in its beauty, was a mere ornament added
to the real materials, which were line in the fourteenth
century, and line filled with light and shade in the fif-
teenth. With Bellini, color began to be the material of the
painter, the chief if not the sole instrument with which his
effects were to be produced. Yet Bellini never dreamt of
abandoning the shapes which the plastic vision had
evolved; he simply rendered them henceforth with color
instead of with line and chiaroscuro; he merely gave up the
plastic-linear for the plastic-pictorial.

Now, Bellini's great followers, Giorgione and Titian,
were far too intellectual as artists, as well as too firmly
rooted in a mighty and still recent past, to surrender, any
more than their master did, the fine feeling for form, for
movement, and for space engendered by the Quattrocento.
They and their companions and pupils remained still
within the plastic-pictorial mode of visualizing, and never
reached the purely pictorial—not Tintoretto, not even
Bassano. But the Veronese, who started with a certain
rudimentary sense of their own for color as material, and
quickly appreciated Bellini's revelation, had no continuous
tradition of form, no steadying intellectual purpose, and
they found it only too easy to drop the plastic element and
to be purely pictorial.

THE DECLINE OF ART

In this volume it has been my intention to sketch a theory of the arts, particularly of the figure arts, and especially of those arts as manifested in painting. I chose Italian examples, not alone because I happen to have an intimate acquaintance with the art of Italy, but also because Italy is the only country where the figure arts have passed through all the phases from the imbecile to the sublime, from the subbarbarian to the utmost heights of intellectual beauty, and back to a condition the essential barbarism of which is but thinly disguised by the mere raiment, tarnished and tattered, of a greater age. I have already treated of what makes the visual, and, more definitely, the figure arts: to test the theory, we must see whether it explains what it is that unmakes them.

It will not be amiss to restate this theory once more; and in brief it is this. All the arts are compounded of ideated sensations, no matter through what medium conveyed, provided they are communicated in such wise as to produce a direct effect of life-enhancement. The question then is what, in a given art, produces life-enhancement; and the answer for each art will be as different as its medium, and the kind of ideated sensations that constitute its material. In figure painting, the type of all painting, I have endeavored to set forth that the principal if not sole sources of life-enhancement, are TACTILE VALUES, MOVEMENT, and SPACE-COMPOSITION, by which I mean ideated sensations of contact, of texture, of weight, of support, of energy, and of union with one's surroundings. Let any of these sources fail, and by that much the art is diminished. Let several fail, and the art may at best survive as an arabesque. If all be dried up, art will perish. There is, however, one source which, though not so vital to the figure arts, yet deserves more attention than I have given it. I mean COLOR. The book on the Venetian painters,

where color is discussed, was written many years ago, before I had reached even my present groping conceptions of the meaning and value of things. Some day I may be able to repair this deficiency; but this is not the place for it; nor does the occasion impose it; for as color is less essential in all that distinguishes a master painting from a Persian rug, it is also less important as a factor in the unmaking of art.

In order to avoid using stereotyped phrases, I have frequently substituted the vague objective term "Form" for the subjective words "Tactile Values." Either refers to all the more static sources of life-enhancement, such as volume, bulk, inner substance, and texture. The various communications of energy—as effective, of course, in presentations of repose as of action—are referred to under "Movement."

It is clear that if the highest good in the art of painting is the perfect rendering of form, movement, and space, painting could not decline while it held to this good and never yielded ground. But we Europeans, much more than other races, are so constituted that we cannot stand still. The mountain top once reached, we halt but to take breath, and scarcely looking at the kingdoms of the earth spread at our feet, we rush on headlong, seldom knowing whither, until we find ourselves perchance in the marsh and quagmire at the bottom. We care more for the exercise of our functions than for the result, more therefore for action than for contemplation. And the exercise of our functions, among those of our race who are the most gifted, rarely if ever dallies with the already achieved, but is mad for newness. Then too we care vastly more for the assertion of our individuality than for perfection. In our secret hearts we instinctively prefer our own and the new to the good and the beautiful. We are thus perpetually changing: and our art cycles, compared to those of Egypt or China, are of short duration, not three centuries at the longest; and our genius is as frequently destructive as constructive. . . .

JOHN WHITE

THE BIRTH AND REBIRTH OF PICTORIAL SPACE *(1957)*

NINETEENTH-CENTURY ART HISTORIANS usually assumed that the Renaissance was simply the result of a new aesthetic sense; but Alberti alone would prove that this aesthetic sense was closely linked with a highly theoretical scheme of vanishing-point perspective, a mathematical system that was often at odds with the alleged naturalism of Renaissance painting. The problem of understanding what happened in Renaissance art almost reduces itself to understanding the Renaissance concept of space, which involves other fundamental problems like point of view and time. One of the classic discussions of the new mathematical perspective and its aesthetic and psychological meanings is Erwin Panofsky's long essay "Perspective as Symbolic Form," printed in the *Vortraege der Bibliothek Warburg* in 1924-25, demonstrating how Renaissance space translates aesthetic space to mathematical space—or vice

versa. John White has reinforced Panofsky's conclusion that Renaissance painting is a function of mathematical theory. The complications inherent in the new Renaissance perspective were not recognized by painters themselves, and White has studied the aesthetic and mathematical inconsistencies attending the development of perspective theory. Far from solving the problem it was intended to settle, orthogonal perspective led to an even more complex form of vision White calls "synthetic." Here mathematics broke down, and the painter was forced to represent space introspectively as well as mathematically. "Synthetic perspective may . . . be described as a thorough-going attempt to express an experience of visual reality which is only to be gained by a process of introspection, of asking what it is that is really seen." Thus the Renaissance painter moved outside the confines of his system toward visual distortions that can be justified not by science but by art. The painter needed a space that has much in common with the space conceived by modern mathematicians—a spherical space at once homogeneous and diversified, finite and infinite.

A technical explanation of this perspective was first presented by White in his article "Developments in Renaissance Perspective," *Journal of the Warburg and Courtauld Institutes,* XII, 1949, 58-79, and XIV, 1951, 42-69. A simpler discussion is William J. Ivins, Jr.'s "On the Rationalization of Sight," Paper no. 8, Metropolitan Museum of Art, 1938, and his *Art and Geometry* (1946). Panofsky returns to the problem of perspective in *Early Netherlandish Painting* (1953) and in his important essay *Renaissance and Renascences* (1960). A stimulating nontechnical discussion is the short essay by Ortega y Gasset "On Point of View in the Arts" (1949, 1956), and Chapter viii of E. H. Gombrich's *Art and Illusion* (1960) deals with the "Ambiguities of the Third Dimension."

ILLUSIONISM AND PERSPECTIVE

(Chapter XIII)

Illusionism is an ugly word in modern critical usage. Yet, to the early writers the illusionist effects that artificial perspective put within the artist's reach were amongst the most praiseworthy, as well as the most revolutionary of its attributes. It is, indeed, the revolutionary aspect of the new realism that accounts for much of the emphasis laid upon it. It has already been seen that this imitative realism is only a single element in early renaissance painting and relief sculpture, and one that varies in importance not only from artist to artist, but from object to object. Instead, therefore, of attempting a generalization that would cover, however uneasily, the whole practice of perspective in fifteenth-century Italy, it seems wiser to try to summarize those principles of illusion on the one hand and of organization on the other, together with certain general principles of perspective practice, that bear directly on renaissance problems. This may at least provide a useful starting point when trying to assess the relationship between contemporary theory and a particular, practical example of the application of perspective, or when attempting to draw closer to the artistic purposes behind the individual work of art.

The main compositional means by which solid objects and three-dimensional space may be counterfeited are well-illustrated by one of the still-life intarsias in the choir of Pisa Cathedral, and by an architectural perspective associated with the school of Piero della Francesca, and now in Berlin. It is important to remember, however, that many of the points which will be made in reference to artificial perspective may be wholly, or partly, applicable to the various empirical systems that preceded it, and that later survived side by side with it.

Clarity is the most noticeable feature of the two works mentioned—clear forms and clear space. In the intarsia there is no ambiguity between one clearly distinguished plane and another. The object is composed of simple forms, and is symmetrical, so that the eye is not confused, and can apprehend the whole in an instant. In the architectural view the main space is large and simple, and its inherent symmetry is emphasized because the spectator is seen as standing in the center of the colonnade, whilst all the buildings are set upon the axes established by the squared pavement. The numerous, and regular indications of the change of scale give clear expression to the distance traveled into space. The vanishing point is not, however, coincident with any solid object. So, at the last moment, the imaginative eye is freed of measurement, and travels into the infinity beyond the far horizon. At the same time, there is no confusion between the many orthogonals, or lines running directly into depth, and the lines lying parallel to the surface. All the surface planes are rectangular in general and in detail. All diagonals lead into depth.

Strong lighting, or strong color, consistently applied, are another means of emphasizing depth and solidity. In both examples the sharply contrasted lighting distinguishes the various planes and their spatial relationships even more clearly than the linear pattern with its insistence on sharp angles. In the same way, strong light on a rounded form stresses its solidity by the smooth transition from an intense highlight to a deep shadow. Only if the forms become complicated, and the lighting arbitrary, is the effect destroyed, and replaced by a dazzling surface vibration. Both strong light and sharp foreshortening may also be used, however, for their attendant dramatic qualities. The intarsia, besides creating an illusion of solidity, demonstrates that violent contrasts of light and shade have an inherently dramatic property as well.

The results obtainable by these means are rendered still more striking if the orthogonals are not only clearly differentiated from any lines running parallel to the surface, but are as far as possible uninterrupted, so that the eye may shoot unhindered into the imaginary space. If, in

addition, the composition is such that a spatial box is formed, the impression of depth may become almost irresistible, and the eye may, in some cases, be unable to dispel the illusion, whatever the promptings of the brain. No matter in what direction it travels over the surface, it is forced back towards the center lying deep in pictorial space. Such a box is largely created by the architectural view, and is a major contribution to its spatial forcefulness.

These are the main internal compositional features which, during the many earlier analyses, were found to bear most closely on the creation of seemingly three-dimensional space upon a flat surface.

The simplest method of avoiding such an illusion is, of course, by steering clear of the whole business of perspective, whether linear or atmospheric, and particularly the former. Artificial perspective finds its clearest means of expression in architectural and cubic forms, the straight lines, sharp corners, and hard, cutting edges of which can most easily tear the delicate fabric of a picture. The corresponding difficulty of the task of controlling such powerful forces of visual realism is attested by the whole history of the evolution of linear perspective.

The easiest way to control such space, other than by abolition or limitation, is to exploit the undistorted frontal surfaces which are a characteristic of the renaissance system. Wherever such forms may occur within a composition, at that point the eye is made to move in the directions established by the picture plane. The apparent movement through the surface into depths that seem to lie beyond it, is, if only for a moment, halted. This slowing of the spatial movement is increased by breaking up the orthogonal lines and planes into short, discontinuous lengths, and may be further assisted by burying these forms behind figures or objects that emphasize the surface. An actual counter-balancing of spatial thrust can be achieved by placing the vanishing point within the confines of an object situated in the foreground. Then the orthogonals, however deeply placed in the pictorial space which they define, also lead the eye back towards the surface of the composition. A gentler method of achieving similar results is the avoidance of sharp contrasts between orthogonal lines and planes, and

the compositional equation of these forms by such devices as the space-enclosing straight line, or the repetition of diagonals, now running into space, now lying parallel to the surface.

The exploitation of the properties of perspective in the interests of harmonizing space and plane can be augmented by a number of more purely compositional devices. One of these is the creation of a vibrating pattern that spreads over the whole surface as a result of filling the design with an extreme complexity of solid forms. Another is the impartial application of strong decorative patterns to every feature of the composition, thereby building up an even, decorative texture. On the other hand, a quiet lack of contrast between one part and the next, ignoring spatial connotations, may be substituted for the positive emphasis of the decorative surface by vibrating patterns of light and shade with their accompanying emotional effects.

Color is another factor which can be used in many ways to balance the too-positive qualities of a perspective composition. The tendency of cold colors to recede and warmer colors to advance may be exploited by moving the one forward and the other back, so closing up the space between one part of the design and another. A similar closing of the spatial gap can be achieved by the reversal of the atmospheric graduation, placing stronger, brighter color further back than softer, gray, foreground hues. Lastly, compositional elements which, in spatial terms, are widely separated, may be linked by color similarities or graduations, or more firmly still, by actual repetitions of a single hue.

The most subtle means of all for harmonizing space and plane, however, is the use of systems of proportion; the building up of the whole composition, for example, on a single modulus, which, since it is measured on the surface, ignores all distinctions between space and plane. In this way, a harmony in the relationship of parts and whole may be created which is independent of foreshortenings or of spatial setting.

In addition to these various compositional elements, which contribute either to the creation of realistic space

or to its harmonization with the surface, there are a number of other important factors which can, by their incorporation or their absence, contribute towards, or militate against, the production of a complete *trompe l'oeil*. These external factors are particularly important in relation to the permanence and completeness of the illusion. The first of them is the harmonization of the object, whether it be easel picture, relief sculpture, or frescoed wall, with the architectural surroundings. The reality of the scene is then increased by a coincidence of the painted fall of light with that from the real, external light source, even if this coincidence is not accompanied by the representation of cast shadows. The easy initial acceptance of the illusion, and the subsequent conviction which it carries, are largely influenced by the familiarity of the thing in itself and in its placing. Books and cupboards painted in a library may cause less conflict in the viewer's mind than, say, the sudden apparition of a coach and four. The startling anomaly—the object seen from an unusual angle, or abnormal range, carries great emotional impact, but also draws attention to the trickery, and may therefore in the long run prove the less successful. For similar reasons, quiet permanence of effect, as well as initial conviction, are more easily obtained in cases where the representation is in full conformity with the possibilities of actual vision. This entails, for instance, oblique disposition in the case of solid objects, such as that shown in the intarsia, in which not a single plane lies absolutely parallel to the surface.

Apart from these internal and external compositional devices, there is the further possibility of direct imitation of the real thing in texture and color. More important in the present context are, however, certain of the more purely technical aspects of the handling of perspective which affect the final visual result.

One of the most significant characteristics of artificial perspective is that it assumes an observer with his eye in one particular position at a fixed distance and direction from the scene before him. In theory everything is dependent upon this fixed viewpoint, for upon it hangs the whole construction, and at it the illusion of reality will be at its most intense. This was clearly shown in the discussion of

the theoretical beginnings of the new construction. According to Manetti, Brunelleschi's first perspective picture was constructed with a fixed peephole, and a similar importance was attributed to the fixed relationship between picture and spectator by Alberti and Piero della Francesca alike. Actual peepholes, and their desirability and disadvantages, are later discussed exhaustively by Leonardo, and the matter is thrashed out again and again by subsequent theorists. Yet in Donatello's work, six out of the seven reliefs completed before the Paduan journey, and mentioned in an earlier chapter, are never, under normal circumstances, seen from the point for which their perspective was constructed. The St. George relief is over six feet from the ground, and not constructed to be seen from below, whilst the "Dance of Salome" is less than two feet from the top step leading to the font, and well below eye level even when seen from the baptistery floor itself. Of the four S. Lorenzo roundels, only one is to be viewed from below, and certainly in one, and probably in at least two, the spectator's distance is supposed to be about six feet from the surface of a relief which is nearly forty feet above his head. Only "The Ascension, and Donation of the Keys" remains, and here the question cannot be decided, since its original position is unknown.

It is possible to put forward facts such as Donatello's inexperience, or the novelty of artificial perspective at the time, to explain the apparent contradiction in some cases. But similar contradictions recur in a very high proportion indeed of the whole of renaissance painting, including the works of the great perspectivists. Masaccio observed the rules quite strictly for the low, main viewpoint of the architecture of "The Trinity," yet in the Brancacci Chapel the viewpoint even of "The Raising of the King's Son" in the lowest zone of all is still placed far above the observer's head. This is not to be explained by postulating an evolution from lesser to greater strictness in the observance of the rules. The viewpoint of the lowest of Filippo Lippi's Prato frescoes is again too high, and of course in these, as in nearly all the decorative schemes involving vertical tiers of frescoes, the disparity grows progressively more enormous as the eye moves up the wall. In this respect the

advent of a focused perspective system makes no material alteration to a decorative pattern well established in Giotto's day, and itself unchanged from the times when spatial realism was of no concern to artist or onlooker. Even such exceptions as Mantegna's Eremitani cycle were not consistent in their conformity to the rules. It was only on the left wall that the spectator's viewpoint was catered for in the low setting of the vanishing point, and then solely in the bottom pair of frescoes. It is, however, interesting to notice that whereas the early fourteenth-century artist always chose the topmost scenes, those furthest from the onlooker, as the most suitable for a heightening of the element of illusion in the frame, Mantegna, working with the focused artificial perspective, took the opportunity of going furthest in the lower scenes. A far more radical degree of realism was thus achieved in characteristically closer contact with the onlooker.

The general position does not alter greatly if, instead of cycles ranged in vertical tiers, those ranged in a single rank, or even isolated, individual scenes are scrutinized. Raphael's Stanza della Segnatura with "The School of Athens" and "The Disputa," Piero's "Resurrection," and Leonardo's "Last Supper" are perhaps the most famous of a varied host of masterpieces in which the viewpoint is set in a physically unattainable position, either as regards distance or direction, or very often both. The factors bearing on this problem are consequently of some importance.

First, there is the question of direction: the viewpoint high or low, or central, to one side or the other, and the relation of this point to the observer's actual position. Here one major consideration is the normal point of view from which both artist and onlooker see the contents of his pictures, whether they be chairs or people, the inside of a room, or the outside of a house. Any departure from such normality will entail juggling with studio props in unusual positions, and other similar difficulties, if the artist wishes to draw from life, and special powers of accurate imagination if he does not. A high degree of compositional skill will also be needed to control the many startling incidental effects which accompany such experiments. Far more important, however, is the fact that difficulty for

the artist entails trouble for the public. A special imaginative effort is required, and even when it is made the perspective effect may continue to distract attention, rather than to focus it unobtrusively. Perspective accuracy as regards a particular site is only one factor amongst many, and important aesthetic considerations frequently make it either unnecessary or positively undesirable.

An unusual viewpoint, say Donatello's "Dance of Salome" seen from high overhead, may, besides straining the spectator's imagination, greatly detract from the solemnity and dramatic intensity, as well as from the clarity, of a narrative scene. The general avoidance of such distortions, and the lack of any necessity for them in most cases, underline the fact that the strongest hold of perspective is normally over the mind, and the imaginative and associative faculties, rather than over the eye in a deceptive or illusionistic sense. The observer usually has little difficulty in associating himself with the desired viewpoint even if, as in many frescoes, it is set far above his head.

Finally there are practical difficulties inherent in the nature of artificial perspective itself. Whatever trouble the artist takes, the people who look at his work will invariably want to move, if only to examine detail, thereby defeating his best efforts. Then again, as Leonardo insisted, only one person can be at the desired point at one time. Moreover, if the artist goes to any extremes to satisfy this individual, the greater will be the unwanted distortions seen from anywhere else. Artificial perspective can, in any case, take no account of the effects of normal, binocular vision, and only by the provision of a peephole, or through the observer conscientiously closing one eye, can the system's fundamental assumptions be given practical reality. Once the method had been demonstrated, such elaborate games were, from the beginning, seen to lie outside the realms of art and of the interest of the artists.

Similar practical considerations influence the choice of the distance of the viewpoint from the representational plane. While the normal comfortable range for viewing a picture is certainly not less than twice its width, in a very high proportion of cases a one to one, or one to one-and-a-half relationship exists. These are the usual propor-

tions for Masaccio, Donatello, and Ghiberti, whilst Maso-
lino and Filippo Lippi frequently use less. In Donatello's
case there are also several examples of much shorter dis-
tances. The explanation for this may well be in part the
psychological effect of the artist's own distance from his
work whilst creating it. Another factor is the difficulty,
where a very long viewing distance is required, in finding
room to make an accurate construction. For a viewpoint
six times the width of his picture away from it, the artist
has actually to control his construction by a point at least
as far away as that from the edge of the sheet of paper
on which he is preparing the design. But this does not
explain the persistence of the same proportions long after
the discovery of abbreviated systems during the seven-
teenth century allowed the whole construction to be made
within the limits of the composition.

Once again, however, important aesthetic considera-
tions also affect the problem. A fairly close viewpoint has
a number of advantages. It means that the orthogonals
or lines running into depth are given the greatest possible
extension. Consequently they have a powerful effect in
creating depth, but at the same time have their maximum
value as surface pattern. As a result they also give maxi-
mum clarity to the receding surfaces, whether they be
ceilings, walls, or more especially floors or ground planes.
Any patterns can be seen clearly, and the disposition of
any figures or objects placed on them is given a similar
clarity. Of course, if the distance is too extremely short,
the resulting change of scale becomes overpowering . . .
while the steep slope of the ground plane may make an
uneasy platform for the figures. Beyond a distance of about
three to one in proportion to the width, on the other hand,
the receding surfaces become very abbreviated. The im-
pression of depth becomes more impelling on the eye, but
also far more limited. There is, therefore, in actual fact, a
special virtue in the proportions of one, or one-and-a-half
to one which are in practice those most commonly used.

The near viewpoint has the further advantage that it
gives the spectator a sense of immediacy, of being close
to the event, and of inclusion in the pictured scene. More-
over, when he is standing beyond the set distance there

is a distinct tendency for him to be "sucked in" towards it. This both encourages the inspection of detail and means that when it is being inspected the impression of the reality of the whole, half-seen beyond the boundaries of clear vision, increases rather than decreases. On the other hand, when the spectator is still looking at the picture as a decorative unity, the perspective, while losing none of its associative power, does become flatter, so that the impression of reality remains without the *trompe l'oeil* illusion of it.

So far, only the absolute necessity for the coincidence of the observer and the painted viewpoint has been challenged. But the very singleness of the vanishing point, the most fundamental conception of all in the theory of artificial perspective, was by no means inviolable to renaissance artists, though more frequently observed than the preceding theoretical demands. In Masaccio's fresco of "The Trinity" the foreshortening in accordance with the lowness of the principal viewpoint was extended to the architecture and the supporting figures. The two main figures, on the other hand, were swung forward into the plane, and seen not from below, but absolutely frontally. This puts special emphasis on them, and removes the danger of an unwanted stress on unimportant details, or the distraction of attention by theatrical effects. It also raises the spectator to the level of the pictured apparition. This particular effect is used in Piero della Francesca's masterpiece, the fresco of "The Resurrection." Here, the framing, which is hardly ever shown in reproductions, is an integral part of the design. Fortunately, although its outer parts are later restorations, all its inner sections are original. They still show the pricking, visible throughout the rest of the composition, with the aid of which the cartoon was transferred on to the wall, a fact which further emphasizes the indivisible unity of the design. This majestic marble framing is painted as if it were seen from below, but in itself has a double function. The bases of the columns converge to a point about a foot below the lower border. The devout are once more looking up towards an extension of reality. The capitals, meanwhile, converge into the body of the Rising Christ, and help, if help is

needed, to increase the concentration of attention. The sarcophagus is in pure elevation, the pricked outline showing that the foot of Christ rests absolutely level on its rim. Similarly there is no foreshortening in the body or the head of the figure of Christ. Within the picture the whole question of the viewpoint is laid aside as unimportant by the very artist who, for the first time, produced a thoroughgoing exposition of the constructional problems involved in the rigid application of the laws of artificial perspective. In "The Trinity" Masaccio carefully avoided pinning the figures to exact positions in space. Here, Piero likewise leaves eye and imagination free. The soldiers form a circle set in space, and a pyramid centering in the head of Christ. They create a triangle upon the surface, or are part of a diagonal cross in space that runs into the distance with the trees that echo in their silvery grays the flesh tones of Christ's trunk. The dual spatial values of Masaccio's composition take on new variety and richness, a new timeless movement, an absolute calm that is reflected in the still completeness of the circling color harmonies.

The use of several viewpoints in a single composition was also seen in Donatello's work. The advantages of such a practice—sometimes even the necessity for it—are shown most obviously in Uccello's Hawkwood, and Castagno's Tolentino monuments in Florence. A fairly high degree of realism was desirable in frescoes which were substitutes for more expensive marble monuments, and this element of illusion is supplied by the steep foreshortening of the architectural bases. On the other hand a worm's eye panorama of a horse's belly and a general's feet can be at best a dubious tribute to his memory. The realism of the low-set viewpoint is therefore restricted to the architecture. In Uccello's fresco there is no foreshortening of horse or rider, while in Castagno's later version of the same design there is extremely little when compared with the rapid downslope of the architectural orthogonals.

These few examples, and the host of others that could be added to them, show that the needs of the pictorial organization often overrode the demands of absolute realism, even insofar as these could be met by the faithful

application of the rules of artificial perspective. Indeed, the multiple viewpoint greatly increases the organizational range and effectiveness of perspective. The principle of controlling attention by means of a vanishing point becomes more important than the maintenance of theoretical unity and of a strict relationship between the onlooker and the pictorial world.

The single viewpoint of the artificial perspective system is in itself a powerful weapon of pictorial organization. It may coincide with the focal point of the action, as in Masaccio's "Tribute Money," or harmonize with it, as in Donatello's "Resurrection of Drusiana." It may even be in conflict with it, fighting for the onlooker's attention in a tug-of-war that communicates its tension to him, as in many mannerist designs. It may be used, as in Filippo Lippi's Pitti tondo, to stress the principal link between the observer and the pictorial action, the direct outward glance welding two worlds together. It may finally be used to emphasize some area of the composition which would otherwise be insufficiently forceful to play the part required of it within the pattern of the whole. The subtlety and range of this differential emphasis on various parts of the composition can be greatly increased by the use of more than one perspective focus. Separate vanishing points, and different foreshortenings, can be used to highlight figures, architecture, special areas or secondary actions, individual personages, and single objects, with a controlled gradation of emphasis that enhances the effect of the whole. The demands of realism can be exactly balanced with those of the subject matter and of the decorative design.

Besides increasing the strength of the artist's grip upon the observer's attention, the features which give artificial perspective its new realistic force, by their very nature, contribute towards compositional unity in certain of its aspects. The subordination of all objects to a single set of rules is far more than a mere device for closer imitation of the natural world. The measured relationship between each element of the pictorial world is a potent factor in increasing the unity of the composition, as well as its realism. Perspective diminution brings space into harmony with the unity of lighting and of atmospheric gradu-

ation of color which was of increasing interest to the artist. As a tool for the construction of new subtleties of pictorial organization the new perspective is as much a revolution, and a consummation of the long-felt desires maturing in the upheavals of the thirteenth and fourteenth centuries, as it is in its other role as a means of heightening the illusion of reality.

The mention of the element of measurability that was introduced into pictorial art by artificial perspective again draws attention to the careful distinction which must be made between the implications of the theory of perspective and its significance as it appears in individual works of art. At first sight Andrea Castagno's "Last Supper" in the Cenacolo di Sant'Apollonia might appear to be a perfect illustration of the mathematically defined relationship between onlooker and picture, and between one object and another within the painted scene itself. The appearance is deceptive. It is quite impossible, in fact, to tell how deep the picture is supposed to be, or how far away from it the onlooker should stand. In the sharply foreshortened, and almost indistinguishable pattern of the floor in front of the table there are ten lozenges in depth and ten in breadth. Does this signify a square? If so, the distance separating this square from the back wall of the room must be twice that which separates it from either side wall, if the room as a whole is to be considered as being based upon a foreshortened square. Such a supposition seems to be supported by the apparent repetition of the six square marble panels of the back wall upon either side wall; two panels on the right wall being taken up by windows. But this is contradicted by the interlacing of the decorative frieze immediately above, in which just over seventeen loops in depth match thirty-three and two-thirds loops upon the back wall. This implies that the room is not a square, but only half as deep as it is wide, if indeed there is any exact relationship at all. Meanwhile, the seemingly simple black-and-white chessboard of the ceiling numbers sixteen rectangles in depth and only fourteen in width. The resulting doubt as to the squareness of any and all of the apparent squares shown in foreshortening carries with it the impossibility of saying with certainty

just how far away the onlooker must stand in order to fulfil the theoretical demands of the construction. The meticulous incising of the whole design, and its geometric clarity, make it impossible merely to assume an inability to count upon Castagno's part. Similarly, pure disinterest in the matter seems, on general grounds, to be less probable than a positive determination to avoid the stiffness and sterility of a too-obvious mathematical logic. A similar intention is revealed in Piero della Francesca's painting even where a modulus similar to that which underlies Alberti's architecture governs the proportions of the whole design.

In Castagno's fresco, the impression of measurability nevertheless remains. Moreover, the lack of certainty about the theoretically correct viewing distance gives an accompanying freedom to the onlooker to stand just where he feels like standing; a freedom which is usually assumed in any case. It would indeed be a lengthy business to count the pictures by the great renaissance painters in which it is not actually possible to measure out the distances that it is within the power of perspective to define. The impression of orderliness and unity, and of connection with the onlooker, was of far greater importance than the counting out in inches of a mathematical diagram. This, like every other element of perspective, was a feature which the fifteenth-century artists felt themselves quite free to accept or to ignore as far as the individual composition was concerned.

The final aspect of this question of the relation between artistic practice and perspective theory at a time when, for social, as well as for the purely artistic reasons, the new science was at the height of its reputation, is the matter of the accuracy with which artists carried out those parts of the construction which they did incorporate in their pictures. The answer to this question throws a certain light upon the problem of illusionism with which the whole discussion opened. It has already been seen that the unified vanishing point is often ignored for particular reasons. But this is not a matter of inaccuracy. On the whole it is true to say that the unified vanishing point, when it is used, is observed with a fairly high degree of

accuracy. The interval between the transversals is often much less certain, particularly when the construction is at all finicky, or difficult to apply in any way. What is particularly interesting, however, is the demonstrable fact that a satisfactory degree of illusion can be obtained despite a high degree of inaccuracy in construction.

The convincing structure of many of Giotto's buildings has been noted, together with the successful element of illusionism in many thirteenth- and fourteenth-century fresco frames. It is therefore interesting to see that Piero della Francesca in his Borgo San Sepolcro "Resurrection" does not bother to make the orthogonals of the bases of the columns run together under the center of the composition. Even more striking is the fact that Castagno, in his decorative scheme for the Villa Carducci, nowhere takes the perspective structure beyond the stage of development reached in the late thirteenth and early fourteenth centuries. The orthogonals of the putto frieze and of the main coffering above the figures all recede in parallel towards a vanishing axis at the center. The dentils of the cornice take no note of this arrangement, and are mechanically repeated as if looked at from the right. Similarly, whilst the framing and pilasters of the figure niches recede towards the central door, the capitals of the latter are seen from straight ahead.

In Mantegna's "Camera degli Sposi," it is only in the illusionism of the circular wall that seems to pierce the vaulting that there is any evidence in the framing of the use of artificial perspective. In this room, where the realism extends to the hanging of a painted curtain on the real, projecting molding of a door, or to suggesting landscapes barely seen through gaps in the hangings that cover the two walls that are devoid of figure decoration, there is no attempt at accuracy in the recession of the pillars which articulate the decorative scheme. Even the accurate construction of the steps in the principal scene only serves to emphasize the conflict with the generally centralized design. As in the Castagno scheme the dentils of the painted molding are all seen from one side in mechanical repetition. Yet this is no vast decorative scheme, but one small room in which there is no possibility of questioning the

master's ability to control the details of execution. On the other hand the successful realism of this painted architecture cannot be denied. Meticulous accuracy was simply unnecessary. The time spent in carrying perspective logic into every detail would achieve no comparable increase in the impression of reality.

It is precisely because such a high degree of realism in architectural bordering can be obtained by relatively primitive means that these schemes by master perspectivists of the mid-fifteenth century reveal in detail no advance upon the achievements of a hundred years before. It is in the conception of the schemes as a whole, and in the handling of the scenes, that the impact of the new ideas is felt. In this, the history of the growth of spatial realism up to its renaissance climax is radically different from the history of the similar development in late antiquity. In Pompeii, secular decoration—the adornment of the walls of living rooms—and in earlier times, the production of the architectural scenery for plays, was the principal occupation of the painter. Consequently, it is in the architectural framework instead of in the small scenes from mythology that the main development of perspective must be traced. In the period leading up to the renaissance all the emphasis was on the exposition of religious history on the walls of churches. The didactic purpose stressed the telling of the story. It is in the history scene that the development takes place, while the technical side of the construction of the relatively unimportant framework changes little.

These discussions of various aspects of the way in which artificial perspective was actually used in fifteenth-century Italy lead to a number of conclusions. The first is that the threefold function revealed in Donatello's work is generally valid. The re-creation of reality, the organization of the composition and the harmonization of the new reality with the flat pictorial surface are indeed the main divisions of the formal potentialities of the new perspective. Secondly, whilst extremely few examples of complete illusionism can be found, some of the elements making for illusion can be seen in varying proportions throughout nearly all renaissance art. The analyses also show that, even in the pseudoscientific realm of perspective, it is only

through the works of art themselves, as opposed to the writings of theorists, historians, and commentators of whatever generation, that the full meaning of any artistic method can be grasped. The importance of the new geometric construction is as incalculable as the pictures which refuse to serve as illustrative diagrams are numerous.

RUDOLF WITTKOWER

ARCHITECTURAL PRINCIPLES IN THE AGE OF HUMANISM *(1949)*

RENAISSANCE ARCHITECTURE, no less then Renaissance painting, was subjected to mathematical theory. If the painter was fascinated by systems of vanishing-point perspective, the architect was fascinated by theories of proportion, and these theories had philosophic—even Neoplatonic and half-mystic—meanings. Indeed, architecture may be more devoted than painting to the profoundest ideals of Renaissance humanism. Wittkower's study irrefutably proves that the Renaissance was not so pagan as it was once supposed to be. In fact, Renaissance architecture is a microcosm that integrates ideals of beauty into a system of proportions that corresponds to a world order and to the structure of the human body, as well as to musical harmony. The appearance of the round church, as a result of this humanistic mathematics, is testimony to the Christian thought of the Renaissance. Wittkower closes his dis-

cussion by suggesting that the breakdown of this architectural proportion symbolizes the dissolution of Christian humanism in Western culture. Above all, he shows how the Renaissance made no divorce between art and science, which were two faces of humanism.

Background for Wittkower's book is Ernst Cassirer's anthology *The Renaissance Philosophy of Man* (1950) with its selections from Ficino and other humanists. Wittkower has treated the breakdown of architectural proportion in his article "The Principles of Palladio's Architecture," *Journal of the Warburg and Courtauld Institutes,* VIII, 1945, 68-106.

THE CENTRALLY PLANNED
CHURCH AND THE RENAISSANCE

(Part I)

Renaissance architecture is nowadays usually interpreted in terms which stress its worldliness. At best it is argued that the classical apparatus of forms was used on an equal level for sacred, profane, and domestic buildings; that the classical forms were adapted for different purposes without any gradation of meaning; and that consequently, Renaissance architecture is an architecture of pure form. Often in discussions of Renaissance architecture this underlying assumption is silently taken for granted. If this customary interpretation of Renaissance architecture as a profane style is correct, then what would be the essential difference between the eclecticism of the fifteenth and sixteenth centuries and that of the nineteenth century? If both are derivative styles—in the sense that they derive from classical antiquity—is the difference between them only that nineteenth-century architecture, as far as it is classical and not Gothic, is twice removed

from the ancient models? The true answer appears to lie elsewhere. In contrast to nineteenth-century classical architecture, Renaissance architecture, like every great style of the past, was based on a hierarchy of values culminating in the absolute values of sacred architecture. We maintain, in other words, that the forms of the Renaissance church have symbolical value or, at least, that they are charged with a particular meaning which the pure forms as such do not contain. Both the theory and practice of the Renaissance are unambiguous in this respect.

Builders of fifteenth-century churches in Italy gradually turn away from the traditional Latin Cross plan consisting of the long nave, transept, and choir. Instead, they advocate centrally planned churches, and these churches have always been regarded as the climax of Renaissance architecture. But in spite of the contrary evidence of the architects themselves, such plans have become something like a touchstone of Renaissance paganism and worldliness. As centrally planned churches appear to be unsatisfactory from a liturgical point of view—how can one separate in such a church clergy and laity? where is one to place the altar, etc.?—it is usually held that the craving for beauty was here given preference over the necessities of the service. Thus the line art historians have generally taken falls in with the attitude of those historians who emphasize the irreligious aspect of the Renaissance. Their interpretation derives from the simple—not to say naïve—formula that medieval transcendental religion was replaced by the autonomy of man in the Renaissance. A new discussion of the ideas underlying ecclesiastical architecture during the Renaissance will, it is hoped, clear the ground for a more correct understanding of the architects' intentions and, at the same time, help to elucidate the element of tradition in some important currents of Renaissance thought.

ALBERTI'S PROGRAMME
OF THE IDEAL CHURCH

(Section 1)

The views of fifteenth- and sixteenth-century archi-
tects are available in sufficient detail to give a fairly correct
picture of their ideas. In fact, the first architectural treatise
of the Renaissance, Alberti's *De re aedificatoria* (written
about 1450), contains the first full program of the ideal
church of the Renaissance. The seventh book of this work
deals with the building and decoration of sacred architec-
ture. Alberti's survey of desirable shapes for temples—his
synonym for churches—begins with a eulogy of the circle.
Nature herself, he declares, enjoys the round form above
all others as is proved by her own creations, such as the
globe, the stars, the trees, animals and their nests, and
many other things. Alberti recommends nine basic geo-
metrical figures in all for churches: apart from the circle,
he lists the square, the hexagon, the octagon, the decagon
and the dodecagon. All these figures are determined by
the circle and Alberti explains how to derive the lengths
of their sides from the radius of the circle into which they
are inscribed. In addition to these six figures he mentions
three developments from the square, namely the square
plus one-half, the square plus one-third and the square
doubled.

These nine basic forms can be enriched by chapels.
For plans derived from the square Alberti suggests one
chapel at the far end, or, in addition, a central chapel at
each side, or an odd number of chapels at each side.
Circular plans may be given six or eight chapels; polygonal
ones may either have a chapel to each wall or to alternate
walls. The shape of the chapels should be rectangular or
semicircular; both types may alternate. It is evident that
by adding small geometrical units to the basic figures of

circle and polygon a great variety of composite geometrical configurations can be produced which all have the one element in common that corresponding points on the circumference have exactly the same relation to the focal point in the center.

Alberti does not directly express preference for any of the shapes recommended by him. But a bias in favor of the round form seems to be implied, judging from his remarks about nature's love for the round. For nature aspires to absolute perfection, she is the best and divine teacher of all things—*la natura, cioè Iddio* . . .

It is well known that Alberti, like other architects after him, was inspired in his centralized plans by classical structures, though hardly by classical temples. However, many of the circular and polygonal remains of Roman tombs and secular buildings were then believed to have been temples in antiquity and, in addition, a number of Early-Christian buildings like Sto. Stefano Rotondo, Sta. Costanza, the octagonal Baptistery near the Lateran and even the twelfth-century octagon of the Florentine Baptistery were regarded as Roman temples turned into Christian churches. It can therefore be inferred that Alberti saw here—in spite of Vitruvius' relative silence about centralized plans of temples—a continuity from ancient sacred architecture to the early Christian church, and took this as historical justification for advocating a return to the venerable forms of temples of the ancients. But whatever Alberti's reasoning, the stress he laid on circular and polygonal churches reveals his passion for the centralized geometrical plan. A controversy during the erection of the choir of the SS. Annunziata at Florence shows that opinions on classical centralized structures were by no means unanimous. Work on this building had been interrupted for fifteen years and when, in 1470, Alberti carried on Michelozzo's unfinished choir, fashioned after the "temple" of Minerva Medica, a "reactionary" critic turned against the continuation of work on this copy after the antique. His argument was exactly the reverse of that which recommended Michelozzo's design to Alberti, for he alleged that such classical buildings had not been temples in antiquity but tombs of emperors, and were therefore unsuitable as

models for churches. It was this liturgical unsuitability of Michelozzo's plan which had been severely censured about twenty-five years before by the aged Brunelleschi. And precisely this question of suitability was approached from a new angle during the second half of the fifteenth century. Alberti's silence on this point suggests that he did not acknowledge the existence of the problem.

It is strange that the normal and traditional type for churches, the basilica, was not among those recommended by Alberti. The fact that churches were built in the form of the basilica appears only incidentally when Alberti explains that the habit was introduced by the early Christians who used private Roman basilicas as their places of worship. This is the only mention of basilicas in the chapters about "temples." But Alberti made the position clear in the introductory chapter of the same book: the basilica, as the seat of jurisdiction in antiquity, is for him closely related to the temple. Justice is a gift of God: man obtains divine justice through piety and exercises human justice through jurisdiction. Thus temple and basilica as the seats of divine and human justice are intimately related, and in that sense the basilica belongs to the domain of religion. In keeping with this, Alberti explains in a later chapter on basilicas that the basilica partakes in the decoration belonging to temples. However, the beauty of the temple is more sublime, and cannot and should not be rivaled by that of the basilica. Thus in Alberti's system the time-honored form of the church, the basilica, has been relegated from its divine to a human function, and it is evident that Alberti must exclude the basilica from being used for churches.

Alberti is explicit about the character of the ideal church. It should be the noblest ornament of a city and its beauty should surpass imagination. It is this staggering beauty which awakens sublime sensations and arouses piety in the people. It has a purifying effect and produces the state of innocence which is pleasing to God. What is this staggering beauty that has so powerful an effect? According to Alberti's well-known mathematical definition, based on Vitruvius, beauty consists in a rational integration of the proportions of all the parts of a building, in such

a way that every part has its absolutely fixed size and shape, and nothing could be added or taken away without destroying the harmony of the whole. This conformity of ratios and correspondence of all the parts, this organic geometry, should be observed in every building but above all in churches. We may now conclude that no geometrical form is more apt to fulfil this demand than the circle or forms deriving from it. In such centralized plans the geometrical pattern will appear absolute, immutable, static, and entirely lucid. Without that organic geometrical equilibrium where all the parts are harmonically related like the members of a body, divinity cannot reveal itself.

Consequently, we find minute guidance for all the proportions of the ideal church. Alberti discusses, for instance, the size of the chapels in relation to the central core of the building and in relation to the wall space between them, or the height of the structure in relation to the diameter of the ground plan. To give at least one concrete example: the height of the wall up to the vaulting in round churches should be one-half, two-thirds, or three-quarters of the diameter of the plan. These proportions of one to two, two to three, and three to four conform to the all-pervading law of harmony as Alberti demonstrates in his ninth book.

It is obvious that such mathematical relations between plan and section cannot be correctly perceived when one walks about in a building. Alberti knew that, of course, quite as well as we do. We must therefore conclude that the harmonic perfection of the geometrical scheme represents an absolute value, independent of our subjective and transitory perception. And it will be seen later that for Alberti—as for other Renaissance artists—this man-created harmony was a visible echo of a celestial and universally valid harmony.

Apart from this concern for proportion, Alberti's advice embraces everything from the general appearance of the church down to the details of the decoration. A church should not only stand on elevated ground, free on all sides, in a beautiful square, but it should also be isolated by a substructure, a large pedestal, from the everyday life that surrounds it. The façade should be formed by a portico

in the ancient manner, and round churches should also be given such a portico or be surrounded by a colonnade. Arches are used in theaters and basilicas, but they do not accord with the dignity of churches; for these, only the austere form of columns with straight entablature is appropriate. In contrast to basilicas, and in keeping with their dignity, churches must be vaulted; moreover, vaults guarantee perpetuity to churches. The chastity of the church should not be compromised by lax appeals to the senses. There should be splendor, particularly in the use of precious materials. But just as Cicero, following Plato, thought that white was the color for temples, so Alberti was "entirely convinced that purity and simplicity of color—as in life—is most pleasing to God." Pictures are preferable to frescoes, and statuary is preferable to pictures, but whatever decoration is used on walls and pavement should pertain to "pure philosophy." Thus there should be inscriptions admonishing us to be just, modest, simple, virtuous, and pious, and the pavement, above all, should show "lines and figures pertaining to music and geometry so that everywhere the education of the mind is stimulated." This last recommendation sounds particularly strange, and it can only be understood if we are aware that for Alberti—who follows here a tradition unbroken from classical times—music and geometry are fundamentally one and the same; that music is geometry translated into sound, and that in music the very same harmonies are audible which inform the geometry of the building. Finally, windows should be so high that no contact with the fleeting everyday life outside is possible and that one can see nothing but the sky. The most dignified ornaments for vaults and domes are coffers in the manner of the Pantheon, but a cosmic significance for the dome is also suggested by a painted representation of the sky. A cosmic interpretation of the dome was common from antiquity onwards and was kept alive, above all, in the Eastern Church.

Alberti gives here a complete picture of the humanist conception of ecclesiastical architecture, and it is apparent that for him humanism and religion were entirely compatible. And let it be said emphatically: it is a serene, philo-

sophical and almost puritanical architecture which his descriptions conjure up before us. This was clearly felt in his own days by people who cherished the old traditions. The critic of the centralized choir of the SS. Annunziata, who has been quoted already, protests also against Alberti's wish to paint the whole choir white and leave it without any ornament whatsoever. The church, in his view, would appear "poor and desolate." But Alberti set the standards for generations of architects with a classical bias who made his ideas and stipulations their own. For them the new forms of the Renaissance church embodied sincere religious feeling no less than did the Gothic cathedral for the medieval builder. . . .

THE RELIGIOUS SYMBOLISM OF CENTRALIZED CHURCHES

(Section 5)

═══════════════════════════════════

Renaissance artists firmly adhered to the Pythagorean conception "All is Number" and, guided by Plato and the Neoplatonists, and supported by a long chain of theologians from Augustine onwards, they were convinced of the mathematical and harmonic structure of the universe and all creation. If the laws of harmonic numbers pervade everything from the celestial spheres to the most humble life on earth, then our very souls must conform to this harmony. It is, according to Alberti, an inborn sense that makes us aware of harmony; he maintains, in other words, that the perception of harmony through the senses is possible by virtue of this affinity of our souls. This implies that if a church has been built in accordance with essential mathematical harmonies, we react instinctively; an inner

sense tells us, without rational analysis, that we perceive an image of the vital force behind all matter—of God Himself. Pacioli maintains that divine functions are of little value if the church has not been built *con debita proportione*. It follows that perfect geometry is essential in buildings even if accurate ratios are hardly manifest to the eye.

The most perfect geometrical figure is the circle and to it was given special significance. To understand fully this new emphasis we must turn for a moment to Nicholas of Cusa who had transformed the scholastic hierarchy of static spheres, of spheres immovably related to one center, the earth, into a universe uniform in substance and without a physical or ideal center. In this new world of infinite relations the incorruptible certitude of mathematics assumed unprecedented importance. Mathematics is for Cusanus a necessary vehicle for penetrating to the knowledge of God, who must be envisaged through the mathematical symbol. Cusanus, developing a pseudohermetic formula, visualizes Him as the least tangible and at the same time the most perfect geometrical figure, the center and circumference of the circle; for in the infinite circle or sphere, center, diameter and circumference are identical. And equally Ficino, based on the authority of hermetic sources and Plotinus, regards Him as the true center of the universe, the innermost of everything, but at the same time, the circumference of the universe, surpassing everything immeasurably.

Renaissance architects were aware of all this. Their own treatises leave not a shadow of doubt. We do not maintain that all or even many of them were familiar with all the intricacies of philosophical speculation. But they were steeped in these ideas which, with the surge of Platonism and Neoplatonism in the fifteenth century, had spread quickly and irresistibly.

The geometrical definition of God through the symbol of the circle or sphere has a pedigree reaching back to the Orphic poets. It was vitalized by Plato and made the central notion of his cosmological myth in the *Timaeus*; it was given pre-eminence in the works of Plotinus and, dependent on him, in the writings of the Pseudo-Dionysius the Areopagite which were followed by the mystical theo-

logians of the Middle Ages. Why then—it may still be asked—did not the builders of the cathedrals try to give visual shape to this conception, why was it not until the fifteenth century that the centralized plan for churches was regarded as the most appropriate expression of the Divine? The answer lies in the new scientific approach to nature which is the glory of Italian fifteenth-century artists. It was the artists, headed by Alberti and Leonardo, who had a vital share in consolidating and popularizing the mathematical interpretation of all matter. They found and elaborated correlations between the visible and intelligible world which were as foreign to the mystic theology as to the Aristotelian scholasticism of the Middle Ages. Architecture was regarded by them as a mathematical science which worked with spatial units: parts of that universal space for the scientific interpretation of which they had discovered the key in the laws of perspective. Thus they were made to believe that they could re-create the universally valid ratios and expose them pure and absolute, as close to abstract geometry as possible. And they were convinced that universal harmony could not reveal itself entirely unless it were realized in space through architecture conceived in the service of religion.

The belief in the correspondence of microcosm and macrocosm, in the harmonic structure of the universe, in the comprehension of God through the mathematical symbols of center, circle and sphere—all these closely related ideas which had their roots in antiquity and belonged to the undisputed tenets of medieval philosophy and theology, acquired new life in the Renaissance, and found visual expression in the Renaissance church. The man-created forms in the corporeal world were the visible materializations of the intelligible mathematical symbols, and the relationship between the pure forms of absolute mathematics and the visible forms of applied mathematics was immediately and intuitively perceptible. For the men of the Renaissance this architecture with its strict geometry, the equipoise of its harmonic order, its formal serenity and, above all, with the sphere of the dome, echoed and at the same time revealed the perfection, omnipotence, truth and goodness of God.

The realization of these ideas in the Renaissance church betrays by implication a shift in the religious feeling itself, a shift for which the change from the basilical to the centralized church is a more telling symbol than the changes in the philosophical interpretation of God and world. It should be remembered that the classical principle of analogy between form and content was never abandoned. The builders of the Middle Ages laid out their churches *in modum crucis*—their Latin Cross plan was the symbolic expression of Christ crucified. The Renaissance, as we have seen, did not lose sight of this principle. What had changed was the conception of the Godhead: Christ as the essence of perfection and harmony superseded Him who had suffered on the Cross for humanity; the Pantocrator replaced the Man of Sorrows.

The new conception of religious architecture was soon to be challenged. Carlo Borromeo in his *Instructionum Fabricae ecclesiasticae et Superlectilis ecclesiasticae Libri duo* of about 1572, applied the decrees of the Council of Trent to church building; for him the circular form was pagan and he recommended a return to the *formam crucis* of the Latin cross. But even amongst those who were surrounded by the fanaticism of the Catholic reform, the humanist conception of the ideal church maintained a firm grip. In his Utopian city-state of the *Città del Sole,* published in 1623, Tommaso Campanella describes thus the principal church: "The temple is perfectly round, free on all sides, but supported by massive and elegant columns. The dome, an admirable work, in the center or 'pole' of the temple . . . has an opening in the middle directly above the single altar in the center . . . On the altar is nothing but two globes, of which the larger is a celestial, the smaller a terrestrial one, and in the dome are painted the stars of the sky." In spite of the Counter Reformation centralized churches played a prominent part in seventeenth- and eighteenth-century architecture: the Neoplatonic mathematical interpretation of the universe had still a long lease of life. . . .

THE PROBLEM OF HARMONIC PROPORTION IN ARCHITECTURE

(Part IV)

===

ALBERTI'S GENERATION OF RATIOS (SECTION 3)

The Renaissance identification of musical and spatial ratios was only possible on the basis of a peculiar interpretation of space which, as far as we can see, has not been properly understood in modern times. When Francesco Giorgi called the relation of width to length of the nave of S. Francesco della Vigna a diapason and diapente he expressed the simple ratio 1:3 (9:27) in terms of the compound ratio 1:2, 2:3 (9:18, 18:27). Is this only a theoretical application of musical ratios to space, or does it imply a particular mode of space perception? If we suppose the latter it would mean that for Giorgi the length of the nave is not simply a triplication of its width, but that the length itself is charged with definite relations; for one unit (9) is seen in relation to its duplication, and the two units together (18) are visualized in relation to the whole length of three units (27).

Giorgi perceives the length like a monochord, on which by stopping at ½ and ⅔ of its length respectively, the octave and the fifth are produced. That for Giorgi these intervals are not simply theoretical breaks is proved by the fact that they coincide with important caesuras in the building: the first unit of 9 with the center of the central chapel and the second unit, 18, with the end of the nave proper. With this kind of "generation" of the compound ratio 9:27 from the simple ratios 9:18 and 18:27 Giorgi expressed himself in a language which was generally understood in his day. He expounded a method for which Alberti had laid the theoretical foundation.

Alberti differentiates three types of plans—small, medium and large ones. Each type can be given three

different shapes. To the small plans belong the square (2:2) and shapes of one to one and a half (2:3) and one to one and a third (3:4). These ratios comply with the simple musical consonances and need no further explanation. Medium-sized plans "duplicate" the ratios of small plans, i.e., one to two, one to twice one and a half, and one to twice one and a third. With these more complicated ratios the matter becomes very interesting. To draw a plan of one to twice one and a half, the architect puts down a unit which we may call 4, extends it until the ratio one to one and a half is reached, i.e., 4:6, and adds to this another ratio of one to one and a half, i.e., 6:9; the result is a ratio of 4:9. In other words, Alberti anticipates exactly Francesco Giorgi's procedure, for he breaks up the ratio 4:9 into two "basic" ratios of 2:3.

We may now say that the ratio of 4:9 is generated from the two ratios 4:6 and 6:9. In the same way the ratio of one to twice one and a third, 9:16, is generated from 9:12:16, for 9:12 = 1:1⅓, and 12:16 = 1:1⅓. The three classes of large plans are formed first, by adding to the double square, 2:4, one half so that the proportion 1:3 is generated from 2:4:6, secondly, by adding to the double square, 3:6, one third so that the proportion 3:8 is generated from 3:6:8 and, thirdly, by doubling the double square so that the quadruple proportion 2:8 is generated from 2:4:8. Now the double proportion 1:2 (musically an octave) is a composite of the two ratios 2:3 and 3:4 (for ½ = ⅔ × ¾) so that it is generated from 2:3:4 or 3:4:6 (musically from fifth and fourth, or fourth and fifth). We can now say that, for instance, the proportion of 1:4 is generated from 2:3:4:8, or 2:3:4:6:8 (i.e., from fifth and fourth, and fifth and fourth), or 3:6:9:12, or 3:4:6:9:12 (i.e., from fourth and fifth, and fifth and fourth), etc. For Alberti the splitting up of compound proportions into the smallest harmonic ratios is not an academic matter, but a spatial experience, as is shown by his explanation of the architect's procedure when planning the proportion 4:9. Harmonic ratios like the double, the triple, and the quadruple are compounds of simple consonant ratios. Alberti is very explicit that subratios of a compound ratio cannot be used indiscriminately by architects; they must be

exactly those ratios which belong to the compound ratio. If one wants, for instance, to build the wall of a room, the length of which is double its width, one would not use for the length the subratios of the triple proportion, but those of which the double is compounded. The same is true for a room in the proportion of one to three; no other than the numerical relations of which the triple is composed, should be used.

The splitting up of ratios for the sake of making the proportions of a room harmonically intelligible appears to us very strange. And yet, this is the way the whole Renaissance conceived of proportions. A wall is seen as a unit which contains certain harmonic potentialities. The lowest subunits, into which the whole unit can be broken up, are the consonant intervals of the musical scale, the cosmic validity of which was not doubted. In some cases only one way of generation is possible, but in others two or even three different generations of the same ratio can be carried through; as we have seen, the ratio 1:2, the octave, can be seen as fourth and fifth (3:4:6) or as fifth and fourth (2:3:4). But the ratios of the musical intervals are only the raw material for the combination of spatial ratios. Alberti's harmonic progressions 4:6:9 and 9:12:16 are a sequence of two fifths and two fourths respectively, i.e., musically they represent dissonances. The ratios of musical intervals are regarded as binding, and not the building up of consonant intervals into musical harmonies. Nothing shows better than this that Renaissance artists did not mean to translate music into architecture, but took the consonant intervals of the musical scale as the audible proofs for the beauty of the ratios of the small whole numbers 1:2:3:4.

In analyzing the proportions of a Renaissance building one has to take the principle of generation into account. It can even be said that, without it, it is impossible fully to understand the intentions of a Renaissance architect. We are touching here on fundamentals of the style as a whole; for simple shapes, plain walls and clear divisions are necessary presuppositions for that "polyphony of proportions" which the Renaissance mind understood and a Renaissance eye was able to see.

MUSICAL CONSONANCES
AND THE VISUAL ARTS
(Section 4)

From all that has been said so far it will be realized that the Renaissance analogy of audible and visual proportions was more than a theoretical speculation; it testifies to the solemn belief in the harmonic mathematical structure of all creation. But beyond this, music had a peculiar place in the scheme of the liberal arts. It was indeed the only respectable "liberal art" ranking amongst the *quadrivium* of the mathematical arts and with an unbroken tradition coming down from antiquity. Painting, sculpture, and architecture, on the other hand, had to be raised by Renaissance theorists and through the agency of mathematics from the level of mechanical to that of liberal arts. No wonder that in the closely interrelated encyclopedia of the arts the mathematical foundation of music was regarded as exemplary for the other arts and a familiarity with musical theory became a *sine qua non* of artistic education. The few scattered notes given here are meant to prepare the reader for the problems discussed in the following sections.

It comes as a confirmation of one's expectations to find that Brunelleschi, according to his biographer, Manetti, studied the musical proportions of the ancients. Manetti, writing after 1471 and under the influence of Alberti, may have read these ideas into the past; his remark, in any case, shows how acutely aware his generation was of the importance of the problem, and this is also illustrated by Alberti's famous warning to Matteo de' Pasti during the erection of S. Francesco at Rimini that by altering the proportions of the pilasters *si discorda tutta quella musica.* Nobody expressed his belief in the efficacy of harmonic ratios behind all visual phenomena with more conviction

than Leonardo. We may recall in particular his well-known saying that music is the sister of painting. This was not meant as a vague simile but as indicating a close relationship; for both, music and painting, convey harmonies; music does it by its chords and painting by its proportions. Musical intervals and linear perspective are subject to the same numerical ratios, for objects of equal size placed so as to recede at regular intervals diminish in "harmonic" progression.

The *exactissima harmonia* of the human body was the subject of Pomponius Gauricus' *De sculptura,* 1503. Gauricus asks "what geometrician, what musician must he have been who has formed man like that?"—thus apostrophizing the fundamental unity of geometry and music. The *Timaeus,* quoted more than once by Gauricus, seems also for him the book of wisdom in which the mystical harmony in the universe was revealed. These ideas remained alive throughout the sixteenth century. Lomazzo, in his scholastic *Trattato dell'arte della pittura* (1584), talked of human proportions in musical terms. He carried on a habit of thought which is first to be found in Alberti's writings. Alberti interprets, for instance, the ratio 4:9 which he analyzed as the product of two ratios of 1:1½, also as a double proportion (4:8) plus one *tone* (8:9), and the ratio 9:16, generated from two ratios of 1:1⅓, also as a double proportion (9:18) minus a *tone* (18:16). Failing an algebraic symbolism, musical terminology was ready at hand for an adequate description of proportions. In the same vein Lomazzo regarded the applicability of musical terms to the proportions of the body as so self-evident that he not only omitted a discussion of the common laws of musical and spatial proportions, but referred constantly to spatial ratios as if they were an acoustic experience. For instance, the distance from the top of the head to the nose "resounds (*risuona*) with the distance from there to the chin in triple proportions, producing the *diapason* and *diapente;* and the said distance from the nose to the chin, and that from the chin to the meeting of the collarbones resounds with a double proportion which makes the *diapason* . . ."

In his later *Idea del Tempio della Pittura* (1590)

Lomazzo formulated theoretically what was implied in the quotation we have just given. Here he declared that masters like Leonardo, Michelangelo, and Gaudenzio Ferrari "have come to the knowledge of harmonic proportion by way of music"; the human body itself is built according to musical harmonies. This microcosm *fatta dal grande Iddio a simiglianza della sua Immagine* contains "all numbers, measures, weights, motions and elements." Therefore all the buildings in the world together with all their parts follow its norm.

Lomazzo's information about the great Renaissance artists strikes a familiar note. A preoccupation with musical theory is also recorded of those seventeenth-century painters who carried on the classical tradition of the sixteenth century. Lucio Faberio in his commemoration speech at Agostino Carracci's funeral tells us that the latter was a student of philosophy, arithmetic and geometry, astrology, and, above all, music; arithmetic, the foundation of music, taught him the origin of the musical consonances. Domenichino who made arithmetic, perspective and architecture his special study, speculated with zest about ancient musical theory; and Poussin, based on Zarlino, compared the different styles of painting with the modes of ancient music. . . .

THE BREAK-AWAY FROM THE LAWS OF HARMONIC PROPORTION IN ARCHITECTURE

(Section 7)

It need hardly be recalled that the doctrine of a mathematical universe which, with all its emanations, was subject to harmonic ratios, was triumphantly reasserted by a number of great thinkers of the seventeenth and eight-

eenth centuries. We find this conception of the world fully expounded in Kepler's *Harmonia mundi* (1619), we find it in Galilei, and later in Shaftesbury, for whom, truly Platonic, the laws of musical harmony are effective also in human nature: "*Virtue* has the same fix'd Standard. The same *Numbers, Harmony,* and *Proportion* will have place in Morals; and are discoverable in the *Characters* and *Affections* of Mankind."

The poets echo these ideas. Dryden thinks in terms of the Greek musical scale in "A Song for St. Cecilia's Day":

> From harmony, from heav'nly harmony
> This universal frame began;
> From harmony to harmony
> Thro' all the compass of the notes it ran,
> The diapason closing full in man.

But long before this was written, the voice of doubt was to be heard. John Donne had sung in 1611:

> And new Philosophy calls all in doubt,
> The Element of fire is quite put out;
>
> 'Tis all in peeces, all cohaerence gone;
> All just supply, and all Relation.

With the rise of the new science the synthesis which had held microcosm and macrocosm together, that all-pervading order and harmony in which thinkers had believed from Pythagoras' days to the sixteenth and seventeenth centuries, began to disintegrate. This process of "atomization" led, of course, to a reorientation in the field of aesthetics and, implicitly, of proportion.

But before discussing the new ideas which slowly emerged, it should be pointed out that a knowledge of the old belief in a universal harmony is to be found in seventeenth- and eighteenth-century writers on architecture. In England Sir Henry Wotton in his *Elements of Architecture,* 1624, pointed to the importance of harmonic proportions. As a student of Vitruvius, Alberti, Palladio and the French theorists like Philibert de l'Orme, he could write: "In truth, a sound piece of good Art, where the *Materials* being but ordinary Stone, without any garnishment of Sculpture, do yet ravish the beholder (and he knows not

how) by a secret *Harmony* in the *Proportions.*" In his chapter on doors and windows he is more explicit, reminding the reader that Vitruvius himself wishes the architect "to be no superficial, and floating *Artificer;* but a *Diver* into *Causes,* and into the *Mysteries of Proportion.*" And following Alberti's interpretation of Pythagoras he explains how to reduce "Symmetry to *Symphony,* and the *Harmony of Sound,* to a kind of *Harmony in Sight.*" One hundred and fifty years later, Reynolds, steeped in classical art theory, still advocated the basic unity of all the arts and the validity of the same proportions in music and architecture, though the following remark in the Thirteenth Discourse lacks conviction: "To pass over the effect produced by that general symmetry and proportion by which the eye is delighted, as the ear is with music, architecture certainly possesses many principles in common with poetry and painting."

It was Palladio's work which remained canonical for those academic architects who abode by the conception of harmonic ratios. But this conception, when and where it was adhered to in architecture, tended to lose its universal application, and soon classical ideas on proportion were completely reversed. There was an important French classicist current, the representatives of which kept alive the Platonic conception of numbers in a doctrinal and didactic sense. François Blondel was perhaps the first architect who gave this academic turn to the old Italian ideas on proportion. Almost a whole book of his *Cours d'architecture,* 1675-83, deals with musical proportions in architecture. His approach to the problem is historic and apologetic, for, in contrast to his Renaissance predecessors, he has to prove a case of which many of his contemporaries were ignorant. Alberti's theory and Palladio's buildings were, as one would expect, used as test cases for his theory; a whole chapter is devoted to an analysis of façades by Palladio, for the proportions of which Blondel found the key in the simple consonances 9,6,4; 6,4,3; 4,2,1, etc. The answer to Blondel was given by Claude Perrault in his *Ordonnance des cinq espèces de colonnes,* 1683. He broke decisively with the conception that certain ratios were *a priori* beautiful and declared that proportions which

follow "the rules of architecture" were agreeable for no other reason than that we are used to them. Consequently, he advocates the relativity of our aesthetic judgment and, quite logically, maintains that musical consonances cannot be translated into visual proportions.

Blondel's treatise was the result of his teachings at the "Académie royale de l'architecture," to which he was appointed first director in 1671. Eighty years later Briseux wrote his *Traité du Beau essentiel dans les arts*, 1752, in defense of Blondel's principles, against Perrault. The author is well versed in Platonism, and he even harnesses Newton's theory of color in support of the ancient truth. Much of his material was based on Blondel whom he follows entirely in the choice and interpretation of the Palladian examples. But in spite of Briseux's claim to the universality of harmonic ratios, he is much concerned with demonstrating that *les mêmes proportions produisent les mêmes effets,* thus revealing a shift of emphasis from universally valid to psychologically conditioned standards.

In his work, Briseux tried to revive a tradition which was in danger of being forgotten. In fact, the chain was broken and proportion in architecture was regarded as a mystery the knowledge of which had to be rediscovered. William Gilpin, in his *Three Essays on Picturesque Beauty*, mourned: "The secret is lost. The ancients had it . . . If we could only discover their principles of proportion . . ." Half a century before him Robert Morris, an architect associated with the Burlington group, believed, in his *Lectures on Architecture*, 1734-36, that he had found the secret "which was by the Antients found out, and but by a few Moderns known and practis'd." For this classicist, Palladio was, of course, the chief restorer of ancient wisdom and, guided by his works, he developed a system of hard and fast rules of harmonic proportions based on the "only seven distinct notes in music" the ratios of which "produce all the Harmonick Proportions of Rooms." From ready-made tables the reader or architect can pick out the shape of rooms, façades, doors, and chimneys with the correct harmonic proportions.

The break with the great tradition of the sixteenth century and the isolation of the problem of proportion is

also to be observed on Italian soil. The architect Octavio Bertotti Scamozzi, undoubtedly the most penetrating student of Palladio, asserted to have found that Palladio used musical ratios; but he made this discovery only after his work *Les Bâtimens et les desseins d'André Palladio* (1776-83) was well on the way. In the preface to his third volume he submits his ideas on that point to the judgment of the critics. After having carefully studied the proportions of Palladio's buildings, he declares to have come to the conviction that they depend *des principes beaucoup plus solides que ce qu'on appelle bon goût dans le sens vulgaire*. These *principes solides*, the musical ratios, are discreetly pointed out by him in the descriptions of Palladio's buildings. It is apparent that Bertotti Scamozzi had no idea of the general principles which directed a Renaissance mind. Though his results are often convincing, because they are obvious to those who are familiar with Palladio's methods, he developed his thesis entirely in a void. Briseux's book had come to his knowledge just before his work was finished, and he notes with satisfaction the correspondence of their conclusions. What he did not know, however, was that discussions on harmonic proportions had been going on all the time and that in the neighboring Treviso they were even practiced in his own days.

In 1762 appeared Tommaso Temanza's *Vita di Andrea Palladio*, which is still one of the most important sources for Palladio's life. Temanza states that in the ratios of length, width and height of his rooms Palladio made clever use of the arithmetic, geometric and "harmonic" means "as is clearly manifest in his works." On this point began a controversy with the Trevisan architect Francesco Maria Preti, which is worth recording because it throws light on the ideas about proportion in architecture and music during the late eighteenth century. Preti, apparently still dependent on Zarlino, advocates *una legge stabile e ferma* which is alone guaranteed by the musical progression 1,2,3,4,5,6 (octave, fifth, fourth, major and minor third). He concludes dogmatically that there is no beauty outside these proportions, for—and here we see the old pattern—the same consonances *che dilettano l'orecchio dilettano anche la visione*. Temanza in his long-winded

answer agreed that in the widest sense numbers regulate buildings as well as music. He still insists on commensurability throughout a structure; but apart from that, proportions in music and architecture are widely different. His criticism of the general applicability of musical consonances in architecture boils down to two objections which reveal an entirely new standpoint. The one objection is that the eye is not capable of perceiving simultaneously the ratios of length, width and height of a room; the other, that architectural proportions must be judged from the angle of vision under which the building is viewed. In other words, architectural proportions cannot be absolute but must be relative. The emphasis has shifted from the objective truth of the building to the subjective truth of the perceiving individual. It is for this reason that Temanza regards the use of the mean proportionals as *più misterioso che ragionevole*. It will be noticed that Temanza's theoretical position is not quite clear; for in spite of his introducing revolutionary factors into the problems of proportion, he still cannot get away from traditional notions. In a later letter addressed to Bottari in which Temanza again states his case, he insists that the use of harmonic proportions in architecture would lead to sterility. For an eighteenth-century classicist this was a very sound observation.

F. M. Preti, Temanza's opponent, had grown up in Treviso in a stubbornly academic tradition, according to which only the "harmonic" mean should be used to determine the height of a room. Giovanni Rizzetto (b. 1675), mathematician and architect, had worked out the theory. His son Luigi Rizzetto, Ottavio Scotti, Andrea Zorzi, Jacopo Riccati and his sons Vicenzo, Giordano and Francesco and, last but not least, Francesco Maria Preti, all of them interested in mathematics and music, had consolidated the harmonic system of proportions, convinced that musical consonances had to be applied to architecture. Preti (d. 1774) was perhaps the most prolific theorist and practitioner of the school which left a number of buildings in Treviso and the province, erected strictly according to the rules of musical harmony. But the school of Treviso was no more than a late and provincial survival of the Renaissance tradition, without that cosmic vision which

had given it breadth and universality. This fact is amply illustrated by the dry, neo-classical imitation of Palladio in that school.

It is true that the speculations about the applicability of musical proportions to art and architecture had a stronger appeal during the middle and second half of the eighteenth century than is generally realized. Girolamo Francesco Cristiani, engineer and mathematician, advertised the conclusions of the school of Treviso at Brescia; and some men of reputation wrote treatises on the subject which—and this seems characteristic—remained unpublished: foremost amongst them were a *Dissertazione metafisica del bello* by the celebrated translator and commentator of Vitruvius, Marchese Galiani, and works by the Roman painter Niccolò Ricciolini, and the architect Antoine Derizet. They made, according to Galiani, *profondi studi, ricerche, esami, e scoperte sopra l'applicazione delle proporzioni musiche all'Architettura.*

Derizet was a friend of Anton Raphael Mengs, and from that fact we may perhaps derive an idea of the trend of his thought. Mengs' friend and the editor of his writings, Giuseppe Niccola D'Azara, reports how he found the painter whistling and singing while painting the "Annunciation," his last picture. When asked for the reason, Mengs explained that what he was singing was a sonata by Corelli, for he wanted his picture to be in Corelli's musical style. This "materialistic" eighteenth-century approach to the translation of music into painting throws a strong light on the change which had come about since the days of the Renaissance, when the conception of one universal harmony towered behind both music and the visual arts.

But another almost anachronistic architectural author and practitioner deserves mention, namely Bernardo Antonio Vittone from Turin, whose *Istruzioni elementari* of 1760 and *Istruzioni diverse* of 1766 are in a class of their own. The dedication of the *Istruzioni elementari*—probably unique of its kind—is addressed to God, "the archetype of perfection" who has revealed harmony and beauty to mankind. Like Briseux, Vittone uses Newton's discoveries in support of the universal applicability of the law of numbers, and he is deeply convinced that a knowledge

of musical theory is essential for an understanding of proportion in architecture. He therefore includes a chapter on the "Generation and Nature of Musical Proportion" which is still dependent on Zarlino, and his *Istruzioni diverse* contains an extensive and cumbersome treatise on music. It is idle to speculate on the fact that for Vittone, the only really creative architect Italy had at this period, the great Renaissance tradition was still a living force.

The relation in the academic camp between Perrault and Briseux finds an interesting parallel in the Baroque atmosphere of Turin. For eighty years before Vittone's publication, Guarino Guarini—for whom Vittone had a great veneration and whose treatise on architecture he even published posthumously—had broken with the Renaissance tradition. Guarini's line of argument differs from that of Perrault and is, in a way, more radical. The eye of the percipient is for him the only judge of proportion— *per compiacere agli occhi, si dee levare, o aggiungere alle Simmetrie, essendo che altro un'oggetto appare sotto l'occhio, altro appare in alto, altro in un luogo chiuso, altro in aperto*—and he does not even discuss the possibility of objective truth on which Renaissance aesthetics was founded. In the same vein, a hundred years later, Milizia, the foremost Italian theorist of the late eighteenth century, subordinated the rules of proportion to those of perspective, as buildings are seen at different distances and in different situations. He goes a decisive step further on the path shown by Temanza twenty years before; his theory of proportion depends on sensation and, like Guarini's, is based on the impression which a building makes on the eye. Logically he refutes the efficacy of the three mean proportionals, and even the necessity of commensurable dimensions. Proportion for him is a matter of experiment and experience. The modern approach of the architect to the problem of proportion is taking shape.

It was, however, in England that the whole structure of classical aesthetics was overthrown from the bottom. Hogarth was only the mouthpiece of the new tendencies when he rejected any congruity between mathematics and beauty. Without an idea of the universality of the classical conception of proportion, he comments on the "strange

notion" that because "certain uniform and consonant divisions upon one string produce harmony to the ear," "similar distances in lines belonging to form, would, in like manner, delight the eye. The very reverse of which has been shown to be true . . . yet these sort of *notions* have so far prevail'd by time, that the words, *harmony of parts,* seem applicable to form, as to music."

The man in whom the new ideas found the most marked expression was Hume. Just as he declared that "all probable reasoning is nothing but a species of sensation," so he turned objective aesthetic into subjective sensibility. In his essay *Of 'the Standard of Taste,* first published in 1757, he broke with unprecedented boldness with the basic axiom of all classical art theory, according to which beauty is inherent in the object provided the latter is in tune with the great harmony. "Beauty," he said, "is no quality in things themselves: It exists merely in the mind which contemplates them; and each mind perceives a different beauty . . . To seek the real beauty, or real deformity, is as fruitless an inquiry, as to pretend to ascertain the real sweet or real bitter"; and later: "To check the sallies of the imagination, and to reduce every expression to geometrical truth and exactness, would be the most contrary to the laws of criticism; because it would produce a work, which, by universal experience, has been found the most insipid and disagreeable."

In the same year 1757 appeared Burke's *Enquiry into the Origin of our Ideas of the Sublime and Beautiful.* With his sensual and emotional approach and his exaltation of sublimity he subjected the classical conception of proportion to a detailed analysis and tore it to shreds. He denied that beauty had "anything to do with calculation and geometry." Proportion is, according to him, solely "the measure of relative quantity," a matter of mathematical inquiry and "indifferent to the mind." His further analysis shows again that his generation had lost the faculty of understanding even the most general principles of the classical conception. He does not see that the Beauty of the classical theory has its roots in the idea of an all-pervading harmony, which is an absolute and mathematical truth, and he is therefore unable to grasp that, for instance, ratios

of parts of a body remote from each other may be compared. Nor can he understand the relation between the human body and architecture which was, as will be remembered, at the basis of Renaissance thought on proportion. What he says on this point reveals most clearly the complete break with the past which, for the perception of proportion, the age of empiricism and emotionalism had brought about. "I know that it has been said long since, and echoed backward and forward from one writer to another a thousand times, that the proportions of building have been taken from those of the human body. To make this forced analogy complete, they represent a man with his arms raised and extended at full length, and then describe a sort of square, as it is formed by passing lines along the extremities of this strange figure. But it appears very clearly to me, that the human figure never supplied the architect with any of his ideas. For in the first place, men are very rarely seen in this strained posture . . ." Burke winds this point up with the remark: "And certainly nothing could be more unaccountably whimsical, than for an architect to model his performance by the human figure, since no two things can have less resemblance or analogy, than a man, and a house or temple."

Lord Kames, in his *Elements of Criticism*, 1761, is perhaps "reactionary" as compared with Burke, and yet he launched a frontal attack against the translation of musical consonances into architecture. He begins his discussion with the words: "By many writers it is taken for granted, that in buildings there are certain proportions that please the eye, as in sounds there are certain proportions that please the ear; and that in both equally the slightest deviation from the precise proportion is disagreeable." From this it is evident that he too was unaware of the deeper bond that for a Renaissance mind united ratios in music and visible objects. He argued against the doctrinal Blondel-Briseux-Morris-Preti interpretation. It is therefore only logical when he carries on: "To refute the notion of a resemblance between musical proportions and those of architecture, it might be sufficient to observe in general, that the one is addressed to the ear, the other to the eye; and that objects of different senses have no re-

semblance, nor indeed any relation to each other." In support of this he refers to the octave which is the most perfect musical concord; but a proportion of one to two, he asserts, is very disagreeable in any two parts of a building. Here his eighteenth-century taste contrasts with that of the Renaissance when, as we have seen, a ratio of 1:2 in architecture was regarded as faultless. His main line of attack is not dissimilar to that of the Italian critics. Judgment of proportion rests with the percipient. As we move about in a room the proportions of length to breadth vary continuously, and if the eye were an absolute judge of proportion one "should not be happy but in one precise spot, where the proportion appears agreeable." Therefore we can congratulate ourselves that the eye is not "as delicate with respect to proportion as the ear is with respect to concord"; if it were, this "would not only be an useless quality, but be the source of continual pain and uneasiness." Thus, apart from the subjective approach to proportion, Lord Kames introduced as a new element the limitations of human sight—an idea utterly foreign to Renaissance theory.

Alison's theory of association, anticipated by Burke, exposes perhaps most clearly the significance of the revolution which had occurred in the course of the eighteenth century. He maintains that any abstract or ideal standard destroys the function of a work of art. It is the "trains of thought that are produced by objects of taste," the spontaneous stimulus to the imagination which make a work beautiful and sublime. "The sublimity or Beauty of Forms arises altogether from the Associations we connect with them, or the Qualities of which they are expressive to us." In Alison's footsteps Richard Payne Knight, in his *Analytical Inquiry into the Principles of Taste*, 1805, declared that proportion "depends entirely upon the association of ideas, and not at all upon either abstract reason or organic sensation; otherwise, like harmony in sound or color, it would result equally from the same comparative relations in all objects; which is so far from being the case, that the same relative dimensions, which make one animal beautiful, make another absolutely ugly . . . but the same proportionate combinations of sound, which produce harmony

in a fiddle, produce it also in a flute or a harp." Thus, a pseudological proof was found to show that musical harmony and spatial proportions cannot have anything in common.

Against the background of a new conception of the world the whole structure of classical aesthetics was systematically broken up, and in this process man's vision underwent a decisive change. Proportion became a matter of individual sensibility and in this respect the architect acquired complete freedom from the bondage of mathematical ratios. This is the attitude to which most architects as well as the public unconsciously subscribed right down to our own days. It is hardly necessary to support this statement with a great many quotations; but brief reference may be made to two authors who interpreted the general feeling on this point. Ruskin declared that possible proportions are as infinite as possible airs in music and it must be left to the inspiration of the artist to invent beautiful proportions. Julien Guadet, in the *Eléments et théorie de l'architecture,* the often reprinted handbook of the students of the "Ecole des Beau-Arts" in Paris, explains that in order to establish a dogma of proportions, authors of the past had invoked science. But *elle n'a rien à voir ici; on a cherché des combinaisons en quelque sorte cabalistiques, je ne sais quelles propriétés mystérieuses des nombres ou, encore, des rapports comme la musique en trouve entre les nombres de vibrations qui déterminent les accords. Pures chimères . . . Laissons là ces chimères ou ces superstitions. . . . Il m'est impossible, vous le concevez bien, de vous donner des règles à cet égard. Les proportions, c'est l'infini.*

"*Les proportions, c'est l'infini*"—this terse statement is still indicative of our approach. This is the reason why we view researches into the theory of proportion with suspicion and awe. But the subject is again very much alive in the minds of young architects today, and they may well evolve new and unexpected solutions to this ancient problem.

HEINRICH WÖLFFLIN

CLASSIC ART *(1899)*

PRINCIPLES OF ART HISTORY *(1915, 1932)*

NO BOOK in modern art-criticism has stimulated more fruit-
ful discussion than *Principles of Art History,* an essay con-
trasting two modes of artistic vision that Wölfflin called
Renaissance and Baroque. The introduction to this work
summarizes the differences between Renaissance and Ba-
roque forms by means of five contrasting principles, each of
which involves a way of looking at the world. As he him-
self later said, Wölfflin never intended to have these polar
contrasts applied too literally or completely, and many
critics have doubted the validity of his scheme; yet criti-
cism of both the fine arts and literature has been widely
affected by his thesis, which interpreted Renaissance and
Baroque, but ignored that intermediate mode of vision
that has since been called Mannerism. In his earlier work
on *Classic Art,* Wölfflin often invokes his contrasting prin-
ciples to illustrate the differences between paintings by
Leonardo, Michelangelo, Raphael, Andrea del Sarto, and

Fra Bartolommeo. Wölfflin's analysis of architecture is found chiefly in his *Renaissance und Barock* (1908, 1926). In *The Sense of Form in Art* (1931, 1958) he develops a correlative scheme of contrasting principles to explain differences between Germanic and Italian art. And in *Gedanken zur Kunstgeschichte* (1941) he looks back over his own work, making qualifications.

Wölfflin's theories have inspired many works on art forms, such as Hans Hoffman's *Hochrenaissance, Manierismus, Fruehbarock* (1938), and Karl Scheffler's *Verwandlungen des Barocks in der Kunst des neunzehnten Jahrhunderts* (1947). Sidney J. Freedberg's *Painting of the High Renaissance in Rome and Florence* (1961) is a monumental re-examination of the "classic" painting. Two special issues of the *Journal of Aesthetics and Art Criticism* (December, 1946, December, 1955) are devoted to Baroque style in the arts. Other important studies of Baroque are Timon H. Fokker: *Roman Baroque Art* (1938), and Werner Weisbach: *Der Barock als Kunst der Gegenreformation* (1921); and Geoffrey Scott: *Architecture of Humanism* (1924) is a famous commentary, along with the impressionistic *Lo Barroco* (1944) by Eugenio d'Ors.

CLASSIC ART

THE NEW PICTORIAL FORM (Part II, Chapter 3)

This final chapter must deal with the new methods of presentation, by which we mean the way in which a given object is made into a visual image suitable for use in pictorial form, in the sense in which the concept of "pictorial form" is applicable to all the visual arts.

It is obvious that the new feelings for mass and movement, as already expounded, must make themselves felt as conditioning factors in the form of a picture; that the concepts of repose, grandeur, and importance in the impression to be made by a picture will emerge as the decisive

elements, irrespective of the actual subject depicted. This does not exhaust the underlying causes of the new pictorial form, for others come into play, independent of the preceding diagnoses and definitions, and which cannot be deduced from them; causes without relation to feelings and states of mind, but which are simply the results of a more complete cultivation and education of the eye. These are the real artistic principles—on the one hand, clarification of the visible object and simplification of appearances, and, on the other, the desire for ever greater variety of content within the field of vision. The eye desires more, because its powers of absorption have been significantly increased, but at the same time pictures have become simpler and more lucid, insofar as the objects represented have been better prepared for the eye. And there is yet a third factor —the capacity to see parts collectively and simultaneously, the power of grasping the variety of things in the field of vision as a single unit, which links up with a type of composition in which every part of the whole is felt to have its necessary and inevitable place within that whole.

These are matters which can be treated only in one of two ways: either at very great length or else very briefly —that is by speaking, as it were, in headlines, for a moderate length would be more likely to bore the reader than enlighten him. I have chosen the shorter way, which alone is suitable to the framework of this book. If, therefore, this chapter seems rather inconsiderable, the author may be permitted to remark that, nevertheless, it was not quickly written and that it is probably an easier task to collect running quicksilver than to catch and fix the different impulses which go to make the concept of a mature and complex style. The novelty of the attempt must serve as an excuse—at any rate, a partial excuse—if this section is more than usually lacking in those things which make for easy reading.

REPOSE, SPACIOUSNESS, MASS AND SIZE

The pictures produced in any one generation have, considered as a whole, as individual a pulse beat as the works of any one master. Quite independently of the sub-

ject depicted, the line may flow restlessly and hastily, or with measure and calm; the planes may be so filled that they appear cramped, or the objects may be so disposed as to appear easy and surrounded with space; and the modeling may be petty and jerky or broad and connected. After what has already been said about the new beauty of the *cinquecento,* in its feeling for the body and its movements, it is to be expected that the pictures themselves would become calmer, more massive and spacious. A new relationship is established between the space represented and the objects which are disposed within that space, the compositions become more impressive and weighty, and in contour and modeling we perceive the same serenity, the same reticence, which are inseparable from the new beauty.

The contrast leaps to the eye, if we put the "Madonna with the book," a youthful work of Michelangelo's, beside a similar tondo relief by Antonio Rossellino, who may be taken as typical of the older generation. In the latter, we have glittering diversity; in the former, a simple style based on large planes: it is not just a question of leaving things out and simplifying the subject matter—this has already been discussed—but of the handling of the planes themselves. When Rossellino enlivens his background with the flicker of light and shade in his rocky landscape and adorns the flat plane of the sky with little wisps of frizzy cloud, it is simply a continuation of the style in which the head and hands are also modeled. Michelangelo first looked for the major planes in the human form and then related them to each other, and, in doing this, the question of how to treat the remainder solved itself. The same principles hold good for painting: here, too, the delight in caprices and in multiplicity of small surface undulations ceases and gives way to a desire for large, still masses of light and shade. In music, the direction would be *legato.*

The stylistic change is, perhaps, still more clearly visible in the handling of line. *Quattrocento* line has a somewhat abrupt intricacy, for the draftsman's main interest is in form in movement, and unconsciously, he overdoes the movement in the silhouette, the hair and in every detail of form. The shape of the mouth, with the full curves of

the lips, is one which the *quattrocento* made peculiarly its own, and a Botticelli or a Verrocchio sought with an almost Düreresque energy to give a convincing representation of the movement inherent in parted lips, the curve of the lips themselves and the swing of the outline defining their contour. In the same way, the nose, with its cartilages giving it the greatest variety of forms, became one of the favorite features of the fifteenth century. The movements of the wings of the nostrils were modeled with the deepest interest, and scarcely any of the *quattrocento* portraitists could forego showing the holes of the nostrils.

This style disappears with the century and the *cinquecento* brings in with it a chastened flow of line: the same model would now have been drawn quite differently, because the artists' eyes saw differently. It now seems that a new sympathy has been aroused for the line in itself, as if it were now conceded that it has a right to live its own life: harsh junctions, violent breaks in continuity and breathless involutions are all avoided. Perugino began the process and Raphael continued it with incomparable sensibility, but even other men of entirely different temperament came to realize the beauty of a noble sweep of line, a rhythmic cadence. It was still possible for Botticelli to make a sharp elbow come right up against the picture frame ("Pietà," Munich); but now the lines take account of one another and make concessions where necessary, with the result that the eye becomes sensitive to the sharp bisections of the older manner.

The general desire for greater spaciousness necessarily entailed a new relationship between the figures in a painting and the space which surrounded them, a relationship which, in the earlier pictures, was now thought to be cramped. The figures in these earlier works stand right at the front of the stage and thus create an impression of insufficient space which is not dispelled by the halls or landscapes in the background, however extensive they may be. Even Leonardo's "Last Supper" shows some of this *quattrocento* limitation, in that the table is brought forward to the very edge of the stage. The portraits of the period show the normal relationship—how uncomfortable life must have been in the little room in which Lorenzo di

Credi sets his "Verrocchio" (Uffizi) by comparison with the large airiness of *cinquecento* portraits. The new generation wanted air and the possibility of movement, and they obtained these primarily by increasing the amount of the figure depicted—the three-quarter length portrait is a sixteenth-century invention—but, even when they showed only a small part of the body, they were now able to give the impression of spaciousness, and Castiglione seems quite content with his existence inside the boundaries of his frame.

In like fashion, the frescoes of the *quattrocento* generally appear cramped and fitted tightly into position. Fra Angelico's frescoes in the Chapel of Nicholas V in the Vatican have a cramped appearance, and in the chapel of the Medici Palace, where Gozzoli painted the "Procession of the Three Kings," the spectator cannot quite shake off a feeling of discomfort, in spite of all the ceremonial splendor. Much the same must be said even of Leonardo's "Last Supper": we expect a frame or border which the picture has not got, and never can have had.

It is characteristic of Raphael that he should have developed during the course of the *Stanze,* and, if we look at one fresco in the Camera della Segnatura—the "Disputà," for example—by itself, we do not notice anything wrong with its relationship to the wall on which it is painted; but if we look at two pictures together, at the point at which the corners touch, we become conscious of an old-fashioned lack of perception of spatial values. In the second *Stanza,* the junction of the walls is treated differently and the format of the pictures, in view of the space available, has been made noticeably smaller.

It is no contradiction if, in spite of the desire for spaciousness, the figures gain in size in proportion to the frame. It was felt that they should have a more imposing effect as masses, since there was now a tendency to seek beauty in solidity. Superfluous space was avoided because it was realized that this makes the figures less forceful in appearance, and the means were at hand to give the impression of breadth in spite of limitations of apparent extent.

The tendency was towards compactness, solidity,

weightiness. The horizontal gained in importance, and, as a result, the outline of a group was lowered and broadened, making a triangular group with a broad base out of what had been a high pyramid: Raphael's Madonnas furnish the best examples of this. The arrangement of two or three standing figures in a closed group is to be interpreted in the same way; and the older pictures which attempt groupings of figures seem thin and fragmentary, and, as wholes, light and almost transparent by comparison with the massive solidity of the new style.

Finally, as an inevitable result, there was a general increase in absolute size—the figures grew, so to speak, under the artists' hands. It is a well-known fact that Raphael continually increased the scale in the *Stanze*: Andrea del Sarto surpassed himself with his "Birth of the Virgin" in the court of the Annunziata, and was in turn surpassed by Pontormo. So great was the joy in the powerful that even the newly awakened sense of unity made no protest. This is equally true of easel pictures and one can observe the change in any Gallery; where the *cinquecento* pictures begin, the pictures are larger and so are the figures in them. We shall have to speak again, later on, about the way in which the individual picture was included in the architectural context, and how it was no longer seen for itself alone, but as part of the wall for which it was intended; so that from this point of view alone paintings were bound to increase in size, even if the art had not been moving in this direction of its own accord.

The style characteristics just mentioned are of an essentially material nature, and correspond to the expression of a specific emotion; but, as I have already said, other elements, of a formal nature, now come on the scene and they bear no relation to the temper of the new age. These matters cannot be balanced one against the other, with mathematical precision, for "simplification," in the sense of introducing calm, encounters a simplification which aims at the maximum of lucidity in the picture, while the tendency towards the massive and the comprehensive is countered by a strongly developed will towards ever-increasing richness of the visual image—that will which created groups concentrated into a single major

unit, and which first revealed a complete mastery of the third dimension. On the one hand, the intention is to make the act of perception as easy as possible for the eye, and, on the other hand, to pack the maximum amount of content into the picture.

We shall now turn to those things which may be grouped under the headings of simplification and lucidity.

SIMPLIFICATION AND LUCIDITY

Classic art reverts to the elementary vertical and horizontal for major axes of direction, and to the primitive fullface and pure profile aspects. It was possible to achieve entirely new effects with these means, since the *quattrocento* had abandoned such extreme simplicity of axis and aspect in its attempt to render movement at any cost. Even an artist like Perugino, who thought in terms of simplicity, does not have a single pure profile in, for example, his "Pietà" in the Pitti, nor is there ever an absolutely fullface view. Now, when artists possessed the whole range of variety, the primitive suddenly gained a new value: it was not that painters were deliberately archaizing, but that they came to realize the effect of simplicity in the midst of riches, since it forms a standard, a norm, which steadies the whole picture. Leonardo appeared as an innovator when he framed his "Last Supper" between two profiles set on absolutely vertical axes—that, at least, was something he could not possibly have learned from Ghirlandaio. From his earliest beginnings, Michelangelo was aware of the value of simplicity, and Raphael has scarcely a picture, at any rate among his mature works, which does not strike us by its conscious use of simplicity to obtain a strong and emphatic effect. Who among the older generation would have dared to render the Swiss Guards in the "Mass of Bolsena" as he did, three verticals side by side? Yet just this simplicity works wonders here, and in the most exalted place, the "Sistine Madonna," he employs a simple vertical with enormous effect, a primitive element in a setting of the most finished art. Fra Bartolommeo's architectonic constructions would be inconceivable without a reversion to these elementary principles.

If we take a single figure, such as Michelangelo's reclining Adam on the Sistine ceiling, which looks so solid and secure, we must admit that the effect could not have been obtained without the placing of the chest in such a way that its full breadth is visible; it is impressive because it is the "normal" view, obtained under difficulties, and the figure is thus secured in place with a certain inevitability. Another example of the effect of such a tectonic view, as one may call it, is the seated figure of St. John preaching, by Raphael (Tribuna of the Uffizi). It would have been easy to give him a more striking, or more picturesque, attitude; but as he sits there with head erect and the full width of his chest towards us, it is not only the preacher's mouth which speaks, for his whole form cries out from the picture and this effect could not have been obtained in any other way.

Simple schemes governing the play of light were also sought for in the *cinquecento*: we find heads seen in full-face which are divided equally down the line of the nose—that is, with one half dark and the other light—and this type of illumination readily combines with the highest beauty, as in Michelangelo's "Delphic Sibyl" and Andrea del Sarto's idealized "Head of a Youth." Another method of securing a calm and peaceful effect, when the light fell from high above the figures, was to give an equal amount of shadow to both eye sockets, as, for example, in the St. John in Fra Bartolommeo's "Pietà" or Leonardo's "Baptist" in the Louvre. All this does not mean that such methods of lighting were always used, any more than simple axes of direction were: it was simply that the effectiveness of simplicity was sensed, and its special value realized at its true worth. In Sebastiano's early picture in S. Crisostomo in Venice, there are three female saints standing together at the left, and I must adduce this group as a particularly striking example of the new method of arrangement, although I am not speaking of the bodies but only of the heads. It is an apparently very natural choice: one profile, one—more prominent—in three-quarter view, and the third which is tilted to one side, intrinsically less important and also subordinated in lighting, forming the only inclined line next to two verticals. If we now go

through the whole repertory of *quattrocento* examples in search of a similar arrangement we shall soon be convinced that the simple was not always the obvious. The feeling for it revived only in the sixteenth century, and yet in 1510, in the very shadow of Sebastiano, Carpaccio could still paint his "Presentation in the Temple" (Venice, Academy) with its three female heads side by side, almost entirely in the older style, all three of equal importance, each slightly different in inclination and yet not one of them decisively different, without pre-eminence or subordination and without clear contrast.

COMPLEXITY

The complete emancipation of bodily movement must head the list of advances in knowledge made in the sixteenth century, for it is this which is the primary condition of the richness of effect made by *cinquecento* pictures. The body seems endowed with greater vitality and the spectator's eye is invited to increase its activity. This movement is not to be understood as a change of position in space, for the *quattrocento* already has a great deal of running and jumping, although a certain poverty and emptiness is inseparable from it, insofar as a restricted use is made of human articulations and joints, and the possibilities inherent in twists and bends of the major and minor joints were usually explored only to a rather limited degree. The sixteenth century starts from here, with a developed use of the human body and an enrichment of the total image presented by even a motionless figure, so that we realize we are on the threshold of an entirely new epoch. All at once, the axial directions of the body are increased and varied, and what was formerly thought of as merely a plane surface is now thought out in depth as well, becoming a form-complex in which the third dimension plays its part.

It is a widespread error among dilettanti that all things are possible at all times, and that art, as soon as it has acquired any expressive power at all, is capable of rendering all movement equally well; yet, in fact, the real development is exactly like that of a plant slowly putting

forth leaf after leaf until it stands rounded and complete, reaching out in all directions. This calm and orderly growth is peculiar to all organic art forms although it is seen at its purest in the antique and in Italian art.

I repeat that this is not a question of movements which aim at some goal or further a specific new expression. It is simply the more or less elaborated representation of a seated, standing or leaning figure, which has the same principal function as before, but which is capable of a very different pattern of limbs and torso, by means of contrasts in the turn of the upper half of the body upon the lower, between head and torso, by the raising up of one foot, by the reaching of the arm across the body or the thrust forward of one shoulder and suchlike further possibilities of movement. Immediately, certain laws were formulated and applied to the use of these motives; and *contrapposto* is the name given to inverse correspondences, such as that when the bending of a right leg corresponds to the bending of a left arm or *vice-versa*, yet this concept of *contrapposto* must not be taken to cover the whole phenomenon.

One may imagine a set of tables laying down the differentiations of corresponding parts of the body in this sense—arms and legs, shoulders and hips—which would give an abstract of the newly discovered possibilities of movement in all three dimensions: however, the reader will not expect any such thing here and will be content with a few selected examples, since so much has already been said about plastic variety of form. The workings of the new style can be seen most clearly when the artist had to deal with an absolutely motionless figure, as in the Crucifixion, when it would seem that no variation was possible because the hands and feet were fixed in position. Yet the *cinquecento* was able to make something new from this apparently barren motive by subordinating one leg to the other through the placing of one knee over the other, and by twisting the figure as a whole so that there is a contrast of direction between the upper and lower parts—this has already been mentioned in connection with Albertinelli. It was Michelangelo who pushed this motive to its ultimate conclusion, and, incidentally, it was he who added emo-

tion, for he created the type of Crucified Christ whose eyes are directed upwards and whose mouth opens to cry out in anguish. . . .

If the sixteenth century introduces a new richness in axial directions, it does so in the context of a general opening up of space. The *quattrocento* was still bound by the spell of the flat plane, placing its figures side by side across the breadth of the picture and composing in strata: in Ghirlandaio's "Birth of St. John the Baptist" the principal figures are all developed along one plane—the women with the child, the visitors and the maid with the fruit, all stand along one line parallel to the picture plane. In Andrea del Sarto's composition it is quite different, for the pure curves, the movement in and outwards, give the impression that the space has been vitalized. All the same, such antitheses as "composition on the plane" and "space-composition" must be taken with a grain of salt, for the *quattrocentisti* themselves made attempts to secure depth, and there are compositions of the "Adoration of the Kings" which employ every means known to them to push the figures back into the middle-distance or the background, away from the front of the stage, but the spectator generally loses track of the thread which was supposed to lead him into depth. In other words, the picture falls apart into disparate strata. The real significance of Raphael's great space-compositions in the *Stanze* is best taught by Signorelli's frescoes in Orvieto, which the traveler usually sees immediately before he reaches Rome. It seems to me that the contrast between two epochs is completely represented by the difference between Signorelli, whose masses of figures seem to close up at once like a wall in front of us, so that he is only able to show, as it were, the foreground of his vast spaces, and Raphael, who, from the beginning, effortlessly develops all the abundance of his forms outwards from the depths of the picture towards us.

We can go still further and say that the whole conception of form possessed by the fifteenth century is two-dimensional. Not only is the composition stratified but even the individual figures are thought of as silhouettes, though not in the literal sense of the word, yet there is a difference between Early and High Renaissance draughts-

manship which can scarcely be formulated in any other
way. Once again I rely on Ghirlandaio's "Birth of St. John,"
in particular on the figures of the seated women. Must we
not admit that the painter has projected the figures flatly
on a plane surface? And then, by contrast, there is the arc
of the servant girls in Sarto's birth scene, where the prin-
cipal search is for the effects of salience and recession in
the parts—that is, the drawing seeks foreshortened, and
not two-dimensional aspects of form. Another example is
provided by Botticelli's "Madonna with the two Sts. John,"
in Berlin, and Andrea del Sarto's "Madonna delle Arpie."
Why is it that Andrea's St. John the Evangelist is so much
more rich and varied in effect? It is true that he is superior
in movement, but, more than this, the movement is so
rendered that the spectator is led to entertain immediately
ideas of plasticity and to experience, in imagination, the
projection and recession of the forms. Quite apart from
light and shade, there is a different spatial effect because
the vertical plane is broken and a tangible three-dimen-
sional image substituted for a flat two-dimensional one. In
this three-dimensional image the axis of depth—i.e., pre-
cisely the foreshortened aspect—is given the freest rein.
There had been foreshortenings employed before this time,
and from the beginning of the *quattrocento* we can match
artists grappling with the problem, but now the matter
seems to have been settled thoroughly and definitely, so
thoroughly that it is permissible to speak of a fundamen-
tally new conception of it. In the "Madonna" by Botticelli
already referred to there is also a figure of St. John point-
ing with his finger in the characteristic attitude of the
Baptist, and the placing of the arm in the picture-plane,
parallel to the spectator, can be found right through the
fifteenth century and has exactly the same form in the
preaching St. John as here, where he points to the Christ
Child. The fifteenth century was scarcely finished before
attempts were made everywhere to work free of this two-
dimensional style, and, within the limits of the illustrations
in this book, the best evidence for this may be found in a
comparison between Ghirlandaio's and Sarto's pictures of
St. John preaching.

In the sixteenth century foreshortening was **reckoned**

the summit of drawing and all pictures were judged accordingly. Albertinelli finally became so bored with the eternal talk about *scorzi* that he exchanged his easel for the bar of his public-house, and a Venetian dilettante like Ludovico Dolce would have endorsed his opinion—"Foreshortenings are really only a matter for experts, so why give oneself all this trouble over them?" It is likely enough that this was the general opinion in Venice and it must be admitted that Venetian painting already possessed means enough to delight the eye, so that they may have felt it unnecessary to seek information on these attractions of the Tuscan masters. In Florentine and Roman painting, however, all the great masters took up the problem of the third dimension.

Certain motives, such as the arm pointing out of the picture or the bowed head seen fullface and foreshortened, occur everywhere almost simultaneously, and it would be not uninteresting to go into the statistics of these cases. Yet it is not so much a matter of single pieces of virtuosity and astounding *scorzi:* what is really important is the universal change in the projection of objects on to a flat plane, the habituation of the eye to three-dimensional images. . . .

UNITY AND INEVITABILITY

Composition, as an idea, is of long standing and was a matter for discussion even in the fifteenth century, yet in the strict sense of the word—the correlation of parts, ordered in such a way that they must be seen simultaneously and in relation to one another—it really occurs first in the sixteenth century, and what formerly passed as composition is now seen to be mere aggregation, lacking any special form. The *cinquecento* not only grasped a grander kind of coordination, replacing the earlier close-up treatment, detail by detail, by an understanding of the function of the detail within the framework of the whole, but it also involves a linking-up of the parts, an inevitability of arrangement, which, in fact, makes all *quattrocento* work appear uncoordinated and arbitrary.

The significance of this is made clear by a single example, if we think of the composition of Leonardo's

"Last Supper" in comparison with Ghirlandaio's. In the former there is one central figure, dominating and co-ordinating, and a company of men, each of whom plays the specific part assigned to him within the general action; it is a building from which no single stone could be removed without upsetting the equilibrium of the whole: in the latter picture there is a number of figures, set side by side, without any law governing the sequence and without in-evitability in the actual number of figures represented— there could be more of them, or fewer, and each one could have been posed differently without any really essential change in the appearance of the whole. The symmetrical principle of arrangement was always respected in votive pictures, and there are also secular works, such as Botti-celli's "Primavera," which hold fast to the principle that there should be one figure in the middle and an equal bal-ance of parts on either side. The sixteenth century, how-ever, could not by any means rest content with this: the figure in the middle was still for the *quattrocento* only one among others, and the whole was a collection of parts of approximately equal importance. Instead of a chain of similar links the new desire was for a structure based on decisive pre-eminence or subordination, subordination tak-ing the place of the earlier coordination. In proof of this, I may refer to the simplest instance, the votive picture with three figures. In Botticelli's "Madonna with the two Sts. John" the three people are placed side by side, each an independent element in the composition, while the three equal niches behind them give additional weight to the idea that the picture could be split up into three parts; an idea which is quite inconceivable in front of the classic version of the theme as we see it in Andrea del Sarto's "Madonna delle Arpie" of 1517, where the side figures are still elements and indeed have considerable importance in and for themselves, yet the dominance of the central figure is obvious, and the links binding them to it are unbreak-able. . . .

In this way, artists ceased to regard architectural backgrounds as arbitrary enrichments, to be added on the principle of the-more-the-better, but came to look for inevitability in the relationship between figures and build-

ings. There had always been a feeling that the dignity of human beings could be increased by an architectural accompaniment, but usually the buildings got out of hand and swamped the figures: Ghirlandaio's architectural show pieces are far too rich to provide a suitable foil for his figures, and, in the simple case of a figure in a niche it is astonishing how rarely the *quattrocento* managed to combine them effectively. Filippo Lippi carries the treatment of parts as separate entities so far that his seated "Saints" (in the Academy) never once correspond to the niches in the wall behind them; an exhibition of casual and accidental treatment which must have seemed absolutely intolerable to the *cinquecento*, for it is obvious that he was more interested in the charms of waywardness and agitation, than in dignity. Fra Bartolommeo was able to give his heroic figures majesty by the very different method of making them cut across the top of the niche, as his "Resurrected Christ" in the Pitti shows. It would be superfluous to refer to all the other *cinquecento* examples of effective buildings, where the architecture seems like a potent assertion of the people themselves. However, while we are on the subject of this universal desire to relate the parts of the whole composition one to another we come upon a feature of classic taste which goes beyond painting alone and invites a criticism of the whole of earlier art. Vasari relates an incident which is very typical of this, when he says that the architect of the vestibule to the Sacristy of Santo Spirito in Florence was sharply criticized because the lines dividing the compartments of the barrel vault do not coincide with the axes of the columns—a criticism which might have been made of a hundred other examples.

The lack of lines running through the whole composition and the treatment of each part as an end in itself, without reference to a unified total effect, are among the most striking peculiarities of *quattrocento* art.

From the moment when architecture cast off its immature and playful flexibility and became mature, measured, and severe it took over the reins for all the arts. The *cinquecento* conceived everything *sub specie architecturae*. The sculptured figures on tombs were assigned their fixed positions, framed, enclosed and embedded; nothing can

be moved or altered, even in thought, and we know why each part is exactly where it is, and not a trifle higher or lower—I may refer back to the discussion of Rossellino and Sansovino. The same may be said of painting, and where, as wall decoration, it was related to architecture then it was always architecture which had the last word. What extraordinary liberties Filippino took in his frescoes in Santa Maria Novella! He extends the floor of his stage out beyond the picture-plane so that the figures stand partly on our side of the wall-plane and are thus brought into the most remarkable relationship with the actual elements of the architectural framing. Signorelli did the same thing at Orvieto; Verrocchio's group of "Christ and St. Thomas" provides a sculptural analogy, since the action takes place partly outside the niche. No *cinquecento* artist would have done such a thing, and it became an obvious assumption, a premise taken for granted, that painting had to seek its space within the depth of the wall and that the frame must make clear the entrance to the stage.

Architecture having become unified in style, it required, as a corollary, unity in wall paintings, and Leonardo already held the opinion that pictures should not be painted one above the other on a wall, as was the case with Ghirlandaio's choir decorations, in which we seem to have a view into the different stories of a house, one above the other, and all visible at once. He would scarcely have agreed to the painting of two pictures side by side on the same wall of a choir or chapel, and certainly Ghirlandaio's method is indefensible when it leads him to allow two frescoes to come sharply together—the "Visitation" and the "Rejection of Joachim's Sacrifice"—with the setting apparently continued behind the dividing pilaster; and yet each picture has its own separate perspective scheme, not even consistent with its neighbor.

The tendency to paint in a unifying style on surfaces which had been architecturally unified has become universal since the sixteenth century, but now also the great problem of harmonizing the pictorial decoration with its surroundings was tackled, so that the spatial composition of the picture seemed created precisely for the room or the chapel in which it was situated, and that the one

explained itself by reference to the other and in no other way. When this is achieved the result is a kind of spatial music, an impression of harmony, which is among the most potent effects ever attained by the visual arts.

It has already been said that the fifteenth century paid but scant attention to the unified treatment of a room and concerned itself only with each detail in turn, but this observation can be expanded to include larger spaces as well, such as public squares. We may ask, for example, how the great equestrian statues of "Colleoni" and "Gattamelata" came to be placed as they are, and whether anyone nowadays would have the courage to site them so completely without reference to the main axis of the square or the church. Modern opinion is represented by the two equestrian princes by Giovanni de Bologna in Florence, but, even so, there remains a good deal for us to learn. Finally, the unified conception of space asserts itself on the very greatest scale when buildings and landscape are conceived as an effect from one viewpoint: the layout of villas and gardens, the enclosing of whole panoramas, and similar schemes may be called to mind as instances of this. The Baroque took up these planned effects on a still greater scale; yet anyone who has ever looked out from the high terrace of the incomparably magnificently situated Villa Imperiale, near Pesaro, towards the mountains over by Urbino, where the whole countryside is subordinated to the castle, will have received an impression of the noble discernment of the High Renaissance, which even the most colossal arrangements of later times can hardly surpass. . . .

PRINCIPLES OF ART HISTORY

INTRODUCTION: THE MOST GENERAL

REPRESENTATIONAL FORMS

This volume is occupied with the discussion of these universal forms of representation. It does not analyze the beauty of Leonardo but the element in which that beauty became manifest. It does not analyze the representation of nature according to its imitational content, and how, for instance, the naturalism of the sixteenth century may be distinguished from that of the seventeenth, but the mode of perception which lies at the root of the representative arts in the various centuries.

Let us try to sift out these basic forms in the domain of more modern art. We denote the series of periods with the names Early Renaissance, High Renaissance, and Baroque, names which mean little and must lead to misunderstanding in their application to south and north, but are hardly to be ousted now. Unfortunately, the symbolic analogy bud, bloom, decay, plays a secondary and misleading part. If there is in fact a qualitative difference between the fifteenth and sixteenth centuries, in the sense that the fifteenth had gradually to acquire by labor the insight into effects which was at the free disposal of the sixteenth, the (classic) art of the *cinquecento* and the (baroque) art of the *seicento* are equal in point of value. The word classic here denotes no judgment of value, for baroque has its classicism too. Baroque (or, let us say, modern art) is neither a rise nor a decline from classic, but a totally different art. The occidental development of modern times cannot simply be reduced to a curve with rise, height, and decline: it has two culminating points. We can turn our sympathy to one or to the other, but we must realize that that is an arbitrary judgment, just as it is an arbitrary judgment to say that the rose bush lives its

supreme moment in the formation of the flower, the apple tree in that of the fruit.

For the sake of simplicity, we must speak of the sixteenth and seventeenth centuries as units of style, although these periods signify no homogeneous production, and, in particular, the features of the *seicento* had begun to take shape long before the year 1600, just as, on the other hand, they long continued to affect the appearance of the eighteenth century. Our object is to compare type with type, the finished with the finished. Of course, in the strictest sense of the word, there is nothing "finished": all historical material is subject to continual transformation; but we must make up our minds to establish the distinctions at a fruitful point, and there to let them speak as contrasts, if we are not to let the whole development slip through our fingers. The preliminary stages of the High Renaissance are not to be ignored, but they represent an archaic form of art, an art of primitives, for whom established pictorial form does not yet exist. But to expose the individual differences which lead from the style of the sixteenth century to that of the seventeenth must be left to a detailed historical survey which will, to tell the truth, only do justice to its task when it has the determining concepts at its disposal.

If we are not mistaken, the development can be reduced, as a provisional formulation, to the following five pairs of concepts:

(1) The development from the linear to the painterly, i.e., the development of line as the path of vision and guide of the eye, and the gradual depreciation of line: in more general terms, the perception of the object by its tangible character—in outline and surfaces—on the one hand, and on the other, a perception which is by way of surrendering itself to the mere visual appearance and can abandon "tangible" design. In the former case the stress is laid on the limits of things; in the other the work tends to look limitless. Seeing by volumes and outlines isolates objects: for the painterly eye, they merge. In the one case interest lies more in the perception of individual material objects as solid, tangible bodies; in the other, in the apprehension of the world as a shifting semblance.

(2) The development from plane to recession. Classic art reduces the parts of a total form to a sequence of planes, the baroque emphasizes depth. Plane is the element of line, extension in one plane the form of the greatest explicitness: with the discounting of the contour comes the discounting of the plane, and the eye relates objects essentially in the direction of forwards and backwards. This is no qualitative difference: with a greater power of representing spatial depths, the innovation has nothing directly to do: it signifies rather a radically different mode of representation, just as "plane style" in our sense is not the style of primitive art, but makes its appearance only at the moment at which foreshortening and spatial illusion are completely mastered.

(3) The development from closed to open form. Every work of art must be a finite whole, and it is a defect if we do not feel that it is self-contained, but the interpretation of this demand in the sixteenth and seventeenth centuries is so different that, in comparison with the loose form of the baroque, classic design may be taken as *the* form of closed composition. The relaxation of rules, the yielding of tectonic strength, or whatever name we may give to the process, does not merely signify an enhancement of interest, but is a new mode of representation consistently carried out, and hence this factor is to be adopted among the basic forms of representation.

(4) The development from multiplicity to unity. In the system of a classic composition, the single parts, however firmly they may be rooted in the whole, maintain a certain independence. It is not the anarchy of primitive art: the part is conditioned by the whole, and yet does not cease to have its own life. For the spectator, that presupposes an articulation, a progress from part to part, which is a very different operation from perception as a whole, such as the seventeenth century applies and demands. In both styles unity is the chief aim (in contrast to the pre-classic period which did not yet understand the idea in its true sense), but in the one case unity is achieved by a harmony of free parts, in the other, by a union of parts in a single theme, or by the subordination, to one unconditioned dominant, of all other elements.

(5) The absolute and the relative clarity of the subject. This is a contrast which at first borders on the contrast between linear and painterly. The representation of things as they are, taken singly and accessible to plastic feeling, and the representation of things as they look, seen as a whole, and rather by their nonplastic qualities. But it is a special feature of the classic age that it developed an ideal of perfect clarity which the fifteenth century only vaguely suspected, and which the seventeenth voluntarily sacrificed. Not that artistic form had become confused, for that always produces an unpleasing effect, but the explicitness of the subject is no longer the sole purpose of the presentment. Composition, light, and color no longer merely serve to define form, but have their own life. There are cases in which absolute clarity has been partly abandoned merely to enhance effect, but "relative" clarity, as a great all-embracing mode of representation, first entered the history of art at the moment at which reality is beheld with an eye to other effects. Even here it is not a difference of quality if the baroque departed from the ideals of the age of Dürer and Raphael, but, as we have said, a different attitude to the world.

IMITATION AND DECORATION

The representational forms here described are of such general significance that even widely divergent natures such as Terborch and Bernini—to repeat an example already used—can find room within one and the same type. The community of style in these two painters rests on what, for people of the seventeenth century, was a matter of course—certain basic conditions to which the impression of living form is bound without a more special expressional value being attached to them.

They can be treated as forms of representation or forms of beholding: in these forms nature is seen, and in these forms art manifests its contents. But it is dangerous to speak only of certain "states of the eye" by which conception is determined: every artistic conception is, of its very nature, organized according to certain notions of pleasure. Hence our five pairs of concepts have an imita-

tive and a decorative significance. Every kind of reproduction of nature moves within a definite decorative schema. Linear vision is permanently bound up with a certain idea of beauty and so is painterly vision. If an advanced type of art dissolves the line and replaces it by the restless mass, that happens not only in the interests of a new verisimilitude, but in the interests of a new beauty too. And in the same way we must say that representation in a plane type certainly corresponds to a certain stage of observation, but even here the schema has obviously a decorative side. The schema certainly yields nothing of itself, but it contains the possibility of developing beauties in the arrangement of planes which the recessional style no longer possesses and can no longer possess. And we can continue in the same way with the whole series.

But then, if these more general concepts also envisage a special type of beauty, do we not come back to the beginning, where style was conceived as the direct expression of temperament, be it the temperament of a time, of a people, or of an individual? And in that case, would not the only new factor be that the section was cut lower down, the phenomena, to a certain extent, reduced to a greater common denominator?

In speaking thus, we should fail to realize that the second terms of our pairs of concepts belong of their very nature to a different species, in so far as these concepts, in their transformations, obey an inward necessity. They represent a rational psychological process. The transition from tangible, plastic, to purely visual, painterly perception follows a natural logic, and could not be reversed. Nor could the transition from tectonic to a-tectonic, from the rigid to the free conformity to law.

To use a parable: The stone, rolling down the mountain side, can assume quite different motions according to the gradient of the slope, the hardness or softness of the ground, etc., but all these possibilities are subject to one and the same law of gravity. So, in human psychology, there are certain developments which can be regarded as subject to natural law in the same way as physical growth. They can undergo the most manifold variations, they can be totally or partially checked, but, once the rolling has

started, the operation of certain laws may be observed throughout.

Nobody is going to maintain that the "eye" passes through developments on its own account. Conditioned and conditioning, it always impinges on other spiritual spheres. There is certainly no visual schema which, arising only from its own premises, could be imposed on the world as a stereotyped pattern. But although men have at all times seen what they wanted to see, that does not exclude the possibility that a law remains operative throughout all change. To determine this law would be a central problem, the central problem of a history of art.

We shall return to this point at the end of our inquiry.

WALTER FRIEDLAENDER

MANNERISM AND ANTI-MANNERISM IN ITALIAN PAINTING (1957)

AFTER THE many studies of Renaissance and Baroque art, critics became increasingly aware of an intermediate form or style identified as Mannerism. Between, roughly, 1520 and 1620 in Italy there occurred a reaction against the conventions of Renaissance style, a reaction suggesting some deep psychological unrest at a phase of culture identified by one writer as a "Counter-Renaissance" bringing with it the complexities of Mannerist or manneristic art. Lately the analysis of Mannerism in art and literature has become almost an industry. In 1925 and 1928-29 Walter Friedlaender printed a pair of articles on "The Rise of an Anti-Classical Style" and "The Anti-Mannerist Style," denoting by these titles two phases in Italian art: the Mannerist reaction against Renaissance forms, then a reaction against Mannerism itself in the guise of a return to Renaissance ideality in the magniloquent form we call

Baroque. The study of Mannerism is not completed, and there is still widespread discussion of the methods and meanings of Mannerism. Yet most historians and critics agree that there is a mannerist interlude in art, and that if Mannerism is not a distinct style, it is, in Ernst Curtius' phrase, a "constant" that reappears at certain periods under certain conditions. Friedlaender's essays identify most of the characteristics of Mannerism in Italian painting, and serve as an introduction to the whole tangled Mannerist question.

In *Die Welt als Labyrinth* (1957) Gustav-René Hocke examines Mannerism as a recurring phase in art and literature, associating it with the "mania" symptomatic of eccentric artists like Desiderio (Monsù) and proto-surrealists like Hieronymus Bosch. He extends the category of Mannerism to all forms of "convulsive beauty," including grotesque and fantastic art, and nearly every manifestation of what is anticlassical. Hocke is able to identify five major Mannerist or manneristic periods: Alexandrian, silver-Latin, late medieval, Italian Renaissance, and romantic-modern. He suggests that Mannerism arises in reaction to classicism (agreeing with Curtius), and that the classic without mannerist tension becomes a hollow formula, just as Mannerism without a classic counterpoise becomes merely manneristic. He supposes that Mannerism is a characteristically modern mood and therefore of especial significance for us today.

The literature on Mannerism is extensive, including Nikolaus Pevsner's *Barockmalerei in den Romanischen Laendern* (1928); Rudolf Wittkower's article "Michelangelo's Biblioteca Laurenziana," *Art Bulletin*, XVI, 1934, 123-218; Sidney J. Freedberg's *Parmigianino* (1950); Erwin Panofsky's early discussion in *Idea* (1924); Nikolaus Pevsner's excellent article on "The Architecture of Mannerism" in *The Mint*, no. 1, 1946; Denis Mahon's *Studies in Seicento Art and Theory* (1947); and Harold E. Wethey's *El Greco and His School* (1962). The catalog of the Mannerism exhibition in Amsterdam in 1955 reviews many aspects. The idea of a classical-mannerist opposition is advanced in Ernst Robert Curtius' *European Literature and the Latin Middle Ages* (1953). Fantastic art is the theme of Jurgis Baltrušaitis' *Le Moyen Age Fantastique* (1955) and *Anamorphoses* (1956), and of André Malraux's essay on Goya, *Saturn* (1957). Also important are the preface to *Fantastic Art, Dada, Surrealism* (1936), edited by Alfred Barr, Jr., *Bellezza e Bizzarria* (1960) by Mario Praz, and *Italian Mannerism* (1962) by Giuliano Briganti.

THE ANTI-CLASSICAL STYLE

In his life of Jacopo da Pontormo, Vasari speaks approximately as follows of the frescoes in the Certosa: "For Pontormo to have imitated Dürer in his motifs (*invenzioni*) is not in itself reprehensible. Many painters have done so and still do. In this he certainly did not go astray. However, it is extremely regrettable that he took over the German manner lock, stock, and barrel, down to the facial expression and even in movement. For through this infiltration of the German manner his original early manner, which was full of beauty and grace and which with his innate feeling for beauty he had completely mastered, was transformed from the ground up and utterly wiped out. In all his works under the influence of the German manner, only slight traces are recognizable of the high quality and the grace which had previously belonged to his figures."

As an artist Vasari is a mannerist of a strict Michelangelesque vein. But as a writer he is for the most part nonpartisan and in general much more benevolent than critical. His harsh words against Pontormo's imitation of Dürer are surely an expression not only of his own opinion, but also of the general opinion of the public. There was a feeling abroad, quite aside from any nationalism, that a major step had been taken here, one fraught with consequences. Vasari saw perfectly correctly that the imitation of Dürer on Pontormo's part involved not merely single features and the imitation of separate motifs, as was the case for Pontormo's teacher, Andrea del Sarto, but rather something fundamental, a change of style which threatened the whole structure of Renaissance painting. And yet Vasari did not see deeply enough. It was not Dürer's woodcuts and engravings—which just at that point had come to Florence in a large shipment and (as Vasari elsewhere records) which were very much admired by all

artists—that were leading to such a radical change in Pontormo's artistic attitude; rather it was the reverse. The new way of feeling germinating in him, but not in him alone, permitted the young and popular artist to cling to Dürer's graphic work because it appeared as something akin to his own feeling and usable in his reaction against the ideal of the High Renaissance.

In spite of the short span of barely twenty years in which it ran its course, the particularly intensive epoch of the High Renaissance had no unified character. The very fact that Michelangelo's art cannot possibly be counted in with the "classic" art of Leonardo, Raphael, Fra Bartolommeo, and Andrea del Sarto destroys any unity. Taken strictly, there actually remains only a relatively small number of works in which the normativeness and balance of high classic style can be demonstrated. It is not my purpose here to distinguish between this classic style and the preceding trends of the *quattrocento*. It might just be remarked that in the painting of the *quattrocento* the dissociation between constructed space in depth and picture surface with figures is for the most part not yet overcome. The volume of the bodies, inwardly organized and enlivened by a central idea, is in most cases not yet set in a circular movement as it is in the drawings of Leonardo or in the Madonnas of the mature Raphael (in contrast to Perugino). In the *quattrocento* the linkage of this volume with the space is for the most part incomplete and in many phases, especially during the second half of the century, often contradictory: for the human figure, there is spiritualization and surface ornamentation; for the space, realism and perspective construction in depth. The resolution of this duality, the subordination of masses and space within one central idea, is the achievement of the High Renaissance, reflected most purely in the works of the mature period of Raphael.

At the same time, both in theory and practice, definite rules and norms (first solidly codified, however, only in much later academic classicistic circles) were created, in large part in adherence to antiquity, and especially to its sculpture. To these the proportions, the internal and outward movement, and such, of the object in nature were

subordinated. Thus there arose an "ideal art" which, however, at the same time laid claims on nature, indeed in a strikingly canonical sense. Only what this artistic attitude set up as right and proper in proportions and the like counted as beautiful and, even more than that, as the only thing truly natural. On the basis of this idealized and normative objectivization, the individual object of the classic style, especially the figure of man, was removed formally, in its organization, and psychically, in its gestures and expression, from any subjective, purely optical, impression. It was no longer exposed to the more subjective whim of the individual artist, but was heightened and idealized to something objective and regular.

Sharply opposed in many and basic elements to this high, idealistic, normative attitude which in Florence (aside from Raphael) Fra Bartolommeo presents in a somewhat stiffly dogmatic way, and Andrea del Sarto in a more conciliatory, easy-going and happily colorful fashion, stands the attitude of the anticlassical style, normally called Mannerism.

What is decisive is the changed relationship of this new artistic outlook to the artistically observed object. No longer, as in idealistic standardized art, does the possibility of observing an object in a generalized intersubjective way, by heightening it, and raising it to something canonical and regular, form art's immovable basis. Similarly, little attention is paid to individually conditioned variations produced by the outward circumstances of light, air, and distance. The mannerist artist, in the last analysis, has the right or duty to employ any possible method of observation only as the basis for a new free representational variant. It, in turn, is distinguished in principle from all other possibilities of seeing an object, for it is neither made valid by any standardized abstraction nor is it casually determined in an optical way, but answers only to its own conditions. This art too is idealistic, but it does not rest on an idea of a canon, rather upon a *fantastica idea non appoggiata all'imitazione,* an imaginative idea unsupported by imitation of nature. Thus the canon apparently given by nature and hence generally recognized as law is definitively given up. It is no longer a question of creating a

seen object in an artistically new way, "just as one sees it," or, if idealistically heightened and ethically stressed, "just as one ought to see it." Neither is it a matter of re-creating the object "as I see it," as the individual person observes it as a form of appearance. Rather, if one may use a negative expression, it is to be re-created "as one does not see it," but as, from purely autonomous artistic motives, one would have it seen.

Out of the object given through artistic observation there thus arises a new and strikingly different one. The form of appearance, heretofore canonical, commonly recognized in an intersubjective way and hence counted upon as something one could take for granted—as "natural," is given up in favor of a new, subjective, "unnatural" creation. Thus, in mannerist art the proportions of the limbs can be stretched, more or less capriciously, merely out of a particular rhythmic feeling of beauty. The length of the head changes from being between an eighth and a ninth of the whole, as had been usual in the Renaissance because this was the norm and the average given by nature, and is now often between a tenth and a twelfth of the body length. This was a thoroughgoing change then, and almost a distortion of the form or appearance of an object commonly recognized as valid. Even such particular affectations as the holding of a finger, the wrenching of the limbs which twine in and out among each other, can be traced to this quite conscious rejection of the normative and the natural through an almost exclusive employment of rhythmic feeling. This freer and apparently more capricious rhythm carries with it the fact that symmetry, that is to say the linkage of parts of the body as they cohere through direct, clearly grasped opposition and distribution of weights, is dislodged or more or less broken up. (Compare further below Pontormo's "Madonna and Child with Saints" in San Michele Visdomini.) The High Renaissance's regular, symmetrical harmony of parts becomes unbearable to the anticlassical style. Linkage occurs through a more or less subjective rhythmic distribution of weights, which, under some circumstances, does not exclude a quite strict ornamental ordering; in extreme cases even thrust and

dissonance are hazarded. All this (as strikes us especially in the early Pontormo) gives the impression that this new form of art is consciously returning to an apparently more primitive stage, since it partly relinquishes the proud achievements of the Renaissance. In adherence to something earlier, there is being formed a new artistic feeling, which forcibly turns aside from the previous normative one of the Renaissance. Thus there arises a new beauty, no longer resting on real forms measurable by the model or on forms idealized on this basis, but rather on an inner artistic reworking on the basis of harmonic or rhythmical requirements.

The relation of this new artistic viewpoint to the problem of space is especially interesting and important. An upholder of the normative, who feels in a classic way, will take for granted an unambiguous, constructed space in which equally unambiguous, fixed figures move and act. It is not familiar, visual space dissolved in light and air, for the most part optically judged, that the adherent of the normative strives for, but a space which expresses or should express a higher reality purified of everything accidental. However, the figures of the rhythmic anticlassical painter function otherwise, for in themselves they express neither an established rule of nature, nor any unambiguous, rationally understood space. In a word, for them the problem of three-dimensional space vanishes, or can do so. The volumes of the bodies more or less displace the space, that is, they themselves create the space. This already implies that an art of purely flat surfaces is as little involved here as one which is perspective and spatial. A certain effect of depth is often achieved through adding up layers of volumes of this sort, along with an evasion of perspective. In the struggle between picture surface and presentation of depth in space, which is of such vital importance throughout the whole history of art, this is a particularly interesting solution. A peculiarly unstable situation is created: the stress on the surfaces, on the picture planes, set behind each other in relief layers, does not permit any very plastic or three-dimensional volumes of the bodies to come through in full force, while at the same time it

hinders the three-dimensional bodies from giving any very flat impression. (Something similar is encountered, with a somewhat different aim, in classicistic art.)

Yet even in the cases where a strong effect of depth is desired or is inevitable, the space is not constructed in the Renaissance sense as a necessity for the bodies but often is only an incongruous accompaniment for the bunches of figures, which one must read together "by jumps" in order to reach the depth. In such cases the space is not adapted to the figures as in high classic art, but is an unreal space, just as the figures are "anormal," that is, unreal. This is accompanied by another important difference from *quattrocento* art. In the fifteenth century the landscape responds to real facts and to effects of depth (partly obtained through perspective means); the bodies, on the other hand, often remain unreal and relatively flat. In the High Renaissance we see this contradiction resolved in favor of a common harmony of figures and space. In anticlassic Mannerism the figures remain plastic and have volume even if they are unreal in the normative sense, while space, if it is present at all apart from the volumes, is not pushed to the point where it produces an effect of reality. This is also true, for example, of the figure paintings of El Greco where, in spite of their coloristic tendency, the space always has something irrational and illogically organized about it. (One might cite the space and the proportions to each other of the foreground and middle-distance figures in such a work as the "St. Maurice.")

In the Florentine aspect of Mannerism, the cult of bodily volume is often so much emphasized, and the suppression of the spatial, of the "ambiente," is so strong, that both architecture and landscape only play small roles as coulisses. The art of *disegno* tending toward the abstract, that art of inward and outward design so much celebrated toward the end of the period in various theoretical writings such as the *Idea* of Federigo Zuccaro (but also playing a part in Vasari), triumphs over the spatial ideal of the Renaissance.

The whole bent of anticlassic art is basically subjective, since it would construct and individually reconstruct from the inside out, from the subject outward, freely, ac-

cording to the rhythmic feeling present in the artist, while classic art, socially oriented, seeks to crystallize the object for eternity by working out from the regular, from what is valid for everyone.

In this pure subjectivism, the mannerist anticlassical current is similar to the attitudes of the late Gothic; the verticalism, the long proportions, are common to both tendencies, in contrast to the standardized balance of forms in the Renaissance. How decidedly the new movement, with its thoroughly anticlassical tone, tries in both spirit and form to approach the Gothic feeling (never completely overcome even by the Renaissance), we see in the works of Jacopo da Pontormo, the true reformer of that artistic period, and in the uncompromising shock which his reversal produced in the public and in the critics, as shown in the passage from Vasari previously cited.

It goes without saying that every artistic epoch prepares the next, and that here once again are to be found powerful elements of its predecessor. The so-called early Renaissance, in spite of its greater freedom with regard to the object in nature, contains in many of its phases much that is still medieval. Likewise, despite their antagonism, the anticlassic, or manneristic style, and the High Renaissance have many and fundamental things in common: the preference, for example, for a plastic, anatomical treatment of the body, which in certain circles is particularly cultivated and exaggerated; their desire for a strongly tied composition; and so on. In such ways Mannerism is linked with the preceding Renaissance, especially if one sets it beside the loosening of organization that occurs in the outspoken Baroque. Yet these relationships, which are only natural, do not go so far as to justify labeling this manneristic style a late Renaissance, or treating it as a decay of the Renaissance, as has been done until quite recently even though this is entirely contrary to every older tradition. The contemporaries and even more the direct successors of Mannerism, as well as the classicists of the seventeenth century, sensed the sharp and painful division from the High Renaissance. This art-historical merger of the two styles was only possible because too little

attention was paid to the whole period, or because of ignorance of its new tone, as shown in the radical reversal of its attitude to space and proportions. With greater accuracy one might have called the strong tendency of early Baroque a late Renaissance or neo-Renaissance, for in it (again in strong contrast with the preceding period of Mannerism), is to be found a conscious and intentional readoption of the Renaissance idea (again without being able to slough off completely the achievements of Mannerism).

Every revolution turns into an evolution if one assembles the preceding storm signals in a pragmatic way. Hence it ought not to be difficult to point out certain signposts of Mannerism in the mainstream of *quattrocento* art. Nor should it be forgotten that the victory of the High Renaissance was by no means complete and final, that a "latent Gothic" or a "latent Mannerism" (depending on whether one looks forward or back) was present even in the mature period of "classic" thought. Yet it is essential to establish that such an anticlassical revolution did in fact take place, datable almost exactly shortly after the death of Raphael; that a thoroughly new spiritual turn of the methods of expression emerged (which as far as I know has until now received no attention[7] or no intensive stress); and finally that this movement was extensive, flaming up at various separate points and for a considerable period, dominating the once triumphant spirit of the classic. First, however, we must clarify the relationship of the greatest genius of the time[8]—who was anticlassical right in the middle of the classic period—to this new trend, and his connection with it. . . .

The third[9] among the creators and prototypes of the anticlassical mannerist style is not a Florentine, but a north Italian. This is Francesco Parmigianino, born in 1503, and thus almost a decade younger than Pontormo and Rosso. Furthermore, he stems from a basically different artistic culture and thus contributes a different artistic pattern. For he did not have to struggle against the stability of Roman and Florentine High Renaissance art, and he had not, in his youth, absorbed like mother's milk the plastic anatomy of the bathing soldiers of Michelangelo. For him

instead the grace and the optical subjectivism of Correggio had been the source in his decisive years, and he was himself inclined by his whole nature to increase and refine the delicacy and the courtly elegance of his master. Thus the transition to the new style is not nearly so rough and revolutionary in him as in the two Florentines. With these limitations in mind, one can say that the relation of the developed art of Parmigianino to Correggio is in general the same as that of Pontormo and Rosso to Andrea del Sarto and the Florentine High Renaissance.

The early works in Parma show the style of Correggio—the "Marriage of St. Catherine" in the Gallery of Parma, for example, is put together out of Correggesque motifs. More interesting are the niche figures in San Giovanni Evangelista which, though their prototype in spatial organization and construction of masses is Correggio's handsome lunette of "St. John on Patmos" in the same church, nevertheless already show a great individuality. For even more than in Correggio's "St. John" the figures fill the space of the chiaroscuro niche, and go beyond Correggio in illusionism, as when a slip of drapery or a foot hangs over the frame into the world of the observer. This subjective optical quality is especially striking in the "St. George," where the rearing body of the horse looms high in the foreground of the picture. Parmigianino again shows this preference for the illusionistic in his curious self-portrait in the convex mirror in Vienna, a trick (of exceedingly high quality to be sure) in which the hand, because it is so close to the mirror, appears unnaturally large. In this way, along with the optical painterly tendency, Parmigianino manifests his inclination toward the bizarre, the unnatural, the anticanonical.

In the course of his four years' stay in Rome (1523 to 1527), he established his personal style, developing it further to its finest maturity after the sack of Rome in 1527 caused him, as it did so many artists, to leave the Eternal City. Thus only a little later than Rosso and Pontormo, Parmigianino underwent the same transformation of style. In the harder Roman atmosphere the grace and softness of the Correggesque style is altered into a harder and stiffer structure, and from the delicate court

ladies of Correggio develop heroines who, to be sure, are still graceful. This appears decisively in the one masterpiece of the Roman period which is preserved to us, the "Vision of St. Jerome," especially in its upper part, for the lower still shows a debt to Correggio.

In contrast to the optical weaving of the figures, the *sfumato*, the lovely softness of the women of Correggio, Parmigianino's composition is reduced to only a few figures with sharper contours, and the figure of the Madonna is of an outspoken monumentality. This is the attitude found in the later Raphael, in Sebastiano, in Michelangelo. But it is characteristic that the Michelangelo of the Sistine apparently exercised little influence on Parmigianino. The motif of the Madonna with the beautiful boy between her knees stems indeed from Michelangelo, but it goes back to a youthful work of the master, the "Madonna of Bruges." Thus the placing of the Madonna is completely frontal. To this extent, and likewise in the type, the painting recalls "classic" feeling. What makes it more modern and anticlassic—in addition to its neglect of the spatial element—is its verticalism. Its frontality emphasizes its utterly unusual format, much more than twice as high as it is wide, a proportion we must recognize as offering an extreme contrast to Renaissance feeling, absolutely dedicated to balancing every relationship. Similarly the proportions of the Madonna are unusually elongated, and still more so in the sketch for the painting, now in the British Museum. In the sketch the Madonna is presented standing on the clouds, the Child upright upon her left hip; the other hip is strongly curved and the figure is so elongated that it takes up three-fourths of the picture surface. Whence came this verticalism of Parmigianino's? He did not bring it with him from his home and the Correggio circle. Nor did he meet with it in the Rome of the 1520s—either within the Raphael school in Giulio Romano (even Peruzzi comes upon it only later in Siena) or among the Michelangelo followers such as Sebastiano. It was not until the end of the 1520s, and even then only in single instances, that Michelangelo's proportions began to stretch out lengthwise as if snapping apart. In any case he is in Florence, not in Rome. On the other hand, these

changes of proportion, this verticalism, which are to be so characteristic of Mannerism in so many of its evocations, are already to be found at the beginning of the 1520s in that new anticlassical tendency of Pontormo and Rosso. Besides, it develops that Rosso went to Rome in the same years as Parmigianino. For the history of early Mannerism it is certainly a significant fact that two leaders of the growing style, Rosso and Parmigianino, came together in Rome and worked beside each other during the years from 1523 to the terrible days of May, 1527. Even if little more can be established in detail, they can scarcely have failed to have been in contact.

Thus, without venturing into the hypothetical, one can, on the basis of stylistic facts, deduce an exchange of influence. Rosso, who was in a position to look back on such brilliant and completely novel creations as the Volterra "Desposition" (even if he did not keep to the same level in Rome but fell into a strange hesitation) must have been the instigator, and must have made a significant impression on the much younger Parmigianino. He could tell him about the anticlassical artistic revolution in Florence, of which he was himself, along with Pontormo, one of the main participants. Compared to the heroic works of the High Renaissance, this style must have been a revelation to the sensitive young Parmigianino, whose whole temperament was desirous of novelty. And this explains the change in format, the new verticalism that is no mere external method, and the other similarities to the new style evident in Parmigianino's pictures.

Further, Parmigianino's conscious and entirely unclassical neglect of the canonical relation of figure to space may perhaps reflect the Florentine tendency, or at least be strengthened by it, even if he gives it other forms.

Both the excessive lengthening of the figure, and the neglectfulness in the handling of space, are acutely emphasized for the first time in a somewhat later painting, the famous, because especially charming, "Madonna of the Long Neck" (about 1535 to 1540). Here the elongation of the body is the more thorough-going in that it does not involve the massive giantesses of Rosso, still partially visible in Parmigianino's own "Vision of St. Jerome," but

instead, a slim elegant lady, an aristocrat, even more distinguished and courtly than Correggio's female saints. This uncanonical elongation enhances still further the elegance and the gracefully and carefully posed effect of the twisted position. The artistic method is the same, but the new proportions have a quite different meaning than in the ascetic Pontormo or in the excited Rosso. The angels have the same elegant grace, and the overlong nude leg of the youthful angel at the front, with the vase half cut off by the frame, carries a quite special accent.

The spatial relations are astonishing. The group of the Virgin with the angels in front of the red curtain is set very high and off to one side; the eye must shift without transition into a deeper space where a column rises and a prophet, much too small in proportion to the group of the Virgin, stands holding a scroll. It is the same evocation of intentionally unrealistic proportions in the sizes of the figures, in their relation to each other, and in their positions in space, as in Pontormo's "Martyrdom of St. Maurice" (Pitti) of 1529 and as later in El Greco.

Thus the Florentines did not (as has been suggested) take over Mannerism from Parmigianino; on the contrary, as is only natural considering his relative youth, he learned from the anticlassical movement of Pontormo and Rosso precisely those things that distinguish him from the preceding generation—the subjective rhythmic quality of his art, the uncanonical presentation of the figure, demonstrated in verticalism and in other elements, and the equally uncanonical handling of space. But Parmigianino is an independent artist. His color is quite different from that of the others; where Pontormo, originally following Andrea del Sarto, has soft, flowing tones, less differentiated and though simplified, greatly strengthened, and where Rosso forces local color and uses it dynamically to divide his layers and let them flicker in light, Parmigianino's coloring relies on the finest nuances. A kind of greenish general tone is spread over the whole, and to it are subordinated the local colors, running from moss green to pea green (in the "Madonna of the Long Neck"), with some reddish tones tossed in. This and the flowing light (similar to Correggio) in themselves prove that Parmigianino does

not create with plastic volumes like Rosso, nor of course so much from within outward as Pontormo. Despite the craftsmanlike contour element that with the subtlest sensitivity bounds his figures, the optical element always remains so essential that the linkage between the figures is set up less in a linear than in an optical way. Thus he never builds his figures exclusively by volume like Michelangelo and some of the mannerists; instead his figures always stand isolated and yet enclosed in space. Only this space is not proportionate to the figures in it, and it is here (as has been suggested) that he approaches tendencies of the early mannerist movement in Florence. He too uses, besides, the system of additive layers, and apparently takes this too from Florence; that is, he constructs three-dimensional space by parallel layers and thus brings it near the picture plane. This is already apparent in his early portraits (for instance, the very typical one of 1524 in Naples), but more insistently still in a late painting, the masterly Dresden picture of the "Madonna with the Two Deacons" seated before a balustrade. But he never interlaces or shuttles the layers, nor the figures either; the optical element of color and light plays such a part, that the effect is different, more loosely spatial, less stiff than in Tuscan Mannerism. In the Dresden picture it is notable how far in space the Madonna in her glory of light on the clouds stands behind the balustrade figures. Individually Parmigianino's own is the "grazia" so famous in the Carracci circle. The infinite distinction of stance, the *recherché* and preciosity of movement and turn in the body, the transparency of narrow, exaggeratedly long-fingered hands expresses his artistic nature, albeit the predisposition was already provided in Correggesque art. This has nothing directly to do with Pontormo and Rosso, neither of them "elegant," but over and above Parmigianino, the individual, it expressed the new mannerist feeling.

The grace of Parmigianino could the more easily influence Florentine Mannerism of the second generation, in that the ground was already laid in the work of Botticelli and others. Thus a mutual influence was possible, in that Parmigianino took over the bases of the new aspects of his style from the Florentine movement of 1520, but him-

self in turn—especially through his prints and drawings—had a reciprocal influence on Florence.

The new style that cast off the classic, and against the Renaissance pattern of canonical balance, set up a subjective rhythmic figuration and an unreal space formation, rests essentially on these three personalities: Pontormo, Rosso, and Parmigianino. In Florence it developed out of the Andrea del Sarto circle as an outspoken reaction against the beauty and repose of the Florentine High Renaissance; between 1520 and 1523 it is already fully formed. In Rome, Parmigianino, himself an issue of Correggio's style, comes to Rosso's side. The sack of Rome in 1527 scattered the seeds of the new tendency far and wide, and it perhaps attained its wider significance in European history through that very fact. In Florence, Pontormo's work proceeds further, his masterpieces appear—the "Entombment," the Louvre painting. Following a Michelangelesque period, which for a time brings him into direct dependence on that great man, he winds up with his strange frescoes for San Lorenzo, of whose monumental abstraction the only traces we have are in drawings. But in his pupil Bronzino his trend is carried on, not only in the portrait, but above all in figure and space composition. From this point on is formed the "mannerist" trend so typical precisely of Florence. Rosso, after some wandering, comes to Fontainebleau and through his paintings and decorations in the new mannerist style (to which scrollwork also pertains) this "northern Rome" becomes the pilgrimage center for northern and especially Flemish artists. Through Rosso and Primaticcio, his follower, the anticlassical style spreads through the northern countries. Parmigianino's works achieve a huge circulation in northern Italy; by way of Venice and the Bassano circle he (joined with Tintoretto, who also covers mannerist ground) becomes a decisive influence on the last and perhaps greatest practitioner of the mannerist style, El Greco. Over all lies the powerful shadow of Michelangelo. We have seen how anticlassical elements were present in him *a priori*. Yet Michelangelo, though he is so typically "anticlassic," is not of decisive influence on the actual establishment of the mannerist style around 1520. His influence begins in a direct way only with the

Medici Chapel, and more significantly, with the "Victor" in the field of sculpture, and in the field of painting with the "Last Judgment," from which even a Tintoretto could not escape. The further development of the mannerist style cannot be followed here; our scope is limited to sketching its establishment in the twenties of the sixteenth century. It is not any too often possible to put one's finger so exactly on a turning point in the flow of artistic things, in the way in which the passage from Vasari—the voice of the public—in dealing with Pontormo's falling away from true art has enabled us to do. This also made it possible to point out the archaic elements so intrinsic to early Mannerism and, in Pontormo especially, to demonstrate the influence of the north.

This turning point, then, is established for Pontormo by a document, but it applies not merely to this one artist personally; rather it is—to seize it stylistically by the hand —a general shift of style, in which Rosso and a little later Parmigianino participate, and which becomes the point of departure for a European movement. With Raphael's death classic art—the High Renaissance—subsided, though to be sure, like the "divine" Raphael himself it is immortal and will always come to life again in a new form. Its immediate successor is the new, anticlassical viewpoint— the mannerist-subjective, which now becomes dominant. Despite all the countercurrents this dominance persists for almost sixty years, until a new reaction is successful, a reaction deriving equally from the Carracci and the diametrically opposed Caravaggio, and consciously laying hold on the preceding period of the early *cinquecento*. Pontormo, Rosso, Parmigianino, with the genius of Michelangelo hovering above them and reaching beyond them, introduced this period, which is not a mere transition, not merely a conjunction between Renaissance and Baroque, but an independent age of style, autonomous, and most meaningful.

HENRI FOCILLON

THE LIFE OF FORMS IN ART *(1934, 1942)*

PERHAPS GEORGE KUBLER had Focillon's *Life of Forms* in mind when he stated that "certain historians possess the sensibility and the precision that characterize the best critics, but their number is small, and it is not as historians but as critics that they manifest these qualities." With great discrimination Focillon explores the notion that styles have a kind of morphological and evolutionary existence of their own, developing and persisting through a range of mutations until their inherent possibilities are expressed. Focillon is especially concerned with the unexpected transformations that occur whenever the techniques of different arts intersect, that is, when a technique belonging to a certain medium is transferred to another medium. He tries to define the various systems of artistic forms in realms of space, matter, mind, and time. In our selection he mentions different systems of perspective and the uses of space as limit and as environment.

The most comprehensive single essay on style in art is probably Meyer Schapiro's "Style" (in *Anthropology Today,* edited by Alfred Louis Kroeber, 1953). Other speculations akin to Focillon's are Adolf Hildebrand's *The Problem of Form in Painting and Sculpture* (1893, 1907), Elie Faure's *The Spirit of the Forms* (1921, 1937), and Konrad Fiedler's *On Judging Works of Visual Art* (1913-14, 1949).

FORMS IN THE REALM OF SPACE

A work of art is situated in space. But it will not do to say it simply exists in space: a work of art treats space according to its own needs, defines space, and even creates such space as may be necessary to it. The space of life is a known quantity to which life readily submits; the space of art is a plastic and changing material. We may find it difficult to admit this, so completely are we influenced by the rules of Albertian perspective. But many other perspectives exist as well, and rational perspective itself, which constructs the space of art upon the model of the space of life, has, as will presently be seen, a far greater propensity than we think to strange fictions and paradoxes. An effort is needed to admit that anything which may elude the laws of space is still a legitimate treatment of space. Perspective, moreover, pertains only to the plane representation of a three-dimensional object, and this problem is but one among others with which we are confronted. Let us note at once, however, that it is impossible to consider every one of these problems *in abstracto,* or to reduce them to a certain number of general solutions which would condition each particular application. Form is not indiscriminately architecture, sculpture, or painting. Whatever exchanges may be made between techniques—however deci-

sive the authority of one over the others—form is qualified above all else by the specific realms in which it develops, and not simply by an act of reason on our part, a wish to see form develop regardless of circumstances.

There is, however, one art that seems to be capable of immediate translation into various different techniques: namely, ornamental art, perhaps the first alphabet of our human thought to come into close contact with space. It is, too, an art that takes on a highly individual life—although one that is oftentimes drastically modified by its expression in stone, wood, bronze, or brushstroke. It commands, moreover, a very extensive area of speculation; it is a kind of observatory from which it is possible to discern certain elementary, generalized aspects of the life of forms within their own space. Even before it becomes formal rhythm and combination, the simplest ornamental theme, such as a curve or *rinceau* whose flexions betoken all manner of future symmetries, alternating movements, divisions, and returns, has already given accent to the void in which it occurs, and has conferred upon it a new and original existence. Even if reduced merely to a slender and sinuous line, it is already a frontier, a highway. Ornament shapes, straightens, and stabilizes the bare and arid field on which it is inscribed. Not only does it exist in and of itself, but it also shapes its own environment—to which it imparts a form. If we will follow the metamorphoses of this form, if we will study not merely its axes and its armature, but everything else that it may include within its own particular framework, we will then see before us an entire universe that is partitioned off into an infinite variety of blocks of space. The background will sometimes remain generously visible, and the ornament will be disposed in straight rows or in quincunxes; sometimes, however, the ornament will multiply to prolixity, and wholly devour the background against which it is placed. This respect for or cancellation of the void creates two orders of shapes. For the first, it would seem that space liberally allowed around forms keeps them intact and guarantees their permanence. For the second, forms tend to wed their respective curves, to meet, to fuse, or, at least, from the logical regularity of correspondences and contacts, to pass

into an undulating continuity where the relationship of parts ceases to be evident, where both beginning and end are carefully hidden. In other words, what I may call "the system of the series"—a system composed of discontinuous elements sharply outlined, strongly rhythmical, and defining a stable and symmetrical space that protects them against unforeseen accidents of metamorphosis—eventually becomes "the system of the labyrinth," which, by means of mobile syntheses, stretches itself out in a realm of glittering movement and color. As the eye moves across the labyrinth in confusion, misled by a linear caprice that is perpetually sliding away to a secret objective of its own, a new dimension suddenly emerges, which is a dimension neither of motion nor of depth, but which still gives us the illusion of being so. In the Celtic gospels, the ornament, which is constantly overlaying itself and melting into itself, even though it is fixed fast within compartments of letters and panels, appears to be shifting among different planes at different speeds.

It must be obvious that, in the study of ornament, these essential factors are not less important than are pure morphology and genealogy. My statement of the situation might appear entirely too abstract and systematic, were it not henceforth evident that this strange realm of ornament —the chosen home of metamorphoses—has given birth to an entire flora and fauna of hybrids that are subject to the laws of a world distinctly not our own. The qualities of permanence and energy implicit in this realm are extraordinary; although it welcomes both men and animals into its system, it yields nothing to them—it incorporates them. New images are constantly being composed upon the same figures. Engendered by the motions of an imaginary space, these figures would be so absurd in the ordinary regions of life that they would not be permitted to exist. But the more stringently the fauna of the formal labyrinth are held in captivity so much more zeal do they show in increasing and multiplying. These hybrids are found not only in the abstract, and boldly defined frameworks of the art of Asia and of Romanesque art; they recur too in the great Mediterranean cultures, in Greece and Rome, where they appear as deposits from older civilizations. I need

mention here but one example. In the grotesque ornament that was restored to fashion by the men of the Renaissance, it is evident that the charming exotic plants shaped like human beings have undergone, by being transplanted into a very large space and as it were brought back into the open air, a formal degeneration. They have lost their powerful, paradoxical capacity for *life*. Upon the light walls of the loggias their elegance seems dry and fragile. No longer are these ornaments untamed, no longer endlessly distorted by metamorphoses, no longer capable of tirelessly spawning themselves over and over again. They are now merely museum pieces, torn from their natal surroundings, placed well out in the open upon an empty background, harmonious, and dead. Be it background, visible or concealed; support, which remains obvious and stable among the signs or which mingles in their exchanges; plan, which preserves unity and fixity or which undulates beneath the figures and blends with their movements—it is always the question of a space constructed or destroyed by form, animated by it, molded by it.

Thus, as I have already remarked, any speculation regarding ornament is a speculation upon the great power of the abstract and upon the infinite resources of the imaginary. It may seem altogether too obvious to say that the space occupied by ornament, with its long shoreline and the monstrous inhabitants of its many archipelagoes, is not the space of life. No, on the contrary, ornamental space is clearly an elaboration upon variable factors. Now such may seem not to be the case as regards the forms of architecture, in that they are subjected in the strictest, most passive way to spatial data that cannot change. This must be so, for, in essence and by destination, the art of architecture exerts itself in a *true* space, one in which we walk and which the activity of our bodies occupies. But only consider the manner in which an architect works, and how perfectly his forms agree with one another to utilize this space, and perhaps to shape it anew. The three dimensions are not simply the *locus* of architecture; they are also, like weight and equilibrium, its very material. The relationship which unites them in a building is never casual, nor is it predetermined. The order of proportions comes into

play in their treatment, confers originality upon the form, and models the space according to calculated proprieties A perusal of ground plan and of elevation gives but a very imperfect notion of these relationships. A building is not a collection of surfaces, but an assemblage of parts, in which length, width, and depth agree with one another in a certain fashion, and constitute an entirely new solid that comprises an internal volume and an external mass. A ground plan can, to be sure, tell us a great deal. It can familiarize us with the nature of the general program, and permit a skilled eye to comprehend the chief structural solutions. An exact memory, well-furnished with examples, may theoretically reconstruct a building from its projection upon the ground, and knowledge of the various schools of production will allow the expert to foresee for each category of plans all the possible consequences in the third dimension, as well as the typical solution for any given plan. But this kind of reduction, or, perhaps, abbreviation of the processes of work, by no means embraces the whole of architecture. Indeed it despoils architecture of its fundamental privilege: namely, the mastery of a complete space, not only as a mass, but as a mold imposing a new value upon the three dimensions. The notions of plan, of structure, and of mass are indissolubly united, and it is a dangerous thing to attempt to disjoin them. Such certainly is not my purpose, but in laying stress upon mass, I wish to make it immediately understood that it is never possible fully to comprehend architectural form in the small and abbreviated space of a working drawing.

Masses are defined first of all by proportion. If we take, for instance, the naves of the Middle Ages, we see that they are more or less lofty only in relation to their width and length. Although it is obviously important to know what the actual dimensions are, these dimensions are in truth neither passive nor accidental; nor are they matters of mere taste. The relation of number to shape gives us a glimpse of a certain science of space, which, founded perhaps upon geometry, is still not pure geometry. In the work done by Viollet-le-Duc upon the triangulation of St. Sernin, it is not easy to determine to what extent a certain susceptibility to the mysticism of numbers intervenes

among the positive factual data. It is, however, undeniable that architectural masses are rigorously determined by the relationship of the parts to each other, and of the parts to the whole. A building, moreover, is rarely a single mass. It is rather a combination of secondary masses and principal masses, and in the art of the Middle Ages this treatment of space attains an extraordinary degree of power, variety, and even virtuosity. The composition of the apses of Romanesque Auvergne, where the volumes build up gradually, from the apsidal chapels to the lantern spire, through the roofs of the chapels, the deambulatory, the choir, and the rectangular mass upon which the belfry rests is a striking and familiar instance of this virtuosity. A similar process occurs in the façades of the Middle Ages, from the western apse of the great Carolingian abbeys to the "harmonic" type of the Norman churches, with the intermediary stage of nartheces so highly developed that they were almost conceived as large churches in and of themselves. Rather than a wall or a simple elevation, the façade appears to be a combination of the most fully organized and voluminous masses. Finally, in the Gothic architecture of the second half of the twelfth century, the relationship of the nave to single or double aisles, of the nave to elongated or truncated transepts, the pitch of the schematic pyramid within which these masses lie, and the relative continuity of the profiles, all present problems which cannot be solved by plane geometry, or even, perhaps, by the interplay of proportions.

For, however necessary proportions may be to the definition of mass, they are by no means the whole story. It is possible for a mass to admit, as the case may be, few or many episodic details, apertures, and visual effects. Even when reduced to the most sober mural economy, a mass still acquires great stability, still bears heavily upon its base, still looks like a compact solid. Light takes possession of it uniformly and instantaneously. On the other hand, a multiplicity of lights will compromise and weaken a wall; the complexity of purely ornamental forms will threaten its equilibrium, and make it seem unsteady and flimsy. Light cannot rest upon it without being broken apart; and, when subjected to such incessant alternations,

the architecture wavers, fluctuates, and loses all meaning. The space that presses evenly on a continuous mass is as immobile as that mass itself. But the space that penetrates the *voids* of the mass, and is invaded by the proliferation of its reliefs, is mobile. Whether examples be taken from flamboyant or baroque art, this architecture of movement assumes the qualities of wind, of flame, and of light; it moves within a fluid space. In Carolingian or in primitive Romanesque art, the architecture of stable masses defines a massive space.

Until now, my remarks have pertained primarily to mass in general, but it must not be forgotten that mass offers the double and simultaneous aspect of internal mass and external mass, and that the relation of one to the other is a matter of peculiar interest to the study of form in space. Each of these two aspects may, of course, be a function of the other, and cases exist in which the composition of the exterior immediately apprises us of the interior arrangement. But this rule is not invariable: it is well known, for example, how Cistercian architecture strove to disguise the complexity of the interior behind the unity of the external mural masses. The cellular partitioning of the buildings of modern America has slight influence on their external configuration. In these buildings mass is treated as a full solid, and the architects seek for what they call the "mass envelope," exactly as the sculptor proceeds from the blocking-out of the gradual modeling of the volumes. But the profound originality of architecture as such resides perhaps in the internal mass. In lending definite form to that absolutely empty space, architecture truly creates its own universe. Exterior volumes and their profiles unquestionably interpose a new and entirely human element upon the horizon of natural forms, to which their conformity or harmony, when most carefully calculated, always adds something unexpected. But if one gives the matter thought, it will be observed that the greatest marvel of all is the way in which architecture has conceived and created an inversion of space. Human movement and action are exterior to everything; man is always on the outside, and in order to penetrate beyond surfaces, he must break them open. The unique privilege of archi-

tecture among all the arts, be it concerned with dwellings, churches, or ships, is not that of surrounding and, as it were, guaranteeing a convenient void, but of constructing an interior world that measures space and light according to the laws of a geometrical, mechanical, and optical theory which is necessarily implicit in the natural order, but to which nature itself contributes nothing.

Relying upon the height of the bases and the dimensions of the portals, Viollet-le-Duc makes it clear that even the largest cathedrals are always at human scale. But the relation of that scale to such enormous dimensions impresses us immediately both with the sense of our own measure—the measure of nature itself—and with the sense of a dizzy immensity that exceeds nature at every point. Nothing could have determined the astonishing height of the naves of those cathedrals save the activity of the life of forms: the insistent theorem of an articulated structure, the need to create a new space. Light is treated not so much as an inert factor as a living element, fully capable of entering into and of assisting the cycle of metamorphoses. Light not only illuminates the internal mass, but collaborates with the architecture to give it its needed form. Light itself is form, since its rays, streaming forth at predetermined points, are compressed, attenuated, or stretched, in order to pick out the variously unified and accented members of the building, for the purpose either of tranquillizing it or of giving it vivacity. Light is form, since it is admitted to the nave only after it has been patterned by the colored network of the stained glass windows. To what realm, to what region in space do these structures, situated between heaven and earth, and pierced through and through by light, belong? The flat, but limitless expanse of the windows, their images, shifting, transparent, disembodied, and yet held firmly in place by bands of lead, the illusory mobility of volumes which, despite the stubborn rigidity of architecture, expand with the depth of shadows, the interplay of columns, the overhang of many-storied, diminishing naves—all these are like symbols of the eternal transfiguration forever at work upon the forms of life and forever extracting from it different forms for another life.

The builder, then, does not set apart and enclose a void, but instead a certain dwelling-place of forms, and, in working upon space, he models it, within and without, like a sculptor. He is a geometrician in the drafting of the plan, a mechanic in the assembling of the structure, a painter in the distribution of visual effects, and a sculptor in the treatment of masses. He assumes these different personalities in different degrees, according to the demands of his own spirit and to the state of the style in which he is working. It would be interesting to apply these principles to a study of the manner in which this displacement of values behaves, and to see how it determines a series of metamorphoses that are no longer the passing of one form into another form, but the transposition of a form into another space. I have already noted its effects when, in referring to flamboyant art, I spoke of a painter's architecture. The law of technical primacy is unquestionably the principal factor in such transpositions—which, indeed, occur in every art. There consequently exists a sculpture exactly conceived for architecture, or rather, commissioned and engendered by architecture, and likewise, a sculpture that borrows its effects, and virtually its technique, from painting.

In a recent work, in which I attempted to give a definition of monumental sculpture, I had occasion to comment upon these very ideas, in order to make clear certain problems raised by the study of Romanesque art. It would appear at first sight that in order to understand properly the various aspects of sculptured form in space, we need only to distinguish low-relief, high-relief, and full-round. But this distinction, which serves well enough to classify certain large categories of objects, is not only superficial, but captious in the plan of our present investigation. These large categories obey more general rules, and the interpretation of space is, as the case may be, equally applicable to reliefs or to statues. The character of sculpture must, in one way or another, be that of a solid, irrespective of its protrusions, and irrespective of whether it is composed upon a single plane or as a statue around which one can move. Sculpture may indeed suggest the content of life and its inner articulation, but it is perfectly obvious that

its design does not and cannot suggest to us anything resembling a void. Nor are we likely to confuse sculpture with those anatomical figures made up of parts indiscriminately thrown together into a single body that is no better than a kind of physiological carryall. Sculpture is not an envelope. It bears down with all the weight of density. The interplay of the internal component parts has no importance save as it comes up to and affects the surfaces, without, of course, compromising them as the outward expression of the volumes. It is, to be sure, quite possible to analyze and to isolate certain aspects of sculptured figures, and this is something that a conscientious study should not omit. The axes establish movements: upon observing how many of them exist and how much they deviate from the vertical, we may interpret them just as we interpret an architect's plans for a building, with, of course, the reservation of their already occupying a three-dimensional space. The profiles are the silhouettes of the figure, according to the angle of our inspection from full front, from the rear, from above, below, right, or left. The variations of these silhouettes are illimitable, and they "figure" space in a hundred different ways as we move about the statue. The proportions are a quantitive definition of the relationship between the parts, and lastly, the modeling translates for us the interpretation of light. Now, no matter how completely conjugate one recognizes these elements to be, no matter how little one loses sight of their intimate reciprocal dependence, they have no value whatsoever when isolated from the solid. The abuse of the word "volume" in the artistic vocabulary of our time is indicative of the fundamental need to recapture the immediate data of sculpture—or of sculptural quality. The axes are an abstraction. In considering an armature, i.e., a mere sketch in wire endowed with the physiognomic intensity of all abbreviations, or in considering signs devoid of images, i.e., the alphabet, or pure ornament, we realize that our *sight* must invest them all, for better or for worse, with substance. And it must do this in the twofold recognition, on the one hand, of their utter and terrifying nudity, and on the other, of the mysterious and vital halo of the volumes with which we must envelop them. The same

thing applies to the profiles of sculpture—a collection of flat images, whose sequence or superposition elicits the concept of the solid only because the exigency already lies within ourselves. The inhabitant of a two-dimensional world might have before him an entire series of profiles for a given statue, and marvel at the diversity of such figures, without ever realizing that he was looking at but one single figure—in relief. On the other hand, if one admits that the proportions of a body imply their relative volume, obviously one can easily evaluate the straight lines, the angles, and the curves without having to call into being any concept of space at all. Studies in proportion apply to flat figures exactly as they do to figures in relief. Finally, if modeling be interpreted as the actual life of the surfaces, then the various planes that compose it are not merely a garment draped across nothingness, but are, rather, the point at which the "internal mass" meets with space. To recapitulate, then: the axes account to us for the movements of sculpture, the profiles for the multiplicity of contours, the proportions for the relationship of parts, and the modeling for the topography of light. But none of these elements, taken singly or in combination, can ever be substituted for the total *volume,* and it is only by keeping this idea closely in mind that the various aspects of space and form in sculpture can be rightly determined.

I should like to attempt such a distinction by differentiating between space as a limit and space as an environment. In the first case, space more or less weighs upon form and rigorously confines its expansion, at the same time that form presses against space as the palm of the hand does upon a table or against a sheet of glass. In the second case, space yields freely to the expansion of volumes which it does not already contain: these move out into space, and there spread forth even as do the forms of life. Space as a limit not only moderates the proliferation of relief, the excesses of projection, the disorder of volumes (which it tends to block into a single mass), but it also strongly affects the modeling. It restrains its undulations and disturbances; it suggests the modeling itself merely by an accent, by a slight movement which does not break the continuity of planes, or occasionally, as

in Romanesque sculpture, by an ornamental setting of folds designed to clothe the bare masses. But on the other hand, space as an environment, exactly as it delights in the scattering of volumes, in the interplay of voids, in sudden and unexpected perforations, so does it, in the modeling, welcome those multiple, tumbled planes which rend the light asunder. In one of its most characteristic states, monumental sculpture displays perfectly the consequences of the principle of space as a limit. This is in Romanesque art, which, dominated by the necessities of architecture, lends to sculptured form the significance of mural form. Such an interpretation of space, however, concerns not merely the figures which decorate the walls, and which occur in a fixed relation to them. Space as a limit applies likewise to the full-round, over the masses of which it stretches a skin that guarantees solidity and density. The statue then appears clothed with an even, tranquil light which seems scarcely to move at all across the sober inflections of the form. Inversely, but still within the same order of ideas, space as an environment not only clearly defines a certain way of making statues, but it also affects those reliefs which attempt to express by all manner of devices the semblance of a space wherein form moves freely. The baroque state of all styles presents innumerable examples of this. The skin is no longer merely an accurate mural envelope; it is quivering under the thrust of internal reliefs which seek to come up into space and revel in the light, and which are the evidence of a mass convulsed to its very depths by hidden movements.

In a comparable manner, we may apply the same principles to the study of the relationship of form and space in painting, insofar, at any rate, as painting attempts to depict the solidity of objects in three dimensions. But painting does not, of course, have at its command this seemingly complete space; it only feigns it. Here is a further example of the final stage of a highly specific evolution; and even so, painting can display an object in but one profile. And yet nothing is perhaps more extraordinary than the variations of painted space. This is especially true since we can give only an approximate idea of them, owing to our lack of a history of perspective, as well as of

a history of the proportions of the human figure. In any case, it will at once be noted that these variations are not only a function of time and of various degrees of knowledge, but also of materials and substances, without the analysis of which every study of forms runs the risk of remaining dangerously theoretical. Illumination, distemper, fresco, oil painting, stained glass could not be realized in an unconditioned space: each of these techniques confers upon space a specific value. Without anticipating investigations which it has seemed best for me to pursue elsewhere, it may be here admitted that a painted space varies according to whether the light is outside the painting or within it. In other words, is a work of art conceived as an object within the universe, lighted as other objects are by the light of day, or as a universe with its own, inner light, constructed according to certain rules? This difference of conception is, to be sure, again connected with the difference between techniques, but does not absolutely depend upon it. Oil painting does not necessarily try to emulate space and light; miniature, fresco, and even stained glass can construct a wholly fictitious light within an illusion of space. We must account for this relative liberty of space always with regard to the material in which it is realized, but we must account too for the perfect propriety with which space assumes such and such a figure in such and such a material.

I have spoken already of ornamental space. This important department of art is by no means one that commands all possible approaches, but it is one that has for many centuries and in many countries translated man's meditations on form. Ornamental space is the most characteristic expression of the high Middle Ages in the western world. It is an illustration of a philosophy that renounces development in favor of involution, that surrenders the concrete world for the frivolities of fantasy, the sequence for the interlace. . . .

These observations on the permanence of certain formal values furnish us with but one aspect of an extremely complex development. Before submitting themselves to the laws of sight itself, that is, before treating the picture image like the retinal image and combining the

three dimensions in a two-dimensional plane, space and form in painting passed through many different states. The theory of the relationship between the relief of form and the depth of space was not defined on the spur of the moment, but was sought out through successive experiments and important variations. The figures of Giotto take their places as simple and beautiful blocks within a strictly limited environment, analogous to the workshop of a sculptor, or better, to the stage of a theater. A backdrop or a few flats, on which are indicated (less as real elements than as forcible suggestions) bits of building or of landscape, arrest the sight categorically, and prevent the actual wall on which they are painted from being weakened by whatever illusory apertures it may contain. It is true that at times this conception seems to give way to another arrangement, one that indicates the necessity of utilizing space not as a limit, but as an environment. An admirable example is the scene of the "Renunciation of St. Francis" in the Bardi Chapel. Here the stylobate of the Roman temple is shown on the bias, and consequently presents, on either side of the leading edge, so distant a perspective that the entire mass seems to be thrown forward and plunged directly into the space we ourselves occupy. This is primarily, of course, certainly a device of composition, intended to separate the figures unmistakably on either side of a vertical line. But in any case, and in spite of their gestures, the figures within this transparent, precisely limited volume are so utterly isolated from each other and from their environment that they seem to exist in a void. It might be said that they are being put to some sort of fiery trial whose purpose it is to detach them from every equivocal similarity and every compromise, to circumscribe them faultlessly, to insist upon their weight as *separate* entities. The followers of Giotto, we know, were far from having been loyal to Giotto's own art in this respect. The scenographic space of that art—comparable to a space soberly established for the needs of a popular theater—becomes with Andrea da Firenze's treatment of the Spanish Chapel a field for abstract hierarchies, or an incidental support for compositions which follow one another very loosely, while Taddeo Gaddi, on the contrary,

seeks in the "Presentation of the Virgin," but without quite attaining his purpose, to "square off" the architectural setting of the Temple of Jerusalem. In this connection, indeed, it may be noticed that there are already proofs— long before the *prospettiva* of Piero della Francesca in the picture gallery at Urbino—that architecture, and not painting, is to be the mistress of those experiments that lead to the discovery of rational perspective.

These experiments, however, do not immediately converge, but are preceded, escorted, and often, for a considerable length of time, contradicted by diametrically opposite solutions. Siena, for instance, exhibits numerous examples of this. One may be the achievement of a sparkling denial of space: ancient backgrounds of gold, sprinkled with flowerets and arabesques, against which forms are outlined, sketched with a stroke as delicate as handwriting—the ornamental space of an ornamental form that is struggling to be free. Or another may be the pageantry of verdure that, like a great tapestry, hangs behind scenes of the chase or of a garden. Or still a third (and the one that is perhaps the truly original element in the contribution of Siena to painting) may be the cartographic landscapes that display the world from the top to the bottom of the picture, not in depth, but in a bird's-eye view, not unlike a theater backdrop that has been made ready for the greatest possible variety of scenes. The need to grasp the totality of space is here satisfied by a wholly arbitrary and yet fertile structure—a structure which is neither the schematic abbreviation of a ground plan, nor a normal perspective, and which, incidentally, even after the final establishment of the latter, takes on a new vigor in the northern workshops of painters of fantastic landscapes. In an eye-level horizon objects are hidden one behind the other, and distance, by progressively diminishing their size, also tends to efface them. But beneath a raised horizon, space unfolds like a carpet, and the shape of the earth is like the slope of a mountain. Sienese influences spread this system over all northern Italy, even though it was at the very time that Altichiero was seeking —by an entirely different process—to suggest by the gyratory rhythm of his compositions that the hollow of

space was spherical. But in Florence the collaboration of geometricians, architects, and painters led to the invention, or rather, to the adjustment of the proper machinery for reducing the three dimensions to the data of a ground plan, by calculating the correct relationships between them with the precision of mathematics. . . .

ERNST KRIS

PSYCHOANALYTIC EXPLORATIONS IN ART *(1952)*

EXPLANATIONS OF MANNERISM and manneristic art have of course involved the psychology of art and the artist, and the relation between art and neurosis or psychosis. This, in turn, involves the question of how art distorts or caricatures reality. The comic is essentially a form of distortion or caricature, and the comic impulse often hides a desire to degrade or unmask or control what is feared or hated. The comic springs from ambiguous motives and has ambiguous effects, and, as a psychologist, Kris is concerned with such ambiguities in all forms of art, plastic as well as literary. He supposes that if Falstaff and Don Quixote express some need to caricature, certain "serious" forms of art are also inspired by a similar need. So he asks a jolting question: are not Michelangelo's statues of Slaves really a kind of caricature in sculpture? Are not Bernini's sketches and models for his grandiose Baroque sculptures

really caricatures? And what do such works have in common with the dream? The rise of caricature in the seventeenth century calls for some explanation, and it may have a bearing upon the distortions in Mannerist art. These are speculations that could occur only in a critic who approaches artistic questions through psychology.

A more technical discussion of the relation between art and mania can be found in Francis Reitman's *Psychotic Art* (1951) and *Insanity, Art, and Culture* (1954) and Wolfgang Kayser's *The Grotesque* (1957, 1963). There is a valuable chapter (X) on caricature in E. H. Gombrich: *Art and Illusion* (1960).

THE PRINCIPLES OF CARICATURE

(Chapter VII, written in collaboration
with E. H. Gombrich)

I

It is a startling fact that portrait caricature was not known to the world before the end of the sixteenth century (Wittkower and Brauer, 1931). What seems so simple and even primitive an artistic procedure to our own days, the deliberate distortion of the features of a person for the purpose of mockery, was a satirical technique unknown to classical antiquity, to the Middle Ages and the High Renaissance. To be sure the artists of these former periods were well versed in many forms of comic art. We find the clown, the comic type, the satirical illustration, and the grotesque, in magnificent profusion, but portrait caricature was never practiced before the time of the brothers Carracci, who worked in Bologna and in Rome at the turn of the sixteenth and seventeenth centuries. Those who witnessed this invention—and we use the word in its full meaning—were quite conscious of the fact that

a new form of art had sprung into being in the studio of these admired masters. The connoisseurs and critics of the period took pleasure in justifying and defining this mode of representation, and thus we find elaborate theoretical discussions of caricature in seventeenth-century writings on artistic theory by Agucchi (1646), Bellori (1672), and Baldinucci (1681). These theorists were well trained in formulation. They define *ritratti carichi* or *caricature* (literally "loaded portraits") as a deliberate transformation of features in which the faults and weaknesses of the victim are exaggerated and brought to light.

> Caricaturing [reads the definition of Baldinucci (1681)] among painters and sculptors signifies a method of making portraits, in which they aim at the greatest resemblance of the whole of the person portrayed, while yet, for the purpose of fun, and sometimes of mockery, they disproportionately increase and emphasize the defects of the features they copy, so that the portrait as a whole appears to be the sitter himself while its component parts are changed.

The recognition of like in unlike produces the comic effect—comparison being the royal road to the comic—but beyond this purpose of fun it is claimed that the likeness thus produced may be more true to life than a mere portrayal of features could have been. A caricature may be more like the person than he is himself. This paradox, favored by the critics, should not only be read as hyperbolic praise of a new art form. It reveals a new creed which is essential to our understanding of the rise of caricature.

"Art" to the age of the Carracci and of Poussin no longer meant a simple "imitation of nature." The artist's aim was said to be to penetrate into the innermost essence of reality, to the "Platonic idea" (Panofsky, 1924). Thus, it was no longer mere mechanical skill that distinguished the artist, but inspiration, the gift of vision, that enabled him to see the active principle at work behind the surface of appearance. Expressed in these terms the portrait painter's task was to reveal the character, the essence of the man in an heroic sense; that of the caricaturist provided the natural counterpart—to reveal the true man behind the mask of pretense and to show up his "essential" little-

ness and ugliness. The serious artist, according to academic tenets, creates beauty by liberating the perfect form that Nature sought to express in resistant matter. The caricaturist seeks for the perfect deformity, he shows how the soul of the man would express itself in his body if only matter were sufficiently pliable to Nature's intentions.

Malvasia (1678), a seventeenth-century biographer of the Carraccis, describes how these artists used to look for victims of their new art while on their leisurely walks through the streets of Bologna when their serious work was done for the day. Among the seventeenth-century caricatures that have come down to us there are sheets of sketches (now in Munich) by a Bolognese artist who obviously continued this tradition. We can see how he circles round his prey before he pounces. The man with the crooked nose is first tentatively sketched from different sides. The features are altered several times till the finished caricature presents him as a comic type with an enormous hat and a pathetically grave expression.

Others of these caricatures are even simpler. A naturalistic portrait sketch of a vivid and fleeting expression suffices to produce a comic effect when placed on a dwarfed body. The victim has been transformed into a dwarf. We need hardly say that caricature since those days has never ceased to use this primitive but easy means of transformation. Even the greatest master, Daumier (1810-1879), did not refrain from employing it in his famous series of *Représentants Représentés,* where, for example, the portrait head of Louis Napoleon is fitted upon a dwarf-like body. It may be emphasized again that it was not the form of such a picture that was new in the seventeenth century. The comic dwarf with an enormous head was known to Greek art as well as to that of later times. But in those times it was only made to ridicule types rather than to reshape an individual as a type. Yet that is precisely what our caricatures may be described as doing.

II

There is one feature of these early portrait caricatures which demands our particular attention—their playful, "artless" character. True, highly finished caricatures do

occur, but then as now the typical caricature had the appearance of a casual scrawl, "dashed off" with a few strokes. This feature, too, was recognized and described by a seventeenth-century critic. André Félibien, the influential member of Louis XIV's Academy, incorporates this trait in the very definition of the caricature which he calls a likeness done in a few strokes (1676). The caricatures he probably had in mind were those of the famous master of Baroque art, the sculptor and architect Giovanni Lorenzo Bernini (1589-1680), whose powerful figure dominates the religious art of Catholic Europe. We know from contemporary accounts that Bernini's magnificent portrait busts had their counterpart in caricatures of amazing virtuosity.

It is in the nature of caricatures that not knowing the "victim" we can no longer estimate their successfulness, but what survives of Bernini's drawings can be savored even without this element of comparison. The strokes of his pen show a sublime freedom. The dominant expression of a long-necked captain of the fire brigade is an inane grin, and this grin is produced by one scrawly line. The face of Cardinal Scipione Borghese with his double chin and his baggy eyes is boiled down to an easily remembered formula. In these simplifications, the abbreviated style itself acquires its own meaning—"Look here," the artist seems to say, "that is all the great man consists of." It was the German painter Max Liebermann who expressed this feeling in the most drastic and succinct manner when he said of a pompous nonentity, "A face like his I can piss into snow."

It is not by accident, then, that simplification and reduction to a formula became part of the tradition of caricature. To Hogarth, in fact, this was the distinctive feature that separated the fashionable craze of *"caricatura* drawing" from the serious artistic pursuit of delineating "character." "I remember a famous caricature of a certain Italian singer," he writes, "that struck at first sight, which consisted only of a straight perpendicular stroke with a dot over it" (Hogarth, 1758). He points to the similarity between the "early scrawlings of the child" and the successful caricatures by amateurs which were then making

the round in English political circles. His eyes, sharpened by the fear of competition which threatened to oust his generalized comic "characters" in the esteem of the public, had perceived another essential trait of caricature—the absence of "drawing," as he calls it, the deliberate or incidental renunciation of academic skill implied in the light-hearted simplifications of the mock portrait.

It was due to this mechanism of reduction that the portrait caricature could be assimilated to the older technique of cartoon symbolism. Just as the Lion may stand for England or the Bear for Russia the distilled formulae mentioned by Hogarth could stand for the protagonists of the political scene, for Lord Holland or Lord Chatham. The process has stood pamphleteers in good stead ever since. David Low demonstrates how the caricaturist transforms a public figure into a formula, a "tab of identity," which is cartoon symbol and caricature at the same time. All you need know of Herbert Morrison, he seems to say, is that he cultivates a cocky forelock—this lock gives you the whole man.

III

Can all this really have been "invented" at so recent a date? Did people of earlier centuries really never use pictorial art for personal aggression and abuse? Were they content with the creation of innocent comic types without any malice aforethought? Of course they were not. Pictures were used in many contexts to give vent to aggressive impulses. But from these aggressive pictures precisely that feature is missing that constitutes the essence of portrait caricature, the playful transformation of the likeness. This aggressive imagery of propagandist art does not aim at the achievement of aesthetic effect. Unlike Bernini's caricatures it lies outside the realm of art. We do not mean to say that the quality of such products is usually low—though it is—but that the whole cultural context of these aggressive images precludes their being taken as "art" in our sense. This is, first of all, an empirical statement. Among the many works of art which have come down to us from earlier times there is not one which may be said to serve exclusively or even predominantly aggressive pur-

,poses. The very examples often listed in histories of caricature seem to prove this point. Take the so-called mock crucifix, a *sgrafitto* probably deriding a Christian who is shown worshiping a crucified God with a donkey's head. Whatever the implications of this image may be, whether its author believed that Alexamenos rather worshiped an animal-headed God or whether he added the ass's head as a piece of vulgar abuse, whether he thought such a God funny or hateful, we are here clearly outside the realm of art. The clumsiness of the drawing betrays lack of skill, not deliberate simplification—it is an abusive scrawl, not a caricature.

There is one sphere in which the aggressive image had become institutionalized long before the invention of caricature—it is the custom of hanging in effigy and similar practices, frequent in the later Middle Ages. It was the custom of Italian cities to have defamatory paintings placed on the façade of the town hall commemorating the overthrow of the community's enemies. The rebel leaders or members of opposing factions were painted hanging on the gallows or hanging head downward, and, to add to the perpetual insult, their coats of arms were added turned upside down. We can call such paintings forerunners of caricatures. But they are forerunners only in a very limited sense inasmuch as they are portraits used to attack a person's dignity. Artistically they were far from being caricatures. The few examples, at any rate, which are preserved from Northern countries (Hupp, 1930), show no comic distortions of the face but probably crude attempts at giving a likeness. The figure shown on the gallows for having failed to pay a debt is a schematic portrait. It is only the context of symbols, the gallows, the raven, which degrades the victim, not the artist's reinterpretation of the man.

The same reliance on pictorial symbolism rather than artistic transformation will strike anyone who studies the propagandist imagery, which gained in importance after the invention of printing (Grisar and Heege, 1922; Blum, 1916). If Luther is represented in the form of a wolf, or if a seventeenth-century preacher is depicted as inspired by the devil, wolfishness or devilishness is in no case ex-

pressed through a transformation of the victim's features. A wolf wears Luther's gown or the preacher's likeness remains unaltered in the degrading context which shows him with the attributes of madness and wickedness. These satirical prints, in other words, are again imagery rather than art. They rely on ideographic methods rather than on the artist's power.

We have seen how the caricaturist's abbreviation developed an affinity to the pictorial symbolism of these broadsides. It was, in fact, when the two traditions merged, when in eighteenth-century England *caricatura* portraits were first introduced into political prints, that the cartoon in our sense was born and caricature was given a new setting and a new function: From a sophisticated studio joke, thrown off for the amusement of the artist's intimates, caricature had become a social weapon unmasking the pretensions of the powerful and killing by ridicule.

IV

Why was it really that such an obvious and apparently simple means of ridicule made its debut at so late a date? Two possible explanations would immediately suggest themselves but both of them seem inadequate. The historian of the visual arts might be tempted to look for a solution simply in the development of representational skill. Such an explanation might be superficially plausible for he could argue that the portrait, too, only acquires its full dimension of physiognomic veracity at the time in question. The century of Rembrandt, Frans Hals, and Bernini had mastered the rendering of play of emotions on the human countenance to a degree unknown even to a Raphael or a Titian. But in a way such an explanation only shifts the problem without contributing to its solution. That the portrait, too, undergoes a profound change in the century in question need not be denied, nor that the interest in expression which manifests itself in these changes was also at play in the invention of caricature. What is questionable is whether we have a right to speak of skills in these contexts. The manual dexterity needed to create the interlace patterns of Anglo-Irish art or of Gothic scrollwork is surely as great, if not greater,

than the skill applied in Bernini's caricatures. Within the history of art alone the question cannot be answered. Recognizing this fact Brauer and Wittkower have turned to social history for an explanation of the rise of caricature (Brauer and Wittkower, 1931). They think that the emergence of the individual on the one side, the spirit of ridicule and mockery on the other were responsible for this invention of mock portraiture. Again the explanation throws light on one aspect of the matter. The climate of an age that created the immortal figures of Falstaff and of Don Quixote was certainly conducive to an art that revealed the comic side of man. But as an explanation this observation is hardly sufficient. Does the Renaissance lack this sense of the individual or the sense of humor that unmasks pretensions? Was the age of an Erasmus (1465-1536), or an Aretino (1492-1556), or was the time of Aristophanes, of Lucian, unable to spot the chinks in the armor of the mighty? The art historian is often tempted to fall back on literature, the literary historian on art, and both on philosophy when they are unable to provide a solution within the realm in which their problem arose. Stimulating as these cross-fertilizations may be, they should not blind us to the methodological problem of "explanation" in history.

<p style="text-align:center">V</p>

As far as history records unrepeatable events the concept of explanation has to be used with caution. But caricature is not only a historical phenomenon, it concerns a specific process and this process is repeatable and describable, for here we are in the field of psychology. Let us look once more at one of the sheets in the Munich sketchbook from the early period of caricaturing. It contains a purely emblematic sketch of a man devouring gold coins, but also attempts at transforming a human head into that of an animal, an ape. This game of transformation too stands in a definite cultural context. It was a widespread belief, codified in a text attributed to Aristotle himself, that to read the character of a man one only had to trace in his physiognomy the features of the animal which he resembled most. The man with the fishlike stare

would be cold and taciturn, the bulldog face would betray stubbornness. During the lifetime of the Carracci a book by Giovanni Battista Porta (1601) expounding this old theory was published for the first time with woodcuts illustrating the similarity between human types and animals. That caricature received an impetus from this doctrine is likely. But it is not this historical fact we want to stress in our present context but the art of transformation which has remained a favorite trick with caricaturists revealing much of the rules of the game. There is nothing astonishing in that, for the process revealed in these transformations rounds off the achievement of the caricaturist as it was postulated by Baldinucci in the seventeenth century—"the portrait as a whole appears to be the sitter himself and yet its component parts are changed."

Perhaps the most celebrated example of such a transformation is the series of drawings showing the metamorphosis of Louis Philippe, the Roi Bourgeois (1830-1848), into *poire* (a slang term for fathead). The idea came from Philippon, the editor of *La Caricature*, the first comic weekly ever to appear (Davis, 1928). Philippon was accused of seditious libel but undeterred by his conviction to a heavy fine he published the famous sheet, which, as the caption says, might have constituted his defense. It is not my fault, he argues with mock seriousness, if the King's likeness has this fatal resemblance to the incriminating symbol of fatuity. And so skillful is the play on features that the transformation really seems to happen imperceptibly in front of our own eyes. The proof is given, the King *is* a *poire*. As the pear became the mocking symbol in countless caricatures and cartoons, we witness once more the reduction of the portrait caricature to the stereotype for political imagery.

VI

The psychologist has no difficulty in defining what the caricaturist has done. He is well acquainted with this double meaning, this transformation, ambiguity, and condensation. It is the *primary process* used in caricatures in the same way that Freud has demonstrated it to be used in "wit." If we fall asleep and our waking thoughts are

submerged by our dreams, then the primary process comes
into its own. Conscious logic is out of action, its rules have
lost their force. One of the mechanisms now in action can
cause, in a dream, two words to become one, or merge
two figures in one. This peculiarity of the psychic appara-
tus is sometimes exploited in jokes. If, for instance, we
describe the Christmas vacations as "alcoholidays," we
understand that the new word, the pun word, is obviously
composed of two parts: of "alcohol" and "holidays": they
are united or—as we say—"condensed." An analogous
condensation could also have arisen in a dream. But unlike
the dream, the pun is thought out, created. We make use
intentionally—which is not synonymous with consciously
—of a primitive mechanism in order to achieve a particular
aim.

Like words in a pun, the pictures in caricatures are
subjected to such readjustment. The confusion that strikes
one as a defect in dreams as against the precision of clear
thought here becomes a valuable achievement. Of course,
the primary process must have an instrument to play on.
It cannot produce a pun which is not hidden in the lan-
guage. Neither can the caricaturist entirely follow his
whim. He is bound by the grammar of his language, which
is form; a grammar, we may add, that differs widely from
the grammar of spoken languages, and that still awaits
analysis.

Sometimes a picture is used merely to stress or under-
line a verbal pun. If, for example, Fox is represented in
the form of a fox (and jokes of that kind have appeared
in satire ever since the Middle Ages) an infantile attitude
toward words is used which is related to all wit. It takes
metaphors literally, as does the child. This is not the only
case in which wit revives infantile pleasures. In fact—as
Freud has shown us—in all play with words, in puns as
well as nonsense talk, there is a renewal of the child's
pleasure when it just learns to master language. It is easy
to understand that in play with pictures the case is slightly
different. Not everyone acquires the mastery of pictorial
construction at all. Yet at bottom caricature, too, renews
infantile pleasure. Its simplicity (as Hogarth knew) makes
it resemble the scribbling of the child. But we have learned

to see it in a wider context. We have learned to define caricature as a process where—under the influence of aggression—primitive structures are used to ridicule the victim. Thus defined, caricature is a psychological mechanism rather than a form of art, and we can now easily understand why, once having come into existence, it has remained always the same in principle. Caricatures like those of Louis Philippe as a pear are at bottom nothing but visual puns and the taste in puns may change but their mechanism remains the same.

VII

Perhaps we are now better equipped to approach the historical problem of the application of this mechanism in the visual arts. Seen in the light of our analysis the emphasis on skill, for instance, acquires a new meaning. Certainly the controlled regression that is implied in the scribbling style of the masters is only possible where representational skill determines the ordinary level from which the virtuoso can let himself drop without danger. The pleasure in this sudden relaxation of standards demands a certain degree of security which we can observe in individual instances in such acknowledged masters of draftsmanship as Michelangelo and Dürer but which the public learned to appreciate only when ordinary naturalistic imitation had become commonplace. To explain the significance of transformation, however, the controlled use of the primary process, that is, the essence of the caricaturist's power, we must view the historical position in a somewhat wider perspective.

Once more the first theoretical formulations on the caricaturist's art may provide us with indicators. These theories, it will be recalled, were couched in terms of Neoplatonic aesthetics. The successful caricature distorts appearances but only for the sake of a deeper truth. In refusing to be satisfied with a slavish "photographic" likeness the artist penetrates to the essence of a person's character. We do not believe that this insistence on the artist's power is accidental. It is symptomatic of a complete change in the artist's role and position in society which marks the sixteenth century, the century of the Great Masters.

This refers neither to the artist's income nor to his prestige as a member of a concrete social group, nor to whether or not he carried a sword—but to the fact that he was no longer a manual worker, the *banausos* of antiquity; he had become a creator. The artist was no longer bound by fixed patterns, as in the Middle Ages; he shared the supreme right of the poet to form a reality of his own. Imagination rather than technical ability, vision and invention, inspiration and genius, made the artist, not merely the mastering of the intricacies of handicraft. From an imitator he became a creator, from a disciple of nature its master (Schlosser, 1924; Panofsky, 1924). The work of art was a vision born in his mind. Its actual realization was only a mechanical process which added nothing to the aesthetic value and indeed often diminished it. This state of mind is best illustrated by the paradoxical remark of a guidebook to Florence published in the late sixteenth century, which expressed the opinion that Michelangelo's unfinished marble blocks of the "Slaves" are even more admirable than his finished statues, because they are nearer to the state of conception (Kris, 1926). It is not difficult to formulate this aesthetic attitude in psychological terms. The work of art is—for the first time in European history—considered as a projection of an inner image. It is not its proximity to reality that proves its value but its nearness to the artist's psychic life. Thus for the first time the sketch was held in high esteem as the most direct document of inspiration. Here is the beginning of the development which culminates in the attempts of expressionism and surrealism to make art a mirror of the artist's conscious or unconscious.

VIII

There are many fields in which the artists of the period sought to assert the priority of imagination over slavish imitation. The *capriccio*, the whimsical invention, became the sure means of impressing the connoisseur and arousing the envious admiration of fellow artists. For a wide range of examples we select one in which the role of the primary process is most easily demonstrable—the fashion in ornaments. In many periods of the past the ornamental border had given most scope to the artist's free play of imagina-

tion. In the late sixteenth century, however, this free play itself becomes emancipated from its shadowy range on the margin of the book or under the seat of the choir stall. Series of engravings or woodcuts proudly displayed the artist's power of creating grotesques. The affinity of these creations with the dream was recognized. "He who wants to create dreamwork," says Albrecht Dürer, "must make a mixture of all things." Often the play with meaning, the ambiguity of form, becomes a predominant feature in these fantastic works. Even the traditional monsters of medieval demonology are now transformed into a mere exercise of wit and formal ingenuity. A characteristic example of this development is a series of woodcuts which appeared in 1569 under the name of Rabelais. In this series the ambiguity of form is used with much virtuosity. Implements are transformed into human beings, the world of the inanimate has come to life. It is instructive to look at the prototypes. These Rabelaisian monsters are escaped from Hieronymus Bosch's hell. But the change of context results in a change of meaning. The uncanny has turned comic, confirming what we know of the character of the comic phenomena—at the same time this ancestry in the sinister world of Bosch explains the double-edged character of our experience of the grotesque.

We seem to have moved far from the sphere of caricature, but the affinity of these creations of the primary process to the mock portraits of the Carracci is greater than might at first appear. In the Rabelais woodcuts, implements, pots, pans, and bags, are turned into human beings. The Carraccis—so their biographers tell us—loved to transform human beings into pots, pans, or cushions. The play with form, the controlled primary process, had found a new outlet in the most striking of *capriccios,* in the *ritratto carico,* the portrait caricature.

IX

The psychological analysis of the caricaturist's procedure has thus given us the tools to describe several aspects of a historical development in terms which bring out their essential coherence. The new role assigned to the artist's fantasy-life manifests itself in caricature no less

than in other spheres of art. But this finding alone would not be sufficient to account for the late occurrence of these phenomena in history. Human fantasy, after all, is universal—why was it kept so long within strict bounds? Formulated in this way our problem becomes, perhaps, even more puzzling. For in the realm of words we know of no such restrictions. Play with words, punning and nonsense talk is one of the most beloved tools of comic creation in many civilizations. How should we account for the fact that play with images requires apparently a much higher degree of sophistication? Why is the visual image as an artistic mode of expression so much more resistant to the free play of the primary process than is the word? If there is an answer to this question it must certainly throw light on the role that the visual image plays in our mind. It was for this reason that we started this investigation. We believe that here, too, psychoanalysis can furnish the answer. We know from clinical experience that visual images do in fact play a different part in our mind from that played by words. The visual image has deeper roots, is more primitive. The dream translates the word into images and in heightened states of emotion the image may impose itself upon the mind as hallucinatory perception. No wonder that the belief in the special power of the visual image is particularly deeply rooted. Image magic is one of the most ubiquitous forms of magical practice. It presupposes a belief in the identity of the sign with the thing signified—a belief which surpasses in intensity the belief in the magic potency of the word. Time and again it is found that the word is more easily understood as a conventional sign that can be distorted and played with, without ulterior effects, while the visual image— and most of all the portrait—is felt to be a sort of double of the object portrayed. The one must remain inviolate lest the other come to grief. We need not look far for evidence of this universal feeling with regard to the image. The lover who tears up the photograph of his faithless love, the revolutionary who pulls down the statue of the ruler, the angry crowd burning a straw dummy of a hostile leader—all testify to the fact that this belief in the magic power of the image can always regain its power

whenever our ego loses some part of its controlling function.

It is precisely this belief which explains the secret and the effect of the successful caricature. Under the surface of fun and play the old image magic is still at work. How otherwise could we account for it that the victim of such a caricature feels "hurt" as if the artist had really cast an evil spell over him? Nor is such a feeling confined to the self-conscious victims of pictorial mockery. If the caricature fits, as Philippon's *poire* obviously did, the victim really does become transformed in our eyes. The artist has taught us how to see him with different eyes, he has turned him into a comic monstrosity. He is not only abused as a fathead or unmasked as a stupid man—he simply cannot shake off the *poire*. He carries the caricature with him through his life—even through history. Great satirists have been very well aware at all times of their magic power to cast this spell of transformation on the memory picture of their butts and victims. The great poet Ronsard (1524-1585) calls out to his opponent:

Qu'il craigne ma fureur! De l'encre la plus noire
Je lui veux engraver les faits de son histoire
D'un long trait sur le front, puis aille où il pourra
Toujours entre les yeux ce trait lui demeurera.

When these verses were written, every reader understood that they were meant metaphorically. And yet the same threat which here applies to verbal satire had not yet been translated into the realm of pictorial art.

X

The conclusion that is forced upon us is this: Caricature is a play with the magic power of the image, and for such a play to be licit or institutionalized the belief in the real efficacy of the spell must be firmly under control. Wherever it is not considered a joke but rather a dangerous practice to distort a man's features, even on paper, caricature as an art cannot develop. For here as in the other spheres analyzed before, the caricaturist's secret lies in the use he makes of controlled regression. Just as his scribbling style and his blending of shapes evokes childhood pleasures, so the use of magic beliefs in the potency

of his transformations constitutes a regression from rationality. This very regression, however, presupposes a degree of security, at a distance from action that we can certainly not expect in all periods. The absence of caricature in earlier times indicates to us that this security, or distance, was absent. This does not mean that a belief in image magic was always consciously held in classical antiquity or in the Renaissance but it does mean that a free play with the representational image would not have been experienced as funny. For this to happen the pictorial representation had to be removed from the sphere where the image stimulates action. Once the artist's prerogative as a dreamer of dreams was asserted the sophisticated art lover of the seventeenth century would be flattered rather than hurt to look at his countenance in the distorting mirror of the great artist's mocking mind. The birth of caricature as an institution marks a conquest of a new dimension of freedom of the human mind, no more, but perhaps no less, than the birth of rational science in the work of Galileo Galilei, the great contemporary of the Carraccis.

But even though the world of art admitted caricature as a sophisticated joke it remained quite aware of the element of regression it presupposes. *"C'est une espèce de libertinage d'Imagination,"* says the *Encyclopédie* on Caricature (Vol. II, 1751), *"qu'il faut se permettre tout au plus que par délassement."* Caricature is relaxation because in its style, in its mechanism, and in its tendency, it relaxes the stringent standards of academic art.

Perhaps it may be legitimate to see in this aesthetic verdict, often repeated, a last remnant of the taboo which had once forbidden the play with a person's likeness. This explanation does not imply that no problem of artistic values is here involved. The license of humor is one thing, the relation of the comic to the sublime another. The best caricatures cannot and do not claim equality with great portraits. The effect of caricatures is sudden, explosive, and tends to evaporate. The great portrait has more dimensions; it continues to stimulate responses, reinterpretations, and thus processes of re-creation.

XI

Looking back on the ancestry of caricature we may, perhaps, conveniently distinguish three stages which correspond to three possible mental attitudes toward image magic.

In the most primitive stage of witchcraft and sorcery the hostile action that is done to the image is meant to harm the person represented. Image and person are one. To pierce the wax dummy means to destroy the enemy.

There is another frequent stage in which the hostile action is carried out on the image *instead* of on the person. In hangings in effigy or in defamatory paintings not so much the person as his honor is the target. The image here serves to perpetuate and promulgate in graphic form a hostile action, injury or degradation. It serves communication rather than immediate action.

In the third stage, to which caricature belongs, the hostile action is confined to an alteration of the person's "likeness." Thanks to the power of the artist the victim appears transformed and reinterpreted and only this interpretation contains criticism. Aggression has remained in the aesthetic sphere and thus we react not with hostility but with laughter.

In comparing these conclusions with the clinical experiences of psychoanalysis, we open a wide field for further research. One thinks of patients to whom caricature and satire are dangerous distortions; the feeling of magic about these comic achievements destroys for such patients their aesthetic value. One is reminded of persons to whom the comic in general is unknown; they fear the regression in all comic pleasure, they lack the faculty of "letting themselves go." One finds in analysis that this is due to a lack of strength in the ego. If patients of this type acquire or reacquire the faculty of humor in analysis, it is only after the dominating power of the ego has been restored, and thus regression to comic pleasure has lost its threatening aspect. We might then say that the patient has made a new step toward freedom in his attitude to life.

The mechanism of artistic creation itself may be illustrated by other cases, in which the faculty of projection

is disturbed. A painter whose interest in caricature is evident is unable to make convincing caricatures so long as he distorts his own personality. Unconscious self-distortion has taken the place of the distortion of his models.

ANTON EHRENZWEIG

THE PSYCHO-ANALYSIS OF ARTISTIC VISION AND HEARING *(1953)*

ALTHOUGH MOST READERS will not relish the more orthodox Freudian chapters in this book, it is surely one of the valuable critical works. The basis of Ehrenzweig's argument is not, however, Freud but William James, who claimed that there occur "interruptions in consciousness" during which we have perceptions we cannot phrase in the discourse of conscious thought: we cannot formulate these deep perceptions in a "good Gestalt." The most potent artistic meanings, therefore, are not stated in a fully rational or intelligible form, but appear at the cryptic level of the "non-Gestalt," the "formless," or the distorted. Ehrenzweig's main thesis, then, is that there are two sorts of perception: Gestalt and non-Gestalt, conscious and unconscious. Since the unconscious perceptions are "danger-ous," they often are repressed by some canon of artistic style that is merely "a superstructure serving to hide and

to neutralize the dangerous symbolism hidden in the unaesthetic inarticulate structures below." These deep, imperfectly repressed meanings are the ones *not* logically represented in a painting, a musical score, or a poem. But in all potent art such inarticulate perceptions will break through, creating a tension between conscious artistic form and unconscious (i.e., half-repressed) meanings. Modern painting, for example, releases some of these non-Gestalt perceptions, and accordingly is¹ thought to be a "dangerous" distortion of reality or an attack upon it. Actually it is highly libidinous, and like the distortions in primitive art, is an intensely charged libidinous drive to "make" something. Here Ehrenzweig agrees with E. H. Gombrich, who in *Art and Illusion* says that the primary artistic impulse is to "make," not to "match"—that is, not to copy the appearances of the outside world. The painter who tries to get a "good Gestalt" by copying the outside world "realistically" is repressing his libidinous interest in reality, just as the scientist is de-libidinizing the outside world by holding to his ideal of "objectivity." Thus, scientific objectivity (or "reification") corresponds to artistic "realism," which has dominated art from the Renaissance to the present, when the unconscious has broken through again to express what is inarticulate. Ehrenzweig concludes that ever since the Middle Ages both science and art, turning "realistically" to the world of nature, have actually been in retreat from their own libidinous impulses because they fear them, and therefore "reify" their world in two guises: artistic and scientific. We must ask how largely Byzantine and Romanesque arts are, in spite of their distortions, an expression of the libidinous artistic impulse to make, not to match.

Ehrenzweig's implications are curiously paralleled in Norman O. Brown's *Life Against Death* (1959), and in Francis Bradshaw Blanshard's *Retreat From Likeness* (1945, 1949). In *Abstraction and Empathy* (1908, 1953), Wilhelm Worringer argues that abstract art is creative and redemptive, in contrast to naturalistic (empathetic) art.

THE REIFICATION OF ART FORM

(Chapter IX)

In artistic perception, and as we shall see also in ordinary perception, there exists another dynamic tension between surface and depth perception. The artist, in his creative state, dissolves not only the 'good' Gestalt of surface perception, he also disintegrates its "thing" quality. In Chapter II, I explained how the artist pays but little attention to the coherent thing shapes around him; he may dissect them into arbitrary fragments and rejoin them into irrational form phantasies to suit his unconscious urge for symbolization. In other words, artistic perception tends to be not only Gestalt-free, but also thing-free. We observe this thing-free mode better in primitive or irrational types of art which also demonstrate the Gestalt-free modes of perception. We saw how in some primitive art the unconscious symbolism, hidden in the images as in picture puzzles, may distort the realistic appearance of the outlines; while the more inhibited civilized artist may be impelled to make the outlines follow a realistic imitation of the real things. We shall see that the artist is forced, to a greater or lesser degree, to "reify" his symbolic form play; while it unconsciously expresses the inner dream world of symbolic expression, the work of art is made to represent the real things of external reality. I am borrowing the term *reification* from the child psychologist Sully who attributes to the child a tendency to "consider as external, to 'reify' . . . , the contents of his mind."

The secondary reification of the artist's symbol play is not merely a covering up of his symbolic forms under a thin façade representing external reality or the projection of a superficial rational meaning into them. As a secondary process reacting against the thing destruction in artistic vision and hearing, it serves to reintegrate the

destroyed thing perception in all its unconscious dynamic processes.

We have already touched upon such complete reintegration of thing perception in our analysis of harmonic articulation. Preharmonic polyphony represented a confusion of acoustic thing perception (differentiation of tone colors); the articulation of harmonic chords reacted against the confusion by differentiating instead the "artificial" tone colors of the consonances and dissonances. The unconscious dynamics of harmonic articulation resemble those of the articulation of the "natural" tone colors; instead of the original repression of the overtones, underlying the "natural" tone colors, we have the repression of the single chord tones (see certain differences in the dynamics of the two repression processes in the next chapter). I am anticipating the results of my later discussion of thing destruction in music, in order to show that the secondary reification process in artistic perception goes beyond superimposing a rational thing meaning on top of the unconscious thing-free symbol play of art; it repeats, on a different level, the dynamics of the original psychological process which, in the first place, enables us to perceive the real things (e.g., the process of repression inherent in the "primary" reification; see later on).

In the first part of this book, the secondary Gestalt articulation of art helped us to understand the primary Gestalt processes in ordinary surface perception. Similarly, we may now hope that the dynamics of the secondary reification process may shed new light on the unconscious processes underlying our ordinary thing perception (primary reification).

The real things impress us first by their *constancy;* they appear to be the same in spite of their many varying aspects. They also excel by their intense *plastic* quality which sets them off from our "flat" perception of abstract Gestalt formations, such as geometrical shapes. Most important of all, they have the quality of *externality,* i.e., of their separateness from the internal world of the mind. We shall see that all these three characteristics also play an important part in the "secondary" reification processes of art, though there they may only create "illusions" of

constancy, plastic reality, and externality; there they will appear to be connected with extensive processes of "repression" (for instance the repression of the single chord tones in the fusion of harmonic chords); shall we be able to discern similar repressions in the "primary" reification process which builds up the external world of real things?

The nineteenth-century psychology of "Introspectionism" discovered that our perception of the real things eliminated from consciousness the various "distortions" which the form, tone, color, localization, etc., of the real things undergo owing to changes in their illumination, or in our viewing angle, etc. It stands to reason that to find our bearings in the world would become extremely difficult and liable to error if we had consciously to discount the ever-changing distortions of form, tone, etc., in order to arrive at the unchanging "constant" properties of the real things which alone are biologically significant for our reality adjustment. As it is, the so-called "constancies" of form, tone, etc., automatically discount (repress) these "thing-free" distortions and give us instead an immediate awareness of the "constant" reality which—and this is the hitherto neglected salient point—contain little, if any, precise form experience. As a rule, we are not conscious of this lack. When we recall the face of a friend it might appear before our inner eye as vivid and seemingly complete in details of form; but if we were asked if we recalled his face full or turned slightly sideways, we would hardly appreciate the point of such a question. So little do we realize—both in recalling and also in actually looking at a real person—how the slightest change of attitude affects the purely abstract Gestalt aspects of a face. The angles of perspectivic distortion and the foreshortenings of the single forms are in a constant upheaval of which we are hardly aware in everyday life. We are irritated by the fussiness of a portraitist who tries to freeze his model into immobility. But try once to realize the enormous changes in abstract Gestalt which occur as a human head turns from a fullface to a full profile. The ridge of the nose was a somewhat indistinct quadrangle seen fullface. As it turns sideways its geometrical shape is transformed into something entirely different and ultimately assumes the

characteristic triangular shape of the nose in profile. Between these polar attitudes are crowded countless transitional attitudes which assume an even wider variety if the sideways movement is combined with a nodding movement and so produces the additional distortions of the bird's- and frog's-eye views. If we wished it, the artist, with his greater sensibility for abstract meaningless Gestalt, could arrange the human form into thousands and thousands of strikingly different aspects which however never penetrate into our everyday experience of reality. As we sit quietly opposite an old friend we do not have to renew unceasingly our efforts in order to recognize his familiar face in his ever-changing "abstract" thing-free aspects. It just appears to be the same all the time; we are not aware that our impression of sameness is bought at the price of having hardly any precise form experience at all. This is due to the "repression" of the inconstant thing-free aspects.

The nineteenth-century Introspectionism could not, of course, realize the depth-psychological implications of its discovery. The elimination of the "thing-free" distortions of form, tone, color, localization, etc., is a true "repression," that is to say, the eliminated distortions are not altogether lost to perception, but are perceived by depth perception from where they may return into consciousness. How are we to know this? It is again the depth-psychological facts of artistic perception which suggest this assumption. The artist not only destroys the abstract "good" Gestalt of surface perception (as we have seen in Part I of this book), but also disintegrates the "thing" constancies under the pressure of his creative urges which strive to symbolize themselves in the Gestalt- as well as thing-free visions of the depth mind. The nineteenth-century Introspectionists too were agreeably struck by the fact that the realism of Western painting had already partly uncovered the distortions of constant form by perspective, of constant ("local") tone by chiaroscuro, of constant color by Impressionistic open-air coloring.

This singular phenomenon of scientific discovery in art would be explained by the return of the "thing-free" distortions into consciousness. The Renaissance painters

were the first to pierce through the "constancy of form" and discover the ever-changing perspectivic distortions and foreshortenings beneath; the Baroque painters penetrated through the "constancy of the local tone" (brightness) and discovered the strong contrasts between light and shade (i.e., chiaroscuro); after the lapse of another three hundred years the Impressionists overcame the "constancy of the local color" and discovered the play of open-air illumination on the constant color of the real things. The painters were not out to discover biologically less relevant unconscious modes of vision. They were out to make their paintings appear more plastic and lifelike; in comparison the previous "naïve" methods of painting appeared to them to be flat and stylized. Perspective gave painting an almost three-dimensional depth; the chiaroscuro of the Baroque used the transition between full light and deep shade in order to mold the solid things in the round; the shimmering open-air colors of Impressionism are said to produce a feeling of the empty space, of "atmosphere," extending between the depicted scene and the onlooker. Here the creative achievement of art represented an advance in the scientific and plastic representation of the external world; strangely enough, this advance rested on the successive breakthroughs of unconscious biologically less relevant perceptions which had been repressed by the constancies of form, tone, and color. Was not the constancy of our thing perception the very basis of our concept of a stable and unchanging external world? How could the disintegration of this all-important constancy be felt as an advance in the scientific representation of the external world? As we shall see, this is due to a secondary reification which transmuted the primary disintegration of constant thing perception into a new and rationally more valuable method of perceiving and representing the real things.

Let us examine in more detail the first two constancies of form and of tone which artistic perception disintegrated during the evolution of realism in European painting. We said that the "constancy of form" discounted (repressed) the ever-changing distortions of perspectivic foreshortening. We hardly, if ever, see an object without some perspectivic distortion of its "constant" form. Of the two

arms of a person the nearer appears bigger on the retinal image, or vanishes as the arm is raised to point towards our observing eye. A table laid with round, equally big plates shows in the retinal image a multitude of elliptical forms, but hardly ever a perfect circle. The ellipses become flatter towards the far end of the table, rounder towards its near end. Owing to the "constancy of form" we instantly recognize their identical roundness and pick out that odd plate which possesses—like a meat platter—a *real* elliptical shape. The "constancy of form" automatically discounts all these distortions of the real constant form. This makes our thing recognition both more rapid and more reliable. It is easy to imagine how difficult our thing recognition would become if we had to discount consciously the perspectivic distortions and foreshortenings. Only complex mathematical operations taking into account the trigonometrical data, such as viewing angle, distance, etc., would calculate the real "constant" form of an object from a given perspectivic aspect. Hence, as already mentioned, the repression of the distortions represents a very important step forward in making perception serviceable for recognizing reality.

The "constancy of tone" (brightness) offsets the distortions of the local tone by the vagaries of illumination (chiaroscuro). A black book placed in the full sunlight might become lighter, or of the same gray tone, as a white paper lying in deep shade near by, i.e., both reflect the same amount of ray light on to the retina. An awkward photograph which fails to take into account sufficiently the possible effects of different illumination might show the book as almost bleached white and the paper a dirty gray. In our normal experience of reality, however, we do not perceive the "true" tone values of chiaroscuro. Instead, the "constancy of tone" automatically discounts the distortions of tone and we perceive at once the real constant tone values of black and white. The Introspectionist psychologists placed a perforated screen between the observer and the two objects so that only small spots (cut out from the surfaces of the black book and white paper) remained visible through the viewing holes. As the different illumination of the book and of the paper is then no

longer apparent it can no longer be automatically dis-
counted (repressed) by the "constancy of tone." Hence
the two grayish spots can reveal their true chiaroscuro
tones. As soon, however, as the screen is withdrawn and
the observer is again made aware of the difference in illu-
mination, the suspended "constancy of tone" springs back
into automatic action and forces the observer to see again
only the constant local tones of black and white. It needs
a careful training of the eye—as the photographer of
today must possess—in order to realize the enormous in-
fluence of chiaroscuro illumination on the local tone values.
Painters have never bothered to investigate scientifically
the tone distortions hidden under the "constancy of tone"
as they had previously investigated the form distortions
by perspective. This may be partly due to the greater
strength of the "constancy of tone" as compared with the
"constancy of form"; had painters reproduced scientifically
the true chiaroscuro distortions, the effect would have been
as little realistic as that awkward photograph of the
bleached black book and dirty paper. (This difference in
the strengths of the various constancies has some bearing
on the history of realism and its recent downfall as we
shall see later.)

As long as the "constancy of tone" is not overcome
we really *see* the local tones between black and white.
The same holds good of the "constancy of form" repressing
perspectivic distortions; as long as we do not overcome this
constancy, we really see the constant form of a thing and
not the accidental perspectivic distortions hidden under
the constancy. As long as the painter and his public have
not overcome the constancies of form and tone there is no
point in the painter reproducing scientifically the repressed
distortions of form and tone. Hence the naïve painter, be-
fore the advent of perspectivic and chiaroscuro painting,
reproduced on the canvas the constant form and tone of
an object which he actually saw, not what he merely knew
to exist. The customary distinction between a "perceptual"
type of painting which reproduces the actual perception
and "conceptual" type which reproduces the object as it
ought to look according to our knowledge of its constant
properties, is at best inexact because it does not take into

consideration the possible dynamic changes which have taken place in our perception since the Renaissance. The realistic artists, by their successive "discoveries," have so altered our thing perception that we wrongly take our present (still limited) awareness of perspective and chiaroscuro in everyday vision for a primary fact of vision and therefore deem perspectivic or chiaroscuro painting the only possible "realistic" way of painting. Art psychologists try to explain to us, almost apologetically, why certain artists dared to neglect perspective or chiaroscuro which others perceived so clearly. This attitude reverses the true position. We are indebted to artists, past and present (and today also to the art of photography), for the limited awareness of the perspectivic distortions of form, and of the chiaroscuro distortions of tone which we now possess. While it is still difficult to overcome the "constancy of tone" (unless we have laboratory equipment) and we realize therefore only imperfectly the distortions of the local tone by the chiaroscuro, it now needs only a slight change in our mental attitude in order to overcome the "constancy of form" and realizing the perspectivic distortions of form hidden underneath. So slight is the effort sometimes that we are liable to think—erroneously—that any conscious perception of a thing must necessarily contain the perspectivic distortions as registered on the retina.

E. H. Gombrich uses recent investigations of animal psychology in order to demonstrate that the awareness of an abstract form (Gestalt) is not a primary fact of vision. It is possible to "deceive" animals with very crude representations of certain things. Man too recognizes biologically important forms not by deducing their identity from a "neutral medley of forms." The more important a thing is biologically, the less form experience will be needed in order to represent it in nature and in art. Gombrich therefore sets out from a different starting point and arrives at the already stated fact that thing perception (which could be defined as the perception of biologically significant forms) contained little or no precise form experience (abstract Gestalt). We shall see later in our dynamic interpretation of the plastic feeling that we wrongly attribute to our thing perception a precise abstract Gestalt

because we tend to confuse the intense plastic appearance of the things with their actually missing precise Gestalt. We feel that the things in their plastic solidity must also possess a clear well-articulated outline.

It was the artists then who taught us to become aware of the thing-free Gestalt forms in real things. We saw how art instruction may advise the art student to treat the picture of the world around him like a flat abstract pattern. In the example of a morning drive in a lifting mist we illustrated the specific artistic faculty of cutting the coherent solid things into meaningless segments which the artist may fit into an irrational play with abstract (thing-free) forms.[10]

This detached "thing-free" way of looking at the outside world, as though it were a flat abstract Gestalt pattern, presupposes a lessening of the normal libidinous interest in reality. As the artist does not care for the real constant properties of the things he is able to overcome the various constancies of form, tone, and color, to destroy in fact his thing perception and bring up the biologically less relevant distortions of perspective, chiaroscuro, etc. This is as true of the present-day art student, who is taught a better awareness of perspective, chiaroscuro, etc., as it must have been true of the Renaissance, Baroque, and Impressionist artists who first "discovered" the laws of realism.

We shall see later that the naïve spectator preserves his libidinous interest in reality and therefore still singles out the real things with their constant properties from the realistic paintings; he thus "represses" again the thing-free distortions of perspective, chiaroscuro, etc. Only this naïve (reintegrated) thing perception of the realistic paintings acquires a plastic, almost three-dimensional quality. We have to distinguish this secondary naïve way of viewing and repressing the various distortions from the original creative vision which brought these distortions to the surface owing to its aloof treatment of reality as a flat, meaningless pattern. It was not the Western artist's heightened interest in external reality which made him "discover" the previously repressed thing-free distortions of constant form, tone and color, but his diminished libidinous interest in

reality, i.e., the very opposite from what we would have expected. But we have got used to the paradox that the artist's creative vision in the end produced—through the agency of secondary processes—an exactly opposite result. Thus, the Western artist, by his libidinous withdrawal from the external world, gave us through the secondary process of reification a new near-scientific grasp on external reality.

We must not confuse the intense scientific interest of the Renaissance artists with a true libidinous interest in the external things. Libidinous and scientific interests (and as we shall see a "scientific" and "libidinous" realism in art) exclude each other. Scientific observation is disturbed by ties of love or hatred; it attempts to be emotionally aloof. An anatomist would hardly care for dissecting the body of a person dear to him however interested he would otherwise have been in examining such a case. We shall understand better the irrational source of the scientific realism which dominated our art from the time of the Renaissance until recently once we have examined the general scientific tinge of Western civilization and its irrational origin.

Since the late Middle Ages the Western artist has steadily retreated from external reality and disintegrated in his vision one thing constancy after another until, as though through a sudden catastrophe, "modern" art brought the progressive thing distortion and destruction into the open. After discussing acoustic thing destruction in the next chapter, I will revert to the visual arts in Chapter XI and demonstrate the continuity of our "modern," openly thing-free (abstract) art with the previous realistic art. . . .

SCIENTIFIC TRUTH FEELING AND EXTERNALITY ILLUSIONS OF ART

(Chapter XVI)

Closely allied to the feeling of plastic Reality accompanying the reification process is the feeling of Truth. The truth feeling guarantees that the internal world of ideas (symbols) conforms with the external world of reality of which it is a replica; the truth feeling, in this function, is a more highly developed variety of the basic feeling of plastic reality which was our concern in the preceding chapter. We speak of a "solid" truth and indicate thereby that the internal world of ideas is made of the same stuff as the plastic reality without. If an idea is "truth," it means that the scientist has successfully reified his primary creative imagery which in the first place symbolized only his subjective repressed urges.

It may very well be that there existed no sharp distinction between the mental imagery of real *things* and the imagery connected with true *ideas* except the degree of their "abstraction" (lack of differentiation) and the quality of feelings (*reality* or *truth* feelings) which accompany them. The form experiences underlying our perceptions always tend to evaporate at every determined effort at introspection; we would not wonder, therefore, if all that would remain in the last analysis to distinguish the abstract image of a thing (equipped with feelings of plastic reality) from the equally abstract image of an idea (equipped with truth feelings) was the quality of the two types of feeling cathecting them.

It probably was inevitable that the psychoanalysis of Western art history should in the end bring us up against the need to examine the scientific truth feeling. We could

not help paying undue attention to the two specific achievements of Western civilization, harmonic polyphony and realistic painting. Their unconscious dynamics—the destruction and secondary reintegration of thing perception—belong more to the realm of creative thinking than to that of artistic form. Polyphony and realism are mere sideshows of the far more significant scientific quest in Western civilization. We could better understand the psychological trend which set into motion the long libidinous withdrawal of realistic painting were we able to interpret the rise of the scientific spirit in the late Middle Ages. We suspected at the time that our scientific rationality reacted against deeply irrational tendencies which broke surface towards the end of the Middle Ages.

There may also be an irrational element in our frequent acceptance of a "compelling" truth irrespective of its scientific value. We shall see that our need for interpreting reality in terms of causal "necessity" is such a psychological compulsion supported by irrational truth feelings. Nowhere is this irrational compulsion clearer than in the pseudoscientific "externality illusions" of art. There they are part and parcel of a more primitive, not yet quite scientific reification process. If the reification process succeeds completely in creating new things—as in the creation of artificial tone colors in music—then an insuperable "externality illusion" prevents us from recognizing their mind-made origin. . . .

. . . This inconsistency agrees with our assumption that the artist's urge of justifying artistic innovations by external laws is not determined by a genuine scientific interest in observing nature, but by an internal necessity, i.e., the necessity of restricting the freedom of the thing-free form play which broke loose after the destruction of the rational thing constancies of size, brightness, and color. The unconscious form play is subjected to laws which are derived by hook or by crook from the external world.

It might be that the true scientist's urge of explaining the external world by compelling laws of nature rests on a similar internal necessity, only that his results can bear the reality test. The difference between the artist's be-

lief in external "laws of art" and the true scientific belief in "laws of nature" might be as uncertain as the border-line dividing normal and abnormal mental life. We can often understand normal mental facts better after we have studied their correlated facts in abnormal mental life. Many functions in both normal and abnormal mental phenomena are the same though their results are of very different value. The scientist's success in discovering true laws of nature is not easily explained. There is no essential difference in the creative mechanisms (*Einfallsmechanismen*) of art and science which could be held responsible for the scientist's success and the artist's failure. The scientist, like the artist, contemplates in his creative vision only his own internal world clad—like the dream—in images taken from the external world; but from this "internalized" vision the scientist returns triumphantly with a new "law of nature" which claims to interpret the *external* world in a new way. This law has the conviction of truth and we are forced to agree with him.

But are we really forced to agree? As it happens the aims of natural science are undergoing a severe crisis to-day. It may well be that the urge of the classical scientist to explain nature by compelling laws of causality is an externality illusion like the artist's urge to elevate realistic mannerisms into compelling laws of art.

The much vaunted crisis of the law of causality can be put into very sober terms. The whole concept of a "law of nature" was recognized as superfluous. It was found unnecessary to describe the movements of the planets round the sun by a compelling law of nature which forces the stars to move on their prescribed course. The stellar movements can be described just as well by a mathematical formula from which any future or past constellation can be calculated at will. Such a formula lacks the two elements of which the concept of causality consists—the element of compulsion and that of sequence in time ("the effect is compelled to follow on the cause"). Now, what is found superfluous in a scientific description cannot be true. It is an adornment which does not conform with reality. The "true" formula must contain neither too much nor too little; either deviation would make it

false. Hence the whole concept of a law of causality which compels the natural events to follow each other in a pre-ordained order is false.

Kelsen in his book *Society and Nature* thinks that the illusion of a compelling "law" in nature rests on an original identity of the laws of human society with the laws of nature. The basic law of society is a law of retribution and of punishment for guilt. Primitive man makes nature a part of primitive society. The objects of nature behave like members of his community and obey the same basic law. If the primitive man is hit by a tree or falls ill or his crops fail, the reason is guilt and retribution for this guilt. As he is interested only in explaining disaster and not his good luck, the principle of retribution for guilt is sufficient to account for all the evil events which alone he wants to explain. If in the modern law of causality the effect is "compelled" to follow on the cause this compulsion is a residue of the guilt interpretation of the world. The Greeks formulated the law of causality in a way which clearly betrays its moral character: "All things pay retribution for their injustice one to another according to the ordinance of time" (Anaximander, after Gilbert Murray, *Five Stages of Greek Religion* [1946], p. 33). The sense-less cruelty of Greek Tragedy can be interpreted as an endless chain of injustice and retribution. Clytemnestra avenges her daughter Iphigenia by killing Agamemnon and this act of retribution is a crime to be revenged by Orestes' matricide who himself falls a victim to the aveng-ing Erinyes. The cruel fate governing human beings is the supreme law of nature itself according to which "all things pay retribution for their injustice one to another." Cause is identical with guilt and the Greeks expressed both with the same word *Aitia*. In German the word *Schuld* is often used to describe causation; in English, too, natural events can be held "responsible" for certain effects. Only today "the notion of causality is stripped of its most im-portant element with which it was still burdened as the heir of the principle of retribution: *Ananke*. This is neces-sity with which Dike, the Goddess of Retribution, punishes evil-doers and at the same time keeps nature on its pre-scribed course" (Kelsen, ibid., p. 262).

Kelsen deals only with the illusionary element of compulsion in the concept of a compelling law of causality. He mentions in passing that the second element of causality—temporal sequence—might also rest on a confusion of natural and social law. The effect follows on the cause as the punishment follows on the crime. I showed that the order in time as we know it existed only in our surface experience, while the depth mind was able to perceive without regard to the order in time. The illusion of temporal sequence is perhaps the most cogent of all externality illusions; time is the mode in which the ego works (Freud) and this mode is externalized into the outer world and perceived there as an objective order in time which all natural events have to follow.

The compelling laws of art show the hybrid character of natural and social (moral) laws very clearly. It has always struck me as unscientific that the aesthetic theorists were not content with proclaiming external laws of beauty based largely on their own subjective tastes which they mistook for laws of nature. Realism, Functionalism, style imitation are not merely the descriptions of certain artistic movements, they are also put forward as peremptory demands with which every artist ought to comply. This confusion of art laws with moral laws and also the moral indignation which so often breaks up an ordered discussion on questions of art are an indication of the strong moral tinge which adheres to the "compelling" laws of art, and as we saw also attaches to the "compelling" laws of nature.

Whence comes this moral tinge? Why should the pre-scientific primitive world interpretation be a cruel law of endless guilt and of endless retribution? Could it not be that the scientific reification process derives its element of *external* guilt and compulsion from some *internal* guilt and compulsion?—that we project a deeply repressed guilt feeling (based on the internal compulsion of the superego) into the external world? Again the usage of language is revealing. It connects "science" with "conscience," "*Wissen*" with "*Gewissen*." The Bible tells us that the first knowledge was bought at the price of eternal guilt, i.e.,

the guilt of the woman and the devil serpent which was cleverer than the other animals in Paradise.

We know from clinical material how easily unconscious guilt feelings undergo externalization. The conscience is projected into the external world and heard there as a reproaching or warning voice. How easily are we inclined to blame our own guilt on somebody else; again we free ourselves from the oppression of the superego by "externalizing" our guilt.

The compelling illusions of external guilt and compulsion which are found in art and science would help us to escape from guilt and compulsion within. We understand now why the artist who dares to break the "laws" of art will evoke moral indignation and even risk prosecution.

Most revealing is the emotional reaction following the recent disintegration of the law of causality. When the concept of causality was recognized as an illusion it could have been quietly dropped like other half-mythical beliefs which are apt to crop up in science now and again. But the fall of the law of causality was dramatized into a crucial crisis of science itself. Man suddenly felt his grip on reality to give way and an abyss of insecurity to open under his feet. This anxiety feeling becomes understandable if we interpret the illusion of an external causal compulsion as an escape from a moral compulsion within ourselves. By destroying the myth of causality we fall a victim to an archaic guilt feeling from which we had tried to escape into the belief in external compulsion and which begins to oppress us again with inarticulate feelings of insecurity and forebodings of disaster.

Worse feelings of guilt and anxiety than those which now mark the breaking up of the causality myth, once heralded its formation a few centuries ago. I refer to the horrors of the witch belief which darkened the most brilliant minds of its time to an extent which is quite incomprehensible to us. To fit the witch belief into the history of the modern scientific belief, one must realize that in the early Middle Ages all interest in explaining the external world had ceased. After the collapse of classical rationality

the few intellectuals were content to guard the literary heritage and to understand the world by logical deductions from classical writings. When the mind of medieval man turned outwards again the beginning interest in the external world assumed the form of the primitive's interest in world explanation. Kelsen shows that the primitive's intellectual curiosity is only aroused by disaster which he explains by guilt. So the medieval man's first interest in explaining the external world was a quest for guilt. When a disaster occurred its cause had to be guilt; and it was— as in Paradise—the guilt of the "Woman and the Devil."

Our horror of a belief of barbarian cruelty should not prevent us from noticing that apart from being based on an unshakeable belief in causation through guilt, the procedure of witch-hunting began to resemble more and more impeccable scientific research methods of today. Some records of witch trials are a testimony to the thoroughness and impartiality of the judges. The witches were made to repeat certain magical ceremonies or formulae which had been established as the cause of disaster and the results of these ceremonies were closely watched. The modern scientist will shudder as he recognizes in these elaborate tests which are half trial, half experiment, the authentic forerunners of his own methods by which he tries to reproduce natural causation in his laboratory. The intellectual ambitions and capacities of many centuries went into the study of witch guilt. It would be quite wrong to assume that the witch belief had begun as a popular superstition and then gradually infected the educated minds. Quite the contrary! It agrees with our assumption according to which the quest for guilt was the first scientific interest that the belief in witch guilt took hold first of the most educated. The common people remained inert for a long time. The educated and more enlightened personalities used all the power and means of their position to shock the dumb masses of the population into the realization of the terrible dangers to which they were unknowingly exposed. They were helped in what today we call a campaign of popular education, by the newly invented art of book printing. When in every family library the latest primer on witch-hunting was found next to the family Bible the untiring popular

educators knew they had won at last. Modern science overcame the old belief in causation through witch guilt by substituting another myth, the myth of a compelling causality, certainly less cruel and harmful, but no less irresistible.

Freud found that the rise of new religious beliefs in the Mediterranean basin two thousand years ago was preceded by an inarticulate feeling of anxiety and guilt connected with the unconscious memory of the primeval patricides. We see now that the rise of modern scientific beliefs a millennium later was preceded by a wave of much stronger feelings of guilt and anxiety among the European peoples. This reveals an unexpected relation between the dynamics of religious and scientific beliefs. Both would articulate some deeply repressed guilt feelings probably connected with certain primeval memories. And these beliefs would be all the stronger the more the memories of primeval guilt oppress us unconsciously. Modern "believers" in science would claim that scientific curiosity was not hemmed in by restrictions like the religious outlook on the world. I would be more modest. If intellectual curiosity was a compulsion imposed by the necessity of escaping from unconscious guilt, it would become dangerous as soon as it touched at its own unconscious source— a question of guilt. This danger is not only demonstrated by the compulsive beliefs in the guilt of the witches. Even today the intellectually educated man has little gift for impartiality in questions of guilt. Why should it be reckoned a progress in dispensing criminal justice that the decision about capital guilt had to be taken away from the "learned" judge and entrusted to the common sense of a lay jury consisting of possibly quite uneducated men? It may be that the half-educated (and to this class belong almost all "intellectuals") might combine with his eager intellectual curiosity a good deal of still unsublimated guilt feelings which he has to externalize into guilt beliefs and which make him quite unable to bear uncertainty in questions of guilt. It seems no coincidence that the only intellectual occupation of many half-educated people is the reading of crime stories. It appears that nothing is able to stimulate intellectual curiosity more than a plot of

"guilt unexplained." This burning interest in the "who's done it" story might well be connected with our innate inability to leave a question of guilt unsolved for any length of time and make us accept without dismay the most improbable solutions of the crime mystery.

This preliminary analysis of the scientific guilt feeling allows us to round off our discussion of artistic and ordinary perception. We are now able to identify the mysterious breakthroughs of irrational thing-free modes of perception at the close of the Middle Ages which gave our art and music such a marked scientific tinge; they may be identical with the irrational tendencies underlying the rise of Western science itself. That the scientific truth feeling should be related with the guilt feelings issuing from the superego permits us to discern an intimate relation between the two main functions of the superego on the one hand and the two varieties of the reality feeling on the other; we saw that the fundamental feeling of plastic reality experienced in our perception of things was sharpened by the repressing function of the superego which was added to the "structural" repression already inherent in the perception process; we now see that the other principal function of the superego, namely that of arousing guilt feelings, becomes externalized into feelings of compelling truth which represent a more highly developed variety of the reality feelings, attaching to the world of true ideas instead of the world of real things. We thus arrive at a conclusion which is familiar to psychoanalytical thought, namely, that cultural sublimations which serve us in our contact with outer reality nevertheless arise in the first place in response to the exigencies of our inner reality. The twin feelings of Reality and Truth, as well as the aesthetic feeling of Beauty discussed in the book's first part, would be determined not so much by objective stimuli coming from the external world, but by dynamic processes occurring within our unconscious mind and thus would be controlled by its subjective needs. Future depth-psychological research might perhaps succeed to link up again the irrational happenings within our unconscious mind with their physiological "objective" basis and might thus re-establish a

somewhat more complex relationship between our perceptive experiences and outer reality than is generally assumed at present. But the simple, direct relationship between our perceptions and the sensorial stimuli coming from without which today's naïve surface psychologies of perception tend to postulate can no longer be sustained. For the time being, the depth-psychology of perception must lend support to the skepticism of idealistic philosophies which doubt the objectivity of Beauty, Truth, and Reality.

POSTSCRIPT

In the analysis of Gestalt perception we found that "modern" art tended to be Gestalt-free, in the analysis of thing perception we found that it also tended to be thing-free. The secondary processes of traditional art had satisfied both principles of surface perception, i.e., the Gestalt principle guiding perception towards perceiving the "best" possible Gestalt as well as the tendency towards perceiving the "constant" things. We thought that for some reason our modern civilization disregarded the rational surface functions of the mind and allowed the irrational (Gestalt- and thing-free) modes of the depth-mind to intrude openly into the structure of "modern" art. We found this disregard for rational functions also in other branches of modern culture, for instance in Bergson's theory of intuition. What is the cause for this significant shift in the stimulation of the surface and depth functions? Our analysis of realism in Western painting showed that a persistent libidinous withdrawal from external reality had been going on for centuries. Only on the surface did realism in art seem to be animated by an increased interest in the real things while in psychological fact the realistic study of perspectivic distortions, chiaroscuro, etc. required a detached "scientific" interest, not in the things themselves and their constant properties, but in one's own changeable subjective perceptions of them. At last we found that the general "scientific" bent of Western civilization too was not inspired by an increased libidinous interest in outer reality, but rested on a compulsive projection mechanism imposed by the

pressure of certain (oral) guilt feelings. In order to escape from unconscious guilt feelings scientific man projected the *internal* compulsion of his superego into the *external* compulsion of causality. We thought that the same guilt feelings which begot the scientific quest in Western civilization also gave our art its specific scientific tinge and increasing libidinous detachment. The libidinous loss which is so clearly marked in our "abstract" (thing-free) art is also noticeable in science. I will comment on the scientific fashion of "debunking" accepted values and try to connect this now passing fashion with the general loss of object libido in our cultural life.

The seeming paradox of a highly "rational" modern science existing side by side with a highly "irrational" modern art is thus resolved. Science itself can be the product of an irrational antilibidinous attitude. We may call a civilization "rational" or "irrational" in the same way in which psychoanalysis would describe an individual adult in these terms. A civilization would be rational if its participants enjoyed a full libidinous life unburdened by irrational anxieties and guilt feelings. What we like to call "primitive" cultures need not be irrational in this sense. Margaret Mead went out to the South Sea Islands and so equipped herself for a new evaluation of Western civilization; on her return she rediscovered in our midst irrational inhibitions, guilt feelings, and anxieties not dissimilar to those which may restrict the libidinous freedom of certain primitives. Yet there were other primitives, such as certain Samoese natives, who were able to conduct their lives in a dignified way, capable of a guilt-free enjoyment of their sexuality, and quite unable to appreciate the message of missionaries which promised them salvation from a guilt they did not feel. Margaret Mead found that these people, in spite or perhaps because of their sober rationality and poise, lacked the stimulus to creativeness. One wonders whether "civilized" Western man through his sufferings from irrational guilt and anxiety feelings was also driven towards his richly creative life. . . .

FRANCIS D. KLINGENDER

ART AND
THE INDUSTRIAL
REVOLUTION *(1947)*

ONE OF THE PERENNIAL THEMES of modern art-criticism is the interaction of science and technology with the arts under industrial conditions. Unfortunately much of the social criticism of the arts has been attempted by writers who have subscribed to a narrowly Marxist line. Therefore Klingender's essays on British art viewed in the context of the Industrial Revolution are indicative of what criticism can accomplish with a more liberal social approach. Klingender finds, for example, that a painter like John Martin is directly affected by the lurid horrors of the nineteenth-century coal mine or factory, which are symbolic of all that is hellish in the painting and writing of the time. Or the desire to give some kind of cultural overtone to machine-made products explains the appearance of "industrial classicism," which is a curious evidence of cultural lag, or what Pierre Francastel calls "blockage" in

the arts: inappropriate and outdated forms are imposed upon machine-made utensils, which thus become artistic anachronisms. Then there is the question to what extent a painter like Turner was indebted to the industrial furnace for his searing light and color. Indeed, many questions are still to be raised about the effect of the machine and the factory upon the Victorian arts. Klingender is occupied with a few of these questions.

A similar social approach is taken in Wilfred H. Mellers' *Music and Society* (1946). A more general social criticism is used in Arnold Hauser's *Social History of Art* (1951). In various books, Pierre Francastel has considered the effect of technology on the arts, especially painting: *Nouveau Dessin, Nouvelle Peinture* (1946); *Peinture et Société* (1952); and *Art et Technique au XIXe et XXe Siècles* (1956). An important but much-attacked book is Frederick Antal's *Florentine Painting and Its Social Background* (1948). The classic Marxist essays on the arts and society are by George Plekhanov: *Art and Society* (1937). Ruthven Todd's *Tracks in the Snow* (1947) was written as "studies in science and art," as was Reyner Banham's *Theory and Design in the First Machine Age* (1960).

JOSEPH WRIGHT OF DERBY

(Chapter III)

INDUSTRIAL DESIGN

The typical product of the Staffordshire potteries until about 1720 was the heavy red or brown slipware, made by the Tofts and their imitators, with its bold crisscross pattern, naïvely drawn figures and crude lettering; on the other hand, even the useful ware made by Wedgwood was carefully designed, while a large proportion of his output consisted of purely ornamental cameos, medallions, vases, and other *objets d'art*. Similarly, until

well into the eighteenth century, one of the main products of the ironmasters in the old forest foundries was the cast-iron fire-back with its delightfully unself-conscious decoration in relief; while the exquisite grates produced by the Carron Company were designed, among other fashionable artists, by the brothers Adam, one of whom was a partner in that enterprise. In the case of both these industries, therefore, what was virtually "peasant art" was swept aside and replaced by sophisticated "industrial design": the revolution in taste brought about by the industrial pioneers was as profound as the revolution in the organization and technique of production. The change was general throughout the industrial field. Matthew Boulton had achieved an international reputation as a producer of buckles, buttons, sword furniture and other "toys" long before he engaged in the engine business. The Sheffield manufacturers of plate and cutlery were his close rivals in excellence of design and craftsmanship. Even in the cotton industry, Samuel Oldknow made his fortune with high quality muslins before he built his great spinning mill at Marple and turned to the manufacture of coarse yarns for mass consumption.

What happened in all these spheres is an excellent illustration of Adam Smith's principle of the division of labor. Goods which had previously been made from start to finish by a single craftsman, were now produced in a series of stages by different specialists, and at each stage this division of functions "improved dexterity and saved time." The most serious division was that between designing and making. Once design became self-conscious, through being made the specialized task of the "artist," who did not himself actually work at the wheel or bench or lathe, the spontaneous taste of the craftsman was inevitably undermined. Nevertheless, since the inventiveness of the worker was now confined to the technical problems of execution, great improvements were made both in the materials used and in the processes of production. Hence the division of labor resulted, during the eighteenth century, in a marked increase in the level of craftsmanship, as well as of design.

The main stages of this development can be followed

fairly clearly in the case of the Staffordshire pottery trade. The first step was described by Wedgwood himself, in an important letter he wrote on 19 July, 1777, to his partner Bentley. In it he describes the two improvements which were introduced in Staffordshire by the German potter Elers during the last years of the seventeenth century. In the first place Elers used the method long known on the Continent of glazing common clays with salt, thus producing stoneware, and secondly, he refined and sifted the red clay of the neighborhood until he could imitate Chinese red porcelain "by casting it in plaister moulds, & turning it on the outside upon Lathes, & ornamenting it with the Tea branch in relief, in imitation of the Chinese way of ornamenting this ware." Thus it was the desire to emulate more elegant foreign products which turned the Staffordshire potters from their traditional methods and started the race for improved materials, techniques and standards of design. During the first half of the eighteenth century, after Elers had left the district, further advances were made by local potters, including Wedgwood's first partner Wielden, the most important being the introduction of white stoneware.

Such was the stage which had been reached, not only in the potteries, but also in the other trades producing high quality consumption goods, before mass production for an international market in factories employing many hundreds of workers began with their opening at Soho by Boulton in 1765 and Etruria by Wedgwood in 1769. How immensely all problems of design and production were complicated by this step may be seen from the correspondence between Wedgwood and Bentley, who was in charge of the London sales office of the firm until his death in 1780. On the production side, there was, first, the organization of research on a systematic and thoroughly scientific scale (Wedgwood himself was made a Fellow of the Royal Society in 1783 for his invention of a pyrometer). Special clays, imported from Cornwall and other districts, including small quantities from America, were used for different kinds of ware, and production was made all but independent of local raw material supplies. In the second place, all the preliminary processes, such as the grinding

of flints and the sifting and mixing of clays, were mechanized. Finally, the actual making of pottery, which could not then be mechanized, was much more subdivided than ever before, specialized throwers, turners, molders, decorators, setters, firemen and their numerous assistants taking the place of the former all-round potter.

In the sphere of design, the old urge to emulate the best products of past or distant civilizations continued unabated, except that the Chinese models imitated earlier in the century were replaced by the "Etruscan" ware and by the ancient medals, cameos and reliefs which the taste of the later period proclaimed as the finest products of the potter's or sculptor's art. Wedgwood ransacked the most famous collections of the time for models. The trouble he took to reproduce, not only the design, but also the texture of the "Portland Vase" with his new materials shows his eagerness to rival the noblest works of the ancients. More important than such direct copies, however, was the drive for a continuous supply of original designs, which were produced both by artists employed as wage earners in the factory itself, and by free-lance designers. It is interesting how many of the problems, familiar to industrial designers today, concerning conditions of employment or the artists' property in their ideas, already occur in the Wedgwood-Bentley correspondence. Both partners were constantly on the lookout for unknown talent, and had a flair for recognizing it. Among the well-known sculptors of the later eighteenth century both Flaxman and Bacon owed their start in life to Wedgwood.

But the most serious problem introduced by the new scale of production arose from that "disposition to truck, barter and exchange" which Adam Smith recognized as the essential basis of the division of labor. "*Fashion*," Wedgwood wrote in a letter dated 19 June, 1779, "is infinitely superior to *merit* in many respects; & it is plain from a thousand instances that if you have a favorite child you wish the public to fondle & take notice of, you have only to make choice of proper sponcers." Although the creators of fashion, Wedgwood, Boulton, and the other manufacturers of luxury goods (especially silk fabrics) were also its slaves. Already in the second half of the eighteenth

century the real arbiter of taste was no longer the designer or even the manufacturer, but the salesman, whose business it was to sense every fluctuation in the public mood and, if possible, to anticipate changes in fashion with a ceaseless flow of "novelties."

It is not difficult to understand why the improvement of design and craftsmanship, which was the immediate effect of the division of labor, proved to be short-lived and was followed by the catastrophic debasement of both in the nineteenth century. Competition, and the progress of technique, forced the manufacturers to produce on an ever larger scale. To sell their increased output, they had to aim at cheapness and no longer primarily at quality, and they had to find a market precisely among those former craftsmen, now turned wage laborers, whose natural sense of design had been destroyed by the division of labor. But as "taste" became the exclusive attribute of an ever narrower circle of specialists, the appreciation of design vanished as rapidly among the middle and upper classes as among the workers. Hence the salesmen's search for indications of public "taste" became a nightmare scramble for "selling points." These developments did not yet, however, become decisive in the period now under review. Indeed, the experience of the later eighteenth century is particularly significant today, because it proves that, given certain conditions, industrial technique is by no means incompatible with the highest levels of design. But that the tendency to debasement was present even at that early period is shown by Matthew Boulton's ceaseless struggle to eradicate the taint attached in the public mind to "Brummagem" ware.

WEDGWOOD'S CLASSICISM

That Wedgwood, like Boulton and other manufacturers of the time, should have adopted the classical forms fashionable in the second half of the eighteenth century for his products, was inevitable in view of his dependence on the international luxury market. But that he produced portraits of Newton, Franklin, and Priestley in the manner of ancient cameos was not as incongruous as it might seem,

for Wedgwood's classicism, like that of Erasmus Darwin, had a thoroughly modern twist. Quite apart from the elements that made the classical revival, sponsored by Winckelmann, Diderot and other intellectuals, an expression of the growing influence of middle-class "enlightenment" in the latter half of the eighteenth century, Wedgwood had a special motive for emulating the ancients. As already noted, that motive was the enterprising manufacturer's desire to excel the noblest works produced at any place or period in his own line of business.

How strong this motive was is shown by a letter in which Wedgwood appears, not, it is true, as an employer of industrial designers, but as a patron of painters. Dated 5 May, 1778, it was written in reply to a note from Bentley on Joseph Wright of Derby, who was showing six pictures at the Academy exhibition of that year. Wedgwood writes:

> I am glad to hear that Mr. Wright is in the land of the living, & continues to shine so gloriously in his profession. I should like to have a piece of this gentlemen's art, but think Debutades' daughter would be a more apropos subject for me than the Alchymist though one principal reason for my having this subject would be a sin against the Costume, I mean the introduction of our Vases into the piece, for how could such fine things be supposed to exist in the earliest infancy of the Potters Art.—You know what I want, & when you see Mr. Wright again I wish you would consult with him upon the subject. Mr. Wright once began a piece in which our Vases might be introduced with the greatest propriety. I mean the handwriting upon the wall in the Palace of Nebucadnazer.

The choice of subjects here considered for a commission shows how misleading it is to apply the label "classicism" without reservations to the taste of a man like Wedgwood. It is clear from the context that it was not its gothic gloom that made him reject the picture which Wright called "The Alchymist, in Search of the Philosopher's Stone, Discovers Phosphorus, and Prays for the Successful Conclusion of his Operation, as was the Custom of the Ancient Chymical Philosophers." His principal reason for turning down this picture, which Bentley had suggested as suit-

able, was evidently that he was prouder of his achievement as a potter than of his fame as a modern "chymical" philosopher. Hence the subject of "Debutades' Daughter" that Bentley had suggested as an alternative to the "Alchymist" seemed more appropriate to him. The mythical Debutades was supposed to have been connected with the earliest infancy of the potter's art at Corinth, while his daughter "invented sculpture" when she traced the outline of the shadow cast by her sleeping lover on a wall and filled in the intervening space with clay. But although the subject had that "noble simplicity" which the eighteenth-century critics so particularly admired in their own idealized conception of classical antiquity, it was for that very reason unsuitable for showing off the perfect craftsmanship of Messrs. Wedgwood & Bentley's Vases. If, on the other hand, Wedgwood felt that the products of Etruria might have been included "with the greatest propriety" among the oriental splendors of Nebuchadnezzar's palace, he was probably thinking of the magnificent table-set his firm had recently completed for the "Modern Semiramis" and despatched to the "Palmyra of the North."

It should be remembered, however, that in writing as he did, Wedgwood was conversing privately with his most intimate friend (hence the great interest of his confession). After much further discussion the subject that was ultimately commissioned, and that Wright duly carried out in 1784 was "The Corinthian Maid." The story does not, however, end here, for, curiously enough, the claims of chemistry as a suitable subject for a picture were strengthened in Wedgwood's mind early in 1779, when Priestley's assistant, Warltire, came to Etruria and arranged a series of experimental lectures for the benefit of the Wedgwood children and their friends. Those lectures suggested just the kind of theme for which Wright was famous, but just then Wedgwood was particularly interested in George Stubbs. Stubbs had been experimenting since 1771 with a kind of enamel painting. He had produced nineteen new fireproof tints, but he could not obtain copper tablets that were large enough for his purposes. After many fruitless trials he had at last approached

Wedgwood & Bentley with the suggestion that they should supply china tablets instead of the usual copper ones for enamel paintings. Wedgwood had taken up the idea in the autumn of 1778 and had obtained the first useful results by the following May. After describing these in a letter to Bentley, dated 30 May, 1779, he continued:

> Mr. Stubbs wishes to do something for us by way of setting off against the tablets. My picture, & Mrs. Wedgwoods in enamel will do something. Perhaps he may take your governess & you in by the same means. I should have no objection to a family piece, or rather two, perhaps, in oil, if he sh'd visit us this summer in Etruria. These things will go much beyond his present trifling debt to us.
>
> The two family pieces I have hinted at above I mean to contain the children only, & grouped perhaps in some such manner as this:
>
> Sukey playing upon her harpsichord, with Kitty singing to her which she often does, & Sally & Mary Ann upon the carpet in some employment suitable to their ages. This to be one picture. The pendant to be Jack standing at a table making fixable air with the glass apparatus & c; & his two brothers accompanying him. Tom jumping up and clapping his hands in joy & surprise at seeing the stream of bubbles rise up just as Jack has put a little chalk to the acid. Joss with the chemical dictionary before him in a thoughtful mood, which actions will be exactly descriptive of their respective characters.
>
> My first thought was to put these two pictures into Mr. Wright's hands; but other ideas took place, & remembering the labourers & cart in the exhibition, with paying for tablets & c I ultimately determined in favour of Mr. Stubbs. But what shall I do about having Mr. S. & Mr. W. here at the same time, will they draw kindly together think you?

Everything went smoothly, however, for instead of encroaching upon Wright's territory, Stubbs painted a charming conversation piece in his own inimitable manner, when he came to Etruria in 1780: Josiah and Mrs. Wedgwood are sitting on a bench underneath a large oak in their park, his elbow resting on a small table on which one of the famous Vases is displayed; in front of them are the

four older children on horseback and the three little ones playing with a go-cart.

Both Stubbs and Wright remained on excellent terms with Wedgwood for the rest of their lives, painting further pictures for him and supplying him with designs and models for his pottery. Moreover, although Stubbs hated the academic as much as Hogarth did and shared his view that nature is superior to art, he was not opposed to the classical ideal as Wedgwood understood it. He is said to have painted a picture of Hercules capturing the Cretan Bull in order to show the academicians that he knew as much about the human figure as about animals. But his peculiar conception of the classical is best illustrated by his "Phaeton," desperately straining to arrest the headlong descent through the clouds of a fiery team of English thoroughbreds while the axles of his chariot are bursting into flames (Saltram). One version of this subject was exhibited in 1762, another two years later, and in 1783 Stubbs designed yet a third "Phaeton" as a black basalt plaque for Wedgwood. But there was a deeper reason for the bond of sympathy that tied Wedgwood to Stubbs and Wright: their passionate devotion to science. Stubbs's excellence as a painter was grounded on his indefatigable research into the structure of living matter. It expressed itself in his treatment of trees, no less than in his knowledge of anatomy. His anatomical studies began while he was still a child. At twenty-two he was lecturing to students at the York hospital. His first published works are drawings of embryos in John Burton's *New and Complete System of Midwifery* (1751). After short visits to Rome and Morocco (where he actually *saw* a lion attack a horse) Stubbs spent the years 1756-60 on a lonely Lincolnshire farm, engaged in the studies which he published in 1766 as *The Anatomy of the Horse*. But his most ambitious project, *A Comparative Anatomical Exposition of the Structure of the Human Body with that of the Tiger and Common Fowls, in 30 Tables*, was left unfinished at the time of his death in 1806.

Joseph Wright was the first professional painter to express the spirit of the industrial revolution. His work is discussed in the rest of this chapter.

JOSEPH WRIGHT

The portraits of Joseph Wright link the circle of Wedgwood, Darwin and the Lunar Society with that of the first cotton lords, Arkwright, Strutt, and Crompton. But Wright was not only a painter of philosophers, he was also a philosopher himself, and the subject of his ceaseless experiments was the problem of light. For these experiments the scientific activities of his friends, and the new industries that were springing up all around him in his native Derby, offered an exciting new field. The cold light of the moon mingling with the dim candlelight and the glow of the phosphorus in the chemical laboratory; dark trees silhouetted against blazing furnaces and a starlit sky; the glare of molten glass or red-hot iron in gloomy workshops, or the flaming pottery ovens to which he referred when he wrote to Wedgwood in 1779 that he hoped "to catch any helps from our fires at Etruria"—it was by studying effects such as these that Wright achieved that distinctly personal style that marks his position in the history of art. As a painter of artificial and natural light effects, Wright links the chiaroscuro style of Caravaggio and his Dutch followers, from Honthorst to Schalken, with the romantic naturalism of the later English landscape school.

That Wright's preoccupation with the problems of light was largely due to his own scientific temperament and to the influence of his environment, is suggested by his isolated position among English artists. He was born the son of a lawyer at Derby in 1734, some twelve years after the Lombes' silk mill had been completed. In Hudson's studio in London, where he studied from 1751 to 1753, and for a further fifteen months in 1756-57, he acquired the sound craftsmanship which the English face painters of the early eighteenth century had inherited from the Dutch, and it was as a portrait painter that he started his career when he returned to Derby after completing his training. The first of his studies of artificial light, "Three persons viewing the Gladiator by Candlelight," exhibited in 1765, was probably painted under the influence of the Dutch "candle-light" painters, especially Godfried Schal-

ken, whose work was much admired in the eighteenth century. Schalken, who was a favorite of William III and twice visited England, had also painted several pictures in which a sculptor views a bust or statue by artificial light. But already in 1766 Wright exhibited one of his best and most original pictures in the rooms of the Incorporated Society of Artists: "A Philosopher giving that Lecture on the Orrery[11] in which a Lamp is put in the Place of the Sun," and in 1768 he repeated his success with the "Philosopher showing an Experiment with an Air-Pump."

PHILOSOPHERS IN ART

Wright's philosophers differ profoundly, both in spirit and style, from the philosophers and alchemists dear to the Dutch and Flemish genre painters of the seventeenth century. In Ostade's "Alchymist" or Bega's "Philosopher," to take two pictures that can be studied in the National Gallery, or in Teniers's "Alchymist" in The Hague, for example, a skilfully diffused half-light casts a mystic gloom over a jumble of fantastic objects. The whole atmosphere, and also the dress of these "philosophers," suggests that they are either ignorant quacks, or else living in a world of dreams, hopelessly out of tune with their time. And, indeed, both these northern sages and their cousins, the beggar-philosophers of Velázquez and Ribera, can trace their descent from the "portraits" of Aristotle and other ancient representatives of the Liberal Arts which the scholastic theologians included in their allegorical picture cycles. Joseph Wright, on the other hand, used the half-light in a manner that is akin to the *camera obscura* of which Darwin wrote. It evokes a mood of wonder. But it also concentrates the attention on essentials. Every superfluous detail is absorbed in the dark shadows of the background, while the light that is reflected from the eager faces of the observers (every one a sensitive psychological study) or from the intersecting circles of the Orrery, emanates from the focal point of the experiment. Rarely before had the thrill of scientific exploration been expressed as dramatically as this. Rembrandt's "Anatomy Lesson" (1632, The Hague) was a noble tribute paid by art to science,

while the tense absorption of Wright's students had also been foreshadowed by Vermeer's "Astronomer" (Frankfurt). But it is greatly to Wright's credit that he followed in the path of two such masters, and how original he was in terms of the English tradition may be seen by comparing his pictures with Hogarth's "Anatomy" in the "Four Stages of Cruelty" (especially the superb woodcut version of 1750), which is conceived as a moral sermon in the manner of the "Dance of Death" cycles.

Wright's essentially modern attitude is evident even in the one picture of his scientific series in which he was deliberately antiquarian, "The Alchymist" (1771, replica 1795). Despite its gothic setting and picturesque accessories, this work is utterly opposed in spirit to its seventeenth-century predecessors. Without a trace of satire, its mood is as serious as that of the "Orrery" and "Air-Pump," for its purpose was not to ridicule the superstitions of the past, but to commemorate the birth of modern science from those superstitions: "The Alchymist in Search of the Philosopher's Stone, Discovers Phosphorus. . . ." The discovery of phosphorus stimulated the research of Boyle and his contemporaries into the nature of combustion, and marks the beginning of chemistry as a modern science.

VULCAN'S FORGE

Joseph Wright's "Orrery," "Air-Pump" and "Alchymist" are the first paintings to express the enthusiasm of the eighteenth century for science. But the work of Wright's early period, up to his journey to Italy in 1774-75, also illustrates the intimate association of science and industry in the minds of his contemporaries. The eight pictures he sent to the exhibition of 1771 included not only the "Alchymist," but also "A Blacksmith's Shop" and "A Small Ditto, viewed from without." In the following year he showed another "Blacksmith's Shop," and, even more important as a record of contemporary industry, "An Iron Forge." The exhibition of 1773 included "An Iron Forge, viewed from without" and "An Earth Stopper on the Banks of the Derwent" (this is a night piece showing a man at work by the light of a lantern), while yet a further "Smith's

Forge, altered from his first design" was shown in 1775. Nor does this exhaust the list of Wright's industrial subjects: two versions of a "Glass-blowing House" were shown by a descendant of the artist at the memorial exhibition at Derby in 1883, while a "Blast-Furnace by Moonlight" was included in the exhibition of 1934. These pictures may date from the artist's later period, when he also painted a "View of Cromford, near Matlock" which he exhibited in 1789, and of which two versions still exist, both unfortunately in a ruinous condition, one in the possession of Mr. C. A. M. Oakes at Riddings House, Nottinghamshire, . . . the other the property of Mrs. Sacheverell Coke at Brookhill Hall in the same county. It presents a romantic view of Arkwright's great cotton mill, its windows blazing with lights, while the moon emerges from a heavy bank of clouds.

In turning to industry for the subjects of so many of his major paintings, Wright was as much a pioneer as he was in glorifying science. Although art was intimately associated with productive labor in primitive society, and also, of course, in the mural decorations in Egyptian tombs, labor plays only a subordinate role in the great tradition of European painting up to the time of the industrial revolution. Its virtual elimination from the visual arts is connected with the contempt for manual work which appeared when industrial production, based on slave labor, began to replace small-scale craft production in classical antiquity. Craftsmen at work are depicted on the early black-figure pottery of Attica and tablets of the same period from Boeotia even contain the earliest surviving drawings of miners. But work-scenes are scarcely ever found on the red-figured vases of the classical era, except as illustrations of myths, such as the "Labors of Hercules," "Penelope at her Loom," or "Vulcan at his Forge," while the sophisticated Eros cult of a later period produced the murals in Pompeii in which children playfully re-enact the occupations of adult life. It was in such mythological or allegorical disguises that work-scenes re-emerged occasionally in European painting with the revival of classical themes from the fifteenth century onwards. But as the artists became increasingly interested in everyday life, and

as the classical canon began to be disrupted by the growth of naturalism in the later sixteenth century, the mythological pretext became more and more incompatible with the realistic content of such scenes. In Jan Brueghel's "Venus at the Forge of Vulcan" (Berlin) this contradiction is taken to fantastic lengths. The nude figures of Venus, Cupid, and Vulcan only occupy a minute spot on a canvas dominated by the ruin of a Roman palace with Mount Etna in the distance. The center of the foreground is piled high with armor closely resembling the work of Pompeo della Ciesa, a famous Milanese armorer of the late sixteenth century. A stall on the left displays splendid specimens of contemporary goldsmith's work, together with the tools of that craft, while the remainder of the composition is devoted to a minutely detailed record of the iron industry, showing the latest methods in use in all its branches in Brueghel's time. Miners are raising and sifting ore in the foothills of Mount Etna, millwork installed on the bank of a stream drives a tilt hammer and grinding wheels, the ruined palace contains a cannon foundry and boring mill of the type that continued in use until the days of John Wilkinson, and even the incongruous figure of Vulcan is re-duplicated by a group of blacksmiths in contemporary dress.

In Velázquez's painting of "Vulcan's Forge" (1630, Prado), the mythological element, though less incongruous, is also wholly subordinate to the artist's interest in actual life: it is into a real smithy that the divine messenger is stepping. But later, when at the height of his powers, Velazquez took the decisive step of abandoning the mythological pretext entirely, his "Tapestry Works" of 1657 (Prado) is the earliest, and will always be one of the greatest of factory paintings. About the same time the Brothers le Nain similarly resolved the conflict between classical convention and realism. The realistic version of "The Forge" in the Louvre, which is attributed to Louis le Nain, is almost identical in composition with the mythological "Venus in the Forge of Vulcan" (1641, Rheims Museum), which was probably painted by Mathieu le Nain, and in which Venus and Cupid replace the blacksmith's wife and child of the Louvre picture.

Joseph Wright appears to have been influenced by this tradition, rather than by the Dutch genre school, when he painted his own version of the "Blacksmith's Shop" in 1770-71. It, too, combines realistic and classical elements, although subordinated to a romantic mood that is new. Whereas both Velazquez and the le Nains had chosen a moment of rest, when work was interrupted, the three smiths, who are striking the iron in Wright's picture, give a dramatic impression of rhythmic teamwork. But while the figures are full of realism, the action takes place in a setting that cannot have had the remotest resemblance to any blacksmith's shop in Britain. The smiths are working at night in a ruined building of classical design, of which only the walls and some arches are standing, while a shelter of wood and thatch has been erected inside it. This is exactly the kind of setting that Italian painters of the sixteenth century often chose for pictures of the Nativity or Adoration, and, in fact, Wright's ruin resembles that in Veronese's "Adoration of the Magi" of 1573, which is now in the National Gallery, but was, in Wright's time, still in San Silvestro at Venice, even in such details as the thatched shelter or the sculptured angels in the pendentives of the arch. No less curious is the similarity between the old smith who is sitting in the right-hand foreground of Wright's picture and the corresponding figure in both the forge paintings of the le Nains. In Mathieu's picture he is Vulcan, and therefore, with Venus, the main figure in the composition; in the designs of Louis le Nain and Wright he has been reduced to the role of an onlooker. Hence it is probable that Mathieu's was the original composition of which the Louvre picture was a brilliant variation, and it is difficult to believe that Wright had not seen that picture when he painted his own "Blacksmith's Shop." It is not impossible that Wright knew the le Nains' work from engravings. A print of "The Forge" had, in fact, been published in 1761 in a book of engravings after paintings in the collection of the Duc de Choiseul. It was evidently considered an important picture, since it was bought for the Louvre for 2,460 livres in 1777, the first example of the le Nains' work to be acquired by the royal collection. In "The Iron Forge," which he exhibited in 1772, Wright

abandoned the classical ruin, although the old man is still sitting in the foreground. The shed gives a good impression of the water-driven forges of the period, while the idyllic element so characteristic of the circle that produced "Sandford and Merton" is charmingly represented by the young mother and her children.

What distinguishes Wright's industrial paintings from most earlier pictures with similar themes is his interest in the labor process as such. This is particularly striking if his work is compared with the Dutch genre pictures that are equally free from mythological or religious elements. It is significant that among the thousands of Dutch works depicting scenes from daily life, there are only a handful that illustrate manual labor. There are a few pictures of farriers or blacksmiths by Wouwerman, Metsu, Steen, the Ostades, and other artists; Terborch painted a knife-grinder, Quirin Breckelenkam cobblers, and Cornelius Decker weavers; but the only kind of work that occurs sufficiently often to prove that the public were interested to have pictures of it on their walls is the domestic labor of women. The rich merchants of the Dutch republic were as contemptuous of manual work as the slave owners of classical Greece had been.

THE "ARTES MECHANICAE"

There are, however, two other traditions that should be borne in mind if Wright's achievement is to be appreciated. The first consists of the partly didactic, partly moralizing illustrations of the crafts which have their roots in medieval Christian iconography. In principle, the Church was just as negative in its attitude to manual work as the ancient philosophers: work was Adam's curse, the punishment inflicted on mankind for the first parents' original sin. It could only, therefore, occupy a subordinate place in Christian art. Thus it occurs in the illustrations of biblical texts such as the labors in the vineyard, the construction of the Ark or the building of the Tower of Babel, and in the representations of craftsman-saints like St. Eloi (a farrier) or St. Crispin (a cobbler). But more important than these occasional work-themes was the ancient peasant

calendar, depicting the labors of each month, which the Church found it expedient to embody in its canon, together with other survivals of pre-Christian imagery. The cycle of the labors of the months, which can be traced in ancient times in Athens and Alexandria, occurs in countless variations as a symbol of the mutability of earthly life in medieval manuscripts and in the carved decorations of the great Romanesque and Gothic cathedrals, and it culminated gloriously as one of the most fruitful subjects for the reawakening naturalism of the fourteenth century in the miniatures of the *Livres d'Heures* of the school of Burgundy.

In contrast to the ancient cycle of the rural occupations, the appearance of the urban craftsman in medieval art was a result of the growing power of the guilds. Since no less than forty-seven out of the 106 stained glass windows of Chartres Cathedral, the earliest of which dates from A.D. 1194, were given by guilds, it is not surprising that they depict the occupations of their donors; similarly, the power of the merchants and craftsmen of Venice is reflected in the splendid, genre-like reliefs that illustrate their activities on the upper arch of the main porch of St. Mark's (early thirteenth century). This shift in the social relationships of medieval society also led to a modification of the doctrine of the Church: according to the Dominican theologian Vincent of Beauvais, the *artes* were a means of mitigating the curse of original sin. Henceforth, the crafts found a place as symbols of the *artes mechanicae* in the scholastic picture of the universe. As such, they appear in the reliefs designed by Giotto and carried out, after his death in 1337, by Andrea Pisano and his assistants on the campanile of Florence Cathedral.

When the invention of printing created a vast new field for popular art, the scholastic theme of the *artes* was absorbed, in a modified form, in the *specula* or mirrors of human life, illustrating the occupations of all ranks and conditions of men, that were published in many versions from the fifteenth century onwards. The most widely known of these series was the *Eygentliche Beschreibung aller Stände auf Erden,* issued at Frankfurt in 1568, with 104 woodcuts by the Swiss artist Jost Amman, and verses

by the Nüremberg cobbler-poet Hans Sachs. Rembrandt's pupil, Jan Joris van Vliet, also produced a series of eighteen etchings of craftsmen at work in 1630-35, while another famous Dutch series illustrating 100 crafts is the *Spiegel van het menselyk Bedryf*, published in 1694 by Jan and Caspar Luyken. The *Books of Trades* that were published in Britain until the middle of the nineteenth century are the final offshoots of this tradition. While the illustrations in these series are objective records of secular life, their scholastic origin is betrayed by the moralizing character of the captions, some of which have but little direct bearing on the illustrations they are supposed to explain. The captions of the German edition of Luyken's book, for example, were written by the famous Capuchin preacher Abraham a Santa Clara. The moral sentiments thus introduced reflect the growing tension of industrial relations since the later Middle Ages, for they generally censure the idleness of journeymen and apprentices and exhort them to obey their masters. Hogarth's link with the medieval tradition of popular art is evident in this sphere too, for he chose the same exhortation as the theme of his cycle "Industry and Idleness" (1747), using the Spitalfields silk trade as his setting at a time of extreme friction between masters and men.

TECHNICAL ILLUSTRATIONS

Joseph Wright's attitude to industry, on the other hand, is much more closely related to another tradition of illustration that arose independently with the revival of learning and the growth of industry in the sixteenth century. This led to the emergence of a new scientific and technical literature based, in the first instance, on the mechanical treatises of the ancients which were then printed for the first time. The art of technical draftsmanship, of which Leonardo's drawings are the outstanding example, developed simultaneously. It is splendidly represented in many of the great technical works of the sixteenth century, especially Gregorius Agricola's *De re metallica*, published at Basle in 1556, and Agostino Ramelli's *Le diverse et artificiose machine* which was printed in

Paris in 1588. During the seventeenth and eighteenth centuries, special works and compendia of a technical character appeared in ever-increasing numbers, and this whole literature culminated in Diderot's *Encyclopédie* (text in seventeen volumes, 1751-65, plates, eleven volumes, 1762-72), and in the *Description des arts et métiers*, published by Académie des Sciences at Paris in twenty-seven volumes in 1761-82. Tilt hammers of the type shown in Wright's "Iron Forge" of 1772, are illustrated in engravings by Benard after drawings by Goussier and Harguiniez in the third and seventh volumes of Diderot's plates (articles "Forge des Ancres," "Forges," "Marechal Ferrant—Travail des Forges"), which were published in 1765 and 1769, and also in engravings by Benard, Patte, and Lucas in the seventh volume of the *Description* (articles "Fabrication des Ancres" and "Art des Forges et Fourneaux à Fer") published in 1764. It is not without interest in this context that the treatise *L'Art d'Exploiter les Mines de Charbon de Terre*, which was issued as part of the Académie series in 1773, contains three drawings of Newcastle mines contributed by an English draftsman, William Beilby.

HILLESTRÖM AND DEFRANCE

To sum up: with Joseph Wright's scientific and industrial pictures of 1766-75, subjects that had hitherto generally been confined to popular art and technical illustrations first entered the orbit of the fine arts. Significantly enough, however, Wright was not the only artist who took this step: the same thing happened at two other key centers of the Industrial Revolution. The Swedish court painter Pehr Hilleström was born two years before Wright, in 1732, and had survived him by nineteen years when he died in 1816. After working in the Stockholm tapestry factory on furnishings for the new royal palace, he went to Paris in 1757-58 and studied painting with Boucher. But the artist whose manner he adopted when he returned to Sweden was Chardin. In 1776 he was appointed court painter by Gustavus III, but soon tired of the mock-medieval tournaments and theatrical displays he was ordered to depict for

his royal master. The sumptuous court of the ruler who had overthrown the constitutional liberties of his realm was not, however, the only center of culture in eighteenth-century Sweden. The dominant role the Swedes were able to play in European affairs during the seventeenth and early eighteenth centuries was based on their great mining and iron industry, which was still in a flourishing condition. Annual exports of bar-iron from Sweden exceeded 50,000 tons during the latter part of the century, Britain, in particular, with its expanding industries, providing an inexhaustible market. There was thus great prosperity in the Swedish mining areas and a thriving cultural life which was distinctly bourgeois in character. Here Hilleström found a market more congenial to his own outlook than the atmosphere of the court, although he did not abandon his official position. He paid his first visit to the famous copper mine at Falun in 1781, and henceforth adopted industry as one of his main subjects. If a few pictures of blacksmiths' shops he painted between 1773 and 1780 are included, the total number of his industrial paintings is 124. Apart from copper and iron mines, he painted smelting works, cannon foundries, forges, the Söderfors anchor factory, and the Kungsholm glassworks.

The other Continental artist who painted modern industrial subjects at this period had a more adventurous career than either Hilleström or Wright. His name was Léonard Defrance, and he was born at Liège in 1735. After finishing his apprenticeship with a local painter, he walked to Rome in 1753 and spent five years there, supporting himself by painting saints and portraits of popes for the dealers. Then he packed up his things again and walked, with a friend who was a doctor, to Naples, and from there, by gradual stages by way of Montpellier, Toulouse and Bordeaux, back to Liège, where he finally returned in 1760. During the next thirteen years he had a hard struggle to support himself with portraits and routine work for the Church, but he was already dissatisfied with this restricted field, for he had made many friends in progressive circles during his travels through France. In 1773 he therefore went to Holland, where he spent a year copying the minor Dutch masters for sale in Paris.

From these, and from Fragonard, who encouraged him in this work, Defrance acquired the light touch and brilliant coloring that distinguish his later pictures. After returning to his native town in 1774, he chose his subjects by preference from popular life. Apart from market scenes, mountebanks, miners at an inn, and similar genre subjects, his pictures preserved in public and private collections in the Liège area depict a coal mine, a rolling mill, a foundry, a coopers' shop and tobacco factories. It is interesting that the social note which is so pronounced in the work of Meunier and other Belgian artists of the late nineteenth century, is already found, a century earlier, in Defrance. In the pictures of the tobacco factory, for example, the ragged clothes of the children who are sitting on the floor and picking the tobacco leaves are sharply contrasted with the smart silk frocks of the ladies who are shown round the factory by its owner. Having been appointed director of the Liège Academy in 1778, Defrance paid an official visit to Paris every second year for the purposes of attending the Salon. While he was there in 1789, he received the news that the revolution had started in Belgium. He returned at once and threw himself into the political struggle, playing a prominent part in the confiscation of Church property and other revolutionary measures during the following years (one of his pictures commemorates the suppression of the monasteries). Later, however, he returned to his academic duties, which he carried on until his death in 1805. His autobiography was published in 1906.

WRIGHT'S LATER WORK

Although he was far less prolific than Hilleström, Wright's influence as a painter of industrial subjects probably exceeded that of his two Continental colleagues, for his best pictures were engraved and published by print sellers of the international standing of the Boydells and William Pether. Indeed, it is not impossible (although there is no evidence either way) that Hilleström or Defrance knew the engravings after Wright's "Blacksmith's Shop," published in 1771, and "Iron Forge," published in 1778, before they began to paint industrial scenes. For it was Wright who was the pioneer in this field, and al-

though he painted only a few industrial subjects after his return from Italy in 1775, the philosophical inspiration of his art, as expressed through his preoccupation with the problem of light, is no less evident in the history and genre paintings, and in the landscapes of his later period.

The themes of Wright's later pictures resemble Darwin's imagery in their characteristic blend of classical romantic and sentimental elements: ancient mythology and motives taken from Shakespeare, Milton, Percy's *Reliques of Ancient English Poetry*, Beattie, and Sterne, share pride of place with the "Siege of Gibraltar" and such subjects as "The Old Man and Death," "The Widow of an Indian Chief watching the Arms of her Deceased Husband," or "The Dead Soldier," which was so successful when engraved that Wright was urged to paint a "Shipwrecked Mariner" as its companion piece.

But it was the play of light in nature that more especially fascinated Wright during the last twenty years of his life. The eruption of Vesuvius, which he happened to witness during his visit to Naples, provided a fitting climax to the dramatic effects of his earlier work, and he continued to paint it repeatedly in later years. As he grew older he became increasingly responsive to nature's lyrical moods, but he never lost the spirit of scientific curiosity. "The water indeed is further advanced than the rest of the picture," he wrote of a small view of Rydal which he was painting in 1795, two years before his death, "for I am keen to produce an effect which I have never seen in painting, of showing pebbles at the bottom of the water with the broken reflections on its surface." And thus it was to the "grand paintings of the eruptions of Vesuvius, and of the destruction of the Spanish vessels before Gibraltar; and to the beautiful landscapes and moonlight scenes" that Erasmus Darwin alluded when he paid tribute to Wright in *The Botanic Garden*:

> So Wright's bold pencil from Vesuvio's hight
> Hurls his red lavas to the troubled night;
> From Calpe starts the intolerable flash,
> Skies burst in flames, and blazing oceans dash;—
> Or birds in sweet repose his shades recede,
> Winds the still vale, and slopes the velvet mead;
> On the pale stream expiring Zephirs sink,
> And Moonlight sleeps upon its hoary brink.

NIKOLAUS PEVSNER

ACADEMIES OF ART PAST AND PRESENT *(1940)*

BAUDELAIRE SAID that the true artist in the nineteenth century was in revolt against whatever is official, against what he called the *poncif*. When one sees the collections of official painting produced under the auspices of the Institute of Beaux-Arts and the Royal Academy, one realizes how correct Baudelaire was. Everything worth accomplishing in painting, sculpture, or architecture, as well as in literature, was done in defiance of academic conventions. To get beyond the *poncif* somehow—that was the aim of even such conservative and limited artists as the British pre-Raphaelites. We know what scorn was heaped upon the Impressionists. Matthew Arnold's term "philistinism" may not mean very much to us nowadays; but philistines were very present enemies to the nineteenth-century artist, who, as Jean Cassou laments in another essay in this anthology, was compelled to prefer ignorance to an academic education in his art. Pevsner's great chapter on the effects of academism indicates why the true artist was forced to rebel.

This theme is developed further in Maurice Z. Shroder's *Icarus: The Image of the Artist in French Romanticism* (1961). Academism in new guises is treated in James Marston Fitch's *Architecture and the Esthetics of Plenty* (1961).

THE NINETEENTH CENTURY

(Chapter V)

. . . Just like the art of the seventeenth century, that of the nineteenth can only be adequately interpreted in terms of a continual tension between the official and the intimate. Recognized art, e.g., art of the academies, art of the grand style in its bourgeois transformation, stood against experimental art of anti-academic character and no social aim or standing. What a gulf between a Robert-Fleury and a Daumier in Paris in 1850, between the PRA and a PRB [12] in London in 1850. The governments supported academic artists; and this made academies grow in reputation and in numbers of students. This caused an ever-increasing over-supply of academically trained artists relying on success with a bourgeois class of indistinct taste. If they went in for the official style, they hoped for public commissions; if they preferred genre, or landscape, or still-life, they counted on selling through exhibitions of some *Kunstverein* or a similar institution. But if their genius pushed them far towards the new and unwanted, they had to wait for enthusiastic patrons. A proletariat of artists, including hosts of mediocre men and some of the best, is typical of the nineteenth century.

How easy had the social position of the artist been a hundred years before, when most private and public commissions came from the same class, from a class of people

who had plenty of leisure to enjoy and appreciate art. The French Revolution, the Napoleonic era, the Industrial Revolution had cleared most of this away. In Germany the castles of all clerical and many secular potentates were abandoned, in France only a small percentage of the nobility survived. It no longer cared for display. The new classes coming up did not think in terms of country estates and palaces. A state of affairs developed which has now become a matter of course everywhere but which was wholly new then, namely that even the wealthiest patron of art is a busy man, spending most of his days working, and regarding art as a recreation, a rest, a pseudoreligious cult, or at any rate something outside everyday life. It was utterly impossible for any artist to know what a prospective patron might want. Demand was so complex, taste so varying that the concentration on the official semi-Classic style was bound to appear absurd to the students. And while before the end of the eighteenth century it was comparatively easy for a young artist to neutralize if necessary an academic influence which after all usually operated on him only for a few hours a week, he was now much more at the mercy of the public art school imparting all the available training.

For it is one of the most important developments in the education of the artist during the nineteenth century that the "academization" of his instruction was completely or almost completely achieved. The roots of this have been discussed in the foregoing chapter. The steady expansion of academic programs was obvious, and various reasons have been given to explain it. One more must now be added: the abolition of guilds and trade-companies, and concurrently of a great deal of regulated workshop training. This differed in various countries and various crafts, and will, in another connection, be discussed later. As far, however, as painting went, the studio of Corot was probably more different from that of Tiepolo than Tiepolo's had been from Dürer's. Now only—or as artists said: now at last—art was really no longer a craft, no longer a trade. And even those who wished to work as humbly and as well as the Dutch still-life or landscape painters could only go to an academy to learn the job, whether it was a public

academy as in Central Europe or a private academy as in France.

The Nazarenes had been well aware of the dangers of the new ascendancy of school over workshop. This is exactly what they had intended to counteract by means of their master-classes. The results of this measure, however, were of necessity quite different from what they were meant to be. A revival of the medieval spirit could not be brought about by one innovation, and an innovation alien to the ruling social system. The illuminated manuscripts of the Reichenau, the sculptures of Reims, Giotto's frescoes were not created because of the existence of a live workshop tradition, but because of a *Zeitgeist* expressing itself in religion, politics, and philosophy, in guild and in workshop. None of the leading Nazarenes was really prepared to regard himself as a craftsman equal to a highly qualified goldsmith or saddler, and certainly none of the students wanted to be treated as an apprentice in the medieval sense. After all the efforts of artists for three centuries to prove that they were literary men, scientists, priests and what not, it was impossible for them to return to the humble life of the Middle Ages which had been the soil from which the greatest achievements of European art had grown. Any attempt at this was self-deception as long as artists were not really ready to serve again, and to serve not art but society. The academician was not wholly convinced that Schiller and the Romantic school had done right in establishing the sacredness of art. He would have been the last to accept a position of servitude. And this creed he tried to propagate in his teaching, and could do so much more effectively in the personal atmosphere of a master-class than had ever been possible in an eighteenth-century life-room. For the student, when he had reached a certain standard, now chose the professor under whom he wanted to work for the following years, and he thus worked, during the decisive years of his artistic education, under one individual only, instead of passing through the hands of twelve visiting professors.

Strange consequences of a step taken for such opposite reasons! The Nazarenes dreamt of the spirit of community and brotherhood in the medieval workshop;

this their master-classes were intended to restore. But what they were bound to attain was only the destruction of the last remains of Ancien Régime collective education and the establishment of a purely individualistic system; divorce where a new unity had been desired.

Schadow's master-class was in no way similar to a workshop like Memling's or Ghirlandajo's. It was in reality a private course just like that run by any of the French heads of ateliers. No more revealing symptoms of the general change between 1660 and 1860 could be imagined than the fact that now in Paris, the city of Colbert and the Académie Royale, private studios supplied most of what was needed in the way of academic instruction, whereas—to two German experts traveling between 1845 and 1850—the École des Beaux Arts appeared only as "a storehouse for teaching apparatus of all kinds" or an "auxiliary institution" run on the assumption that "other opportunities for a real training of artists" were available and that the student could "spend his day with the master whom he had chosen as his patron."

The most famous of the private studios after that of David and Gros were maintained by Delacroix, Delaroche, Ingres, and Coigniet. In the second half of the nineteenth century Bonnat's studio is frequently mentioned, and also the studios of Gleyre, and of Couture, the École Suisse, and the Académie Julian. The system of tuition was still more or less that of David's atelier. Of Delaroche, e.g., we know that he came three times a week and that the exactness and exactingness of his criticism impressed even the roughest and noisiest amongst his fifty or a hundred students. Couture had about twenty-five to thirty pupils and visited the studio twice a week. There was quite a matter-of-fact atmosphere of plain teaching and learning about the best of these studios; the German ideal of master and faithful follower was absent. It may well be that this was all for the best, for in Germany the system of the *Meisterklassen* could not be successful in the long run either. Liberalism and realism go hand in hand, and as the nineteenth century was the Golden Age of the one, it also saw the acme of the other. In spite of Cornelius, the *"Fächler"* [13] carried the day, and in spite of the last

remarkable attempt at a Romantic school of painting which England saw in 1848, the great masters of the century were the realists of East Anglia and Fontainebleau and the Impressionists.

This irresistible development forced academies everywhere to give in. Though they tried to hold up their ideals, they had grudgingly to accept one innovation after another. But since they did it grudgingly, they never did it in time, and so the history of art academies from 1830 until the twentieth century exactly reflects the history of art during the same period, only with a time lag, varying in different countries and different centers. The remaining pages of this chapter have therefore to deal with the opposition of the progressive artists to the academies, and with the belated changes brought about whenever a new tendency had succeeded in holding its own against the disdain of the academies, and could no longer be overlooked.

As for the reforms, enough has been said about the most important of them, the master-classes. Before, however, a student could enter a master-class he had to go through a curriculum all too similar to that of a hundred years earlier. Of French schools about 1850 we hear that drawing was taught only once a week, and that the method followed was the copying of mediocre drawings. Of the Royal College of Art in London about 1870, Fred. Brown describes the copying of "mechanical live engravings of classic ornament" called "officially freehand drawing." Of a German academy of a slightly earlier date we have a detailed report written by a well-known German journalist who attended the Berlin academy just after the middle of the century. The future artist had to pass through three general drawing classes, before he was accepted into the academic forms proper. In these three classes work was only done from drawings, first of hands, feet, and parts of faces, then of complete heads, and finally of whole figures. It is not necessary to repeat that this elementary department was a reactionary feature of the Berlin academy. No pencils, only red and white chalk, were allowed. Perspective and optics were taught, and drawing from illustrations of anatomic details. So the student gradually

made his way into the antique class, and from there into life-drawing. At Düsseldorf elementary teaching had been simplified according to Schelling's, Langer's and Cornelius's ideas, but drawing from drawings of heads and parts of bodies was still in use. This applied even to the Karlsruhe school, founded in 1854. It was also, in spite of Carstens and all his followers, not regarded as antiquated at Düsseldorf to let changing visiting professors set the model.

This is what time and again surprises the historian today who tries to understand and interpret the development of academic art education. The Nazarenes, and the Romanticists in general, had declared war on the old academies. The victory was theirs—as complete as could be. One after another they had entered the strongholds of the enemy. And then, when they could have established a new régime, the spirit of Colbert, if it may be called that, proved stronger than theirs. How can this be explained? Largely, it seems, by politics. Germany and Italy, the countries with the most highly developed academic organization, had had no revolution of the extent of the French. The age of Goethe, Schiller, and the Romantic school, was soon followed by reaction; and restoration was also the predominant tendency in France after 1815. Not that political retrogression had actually caused the failure of the Nazarene reforms; on the contrary, it probably helped to spread their medieval ideals. But the *Zeitgeist* which paralyzed political development on the Continent just at that time may also be responsible for the drooping energy of the art school reformers. Instead of smashing the eighteenth-century system entirely, they put up with most of it, and only introduced innovations where they were personally most interested, i.e., in the advanced and post-graduate schools. The lower forms, the preliminary classes, were in any case regarded by the academicians with indifference or positive dislike. So, where they could not get rid of them entirely, they did not bother to reform them, and everything remained virtually as it had been fifty years earlier.

In most cases, however, they succeeded in doing away with the trade classes. It usually proved quite easy to dis-

pose of them, because in the meantime, what with the development of technique and industry, and what with the improvements of general education, it had been found out in most countries (but not in Britain) that trade schools or technical schools, which were being opened everywhere, served the purposes of industry more effectively than trade classes in art schools. A few dates may illustrate this move. In Berlin, a special *Gewerkschule* was opened in 1809, and a special Academic Drawing School for elementary tuition in 1829. At Augsburg, drawing for trade purposes was transferred to a trade school in 1836. The same change was made in Vienna in 1849, and in Copenhagen after a long struggle in 1857. In Florence, the new rules of 1860 state that only students who are conversant with the rudiments of drawing shall be admitted. Since the Karlsruhe school was founded only in 1854, it had from the start no trade classes. But in 1877 —after a discussion which had already begun in 1868— the existing preparatory class was also dropped. At St. Petersburg the big Seminary was given up in 1830, and in 1840 the secondary school classes as well, probably because by then Russian schools had reached a standard which allowed the academy to draw from them. The same of course applied in another way to Germany. Here drawing lessons were gradually introduced into elementary and secondary schools, and these together with the spreading trade schools were now in a position to replace the elementary part of academic art teaching.

However, even this was only shifting, not reforming. The method of elementary drawing, of which the Romanticists had strongly disapproved without abolishing it, was not only, as we have seen, kept unchanged in the art schools, it actually spread into trade schools and schools in general. How long did children learn to draw by copying drawings or prints in outline? Right into our century anyhow. As to my own school experience in Germany, cubes and spheres in outline were still my models under an old drawing-master in 1912 and 1913, and the changeover to tasks like drawing a country walk was effected by an adventurous young teacher in 1914, and seemed highly revolutionary. As to a German trade school

a few years earlier—in fact one year after the foundation of the *Werkbund*—this is what was done according to the recollections of a postwar painter: "I first learned to copy plaster ornaments in exact outline. After that I was allowed to hatch them. But this skill had first to be acquired by drawing simple cubic or semi-globular shapes without dreaming of what such celestial bodies would mean to art ten years later. Then I advanced by the death masks of Leonardo (?) and Frederick the Great to the plaster-head of the Niobe, and via the Dying Gaul to the live model."

Amongst the innovations in European academies, besides the dismissal of elementary drawing classes, the following must be mentioned. In connection with the development towards university or college standards which we have found everywhere, the entrance age was put up. It had not been unusual in full-grown academies of the eighteenth century to admit boys of twelve. Sixteen to eighteen became now the customary age. Reception-pieces were given up in most academies, and so were competitions. London remained an exception to the first, Paris to the second rule. As to the competitions in Paris, one reason for this survival was probably that they enabled the Académie to interfere visibly at least once every year with the affairs of the École. For it has been mentioned earlier in this chapter that in France since the beginning of the nineteenth century a complete separation of academy and school had been effected. Until 1863 the academy elected at least the professors, then this was dropped too. In many countries, a tendency can be found to isolate from the fast-growing routine work of the schools the academic bodies, representational and advisory as they had become. In Vienna the step was taken in 1849, and again— and now finally, in 1872. In Berlin the same had been demanded by Kugler in 1849, and was at last granted in 1882. Only the master-classes remained in the hands of academicians. It is significant in this connection that Düsseldorf, the leading German academy at the middle of the century, was but a school.

While thus the average academic program of the nineteenth century is in some ways narrower than that of

the previous century, these reductions were made up by several additions, and it is chiefly here that the unwillingness of the academies to follow new tendencies can be demonstrated. The most glaring case is that of female models. These were still forbidden in almost all public art schools in 1850 and later—a state of affairs hardly believable. For individual artists had of course drawn women from the nude since the fourteenth and fifteenth centuries. The Carracci academy, and other Italian private academies —we know it, e.g., of Bologna and Venice—also used female models. So in all probability did studio academies in other countries. It happens to be recorded in the case of the circle of the Stockholm court artists about 1700, the circle around the Dutch painter B. Graat, also about 1700, the circle in which Thorwaldsen used to draw about 1790, and Vandenbank's academy in St. Martin's Lane in 1722 (Vertue just states: "a Woman being there the Moddel to draw after"; but Hogarth shrewdly adds: "To make it more inviting to subscribers"). But the only official academy which in the eighteenth century seems to have allowed the female model was London, the reason perhaps being the unusual nongovernmental nature of the institution. How far we can interpret this as a symptom of open-mindedness, appears doubtful, if we hear that lady students were not admitted to life-drawing at all until 1893, and even then the model had to be "partially draped." A similar Victorianism in Berlin is described by an old student referring to a show of a group of models in 1841-42. There you could see the heroes of classic sculpture with salmon-colored trunks, and the Venus de' Medici with a shawl. Female models in the life-class were introduced in Berlin in 1875, in Stockholm in 1839, in Naples —to quote just one Italian example—in 1870. At the Royal College of Art in London they were not yet allowed in 1873-75, when Sir G. Clausen was a student.

The academies were also late, though not by several centuries, in adopting some other innovations. Two typical instances are painting classes and landscape classes. It became obviously impossible to maintain governmental establishments for the training of artists as mere figure-drawing schools at a time when Delacroix, Delaroche,

and the Belgians, when Turner, Crome, Constable and
Bonington, when Rousseau, Corot and Daubigny, when
Blechen and Wasmann painted. The Romantic school,
represented by Schelling, Langer, Cornelius, Schadow, had
already pleaded for painting courses. So they were insti-
tuted at Copenhagen in 1811, and at the initiative of
Lund and Eckersberg made permanent in 1822. In Lon-
don 1816 is the date, although the painting class did noth-
ing but copying from pictures lent by the Dulwich gal-
lery; in Madrid it was 1823, in Genoa 1841 and again
1851. In Berlin, where the academic studios mentioned in
connection with Schadow and Wach taught painting quite
adequately, it was only taken over by the academy later
in the fifties. As to landscape painting, Schadow at Düs-
seldorf clearly saw that it would be no good neglecting it
at a moment when realism was so much in the center of
most young artists' interest. So he appointed Schirmer,
one of the representatives of ideal Italianizing landscape,
as assistant teacher in 1830, and made him professor in
1839. He may have hoped that by encouraging heroic
landscape, he could keep out the lower manifestations of
realism. The same feeling made him appoint a few genre
painters although a special genre class was not founded
until 1874. In any case, Schadow succeeded in gaining
for Düsseldorf the reputation of being one of the out-
posts of realism in Europe, although the theatrical pseudo-
realism of Düsseldorf cannot be compared with that of
Courbet or Menzel or Madox Brown. As to landscape
classes in other academies, they had been established in
the Austrian academies of Venice and Milan since 1838,
at Modena also in the thirties, at Madrid in the forties,
at Cassel in 1867, at St. Petersburg in the seventies.

It is important, however, to stress that all these dates
refer to courses in landscape *painting*. The tradition of
academic landscape drawing is much older. Vienna is a
good example to demonstrate this difference. In the eight-
eenth century, landscapes, both idealized and treated as
"landscape portraits," had been very popular. They were
commissioned as decoration or as souvenirs, or as both.
So the private Schmutzer academy, and, since Kaunitz,
the Imperial Academy had included landscape drawing as

a subject. It was kept in the constitution of 1800. Of other art schools, Berlin and Dresden, e.g., taught landscape drawing, and it is a sadly significant fact, that at Berlin, Blechen, one of the few German landscape painters who can be compared with the contemporary geniuses of East Anglia, was in charge of a landscape class, where in 1831 he still had to teach drawing exclusively. We can assume that eighteenth-century academies regarded landscape in the same matter-of-fact way as they regarded ornament. There was a demand, and so courses had to be supplied. It was the Winckelmann-Lessing-Schiller school of thought that first objected to them on principle. As we have seen, they, and Cornelius as one of their most powerful spokesmen, despised all *"Fächler"* as unworthy of the high task set to the artist by God. So Hirt, Goethe's admirer and Humboldt's friend, proposed in 1808 to dissolve the existing class in Berlin; and in Paris, when in 1816 a special prize for *Paysage Historique* was introduced, the subject was nevertheless branded as a *genre secondaire*. When in the Vienna academy in 1849-50 the Nazarenes could carry out their long-planned reform of the constitution, they abolished the *Spezialschulen* immediately. However, they were forced to reopen the landscape class in 1865, and this time as a school of landscape painting. So the academy had at last to give in—in the year of Waldmüller's death, and forty years after the young Romantic landscape painters such as Olivier had created their charming Salzburg pictures, another German parallel to the work of Crome and Constable. But, then, Constable was not made a Royal Academician either until he was fifty-two years of age, and even then the president, Lawrence, emphasized the fact that this was a special, noteworthy honor for a mere landscape painter. As for Italian academies, Signorini, the great exponent of the school of *macchiaiuoli,* states in his history of the Café Michelangelo that no instruction in landscape painting was *"fortunatamente o disgraziatamente"* given about 1848. The symptom of the final acknowledgment of landscape was Palizzi's appointment to the presidentship at Naples in 1878. In Germany the earliest action in favor of landscape painting was taken by the Karlsruhe school

which, as was said before, was founded in 1854 with the explicit aim of being modern in its methods throughout. So the first thing done was to call it an "Art School for landscape painters," and the second to induce Schirmer to leave Düsseldorf and accept the directorship. Other artists from Düsseldorf followed. The organization was also modeled on the Düsseldorf pattern, but everything was intended to be smaller and more personal, less "factory-like" than it had become at Düsseldorf. Karlsruhe remained exceptionally enterprising for some time. When G. Schönleber had been elected professor of landscape painting in 1880, he was bold enough to put his students into a room with a skylight and let them paint "fish from the Rhine, reed, straw, cabbages, the most incredible bottles and flasks from a grocer's shop, whole carriages and boats." A good deal of progress in academic teaching had thus been made since the time when Constable, for the first time a Visitor at the Royal Academy in 1831, ventured to place the female model as Eve in front of some evergreens cut from his garden in Hampstead. But compared with what progressive artists—such as he himself—painted in 1830, his feat was as belated as Schönleber's at a time when Manet painted Claude Monet with his easel in a boat on the Seine.

The fact remained that even the most self-denying goodwill could not achieve more for the academies than to keep the time lag reasonably small between their methods and the tendencies which were modern at any given moment; and doubts can hardly be suppressed as to whether it really was worth keeping up the race against such odds. Public opinion in the Victorian days was perhaps convinced that it was; those who had given some thought to the problems of art education—mainly artists—were not. There are comparatively few nineteenth-century pamphlets or books of any constructive value dealing with the public tuition of artists, and after 1860 they seem to grow fewer and fewer; but there are only too many remarks of painters and sculptors recorded condemning academies root and branch. The original love of freedom that characterized *Sturm und Drang*, and the Romantic

school had survived the pro-academic reaction of the later Nazarenes and their followers.

Here a few instances, first, of critical writings between 1830 and 1860. There is Waldmüller to begin with, a Viennese Romanticist, combining something of the sugary taste of his time with a surprising Pre-Impressionism that sometimes enabled him to paint as freshly as Bonington. In two pamphlets of 1846 and 1849 he proposed a reduction of the academic curriculum to one year, and a training method similar to that of the old masters. That in itself was by no means new, nor were his suggestions as to details. The human figure should remain in the center of the teaching program. No objection about drawing from drawings was raised. More violently worded were the attacks which that tragic figure, Benjamin Haydon, directed against academies in general—he called them "royal and imperial hotbeds of commonplace"—and against the Royal Academy in particular. Meanness, fraud, and all kinds of knavery are amongst his accusations. He resented especially the mixing up of educational and representational tasks, and wanted to reduce the academy to nothing but a school. This, as we have seen, was also not at all new, and beyond it he did not go. On the contrary, it is surprising to see that here a figure-painter believing passionately in the grand style insulted an academy because it did not do enough to foster the grand style. To him the Royal Academy stood for portraiture, i.e., something smacking of the *Fächler,* and against the heroic. Even for schools of design he regarded figure-drawing as the one all-important means of instruction. And there was thirdly Marchese Pietro Selvatico, secretary of the Venetian academy and the author of many books and pamphlets on art, who in 1842 strongly emphasized the necessity of the teacher taking a close personal interest in the individual student. It was the old story of the Romanticists again, new perhaps to Italy, but not to Europe. Is it possible to find more original suggestions in the writings of other authors? A German art historian, Guhl, demanded in 1848 the introduction of history courses, in order to encourage a national school of historical painting—an interesting

point, but chiefly as an illustration of a mid-nineteenth-century attitude towards art. Far more remarkable seems a proposal made in 1859 by another German art historian, Herman Grimm, author of one of the best biographies of Michelangelo. He stated with surprising frankness that art "being altogether unteachable . . . should not be taught in an academy. Its only task can be to give elementary tuition in painting, modeling and carving, and an introduction into those subjects of general education without which no great art is possible." The second part of this shows that Grimm, who was the son of Wilhelm Grimm, one of the two Grimm Brothers, was still connected with the German ideas of the Romantic movement, the first contains an argument still to be found in discussions in our century. A convinced Impressionist such as Whistler could say exactly the same: "I don't teach art; with that I cannot interfere; but I teach the scientific application of paint and brushes." This attitude we shall meet again in connection with the most promising twentieth-century efforts to reform academic art training.

The conclusion usually drawn from the evident deficiencies of existing art schools and the equally evident dislike of art schools amongst the young, was what is worded diplomatically by Selvatico: *"Non sarebbe forse gran male lo smetterle affatto,"* [14] and more bluntly by Edward Lear and Ferdinand Waldmüller. Lear: "I wish the whole thing were abolished, for as it is now it is disgraceful"; Waldmüller: "As it has been found that the purpose of these institutions has not been achieved, there is not the slightest reason for retaining what is recognized as utterly useless. No more academic teaching then; let the State abolish the academies, and release all art training entirely." The irony of the position at this juncture should be fully recognized. Here are the champions of latter-day Romanticism joining hands with the Realists and the Impressionists in fighting the same academies that had been triumphantly reorganized by earlier great representatives of Romanticism. In explaining the seemingly paradoxical situation, one must consider this: in that most complex phenomenon, the Romanticism of the late eighteenth and early nineteenth centuries, a reflected ideal of

medieval community spirit was linked up with a new cult of unthwarted personality. The Nazarenes had aimed at embodying both in their reshaped art schools. However, the century was against this. Liberalism was progressing at a more and more alarming speed. The victory of the spirit of Manchester in the thirties showed how far from the dreams of Shelley things had already moved. So, within the Romantic movement, individualism prevailed more and more, an aesthetic individualism of just as little social conscience as the economic individualism that had built the industrial cities of England and established the shocking conditions in which most of their inhabitants lived and worked. Where tendencies can be pointed out that recall the fullness of Romanticism, such as that which inspired first the Pre-Raphaelites and then William Morris, or those which animated Puvis de Chavannes in France or Marées and Böcklin in Germany, they remained under the surface.

On the surface we see Benjamin Haydon showering abuse upon the Royal Academy, and at the same time Joseph Hume, a leader of the Radicals in Parliament, demanding an inquiry into the finances of the institution and insisting on the abolition of entrance fees to the exhibitions. That was in 1834, and 1837-39. However, as the academy was economically independent, his motion was defeated. So he appealed to Queen Victoria in 1844, asking her to withdraw the royal charter from an establishment of no use to the arts of the country, and to turn it out of the new National Gallery building into which it had moved a few years before. Hume was not more successful this time than he had been before, and the Royal Academy was able to keep its original character for another century, i.e., to the present day, sharing with Paris the reputation of being the most reactionary of European academies. Roger Fry made a few vivacious remarks on the École des Beaux Arts at the time when he was young. We read of the "dirty brown plaster casts," and the "dusty, foxy, and flyblown copies of Italian pictures and frescos" kept in what he calls "the most admirably equipped of these laboratories for inoculation against art."

And as we are now once more at artists' invectives

against academies, let us go on for another moment and bring them up to date by quoting at random just a few sayings of painters, architects, and critics of the last seventy or eighty years. Cammarano: "Lucky he who has nothing to do with . . . what is crazily done in academies"; Fattori, speaking of his friends, the young "*macchiaiuoli*" in Florence, "who had become enemies of the professors in the academy; and it was a war to the knife"; Ruskin: "Until a man has passed through a course of academy studentship, and can draw in an improved manner with French chalk, and knows foreshortening, and perspective, and something of anatomy, we do not think he can possibly be an artist; . . . whereas the real gift in him is utterly independent of all such accomplishments"; Whistler: "The Academy! Whom the Gods wish to make ridiculous, they made Academicians"; Fred. Brown: "Throughout the school, every natural instinct of the student was prevented or frustrated"; Sir G. Clausen: "We gained little or nothing from our masters"; Feuerbach: ". . . something peculiar, damp and mouldy, which I should like to describe as 'academic air' "; Liebermann: "Only the most talented can go through the academic drill without harm to their powers of imagination"; Gasquet on Cézanne: "He detested public art schools all through his life"; Sant' Elia, the futurist architect: "Academies where the young have to force themselves into masturbatory imitation of classic models"; Le Corbusier: "They are mortuaries; in their cold-rooms there are only the dead. The door is kept well locked; nothing of the outside world can penetrate."

The florid language of the modern artist does not seem to have gone far beyond that of his ancestors of 1800. It is masturbation and mortuary now, it was myriads of maggots and mummification when Koch and Schick wrote. The meaning is the same, and it appears only surprising that academies have stood these hundred-and-fifty years of never abating assaults. This must be explained now, before we can leave the Fine Arts of the nineteenth and twentieth centuries.

It has been tried in the foregoing chapters to explain the rise of art academies during the *cinquecento*, their

acme during the *siècle de Louis XIV*, and their sudden spread after 1750 for reasons rooted in the general history of civilization and more especially the history of social movements. Strong states had made and developed the idea of the academy of art. Their legitimate reason had been to issue a certain quantity and a certain quality of art, useful to, and desired by, court or government. Now art had emancipated itself since about 1800, first through Schiller and then through the Romantic movement. After this the artist regarded himself as the bearer of a message superior to that of state and society. Independence was consequently his sacred privilege. To serve society would have been to degrade himself. A public art school could therefore not seem anything to him but a workhouse. No individual reform of existing academies could alter this. The doctrine of the freedom of Art is the fundamental tenet of nineteenth-century aesthetics. It prevails from Keats down to Oscar Wilde's cheap paradoxes, and still looms in the present-day writings of most painters. Thus the readiness of the Nazarenes to enter upon academic offices must at long range be considered an error; and thus, for the very same reason, all the vast and not ungenerous public furtherance of art during the nineteenth century must be indicted as another grave error. The prince of the eighteenth century supported his academy because he needed it, the state of the nineteenth century because it believed in that sacredness of art preached by Goethe, Schiller, Humboldt. It was a lofty ideal indeed, when it was conceived, and it is all to the credit of the public authorities of that age that they recognized and appreciated it. It sounds dignified and cultured, though remote, to hear Franz Kugler say in a document meant to be regarded as official: "In consideration of the beneficial influence which Art can have upon the refinement of morals and upon education in general, its cultivation is being recognized as a public necessity. It is therefore a duty of a State . . . to provide in an adequate way for thorough art-education." But what a humiliating position have the European states accepted by not opposing a claim that, though it had been justifiable in Schiller, had certainly become meaningless by 1875 or

1890. Public authorities everywhere seemed only too ob-
trusively eager to help Art, wooing and proposing all the
time, but the artists of genius answered only by intensify-
ing their scornful rebuff. The states and cities or private
associations of patrons arranged exhibitions to show the
works of the artists, built museums to preserve them for
eternity, gave commissions so that no town hall was left
without its series of paintings from local history and no
square without a monument to some distinguished citizen.
Drawing lessons in elementary and secondary schools were
developed, trade schools and art schools (and their grants)
grew, until they either reached monstrous sizes, or were
split up so that the art school proper remained a college
or university with sometimes only thirty or fifty students
in all. Master-classes, when they had been established,
guaranteed an individual treatment and a free develop-
ment of every promising student. He had a model and a
heated studio at his disposal free of charge for years after
the end of his actual studies. Did he feel under an obliga-
tion for this? No—he made a point of assuring everybody
in later life that he did not learn anything while he was
at the academy, and that what he had achieved was all due
to his own unaided efforts.

One understands this. It would have been against
the fundamental credo of a nineteenth-century artist to
admit that he owed something to the community. That
was a clear position, whereas the attitude of the liberal
statesman was ambiguous and muddled. He accepted it
as a duty to support Art, and did not see that this had
lost all its sense, when Art was no longer what Schiller
had wanted it to be—a school of humanity, an ultimate
interpretation of the universe addressed to all and every-
body. The statesman, the civil servant, the town councilor,
the public benefactor, kept paying money to art schools
and purchasing works of artists who had entirely re-
nounced any social duty and preferred to revel in Art
for Art's sake. And nobody ever ventured to ask what
Heinitz had asked at the end of the eighteenth century:
What are you artists prepared to do in return for us, the
representatives of the public, of society, of the state?

So deep-seated was the uneasy conscience of the century of bourgeois prosperity.

Since public compulsion remained absent in matters of art education, and Art had only one wish: to be completely free, was it not right to plead for the abolition of academies? And would it not be right today? Liberal cultivation of Art could express itself in purchases and commissions, but governmental art education in a nineteenth-century state was absurd.

So parliamentarianism would probably in the long run have freed itself from the prejudices of 1800 and finished with the academies once for all, had it not been for an entirely different development which came to their rescue about 1900. This was the outcome of the English Arts and Crafts Movement, and as it is due chiefly to this movement that by 1914 a great and very promising renaissance had begun in many art academies, especially in Germany, the last chapter of this book must be devoted to art education in connection with the applied or industrial arts.

PIERRE FRANCASTEL

THE DESTRUCTION OF A PLASTIC SPACE *(1951)*

AFTER AN EARLY STUDY of Impressionism, Francastel has devoted a series of books to analyzing how Renaissance painting succeeded in formulating a new geometric conception of space and how this space was gradually destroyed by painters in the nineteenth century, then reformulated in Cubism. Francastel shows that the Renaissance perspective was a form of myth as well as a system of geometry; it contained irreconcilable premises and methods, and these irreconcilables became increasingly apparent as the Impressionists, again under the influence of the science and philosophy of their day, attempted to find some way of representing their altered vision of reality. The Impressionist *tache* (or daub) was more than a new method of painting; it was a new comprehension of the universe, reflecting a change in the total social, technological, and philosophic situation of man in the modern

world. Francastel has always been attentive to the relation between art and techniques (what Lewis Mumford calls technics) and to the relation between art and society, treating Impressionism as an aspect of the revolutions in a post-Renaissance order. Impressionism left many problems unresolved, since it was an art in which there remained a conflict between style and perception. The Cubists resolved many of these conflicts, and in the process created a new space unlike Renaissance space. One of Francastel's shrewdest observations is that the real primitives in painting are not those who turn back to primitive subjects but those who experiment with new methods. In this sense, the Impressionists were the real primitives in modern art.

Francastel's works fall into a coherent design: *L'Impressionisme* (1937), *Nouveau Dessin, Nouvelle Peinture* (1946), *Peinture et Société* (1952), *Art et Technique aux XIXe et XXe Siècles* (1956). The selection that follows is from an essay that was expanded in *Peinture et Société*.

THE DESTRUCTION OF A PLASTIC SPACE

(from *Formes de l'Art, Formes de l'Esprit*, 1951)

It is often said that the common aim of all independent painters at the close of the nineteenth century and the opening of the twentieth was to destroy the Renaissance. I think it not without interest to examine the precise reasons why Renaissance plastic space ceased, at a certain instant, to satisfy the needs of painters.

It is not possible to accept Renaissance plastic space as a permanent datum supplied by experience. Elsewhere I have tried to show that it is chimerical to interpret *quattrocento* experiments as approaching, consciously or

unconsciously, a kind of superior rendering of eternal Nature. The Renaissance "inventors" of the perspective treatment of space are creators of an illusion, not uniquely clever imitators of what is real. Besides, they differ among themselves, at least in the beginning, about the most convincing ways to impose upon their contemporaries a ready acceptance of this illusionism, which was as consonant with the technical and scientific demands of their day as it was with the imaginative demands. The new space is a blend of geometry and mythical inventions in which technical theory has no greater share than personal and collective beliefs.

I do not intend to deny the fact that today the Renaissance illusionistic system still meets the needs of certain rational conventions most congenial to the mind —at the same time avoiding any question of deciding how far such habits are general among mankind and not simply among a certain historic and geographic group of persons. Doubtless men everywhere can learn to see two sides of a street drawing together in the distance once their notice has been called to this optical phenomenon. But nothing proves that they cannot equally well accustom themselves to see in another pattern by cartographic perspectives, or indeed, to read in an entirely free way a series of juxtaposed or superposed images in Egyptian fashion. We must beware of taking the Western cast of mind as the only form of intellectual development available to man. Above all we must understand that what is happening here is not an approach to reality but the elaboration of a system. It is far from my purpose to deny the theoretical and practical value of Western logic since the Renaissance. Only let us consider that we here have an intellectual and social construct, and not a reliable and accurate revelation, so to speak, of an essential mode of reality. The plastic Renaissance space is not a perfected representation of what "Space" is, but only a singularly apt expression of a world order for one era and for a given body of men.

This being granted, one can readily imagine the possibility of seeing the mode of rendering space modifying itself in line with deep changes in technical or theo-

retical knowledge along with changes in beliefs and motives for action in any given society. If a certain plastic space symbolizes the general activity and the mathematical, physical, topographical notions of a society, it is inevitable that it change whenever the society itself changes sufficiently, so that all the intellectual and moral attitudes are undermined which during a particular age made this representation of space meaningful. Consequently, one can state in principle that societies enter and leave their characteristic plastic spaces just as they base themselves physically within various topographic and scientific spaces. What we are seeing just now is the effort of a society that, endowed with new technical and intellectual equipment, is tending to emerge from a space where men have moved comfortably since the Renaissance.

We must add a few more words before attempting a fuller analysis of the experiments that have resulted in the destruction of plastic space in societies sprung from the Renaissance. Originally this space evolved from extensive speculation upon light as well as upon the relative position of objects in nature. But in bringing into painting a Euclidean figuration of space, the first Renaissance attempt was filled with many possibilities that were never completely exploited. As early as the era of Alberti and Piero, a generation after Brunelleschi, artists postulate a convergence toward a vanishing-point. Thereafter they are satisfied with thinking about a strictly limited space: cubical space. Investigations are, indeed, forthwith governed by three hypotheses. It is granted that the new geometric space has the form of a cube—witness the previous early Masaccios; it is granted that all orthogonals converge at a point deep inside the painting, which is to say, one takes for granted the existence of a single point of view; finally, it is granted that the representation of forms by values and by light has to coincide with a linear scheme of representation even at the cost of sorry technical tricks like chiaroscuro. In fact, we can see a double grid being set up at the interior of the cube: that of imaginary lines like musical staves or, better, like an academic diagram of centicubes in the area, and that of colored passages controlled by light cast from a single source of illu-

mination. Within the cube each object, every rendered detail, happens to be located exactly at a point of intersection between this double grid of lines and colored spots. In short, there emerges a conception of space (or more precisely, of the world) less Euclidean than scenographic. This conception, popularized by the theater—which evolves in close parallel with the new notions held about space—imposes itself with great authority for generations. During four centuries man-as-actor will reside, for the human imagination, in a "world-theater" which will have a cubical design and fixed planes limited in number like those of the Western stage.

To be sure, nothing will remain unchanged during this whole period. The great geniuses of painting, the Tintorettos and Grecos, the Velázquezes and Rembrandts, will open new paths to the dream of each generation. Nevertheless, it is true that all images of man will be inscribed in frames that do not even denote a complete Euclidean system capable of an infinite number of combinations, but a scenographic system in behalf of which the second generation of the Renaissance furnished apologists less for mathematical than for literary and poetic reasons. Thus it appears that after the *quattrocento* culture the Aristotelian canon of three unities was imposed not only in theater: it dominated all mythical and plastic creations of the Renaissance.

If it be a fact that this rigid law of singleness of point of view—or, rather, an empirical conciliation of linear and color visions—and of a cubical world-structure has dominated not only art but the imagination of men for four centuries, certain features have nevertheless been gradually added. More especially, after the *quattrocento* a conflict is latent between the global mode of representing places with figures arranged inside the imaginary cube, and the desire for detail: the ancient bas-relief furnishes a source of ideas, or perhaps effects, not unimportant in this area. It does not avail to give a specious unity to the history of art from the fifteenth to the nineteenth centuries. Yet, based upon a certain method of instruction exactly suited to the tendencies of the literary imagination of the time, and devoted to perpetuating a

certain number of mythological and mythical themes as familiar to the public as to the painter, art has shown a remarkable stability during this long interval.

Thus, although it is wrong to believe in the existence of a "Renaissance" as a kind of miraculous revelation one day bestowed on men and in a way regenerating them, it is possible to recognize the existence of a deep continuity among artists and their work for a prolonged period. The Renaissance is not the discovery of a unique secret; it is the slow work of generations that together accepted a certain number of hypotheses about man and nature. During this period men dwelt in a special physical, topographical, imagined space controlled by fixed laws of representation. They may have modified legends or put emphasis upon this or that new method, but they nonetheless accepted the basic laws I have tried to mention where painting is concerned. It is a fact that at a certain moment this system, resting upon a sort of balance between theories and figural signs, broke down. To put it suitably, artists and their public have exited from traditional plastic space. I hope here to examine by what stages and to what extent they have succeeded in doing so.

The opening of the nineteenth century witnessed the appearance of the greatest change in imagery that occurred in the course of Western culture since the Renaissance. Everything has been said on this matter, and there is no need to enlarge upon this aspect of romanticism. The East and foreign literatures, especially modern, alike provide painters with new themes to feed their imagination and to renew their dialogue with the public.

As a result there came a considerable alteration in what one may call the mythical space of art. The heroes of the Napoleonic era reach Ossian's Eden, and this Eden has features very different from the classical Eden. David's Horaces or his Paris may somewhere meet Piero's Queen of Sheba, but they will never see Girodet's Ossian. Delacroix's Dante and Virgil will meet Michelangelo's damned, but the hellish fiery river is henceforth distant from the Mincius and more nearly resembles the savage seas where the raft of the *Medusa* will founder.

However, we do not need to exaggerate the breach.

Delacroix intends to be a classicist, or at least he wishes to keep in touch with the great masters of classic art. Romanticism accommodates itself to the baroque, the Venetians, the Flemish rather than entirely breaking away from Raphael. It widens the choice between various past manners instead of repudiating tradition as a whole. It is easy to show how Delacroix preserves stylistic traditions and frequently even classic schemes of composition. Into the ordered cubical Renaissance space he introduces figures whose dress and acts are original; but he painstakingly keeps the framework, the planes, the design, in fact, the compositional formulas.

The greatest aesthetic innovation of romanticism is its replacing classical treatment, which coordinates every passage with a view to total effect (in short, pushing the rule of the unities to its extreme), with a treatment by means of episode or variant. This principle is supreme in all media, whether it be music—Chopin and Liszt, Schumann or Weber—or the dance, or painting. To familiarize his age with Shakespeare or Goethe, Delacroix will work out a whole series of paintings where the same figures appear in the same dress but at different phases of a narrative. In a painting like his "Bain Turc," Ingres will do nothing more than draw his inspiration from this new mode of recombining ideas and images. After Chateaubriand's great stories, literature itself is a kind of "variation," even in its settings.

All this, whether it involves a picturesque regarbing of figures or a reassembling of images, confirms the importance romanticism gave to renovating themes picturesquely. But all this likewise indicates the fact that romanticism relied upon imagination instead of on any structural composition of space. In 1855, on the occasion of the great retrospective exhibit of contemporary art, Paul de Saint-Victor wrote: "The gods have departed from modern painting—the gods and the heroes. . . . After four centuries of pictorial treatment the great types of Christian art, Christ, the Virgin, the Holy Family, seem to be exhausted. Greek mythology, revived by the Renaissance, is at the end of its new life." Great Pan is dead! And indeed it is true that the plastic imagery was the

first thing overturned by a modern society shaped by the French Revolution and even more by the industrial and technological revolution stimulated by the scientific discoveries of the eighteenth century. The symbols by which one was intelligible during preceding generations lose their clarity; a new culture and education are developing. Yet if these first ventures in a new art cause a considerable renovation of the setting and imaginary milieu for actions, they readily enough accommodate themselves to the two basic Renaissance hypotheses as far as representing space on a two-dimensional plastic surface is involved. Romantic space remains scenographic, and the painter always designs his effects to be seen from an angle of vision opening up from a single point of view exterior to the canvas, symmetrical to the degree of coordinating parallels inside the picture, besides always harmonizing (thanks to certain concessions and studio tricks) the system of lighting coming from a single source with the system of a linear grid deduced from Alberti's rules.

From this it follows that romanticism can be taken as having provided for its heirs a rich fund of images and even environmental notions, but that it avoided any question about the rigid framework of plastic representation, notably space itself. As I have already shown elsewhere, before an innovation reaches the public mind, which, by definition, is less venturesome than that of artists, it is necessary for artists themselves to conserve some aspects of tradition; otherwise their ingenuity will continue to be inaccessible to the crowd. Here is an absolute law of reform.

In speaking of the romantic era I shall not make the blunder of identifying it with Delacroix alone, or even with the well-known artists. Yet I do not think that the proposal I have just made will be weakened by glancing at the general performance in painting at that time. So far as Corot, for instance, is concerned, it is obvious that in most ways he was a precursor even more than Delacroix. One can suppose it is he who leads toward Impressionism, the next step in the evolution, or revolution, in plastic arts. However, with Corot, as with Delacroix or Dévéria, spatial invention is limited to inserting new

vistas, new aspects of reality, into traditional frames of representation. Corot will reveal to his contemporaries the beauty of a Roman landscape or the ponds at Ville-d'Avray or the streets of Douai and Saint-Lô. He will lead his age to undertake a major renovation in its very frame of existence; but he wants to people the shores of Nemean lakes and the Ile de France with nymphs, and he goes to the opera for his ideas! He will always project his picturesque or fancied vision within the boundaries of a space that is scenographic, if anything.

Here one touches, in addition, a point of greatest importance. If the romantics, hungry for novelty, stay thus attached to the imaginative mold furnished by former generations, this is because a desire for novelty does not suffice for the discovery of new lands. If Columbus discovered America, it is because he had the astrolabe. Artists do not create in a void; their activity is not unmotivated nor unrelated to their times. To have true creativity and a new plastic idiom, progress in thought and in technique must be concurrent. The romantic period gives us a typical instance of what can be done by a generation intoxicated with originality but having an imagination in advance of its means of execution. It proves that the problem of plastic space is not merely a problem of content and form, but of adapting content to form, neither being isolable from the other. Romanticism did not transform plastic space in any decisive way because it was given only to renovating themes and manners of handling them, without involving the technical basis of the spatial idiom itself.

In the following generation it is precisely the technical side of painting that was the object of passionate investigation.

The barrier that rises between generations—between those veterans of romanticism, Delacroix, Ingres, Corot; the "realists," Courbet, Millet, Constantin Guys, already equally outmoded; and finally, the truly "young" Manet, Monet, Degas, Sisley, Pissarro—is based squarely on the fact that the first seek still to revive art by means of renovating theme alone, while the others discover that progress

in the plastic realm comes only if one simultaneously involves art's content with its form.

Far be it from me to depreciate the originality of a Courbet or Guys. Each in his own way was able differently to reflect the life of his time—painters of modern life, painters of contemporary fashions and notions, but, after all, not essentially moving beyond the position of their predecessors. Doubtless they said new things because they did look about them instead of settling down amid stereotyped themes, but they did not grasp the idea that the change going on in their society, the new means of making man dominate nature, involved a complete change in the vision, and especially the spatial vision, of the world, and a renovation of the graphic means of denoting living forms on a fixed plastic surface, the only one still available. When a Veronese, after so many others, brings the Venetians of his day into a fanciful intimacy with sacred personages, or when a Greco in one of his most beautiful works, "The Burial of Orgaz," reverts to the formula of dividing his canvas into two worlds, celestial and mundane, they represent the ideas of their time by following academic formulas, just as Courbet in the "Atelier," "The Burial," or "The Stonebreakers" describes the activity and behavior of his contemporaries, meaningful on their own account and not for choice of a mode of plastic transcription. They do not take any revolutionary step. When he lays out his picturesque landscapes for us, Corot carries on the work of Fragonard and Hubert Robert; and like the Barbizon group, Courbet phrases his ideas and treats his figures in the manner of Chardin or Troy; in his drawing, Millet often recalls Rembrandt. What changes is the objects, not the system or figuration, of which space is a fundamental element. Admirers of Courbet, the "young" generation never really thought of him as one of their number—and with good reason. The reformulation of plastic space required by the radical change in the place man held in the world could not come only by renovating narrative themes or by shifting the hierarchical ranking of genres.

It meant replacing the very conceptual framework,

inseparable from the notion of space or, if you will, of "place" in the older sense of the word. There were not only new classes of men affirming their entry into history and art; there was posed the basic problem of the relation between man and the universe and between individuals themselves once the presence of old religious and social gods had been rejected. This is the very problem the "Impressionists" tackled. Thence results their immense historical importance, still inadequately understood on many sides, I fear.

If one grants that with Impressionism the question of really discovering a new space is posed, there is still, in addition, a need to discriminate. Not for a moment do I wish to maintain the absurd notion according to which the Impressionists (I should like to substitute the term "Independents" or more simply, "painters of the School of Paris") were all, and suddenly, innovators and nothing but that. They proceeded only painfully, timidly, with backslidings and false steps. They were precursors rather than fulfillers. Laying aside their bearing on the renovation of subject, I should think that their theories about space can be grouped in three kinds of attempts of quite variable originality and meaning: Some of them faced the modern problem of the relations between form and light; others faced the modern problem of the triangulation of space; still others faced the modern problem of tactile values or, if you will, the polysensorial representation of space.

Everything has been said about the role played by light in Impressionism. This was precisely the first aspect which the few kindly disposed critics of the movement were aware of. But I fear they all stressed chiefly the literary side of the venture. They spoke especially of Impressionist sensibility, the moving way these new painters had rendered atmospheric vibration, the impalpable breezes blowing through the air. In a word, this lyrical aspect of their work was caught first by the few well-intentioned beholders. But it seems to me we have now left the day when we have to be concerned with explaining the seriousness of their attempt. We can try to interpret their art in a freer manner than those who were in the

struggle and who had the rare merit of stating, immediately, that these innovating canvases stirred in them deep echoes of feeling. Specifically, we can ask in what degree certain Impressionist techniques helped modify drastically the traditional system of representing space.

For us the real problem is finding what effect the actual recording of sensations of light apart from form may have had upon the idea and the method of rendering space plastically. Yet, if one thinks only of the work of those Impressionists who particularly devoted themselves to the problem of light, one will be tempted to depress their historical importance. In sum, if one looks carefully, he quickly sees that the compositional scheme of many Impressionist canvases closely resembles that of a realist or even Davidian work. Take Monet's famous "Grenouillère," one of the first purely luminist paintings of the century. The pivotal points of the composition are blurred by sowing colored "touches" suggesting the vibration of light. But reduced to its general pattern the picture everywhere suggests the Renaissance spatial cube, even the famous orthogonals, and it is throughout constructed in relation to a single point of view, the artist-spectator placing himself by hypothesis outside the canvas and having a distant vision of the world (one called "remote") framed by the pillars of a proscenium. Some Impressionists—those arbitrarily called leaders of the movement—remained loyal to this approach. Take the haziest of Monet's canvases, the Cathedrals or London Bridges, the "Débâcle," or the Mills, and you will always find that the whole layout is traditional so far as designing and the framing of space are concerned. I have suggested speaking of a "grille" to characterize this aspect of Impressionist art. The system of representing the world by color comes to lie flat upon a canvas that is cubed, quite in harmony with previous methods.

Further still, I am not convinced that the pure luminists innovated so thoroughly as they are said to have done in the area of handling colors. Everybody goes about repeating that the "Impressionists" painted green and blue shadows. However, they are not the first to have felt the need for placing about figures or things the spots

of color—values—indispensable to suggestive configuration in a work of art. Even Renaissance painters put draperies under their nudes or near objects in order to heighten the marquetry, the compartmenting of color in their canvases from which came a large part of their meaning. Unfortunately there does not exist at present any exact study of this question of color-composition in classical painting. One reasons curiously in this case, as if the drawing were the real foundation, a coherent outline within whose boundaries color normally comes to be put. Yet this is a bad mistake. Ever since the *quattrocento*, the two systems, linear and luminist, which are intended to render jointly a "total" representation of nature, have been in action—but one *in opposition to* the other. So long as Uccello paints without cast shadows, his work is a mosaic of outlined forms and areas of color more or less reconciled. Refusing to seek this conciliation between two systems—colored areas and material forms —Leonardo praised chiaroscuro which, submerging contours, offers a ready solution to the thorny problem of consonance between representing by drawing and representing by color and light. On another tack, the eclectics and academics set up a whole scale of conventional values by which blues, reds, yellows, and greens take on a significance at once symbolic and indicative of space. A certain hue (green) denotes distance, and one can render distance and depth by foliage, for example, or by fabrics, indifferently; another (blue) denotes repose, and still another (red) movement. There is a complete system for expressing characteristics by color, which is progressively codified. Thus, if the Impressionists at a given moment bathe their *plein-air* figures in colored shadows, painting the grass green or blue—for instance in Monet's "Femmes au Jardin"—instead of setting their model against drapery, they actually introduce only a minor novelty without altering the basis of plastic treatment, especially the suggestion of space. Quite simply they substitute one device by another.

Chiaroscuro permitted a solution to the problem of the severe clash between a linear representation of objects and a system of representing these objects by color, effect-

ing a compromise: the creation of a zone of shadow that to the injury of linear clarity sustained the primary importance of form. The Impressionists reverse the terms of the problem. It is form that yields. The form of the colored "touch" dominates the form of objects. Previously color obeyed contour, thanks to a kind of fluidity, or a kind of confusion of values in shadow; henceforth the outline will be no more than a trace barely suggested through the fringes of the triumphant colored splotch.

So if there is an absolute reversal of technique, the two basic factors of the problem remain. And here the optical elements of the Impressionist grille reveal themselves and set a limit to inventiveness among the pure luminists of the school: Monet, Sisley, and Pissarro. Reversing the relations between the unchanged technical and perceptual elements, this brand of Impressionism does not effect a complete revolution in the art of painting and representing, whatever may be said. It offers a new mode of figuring space instead of a new conception of space. It makes possible a notation of certain effects until then inexpressible. One is now able to observe, for instance, the variable and coloristic qualities of atmosphere, instead of relying on a notion of a light white in itself. And this latter is—we may say, Mr. Rewald permitting—directly related to the work of contemporary science. Yet these artists always cling to a fixed framework, and to a scenographic view of the world.

This is not to underrate Impressionism further than to show how it remains attached to certain concepts so deeply rooted in men's imagination at a certain mental and social plateau in their history that we are not yet entirely free from them. And one must add that by reversing the relations between different methods of figuring atmosphere spatially, Impressionism made possible the discovery of new problems immediately exploited by the next generations.

Above all, we must emphasize that it is not fair to judge the generation of 1860-1880 from the point of view alone of the new relations between line, coloristic "touches," and form. As I have already said, the first devotees were straightway responsive to the sentimental

and lyrical side of Impressionism. But I think the time has come to judge the movement in its entirety. Yet it seems to me that the daring feats of a Degas—more loyal than Monet to the exhibitions of the Impressionist group— or of the Manet of "The Fifer" account for the course of events better than the new methods of Monet, Sisley, or Pissarro.

I have said that some Impressionists tackled the problem of the triangulation of space along with the problem—not new, but major—of the representation of light. And there, I think, much more than in the handling of color, they ceased to be faithful to the traditional Renaissance canvas. In their effort to render impalpable atmosphere, the Impressionists retained old emotional and representational elements, limiting themselves to inverting the technical factors. On the contrary, in their effort to modify the triangulation of space, they based themselves upon another civilization that spoke another language, and they truly innovated.

The import of the influential role played by the discovery, about 1870, of Far Eastern arts has already been shown. But it looks to me as though we have inadequately distinguished between experiments truly based upon a new spatial configuration and those which merely aimed at refurbishing notations of traditional sensations. The Manet of "The Fifer," for example, who devises a scheme of biased spatial structures where the play of values is combined with linear rhythms with the aim of detaching the figure from a background still half-cubical instead of mounting it neatly in bas-relief in the old way, allows us to glimpse a new sense of form built upon a new comprehension of weights and densities; but the Manet of "Olympia" or "The Beach" is nothing less than an immediate inspirer of the Degas who explores the angular spaces of theater-settings seen from unusual points of view. Right here is a whole sequence of experiments carried on in the famous portrait of Vicomte Lepic, in Mary Cassatt in the Louvre, and in many other ventures resulting in the various series of dancers and acrobats. To put it briefly: *Japonisme* leads chiefly not so much toward a discovery of the cartographic space of the Far

East (which, we note, was not unknown to Renaissance man) as to a synthetic use of dissimilar fragments of space. This observation seems to me crucial because it enables us to show how a period uses from among the range of new possibilities open to it only that which suits its interests. Indeed, contrary to what one might think, bird's-eye space was by no means adapted to Impressionist art—that is, space seen from above as extended but remaining unified, with all areas represented from the same point of view, if not on the same scale. Primarily the real novelty consists in the fact that the painter often refused to take the single eye, according to Alberti's rule, as a scale of measurement, in order that he might take any point of view at all, no matter at what elevation. Then he finds that according to distance and angle of vision the world takes on a very different aspect. He treats the eye as a projector without, however, refusing a cubic and global vision of the world. Only later the great discovery of Degas and his generation will be, by contrast, that of broad planes leading to a fragmented and closely seen vision of the world.

We readily see how this development in Impressionist painting accords with the discoveries the age was making, thanks to the methods of photography. Gone are the staggered echelons of vertical planes as if on a stage; one finds that when the eye is displaced to another spot, the world entirely changes its structure. Gone is the rule by virtue of which one really composes nothing but wholes: art discovers the autonomous detail. Until then, space had always been conceived as a milieu in which systems of things immerse themselves; one could represent space, however one tried, only by showing many things gathered simultaneously together inside a framework. Henceforth, one conceives the possibility of suggesting space as originating in the representation of a single detail. This being done, one is at last ready to abandon the traditional point of view. The viewer will stop seeing a scene coordinated inside a frame; he will fix his attention sharply upon a point of detail, which will become a center of radiation, so to speak, for the whole vision.

At this juncture Degas' final experiment joins that by Renoir, who follows with him the third Impressionist tack. Renoir starts from color. And he reaches a kind of spatial organization radiating out around a small number of details expressed by values. Rejecting all Euclidean organization of depth in his "Bathers," for instance, Renoir sets his figures in a neutral ground; he draws close to the model, touches it, feels it with his eye and hand; he clings to it, more sensitive to the qualities of contact than, like Degas, to the unusual aspects of contour.

By another route, Degas ordinarily unites an intense and prodigiously novel analysis of foreground details with a background composition that renovates but retains the laws of recession and frame—from which arises the delicacy of his work, linking in paradoxical accord two contradictory modes of representation. For his part, Renoir more easily accepts the untidiness, the fluidity, the neutral character of spatial areas spreading out from a chosen center of attention. With Renoir, in brief, there is a sort of closeup of nature retaining the value of bas-relief or, more frequently, of even the freestanding statue caressed by hand, rather than of the panorama that replaces the figuration of a marionette-theater. Think of the method of Poussin, who placed figurines in a box to study the play of lights: insufficiently pondered evidence, its sole worth being to confirm a theory about the transformation of space occurring there. Classical generations, devoted to the scenographic, thought of man as an actor on the stage of the world; they always presented him upon a kind of set platform; they imagined him inside a rigid framework almost alien to him; they retired to a distance necessary to place him upon his scaffold, keeping the eye fixed, as Poussin was able to fix it, from one side of the stage. This conception was demolished after Impressionism, or, more precisely, after those Impressionists who with the draftsmen Manet and Degas, then with the colorist Renoir, set their attention upon the detail and entered into reality, so to speak. One could say that the Middle Ages had a compartmentalized conception of space, that the Renaissance had a scenographic concep-

tion, and that modern art has an apprehensional conception.

The direction thus taken by plastic theory about the 1870's is explained not only by the general development of techniques external or incidental to painting, but also by the different attitude all society took toward the natural order. It has been repeatedly said—and first by me—that Impressionism was the art of an epoch facing, at a philosophic level, the problem of scrutinizing the primary data of sense experience. More accurately, it is the art of an epoch that denied the mechanistic conception of a universe whose eternal structure was believed intelligible, in favor of developing an analytic study of nature. The human eye penetrates matter; and tomorrow it will conceive a world whose general structure will no longer be determined by the habit of projecting everything, including plastic space, inside a kind of abstract cube, the Euclidean image of an abiding physical order which man traverses like a visitor.

Let us not forget that the space which was evolved during the fifteenth and sixteenth centuries expresses the same needs that inspired a complete philosophy. Here Platonism played a controlling role. The men of that day believed there was a harmony of the spheres and that this harmony phrased itself in mathematical theorems transferable from the representation of man to the representation of the universe. They believed in the eternal unity and order of the cosmos; more specifically, they believed that the world had geometric form, that nature was a changeless reality openly revealed to men. Only with difficulty can one today appreciate the influence that this humanistic or, better, literary, notion had upon the course of modern culture. After the close of the nineteenth century, inspired by the science that had disclosed complex features of the universe, society was led to revise its traditional representation of space.

We may add that exactly while it was demolishing the established forms of a secular tradition this society created in romanticism and realism new heroes and new mythical landscapes. It would indeed be wrong to think

that Impressionism alone altered the conditions for figuring space on its canvases. The spatial problem is double. It requires that one reckon simultaneously with what one represents and with the way one represents it. In this area Impressionism followed a path hewed by former generations. We have seen that after romanticism a giant effort was made by artists to reshape imaginary settings, while realists were bringing into art a new range of commonplace scenes. Throughout the nineteenth century every generation had its own milieu, realistic or fanciful. Madame Bovary no longer lives in romantic chateaux. In a general way, this century more than previous centuries had a sense of the nearby and the variable. This sprawling society was no longer satisfied with a few typical settings. On the other hand, it rejected the conventional, fashionable, classic, and religious milieus of earlier ages. From Masaccio and Piero to Delacroix and Ingres there had been a world of gods, a Christian world, and a social world almost entirely unchanged. At Saint-Sulpice, Jacob wrestles with an angel in a garden Raphael described; Homer attains his Ingresque apotheosis before a Palladian temple. For ages the only world that mattered was so limited that it reduced itself to a few large patterns. During the eighteenth century a variety in landscapes appeared. Already between Chardin and Robert everybody's world enters art. In the nineteenth century painting feels a need to depict more and more locales and, we note, increasingly intimate, in which feeling for detail dominates the theme—a total reversal in imagination, which stops stressing groups and ensembles in order to focus upon the fragmentary as the basis of structure. Thereafter one moves from the particular to the whole instead of deducing the details by the requirements of a formula. Thus, the development in nineteenth-century art parallels the deeper developments in thought and science.

The main thing to understand is that no plastic representation of space can be divorced from its context of intellectual and social values. Borrowing a term from the ethnographers, one may here speak of cultural lag. The transition from Middle Ages to Renaissance came when natural philosophy began to develop. The Middle Ages

believed that God embraced all, that the universe had a profound oneness even while it had selfhood. This age was satisfied with a representation of juxtaposed spaces: no distance between things, since everything, men and objects, are attributes of God. Quite simply out of reverence they refuse to locate things or divine personages in a space that is in the slightest way illusionistic. The contrast is between incorporeal essence—hence flat—and accidents. But even these are only a concrete manifestation of essence. The Renaissance conceives the opposition or conflict between God and Nature. So it introduces the representation of closed space in a universe where, under God's eye but in opposition to it, men and things are transferred into a world run by a limited number of fixed self-operative laws whose action is brought to bear upon them. The basis of Renaissance perspective is perhaps an hypothesis of the existence of physical as distinct from spiritual laws. But it is likewise belief in the reality of things and their permanence. The modern era, having refused to take things as primary data in nature, has perforce changed its notion of the relations between subject and object as well as between objects themselves. At the same time it has changed its mode of daily existence and its notion of the hierarchical relations that bring men into adjustment with each other. It now has found itself unable to denote things accurately by their outline and appearance. It is obliged to delve deeply into all aspects—psychological, physical, geometric, social. Thus, the values of unchanging identity in old symbols have gone; Renaissance spatial and social codes are no longer useful.

Hence, modern society has stopped existing, physically and artistically, in traditional space. Literally it has *gone out,* in the proper sense of the word. But it was inevitable that artists should find themselves unable at a stroke to establish a new coherent and complete system for representing a new universe, which even today does not yet exist in any area. This is why speculations on space during the Impressionist era had the guise of incomplete investigations; and this is why any study of them should not be undertaken with the aim of deciding what new consistent system suddenly replaced the old one. To

take an absurd supposition: if some catastrophe had interrupted the way of life in Western society about 1480, all the meanings which now serve us to interpret what we call the "Renaissance" would be nonexistent. Once given the general situation of men *vis-à-vis* the problems of nature, two or three centuries were required for society to settle itself into a stable attitude. During its origins, the Renaissance was not prefigured in the work of the first *quattrocento* innovators. The same applies to the modern era. Certainly one sees that a kind of break occurs, for instance, between the Middle Ages and the Renaissance, as it does between the Renaissance and the present era. Certain appearances to the contrary, there is a greater difference between Ingres and Degas than there is between Ingres and Raphael—as much as between Duccio and Uccello.

Deep shifts in comprehension are as rare in the life of societies as they are in the life of people. Time is needed to erect a system, and that system is never finished until the very moment when it ceases to be useful, yielding its last results. It is very difficult for us to judge the nineteenth-century plastic revolutions because we are still engaged in the struggle. Nevertheless, I believe we can say that about 1870 a small band of men, certain ingenious painters of the School of Paris, finally destroyed the possibility of any plastic representation of space consistent with tradition. Furthermore, they set themselves some problems for investigation and experiment from which art is still evolving today. . . .

THE NOSTALGIA
FOR A MÉTIER *(1951)*

IN THE FOLLOWING ESSAY, Cassou has addressed himself
to one of the most inhibiting disabilities of the modern
artist—his lack of training in the technique peculiar to his
medium. This amounts, of course, to a lack of education
in the traditions of his art, and is similar to the problem
often faced by the modern poet, who, as T. S. Eliot said,
has trouble adjusting his individual talent to poetic tradi-
tions that should be "his." Like Eliot, Cassou implies that
the artist today is often necessarily ignorant exactly where
ignorance is most injurious—he is ignorant of the funda-
mentals of his craft. To be ignorant of one's craft is to face
obstacles no former artist had to face. For example, through
no fault of his own, the painter has to use pigments the
nature of which he cannot know, since modern chemistry
offers him colors made of synthetic substances that may or
may not be "pure" and durable. Medieval and Renaissance
painters prepared their own pigments from materials on
which they could rely and which they were trained to use;

now the painter is at the mercy of whatever pigments are available on the market. Even more damaging in another way is the separation of our "fine" arts from training in craftsmanship: meanwhile, the so-called "minor" or "applied" arts have kept craft alive.

During the later nineteenth century, William Morris realized quite as clearly as Cassou the dangers of alienating art from craft, and his essays collected under the title *On Art and Socialism*, edited by Holbrook Jackson (in 1947), anticipate what Cassou says. The many accounts of the Bauhaus Movement also deal with the same problem.

THE NOSTALGIA FOR A MÉTIER

(from *Formes de l'Art, Formes de l'Esprit*, 1951)

The history of modern art is one of alienation. From the middle of the nineteenth century through the first quarter of the twentieth, art has achieved its originalities and revolutions outside the sanctions of society and often in defiance of it. Powerful creative personalities have stood out during this era: today they may seem glorious to us, but their situation has been paradoxical and their fate unhappy. Then too, consider the notion developing in artists' minds that this state of things cannot be an inescapable necessity. They think, or dream, of an era when the artist lived in accord with society, and they associate this aspiration with the figure—the myth, if you will—of Peter-Paul Rubens. Such aspiration reveals itself no less definitely in what we shall call the nostalgia for a *métier*.

In coherent and closely knit cultures like primitive societies, as well as in grand artistic epochs like that of Rubens—that is, whether the artist sees himself called upon to provide things required for religious purposes or to give

full scope to his creative abilities in vast enterprises—
he was obliged to exercise a competent and prescribed
skill. He was artisan, laborer, architect, inventor, builder.
Such function has disappeared since the day when, in the
free-for-all in modern art, he became no more than an
individual sensibility, a man among men who hears the
call of his vocation and henceforth sacrifices to it his life
and his leisure. His artistic activity can hardly be called
work. It is only tragedy. It is only struggle against fate,
against poverty, chance, abuse, folly. Nobody has taught
him anything; he will teach nothing to anybody. He is
ignorant of those methods, those lessons handed down
from master to apprentice, from workshop to workshop
like a tool, and a precious tool. He owns nothing, not even
that. He is alone, without guild and without fellowship.
And just as he will create his own style, he will create his
own methods. At the heart of this calamity and amid this
fruitful penury he will feel the yearning for a lost secret.

Baudelaire, who lived at the beginning of this age of
art *maudit* and who was one of the first artists *maudits,*
already felt this yearning and analyzed it, never more
lucidly perhaps than in a sarcastic page of his *Salon of
1846:* "The present state of painting is a result of the
anarchic liberty that glorifies the individual, however
feeble he may be, at the expense of communities, that is
to say, of schools. . . . That glorification of the individual
has necessitated an infinite partition of the artistic domain.
Absolute and eccentric freedom for each, a division of ef-
forts and a fragmentation of the human will have brought
about this weakness, doubt, and dearth of originality;
a few freaks, sublime and tortured, ill compensate for the
swarming crowd of mediocrities. Individuality—that fragile
singularity—has eaten up the communal originality, and
as it has been shown in the famous chapter of a romantic
novel that the book has killed the monument, one may say
that for the present it is the painter who has killed paint-
ing."

We must doubtless see here the state of irritation that
these new confusions inspired in Baudelaire's reactionary
disposition; then, too, he could not foresee the works of
genius that were about to be produced by anarchy, individ-

ualism, or, in brief, to use one of his own terms, the *republican* state of things which his aristocratic taste for authority deplored. Yet he has identified the situation. He has seen that painting was facing anarchy and eccentricity and that what vanished during this venture was the school, the *métier*, the possibility of creating a public art capable of expressing itself in monuments.

More temperate in his views than Baudelaire, but no less a shrewd observer of the course of affairs in art, Eugène Fromentin, in his *Masters of Yesteryear* in 1870, was depressed by the decline in artistic training. He affirmed: "That there is a *métier* to be learned in painting and therefore one that can and must be taught, a basic method which can and should be passed on—that this *métier* and this method are as essential to painting as the art of speaking and writing well to those who use the word or the pen—that there is nothing improper in our all sharing these elementals—that to hope to distinguish one's self by dress when one is not distinguished in person is a poor and empty way of proving that one is somebody. Formerly it was otherwise, and the proof is in the entire agreement in the schools, where the same familial air belonged to individualities so unlike and eminent. Well, that familial air came to them from a simple, standard, well-understood, and, as we see it, largely salutary training. But what was this training of which we have conserved hardly a trace?

"This is what I want to have taught and what I have never heard stated in a lecture, a book, a course in aesthetics, or classroom recitations. It would be one more professional training at a time when almost every professional training is given except this."

To be sure, in that state of anarchy which hurt Baudelaire and disturbed Fromentin and which made the latter a herald of the current renaissance in professional and technical training, some inspired individuals (who are also ignorant, that is to say, formed outside of or in rebellion against all schools) will create masterpieces; but they will have a sense of living in a condition of anarchy and ignorance: they in turn are injured by it, and they admit their injury.

Renoir confided to Albert André: "Really we know nothing any longer, we are sure of nothing. When one considers old paintings, one really doesn't have to try to be clever. What admirable craftsmen, first of all, these people were! They knew their *métier*. Everything is in that. Painting isn't dreaming. First of all it's workmanship, and one must be a good craftsman." He said to Vollard: "Today admittedly we all have genius, but surely we don't know how to draw a hand and we're utterly ignorant of our craft. Because they had their *métier* the oldtimers knew how to get that marvelous texture and the limpid colors we vainly seek the secret of. I fear indeed that the new theories won't yield us that secret." Regret for the lost secret forced Renoir to doubt himself and the revolution he and his friends brought about in painting, even to the point of depreciating himself and his genius. During the course of his crisis of 1883-1885, after his visit to Italy and his contact with Pompeiian and *quattrocento* frescoes, he gave up the theories by which his genius affirmed itself in its most personal, private, and unorthodox vein, suspending the experiments that inspired his devotion to *plein-air*, and he—Renoir!—yearned for the light of the studio. And listen to Cézanne's anguished voice: "What I lack," he told Émile Bernard, "is realization. I perhaps shall achieve it, but I'm old and I may die without having reached this final point: to realize, like the Venetians!" This same dissatisfaction was an obsession with Degas: "We live in a ridiculous age, I must say. The oil painting we do, this difficult craft we practise without understanding it—an incoherence like this doubtless hasn't ever been seen! There are very reliable methods used by artists of the seventeenth and eighteenth centuries, methods still known to David, the pupil of Vien, who was dean of the Academy of Beaux-Arts, but no longer known to painters at the beginning of the nineteenth century."

In the puzzling situation where he is, the modern artist cannot help dreaming of the position of the painter in the opposing camp. In a society that employs the painter as functionary and assigns him a strictly social role, the artist has a craft; he has rules for making his works. The Negro who carves masks, or the academician

who paints battles or portraits of generals has a craft and uses it. One must say they are lucky, for the practice of this craft insures them a happy confidence. It gives them a means of judging the worth of their works. For they have rules and thus a criterion. They can compare what they do with accepted models, with works by their predecessors and contemporaries. The public and its leaders hold the same standard, which allows them to bring to bear opinions about worth. Success is determined by known tests. In my own sphere I admit that I envy the good fortune of the middle-class novelists and playwrights for the commercial theater. I should have liked to be one of those caterers to the society of my day. Then I should have had a craft. They would have told me what to do to enter the trade, to take part in its production, to turn out on my own account works comparable to those that have an established clientele in a ready-made market bringing profit and esteem. Undeniably, this sort of craft tends to be only routine. But as we have said, history also shows us more complicated ages when if art had a social function it was nonetheless art—that is to say, invention and creation, although it involved the craft-element.

The medieval workshop recognized craft. Rubens knew his craft. In the eighteenth century the artist knew his craft, or even his crafts; he was artist and technician; he made an altarpiece, a portrait of a princess, a decorative panel for a great man's house as skillfully as he made a signboard, a design for a fan, a sedan chair, or a processional banner. Thus, his craft had nothing of the humdrum since it adapted itself to sundry uses; it posed him various problems to which the flexibility of his inventive fancy had to bend itself. But from the modern heretical artist— Renoir, Cézanne or Degas, Gauguin or Van Gogh—society asks nothing, either to solemnize its ceremonies in traditional and ritual fashion, or to extend his knowledge and ingenuity to diverse uses, leading him to make surprising discoveries. It gives him no chance for such discoveries. It furnishes him no more-or-less set forms into which his talent may introduce one of the variations by which genius expresses its personal distinction. Today's artist sets out from no convention. Nothing is "given" him beyond him-

self, his individuality, his talent. Craft—the taught, inherited, recognized craft—is exactly what he is against, since all that he achieves, craft included, he invents by himself. Every modern artist devises not only his aesthetic, his sensibility, his plastic and spiritual world, but his technique besides. He is ignorant of what it is to know how to paint, how to draw, how to etch, how to carve. His methods are wholly empirical.

Such disability can seem only the bitterer in an age ushered in by the hullabaloo about industry. Ours is called an age of work. The new techniques, their complexity, their promise of expansion open to the public mind infinite and exhilarating perspectives. Innumerable mechanisms are available, which year after year are perfected and year after year lead to further inventions, to expanding production more rapid, more efficient, with comfort more assured, a thousand facilities, a thousand gratifications. Everybody from day laborer to scholar takes part in this enterprise, this boisterous management of the world; everybody is a specialist and knows and feels it. Support for this feeling is given us by results, which are in line with the achievements of our planet-factory. But the artist?

Think of the tragedy of modern artistic consciousness. Try to discern first of all what it really is. We are led back to the inception of the creative act, where the artist can do only what springs from himself alone; and without knowing what his work will be or how it will be received (save that he is utterly sure it will be refused) he appears as a nearly unknown, useless, nameless creature

Black, with pale and bloodied wing, plucked.

It is the grandeur and honor of modern art to have put the accent on this first step in the artistic process, that of conceiving, to have reduced the definition of art itself to conceiving, it being clearly understood that such conception is not an *a priori* abstraction, that it comes into being only by manifesting itself as a form. But in that form what signifies is its problematic character: it is a proposal, a hypothesis, an abnormal and subversive venture. And its inventor can only doubt its viability. For in

its behalf he has no guarantee, no guarantor. No teaching has guided him in developing it, and since he is alone in his corner and it in no way resembles things produced by certain, sanctioned, and regular methods, it seems to him that the world will not know what to make of it.

Besides, this is precisely one of the current opinions about modern works of art: they are studio experiments, fabrications of the mind, theories. And Cézanne, on his own account, mentioned his "little feeling": he said of Gauguin, "He's filched my little feeling." Each of these lonely, odd creators, each of these paupers who had only their own talent, devised a little sudden and surprising thing with the depth of a cry. But it seemed necessary to them to make this cry live, to give it endurance that it might be accepted. Therefore, Cézanne, in his humble and pitiful jargon, spoke of "realizing." He had to accomplish this realization. So two aspects of creativity distinguish themselves: that of conception, the meditation by which the artist under the sting of his gadfly invents for himself his needed symbols, his plastic world, that by which he is himself—his "fatality," as Baudelaire said, it being necessary to give that term all its pathetic sense which makes the artist a stranger and his creation a monster; and on the other side, the elements of craft, technique, proven methods which make the artist a worker in a working world and his work a living reality, recognizable and acceptable in the monumental unity of a culture. Under this second guise, artistic creation enters a domain where society encounters it. Art and society: the *métier* is their common meeting point.

Undeniably, the revolutions in modern art, formidable in their bursting variety and their dizzying succession, have obliged us to stress the speculative nature of artistic creation: everyone has had his theory, this one, an analysis of light, that one, about the structure of things, and in behalf of each, a single man among men, lonely among men, has spoken his word, cried his cry. Yet the need for realizing that tormented Cézanne, the nostalgia for a *métier* his fellows confessed, leads us to understand another essential step in the process which is a *making*, and which ought to create works by means of a synthesis of all

kinds of knowledge and experiments, those which *homo faber* has at his disposal as master of his medium, his tools, his hand. And in fact, modern art has produced works—innumerable and admirable works. And for all his anguish, Cézanne did *realize*.

Confusedly aware of that basic necessity for a work of art to manifest and maintain itself as a rich and organic product of workmanship, modern artists have dreamed, and do dream, of seeing themselves identified by society as craftsmen, and *qualified* craftsmen. A craftsman qualifies by his *métier;* and by demonstrating that he knows rules proper to his *métier,* the artist inevitably determines his personal genius—not by rules imposed in any way from outside, but evolving inside the *métier* itself from the nature of the material worked and from adapting this material, at last, to a style in art.

This social restoration of the artist's *métier* goes along with the rehabilitation of the notion of the craftsman. The term "masterpiece" belongs less to the vocabulary of the artist than of the artisan. Doubtless the artist's masterpiece, and especially the modern artist's, appears at first glance like the fruit of theoretical speculation, the discovery of a new world of sensibility, a system of freakish forms, a stroke of fantasy, the exhibition of a unique, strange, unbalanced mind. It also is, and should be, and purports to be, a thing well-made, a masterpiece in the craftsman's sense, an artifact: and let us think of it as an artifact, a thing worked up. Worked up, indeed, by methods simpler than those at the command of the powerful and complex industry of our day with all its apparatus of vested interests, offices, and services, but analogous to its products, and no less deserving esteem, worthy in every way of inspiring pride in its maker had he, like the craftsman of yesterday or the skilled worker of our own age, been the one to make it alone. For this reason, today's painters are anxious to train themselves in the crafts one calls "applied," ceramics and glasswork, whose products are devoted to practical use. Many—and among them, the best —have turned to tapestry. And everyone realizes that they have fully revived this old French craft after a century of decline, and have given it a luster equal to that of its most

brilliant epochs. Talent has lost nothing in submitting to the rules of a craft. On the contrary, it has shown itself and continues to show itself precisely there, in endless variety. Our admirable revivers of tapestry—Lurçat, Gromaire, Saint-Saëns, and many others indeed—have tackled their work by accepting the strictest demands of this *métier* as it was practiced in its purest days, i.e., the Middle Ages, in contrast to that virtuosity and bravura into which it was allowed to fall while seeking to imitate the iridescent nuances of painting—namely, while encroaching upon the realm of a neighboring *métier*. But what a lesson a true, honest *métier* that knows itself and keeps its bounds, its logic, its terms, brings to the talented creator—what a chance to develop a severe and robust power.

From all this arises the urgent duty of revising our artistic education and of heeding the growth of technological and professional schools which are increasingly moving back into territory until now restricted to what we pompously continue to call Beaux-Arts. Such are the schools of *arts et métiers* which alone should thrive in our country, providing a training no longer academic but basically technical. Not creative talent is taught, but sciences: like optics, materials, the preparation of canvas, the chemistry of colors, differences in stones, and, in a word, the various skills it is good for a painter, sculptor, or etcher to know as his own. For the academic hierarchy of major and minor arts belongs to a bygone era, and the art of landscape painting, however embellished with nymphs, is no nobler than that of glasswork or posters.

We have referred to the diversity of talents displayed by artists of yesteryear. This is an historical fact which ought to be exemplary; yet surely we are aware that it has always been at odds with the narrow official curricula, and especially with the control of the Academy, whose principles we are amazed to find surviving into our own day, entrenched in our education and our ways. In 1749 the Academy decided to close its doors to pastellists, and in order to enter it, Perronneau had to confine himself to doing portraits in oil, the only medium worthy of esteem. On the contrary, we find that in his decree of the Council

of State for May 26, 1660, Louis XIV acknowledged the status of copper-plate engraving with burin and *eau-forte* as a fine art "which rests upon the imagination of its creators and which cannot be governed by rules other than those of its own genre." I want to see some substance given to those generous words proclaiming liberty of artistic creation not in the interest of one of the major arts but quite literally in behalf of an art one might think minor and applied. Unfortunately, Colbert later caused etching again to be put in the technical curriculum, assigning to it the reproducing of paintings for the royal library. Little by little painters restored the autonomy of etching through the interest they had in these reproductions. The history of changing social esteem for various arts and *métiers* deserves a chapter apart. Here we shall only affirm the possibility that they all, with the aid of freedom and talent, can attain equal dignity. We shall claim that in the past, during eras of "grand art" and in spite of the pressure of academic prejudices, this possibility existed for artists. In this fashion, each artist, inspired by such examples and by his own nostalgia, ought today to feel led on toward an encyclopedic familiarity with the arts and become a true inventor of forms: in all areas, in the use of all media, and in all the opportunities open to his talents he might more easily hope to give our epoch its unity of expression.

RUDOLF ARNHEIM

ACCIDENT AND THE NECESSITY OF ART *(1957)*

AFTER CUBISM—or even during Cubism—the relation be-
tween science and art became closer than at any time since
the Renaissance. Mondrian's abstract painting obviously
has kinship with some aspects of modern geometry, and a
great deal of art produced under the influence of the
Bauhaus movement has a purity of design that might be
called technological if not scientific. But there is another
sort of purity in Abstract Expressionism, which is "lyrical"
if not downright romantic. This "other" abstract art like-
wise has relations with science, for it manifests what the
modern scientist knows as "accident" in contrast to "neces-
sity." Chance seems more and more significant in scientific
theory as well as in art, and Arnheim's essay indicates how
the accidental can be transformed into painting. Much of
the "action" or "informal" painting in Abstract Expression-
ism evolves, we are told, spontaneously into patterns that

resemble designs in molecular activity. Arnheim explores the borderland where pattern dissolves into texture, and where texture breaks over into pattern. Painting is not science; but science is constantly more attentive to some of the things that "happen" in our painting.

Perhaps the best general commentary on both sorts of abstract painting, geometric and lyric, is Marcel Brion's *Art Abstrait* (1956), or else Charles-Pierre Bru's *Esthétique de l'Abstraction* (1955). A very discriminating essay is Pierre Restany's *Lyrisme et Abstraction* (1960). In *The Listener* for January 12, 1956, Anton Ehrenzweig printed "The Modern Artist and Creative Accident." Arnheim himself has also written *Art and Visual Perception* (1956). The philosophic background for the new relation between art and science is presented in Gyorgy Kepes' *The New Landscape in Art and Science* (1956, 1961).

ACCIDENT AND THE NECESSITY OF ART

(from *Journal of Aesthetics and Art Criticism,* XVI, September, 1957)

The immediate impulse for this inquiry came from the practices of certain modern artists, writers, and composers, who deliberately rely on accident for the production of their work. One of our more experimental composers is said to be fond of drawing a large staff of five lines on a piece of paper, putting it on the floor, throwing a handful of pennies on it at random, and then using the accidental assortment of notes thus obtained as a musical composition. The surrealists have taken over a parlor game in which a group of people write a poem or draw a figure collectively but without seeing each other's contributions (*cadavres exquis*). The surrealists have also

cultivated automatic writing, that is, the technique of jotting down as fast as possible and without reflection or choice any phrases that come to mind. These are extreme examples of a rather widespread tendency. There is the scrapheap as a supplier of inspiration for sculptors, the adoption of nature's shapes and textures, the exploitation of the chance effects of running paint, molten metal, etc.

Lawfulness in science and art. Offhand, the use of accident seems to be the very opposite of what the artist is expected to do since one of the functions of art is that of discovering order, law, and necessity in the seemingly irrational world of our experience. Art is a basic instrument in man's struggle for survival, which requires him to understand something of the nature of things by observing them, and to predict their behavior by what he has understood of their nature. Schiller in the preface to *Die Verschwörung des Fiesco zu Genua,* points out that historically the hero of his play perished by an unhappy accident, but that this course of events had to be changed because "the nature of the drama does not tolerate the finger of the thereabout or of close range fate. . . . Higher beings are capable of seeing the tenuous cobweb threads of a deed run through the entire expanse of the universe and perhaps attach themselves to the remotest boundaries of the future and the past—where the human eye sees nothing but the mere fact suspended in free air. The artist, however, makes his selection for the narrow view of humanity, which he wants to instruct, not for keensighted omnipotence, by which he is instructed."

In order to go beyond the puzzling face of the apparently accidental, man has developed two techniques, which in their perfected and professionalized form are science and art. By science I mean the interpretation of events through conceptual generalizations. Art serves a similar purpose by making images, through which the nature and functioning of things can be experienced. In its early stages, scientific thinking imposes a simple order by a few sweeping generalities, such as that all heavenly bodies move in circles or that the sexual instinct is the root of all human motivation. Under the impact of reality science gradually refines its descriptions to take care of complexi-

ties and variations—so that at times the intricate tissue threatens to hide the underlying structure. And since enlightening order remains its aim, science must try constantly to organize the increasingly unwieldy material under simple over-all forms. It is relevant for our purpose to note that science proceeds from the specific to the general in two different ways. On the one hand, it collects the outwardly observable attributes that the members of a given group have in common. (Kurt Lewin, in criticizing this method, has used the following example: "Whatever is common to children of a given age is set up as the fundamental character of that age. The fact that three-year-old children are quite often negative is considered evidence that negativism is inherent in the nature of three-year-olds . . .") Such induction is a superficial way of arriving at generalities, but it stays comfortably close to what people directly observe. The other scientific way of making order is to move from the overt effects to the hidden causes and to proceed to more and more abstract and general principles until the whole universe is caught in a short, profound formula, in which the common man no longer recognizes anything he ever saw, heard, or touched.

Art goes about its job in a rather similar way. It also starts with simple generalities. We find them in the elementary symmetries of children's drawings, or the sculpture of early civilizations; we find them in the black-and-white characters of fairy tales and legends. Under the impact of reality, art, too, develops toward more and more complex patterns in order to take care of the variety of appearances and the peculiarities of the individual mind. In Western art, growing complexity takes the form of increasing realism. The simple, schematic figures found in the archaic styles and later, once more, in Byzantine art give way to the highly individualized likenesses of human beings shown in a wide variety of attitudes and settings.

Accident as subject matter. Now, realism enhances the element of chance in the relationship between the work of art and its ultimate purpose. For when we proceed from a Byzantine saint to a Rembrandt portrait we move farther away from the prototypical image of man, which is the final subject matter of art. Rembrandt presents

us with the likeness of a particular individual that happened to capture his attention. The gesture and posture of Michelangelo's "David" are more specific than those of a Romanesque knight, and the Renaissance play with costumes, perspectives, lights, and groupings is rich in accidental features. Accident always refers to relations, and when we call a relationship accidental we express our belief that it did not come about through a direct cause-and-effect connection between the parties concerned. The stylized Byzantine features are more closely controlled by the primary concept of man than the Rembrandt figure, which shows the intrusion of extraneous individual encounters. The difference may be expressed also by saying that with increasing realism the solution offered by the artist becomes a less probable one.

We must add hastily that whereas from the viewpoint of science the more schematic image may be considered nearer the truth, art is not satisfied with the bare quintessence extracted from the variety of appearances. To a larger or smaller extent, it always uses the chance inventory of the artist's world and the chance perspective of his personal outlook in order to present the prototypical essence under ever new aspects; and when related to the particular conception of a given artist or style period, the choice and presentation of the material is of the strictest necessity.

It is, however, in the nature of the human mind that what turns out later to be controlled by necessity looks first as though it were due to chance. This happens because at any given time a deviation from, or broadening of, the accustomed order is perceived as disorderly rather than as a necessary part of a new order. By the standards of medieval art an individual portrait face would have been considered accidental to the task of depicting sanctity, royalty, or suffering. It took a new interest in the specific manifestations of human nature before individual features could be accepted as the necessary solution of an artistic task.

Fra Angelico's "Annunciation" in San Marco might have looked like a snapshot to an observer accustomed to the formally arranged religious paintings of, say, the thir-

teenth century. The architectural setting is losing its symmetrical relationship to the figures and is perceived from an oblique angle. The two figures would seem to our observer to have been caught or placed somewhere at random, and the station point of the perspective would appear similarly accidental. Actually, Fra Angelico's composition springs from a new, more complex order, which determines the position of each object with necessity. The balanced serenity of the Virgin is conveyed by her central position in relation to the right-hand arch and is contrasted with the forward push of the eccentrically placed messenger. But the larger arch contains a smaller one, and with regard to this subordinate framework the Virgin, too, is placed eccentrically—an expression of her timid withdrawal that counterbalances the advance of the angel and is properly made secondary to her more "official" attitude of poise. We also notice that the seemingly accidental angels of the perspective produce an abstract wedge of oblique lines, which underscore the forceful intrusion. Here, then, the concern of a new age with the human aspects of arrival, announcement, bewilderment, and modesty interfere with the traditional static symmetry of the religious scene. The deviation from the prototype, which would have looked like sheer accident earlier, is used here as an essential pictorial device for interpreting the interaction of two sets of forces: the dogmatic and the psychological.

The phenomenon repeats itself at more advanced levels, for instance, when Tintoretto's "Last Supper" in San Giorgio Maggiore looks like a rush-hour turmoil to an observer brought up on Leonardo. Only after we have understood that the oblique position of the main scene, the violent variations of figure sizes and postures, the crowding, the overlapping, and the splashes of light create a new, intensified version of the old drama, the apparently accidental use of the accidental is revealed as a necessity.

In the course of the centuries the ever bolder presentation of accident serves various purposes. A humorous application of the kind of pattern that creates emotional frenzy in Tintoretto produces the merry confusion of the Dutch tavern scenes in the work of Jan Steen or Ostade,

and a similar teeming disorder depicts the casual abundance of material wealth in the still-life arrangements of choice food stuffs and other luxuries. Later, accident is used by the romantic artists to defy the rigid order of rationalism; and the same device points up the homely imperfection of everyday life in the harsh statement of the social critics and naturalists.

Accident always suggests that things are not stable in their mutual relationships but are rather in a state of constant change. Some painters of the nineteenth century insist on this conception of the world by gathering within the frame of the picture figures that seem to have little or nothing to do with each other. The milling crowd in any of the great Baroque scenes was at least united by a common center of action so that even though a great deal of turnover was suggested in the secondary episodes, the overall constellation appeared stable. In Degas' "Cotton Market in New Orleans" there is no such focus. The participants are all in the same business, but they hardly trade with each other. As though they were unaware of each other's presence they read their papers, test their samples, work on their ledgers. In other pictures of the period, people walk past each other in the street, dancers hurry crisscross without any evidence of choreography, holiday-makers are spread irregularly over a lawn and look at the river instead of each other. Viewed with the eyes of the pictorial tradition, these figures may appear scattered over the canvas at random, but again it is only by the standards of an older order that the relations presented in the composition seem to be devoid of necessity. They cease to appear accidental and instead become compelling and unchangeable as soon as we recognize that the lack of a common purpose, the atomization of society in an age of individualism, is precisely the theme of these pictures. They suggest a communal pattern in which all joints are loose. No overall constellation holds the crowd together, and hence there is no limit to the changes that may occur in the relationships between the participants.

Accident interpreted by necessity. Our sketchy survey reveals in Western painting an increasing use of accident, that is, of showing objects in relations that have not

come about by direct cause-and-effect connections between them, and of presenting subject matter less and less directly related to the fundamental prototypes that art is expected to interpret. It also becomes evident, however, that while accidental relationships crept into the subject matter the artistic representation of their effects was not based at all on chance selection or grouping. In order to have necessity, it is not enough for these pictorial compositions to derive from a definite intention of the artist, who, wittingly or unwittingly, wants to express ideas. They must actually convey these ideas by compelling, neatly defined visual patterns. This, in fact, they do in our examples. In the "Annunciation," among all the possible relationships by which accident could connect the figures with the architecture, the painter has chosen those that precisely express the attitudes of the angel and the Virgin. Similarly, among the innumerable groupings in which accident could combine the figures of the cotton market, Degas presents one that shows with great visual precision that these people are not concerned with each other. For instance, he collects all the heads of the background figures in one horizontal row, and another oblique line leads from the man with the top hat in the foreground via the newspaper reader to the head of the bookkeeper. Degas thus makes us see his men in relation and discover the paradoxical isolation of people whom life has put in the same boat.

Degas and some other painters of his generation used the theme of accidental encounter as a subject matter to portray indifference, isolation, unawareness. The cubists carry the principle further and make it express the conflict of everything with everything. In the best works of this school great skill is applied to defining with visual precision the oblique relationships among the single cubic units. These units constantly interfere with each other, breaking into each other's contours. They tend to destroy the remnants of overall compositional groupings and instead fill evenly the entire surface within the picture frame. This is a logical development because when structure is reduced to a point-to-point interaction between individual elements, no larger shape can build up. The pat-

tern can extend forever, and any delimitation is arbitrary. In its pure and extreme form this style represents a level of order that, although intricate, is quite low—because it lacks hierarchy and diversity. But a definite form of order it still is: it is classically described in Plato's *Timaeus* as *ananke*, which is put in opposition to the lawful cosmos. In the realm of *ananke*, necessity is reduced to the causal action of any one object upon any other, but all of these actions add up to nothing more organized than an overall balance. To use a modern and practical example: a completely free economy would function according to this structural pattern.

Accident as a compositional principle. There remains for us to consider the most recent and radical phase of the trend we are examining, namely, the use of accident not merely as subject matter but as the formal principle of the pictorial composition itself. There is, of course, a difference between portraying chance artistically and producing a chance assortment of shapes. All the examples discussed here so far showed that certain effects of accident were interpreted compellingly through such means as the controlled deviation from symmetry or from the basic framework of the horizontal and vertical; furthermore through the irregular distribution of objects in space, through overlappings that cut across the structure of things at oblique angles, etc. However, accident does not always produce disorder, deviation, lack of connection, or interference. Patterns produced by a random scattering of elements will not depict obliqueness of relation only. They will show any kind of relation: some will have order or even symmetry, others will be quite irrational; some will be harmonious, some discordant. But since they are all thrown together by chance, none of them can make its point.

This can be demonstrated by an increasing number of dismal examples that accumulated in the Western art of the last centuries when the compositional patterns of realism became so complex that the average painter's eyes could no longer organize them. Here accidental patterns were produced not by intent but by the degeneration of the sense of form. The desire for the faithful imitation of

nature finally conquered man's natural and traditional sense of form and need of meaning to such an extent that the occasional great master was increasingly hard put to impose order and significance upon the multiplicity of appearances. In looking, for example, through the American *trompe l'oeil* still-lifes, one finds that in the work of a relatively better painter, such as Harnett, the assorted household goods are organized in such a way that the place and function of each object are defined by an over-all pattern. This pattern makes it possible for pictorial devices such as the irregular distribution of objects or the overlapping at oblique angles to attain visual necessity and thereby to interpret the charms of chance. In the lesser members of the same school, the passion for mechanical reproduction and a very modern fascination with disorder produce random displays, which the beholder's eye can identify but not understand. The phenomenal chaos of accident from which man seeks refuge in art, has invaded art itself.

Photography should be mentioned here since by mechanically reproducing the visual surface pattern of the physical world it introduces accident into every one of its products. The artifices of selection and transformation draw an approximate order from this raw material, but a photograph is never more than partially comprehensible to the human eye. In fact, the uniqueness and cultural worth of photography—just as, incidentally, the charm of mobiles—lies precisely in the encounter of natural accident and the human sense of form. As a medium of art, however, photography will always suffer from the inherent compromise.

What objection is there aesthetically to random patterns? Not that they are not interesting, suggestive, stimulating. They are—as anybody can testify who has looked at a pebbled beach, the New York City skyline, or certain modern painting and sculpture. There is also great recreation in an occasional escape from sense. It cannot be said either that such patterns are unbalanced because even the most outlandish conglomeration of elements balances perfectly about one central point. But stimulation, pleasure, and balance are not enough. A work of art must do more

than be itself: it must fulfill a semantic function, and no statement can be understood unless the relations between its elements form an organized whole.

The "statistical" use of accidental patterns. There is one means by which accidental agglomerations can acquire organization and meaning, namely, quantity. The larger a random collection of elements is, the more the individual characteristics of the elements and their interrelations will recede while their common properties will come to the fore. The more diverse the material, the larger the number of elements will have to be, and the more generic will be the qualities they share. If the pattern is given a semantic function, these common properties will represent the statement the pattern makes. Such statistical induction works not only by intellectual extraction but also by simple perceptual inspection. If we observe two persons who happen to sit next to each other, say, on the long bench of a waiting room, meaning may emerge accidentally from their combination (for instance, "young and old"). As the row of people on the bench gets longer, the individual connections we have made between the first two and those between any other members of the group begin to compensate each other, and instead, there come forward and survive certain common properties, perhaps that of "metropolitan man" or "resignation," or what have you.

What is noteworthy about this inductive procedure is that it neglects all relationships between the items concerned except their resemblances. This is why it alone can extract order from chance patterns, but this is also why its yield is so poor. When examined piecemeal, the random collection seems to possess the wealth of universality since it contains an enormous variety of being, behaving, and relating. But the riches turn out to be useless when we attempt to draw the essence from the whole.

This letdown is nicely illustrated by a recent experiment that we owe to Dr. Fred Attneave, a psychologist, who is interested in the theory of visual information. He divided a square-shaped surface into 19,600 little squares, each of which he had either painted black or left white in the order suggested by a table of random numbers.

Since nothing but chance predicted the color of any one square, a maximum of piecemeal information was furnished by every unit of the pattern. Yet, looking at the total result, the psychologist was impressed with its monotony, which struck him as remarkable because he had previously associated homogeneity with redundancy, and the random field had been constructed to be completely nonredundant. Which goes to show that piles of accidents add up to very little.

Attneave observes that the sequence of point-by-point communications, when viewed as a whole, changes into "texture." We may define texture as the result of what happens when the level of perceptual comprehension shifts from the scrutiny of individual structural relationships within their total context to that of overall structural constants.

The random field bears a striking resemblance to a well-known type of modern painting. (If reference is made here to certain works by the late Jackson Pollock or Mark Tobey, it should be understood that this paper is not concerned with individual artists but rather with a general principle, which may be embodied in a given painting more or less perfectly.) Such a picture can be perceived only as texture—not because the number or size of the units of which it is made up go beyond the range of the human eye's capacity but because the units do not fit into more comprehensive shapes. The number of elements is large enough so that their variations as to color, shape, size, direction, relative position, etc., compensate each other, and a common denominator of textural qualities such as prickliness, softness, excitation, viscosity, mechanical hardness or organic flexibility emerges from an inspection of the whole. All movements also are compensated so that nothing "happens," except for a kind of molecular milling everywhere.

What was said before about the compositional principle of cubism holds true here even more radically. The pattern in itself is endless so that its limits are dictated only by the rule of parsimony, which prescribes in this case that the number of units employed should not be larger than that needed to attain the effect of global

uniformity. Furthermore, the level of the structure is low because it lacks diversity and hierarchy. As far as diversity goes, such pictures typically look more like [the random field], which derives its variations from nothing but a standardized square in one of two colors, than like the junk shop type of still-life, which is its spiritual ancestor and whose texture is made up of many different objects. Lack of diversity, that is, the fact that the same kind of thing happens all through the picture, seriously limits the importance of the content that can be conveyed. An artistic statement, be it representational or "abstract," hardly begins to be interesting until it deals with segregated, different entities, whose interrelations are worked through. All such distinctions are submerged in the texture pattern.

Another minimum demand on a work of art is hierarchy. In order to hold our attention, the dominant masses, which determine the basic "plot" of work at the top level of structure, are made up of secondary units, whose interrelations represent an enriching refinement of, or counterpoint to, the top structure. Additional, lower structural levels often develop the main theme down to the capillaries. The complexity of human existence demands some such corresponding complexity from even the simplest work of art if we are to recognize ourselves in it. The statements produced even by the most artful filigree texture, however, are as disconcertingly elementary as a train whistle or a flash of light. In no way can such texture work be compared with the overall uniformity of pattern found in the mature style of the masters, for instance, in Cézanne's late water colors. For in the masterwork the multiform manifestations of life are brought into an overall unity that still preserves all the richness, whereas the texture pattern reduces the content to the poor extract of perceptual induction.

The spontaneous stroke. An extreme of accident, that is, minimum lawfulness of relation, is embodied in the texture patterns. To produce them by human rather than by mechanical means is quite difficult because in all organic behavior—be it perceptual, motor, or intellectual, conscious or unconscious—there is a measure of spon-

taneous order. On the other hand, an admixture of accident is also one of the trademarks of human behavior, owing to the multiplicity of impulse that complicates all organic functioning. We have learned to value the charm of such imperfection since we met the immaculate products of machines.

This modern taste for the human "touch" derives historically from the new appreciation of creative man that develops during the Renaissance. As long as the artist's task was defined as the making of objects that met specifications of correctness, faithfulness, and proportion, the marks of the maker were carefully wiped off. The change took place slowly, however. In a recent monograph on "the handwriting of painters," Volavka notes that even Leonardo objects to *"pennellate terminate e tratteggionati aspri e crudi,"* [15] and that Vasari takes a dim view of Titian's late paintings, *"condotte di colpi, tirate via grosso, e con macchie . . ."* [16] Vasari admits that while these paintings cannot be looked at from close by, they appear perfect from a distance, and that the effect is beautiful and stupendous *"perchè fa parere vive le pitture,"* [17] but he concludes that it would have been better for Titian's reputation if in his last years he had used painting only as a pastime. The artistic virtues and vices of the "divided" stroke, as Volavka calls it, play a part in the controversy of the classicist school of Poussin against the colorists around Rubens; and to Diderot the paintings of Chardin were crude, and tolerable only when viewed from a distance. Apparently, there is no true appreciation of the "touch" before the late eighteenth century. For a long time, the bold innovation must have been taken as an accidental intrusion of the maker into the world of the making.

In the meantime, however, there developed an admiration for the virtuoso, who with a few rapid but controlled strokes outpaints the slow average craftsman. By the conspicuous traces of their *bravura*, masters such as Titian, Velázquez, or Rubens authenticated the products of their workshops. What was boasted and admired here was not so much a pictorial quality of the work as the facility of the making. It was the capacity,

acquired through decades of practice, to attain a perfectly controlled objective by a motor process that in itself was not controlled but spontaneous, and whose traces on the canvas showed the freshness, elegance, and ease of the freedom from conscious guidance. The artist must have experienced a partial surrender to an organic power—often interpreted as divine inspiration—quite different from the capacity to calculate, plan, and carefully accompany the stroke: he may have felt awe, pride, and the relief of confidently delegating responsibility to an ingenious agent.

Accident as a creative device. The free brush stroke of the Baroque, then, was a first step toward the surrender of artistic initiative. It was not before the time of the romantic movement, however, that the contribution of spontaneous forces was explicitly acknowledged and sanctioned. Herbert Read says: "What was achieved in this first phase of romanticism was a dissociation of the will, as the active aspect of the intellect, and the imagination. The will was seen as always inhibiting or distorting the free play of the imagination, and this 'free play' was identified with the 'real self.' The unconscious, the dream world, became a refuge from an impersonal and harsh materialistic world." We notice that by then the helpful power had been identified as the unconscious, and also that the surrender was no longer limited to a technical detail of execution but tended to apply to the very conception of the work of art. When, finally, in the twentieth century, the surrealists entered the scene, the necessity behind the seemingly accidental images of dreams had been confirmed by Freud, so that we are not surprised to find André Breton say in the first of his manifestos of surrealism: "I should like to sleep, to be able to deliver myself to the sleepers the way I deliver myself to those who read me with open eyes." And he tells of a fellow-writer who every night when he went to bed put a sign on his door: *Le poète travaille.* Breton did not hesitate to maintain that "psychical automatism" was a technique for expressing "the real functioning of thought." How valid is this claim?

Passivity and the unconscious. The psychological discussion has been made difficult by the fact that the term "unconscious" has become a catchall for whatever activities lie beyond conscious control. In consequence, all of them tend to be identified with the very specific kind of unconscious process that is treated in analytical depth-psychology. It is assumed, for example, that any surrender of awareness at all will open automatically the resources of wisdom that, according to the romantic version of psychoanalysis, hide in the treasure house of the unconscious. In order to point up the confusion it may suffice roughly to distinguish between (a) the basic motivational strivings investigated by psychoanalysis, (b) the creative cognitive processes that also operate below the level of consciousness and are responsible for intuitive insights and for the flash solutions of stubborn scientific or artistic problems, (c) the automatic practicing of skills or aimless doodling, made possible by a detachment of partial psychical functions from central control; finally, there are (d) such purely physical chance operations as the throwing of dice or pennies, which are controlled by no agency of the mind at all, as long as they are not subject to telekinesis.

Since the non-conscious is a house of many mansions, there is no reason to believe that whenever conscious control lapses, the deepest layers of the mind will be tuned in automatically. More normally, what comes to the fore in relaxation will be the fairly disorganized result of the interaction among the various layers. When the process is close to the surface—as in daydreams, doodles, or free associations—automatisms will go into action, daylight thoughts and the after-images of recent experiences will float by, modified through erratic intrusions from deeper levels. In dreams, the proportion will be reversed; but the stream of unconsciousness is no more orderly than that of consciousness. According to Jung, "dreams that satisfy logically, ethically, and aesthetically are, of course, exceptions. As a rule, the dream is a peculiar and strange contraption, distinguished by lack of logic, dubious morals, unattractive form, and obvious

contradiction or nonsense." Such mental products can be interpreted analytically but they are nothing better than raw material artistically.

Furthermore, we must not be caught by the prejudice that the mental layers most remote from consciousness are the "deepest" ones in any other sense than the purely topological, and that, therefore, they are the most valuable for artistic creation. Presumably, little of genuine value will arise either in the extreme depth, namely, from the crude primitivism of mainly "archetypal" vision, or at the extreme surface, that is, from the flatness of mainly perceptual or intellectual productions. Any true work of art requires the cooperation of all the essential layers of the mind—not, however, in the form of the erratic interpenetration I just described as the state of relaxation. Art is no occupation for relaxed people; because the resources of the mind must be forged into organized shape by conscious and unconscious discipline, which requires the effort of concentration. Accident is a shrewd helper, and the unconscious is a powerful one. Art has always profited from both; but they are only assistants. The sudden inspirations of creative men seem to take place after insistent wrestling with the problem, and the Zen Buddhists, who preach against conscious control and willful effort, do not recommend sleep, distraction, or parlor games: "A painter seats himself before his pupils. He examines his brush and slowly makes it ready for use, carefully rubs ink, straightens the long strip of paper that lies before him on the mat, and finally, after lapsing for a while into profound concentration, in which he sits like one inviolable, he produces with rapid, absolutely sure strokes a picture which, capable of no further correction and needing none, serves the class as a model."

Withdrawal and surrender. The texture pictures which we discussed are probably somewhere in between accidental production and the production of accident. On the one hand, they are due to what I described as the detachment of partial psychical functions from central control. Certain relatively self-contained mechanisms, such as motor behavior or perception, can operate practically on their own. When released from control, they will rely

on routine reactions and automatic skills—as when we are driving a car without being aware of what we are doing or when the brush of Frans Hals plays over the canvas—or they will betray their detachment from the central concerns of the mind by the monotony and lack of organization in their performance. We can thus account for the weave of strokes, which surely is not constructed but is rather the largely accidental product of what a pair of hands and a pair of eyes felt like doing at a given time in a given material.

However, the evenness of the pattern throughout the picture suggests that something more than laissez-faire accounts for the result. We know from doodling that when the hand of the draftsman is left alone, the monotonous rhythms of the detached process will be disrupted by impulses, reminiscences, associations from other areas of mental functioning. In the texture patterns we look in vain for the projections from the unconscious that attract the psychologist's attention in doodles. Only by careful perfect homogeneity of the texture, and such control supervision throughout the work will the artist obtain the must be guided by a definite image of what he is trying to accomplish.

This image is clearly the visual embodiment of a maximum of accident, spread with mechanical universality, and not even alleviated by the islands of sense that would intrude if the mind were left to its spontaneous impulses. We recognize the portrait of a life situation in which social, economical, political, and psychological forces have become so complex that at superficial inspection nothing predictable seems to remain but the meaningless routine of daily activities, the undirected milling of anonymous crowds. The well-defined mutual independence of the individual units, observed in Degas and even the cubists, has given way to a lack of any definable relation at all. Fascination, fear, contempt, withdrawal, but also temptation—we can only guess at what the artist feels about the subject matter of his work. In any case, the very depicting of standardized chaos makes him share the attitude of which he creates an image: the machine-like monotony of production, brought to further perfec-

tion since Seurat and the pointillists tapped out their pictures through thousands of frighteningly uniform color dots, the willingness to put up with the façade of shapelessness, and the surrender of initiative to transcendent powers, which makes people entrust themselves to gods, ghosts, instincts, archetypes, or the mathematics of probability "when there is distress of nations and perplexity."

NOTES

1– These warriors are now called inauthentic.

2– Hathor was the Egyptian goddess of love. The cow was sacred to her.

3– Belonging to the type of god standing on a bull. See Harold Mattingly, *Roman Imperial Civilization* (Anchor ed.), 253.

4– The type of god or hero hunting or fighting on horseback (on a slab or stele).

5– Mèn and Sabazios were represented with a foot on an animal.

6– Formal descriptions of works of art.

7– Friedlaender was writing this in 1925, before the essays were printed as a book.

8– The reference is to Michelangelo.

9– Pontormo and Rosso are discussed after Michelangelo.

10– That is, forms that are not "reified" or "realistic."

11– An apparatus to illustrate the motion of bodies in the solar system. It was devised by Charles Boyle, fourth Earl of Orrery.

12– President of the Royal Academy (PRA) and Pre-Raphaelite Brother (PRB), a member of the Pre-Raphaelite Brotherhood.

13– Specialists in landscape, genre, animal life, or portrait. Cornelius said, "True art knows no separate genres."

14– "Perhaps it would not be wrong to abandon this great evil."

15– "Brushwork harshly and roughly touched and finished."

16– "Executed in bold strokes and with splotches."

17– "Since it makes the painting seem lifelike."

WYLIE SYPHER is professor of English, and chairman of the division of language, literature and arts at Simmons College in Boston. Born in Mount Kisco, New York, Mr. Sypher was graduated from Amherst College, received master's degrees from Tufts College and from Harvard, and a Ph.D. from Harvard. He has taught summers at the University of Wisconsin, the University of Minnesota, and at the Bread Loaf School of English, and twice has been awarded a Guggenheim fellowship for research in the theory of fine arts and literature. His book, *Four Stages of Renaissance Style*, published in 1955, has become an influential work on its subject. His other books include *Enlightened England, Guinea's Captive Kings, Rococo to Cubism in Art and Literature*, and *Loss of the Self in Modern Literature and Art*.